LOULOU
DE LA FALAISE

" The portrait that I did of Loulou is one of my favorites because it is so spiritual and beyond fashion, just like her. "

— Michael Roberts

"Loulou, thank you for being you, thank you for all you gave us, this is for you."

— Ariel de Ravenel

The Glamorous Romantic

Editor ———— ARIEL DE RAVENEL

Writer ———— NATASHA FRASER-CAVASSONI

Art director ———— ALEXANDRE WOLKOFF

RIZZOLI
NEW YORK

New York · Paris · London · Milan

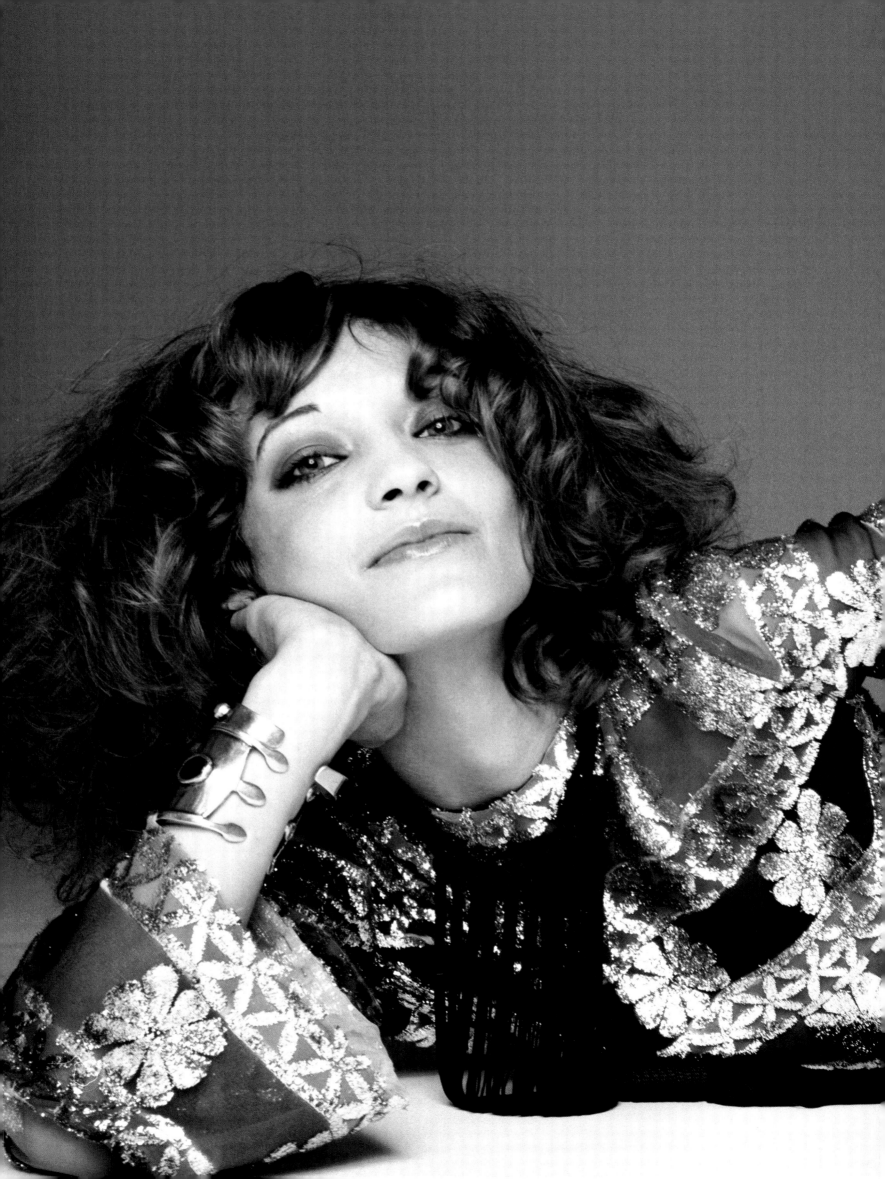

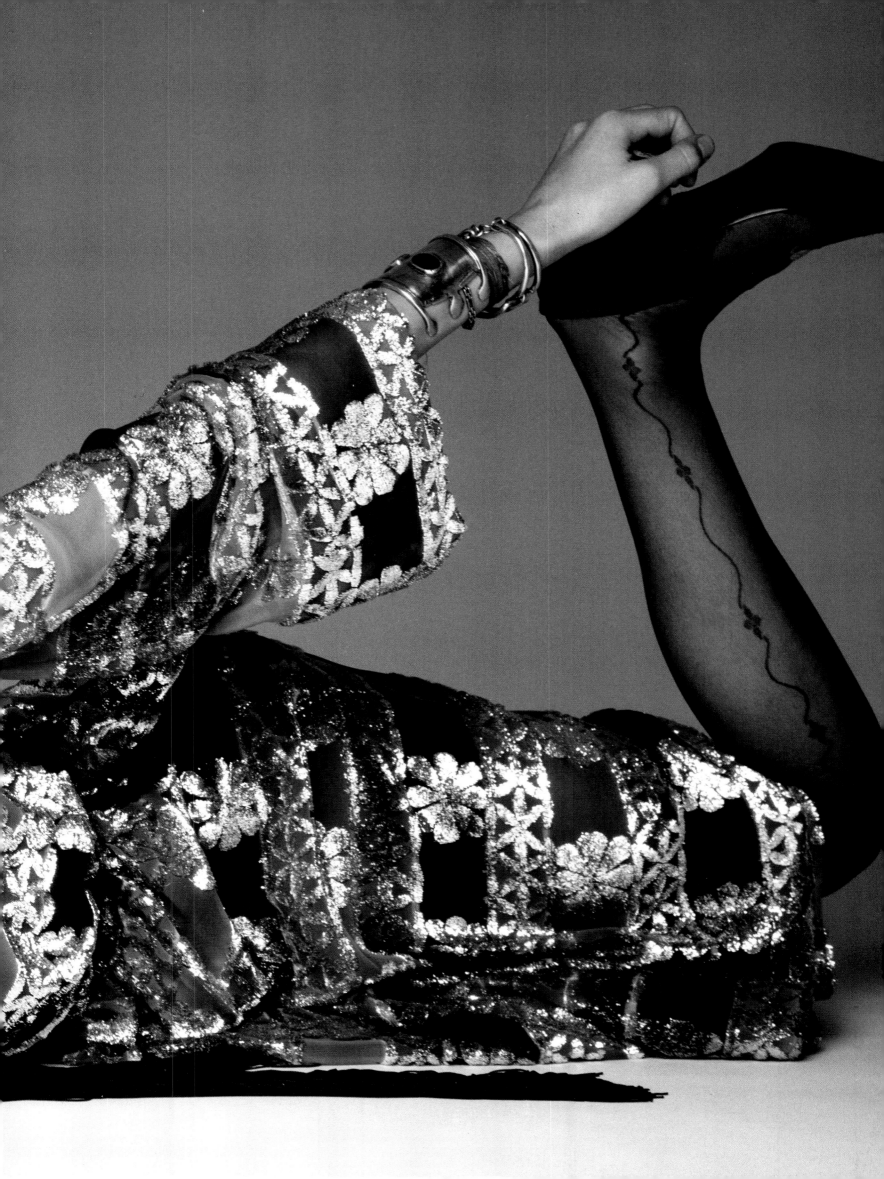

"Loulou was a walking art piece. I always remember her as having the most unique style."
— Marisa Berenson

"Loulou was so original and it was brilliant that Yves Saint Laurent found her. Those relationships are quite rare in fashion."
— Celia Birtwell

"Loulou had a rare gift, which words can only weigh down, communicable sparkle."
— Joan Juliet Buck

"We traveled to China, Japan, Marrakech. Due to Loulou's spirit, it always felt like a holiday."
— Betty Catroux

"She was always true to her own style, with extravagance and panache."
— Carlyne Cerf de Dudzeele

"You took one look at Loulou and gasped."
— Grace Coddington

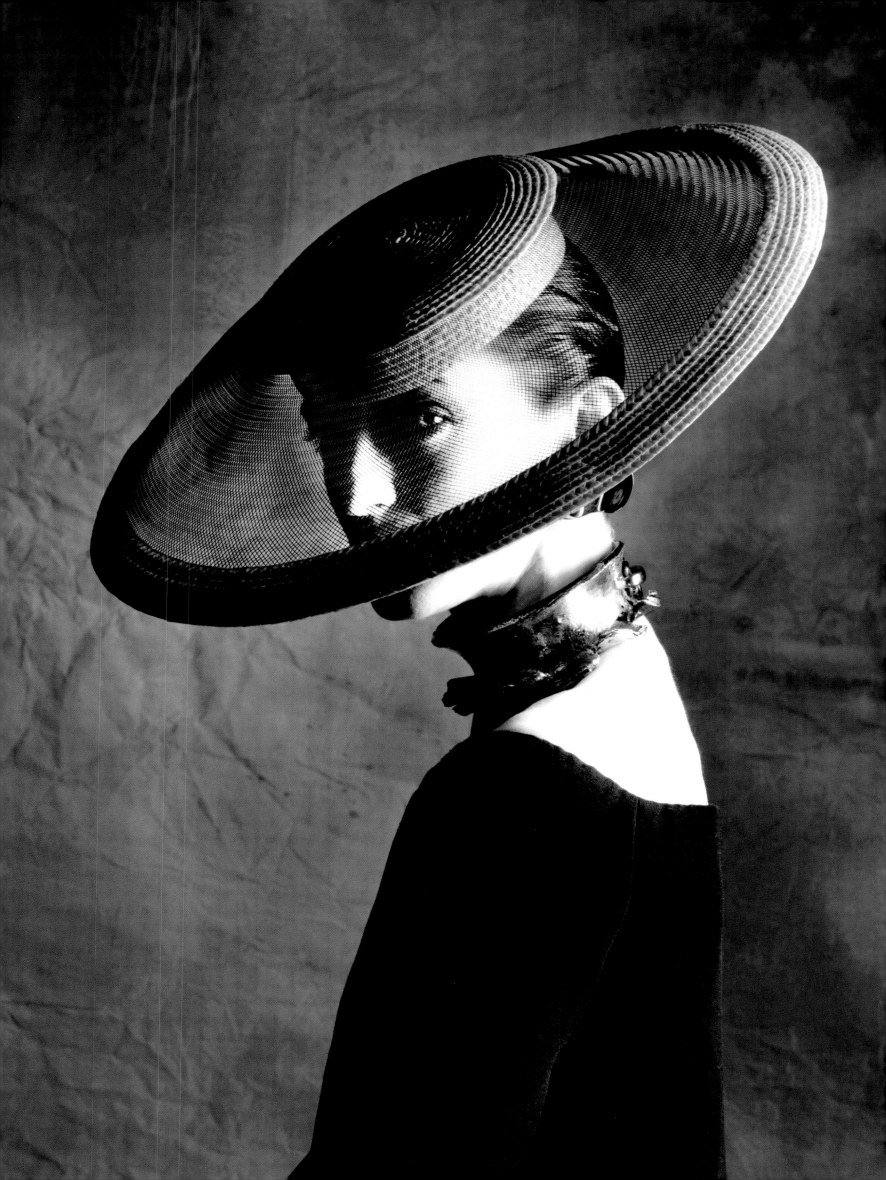

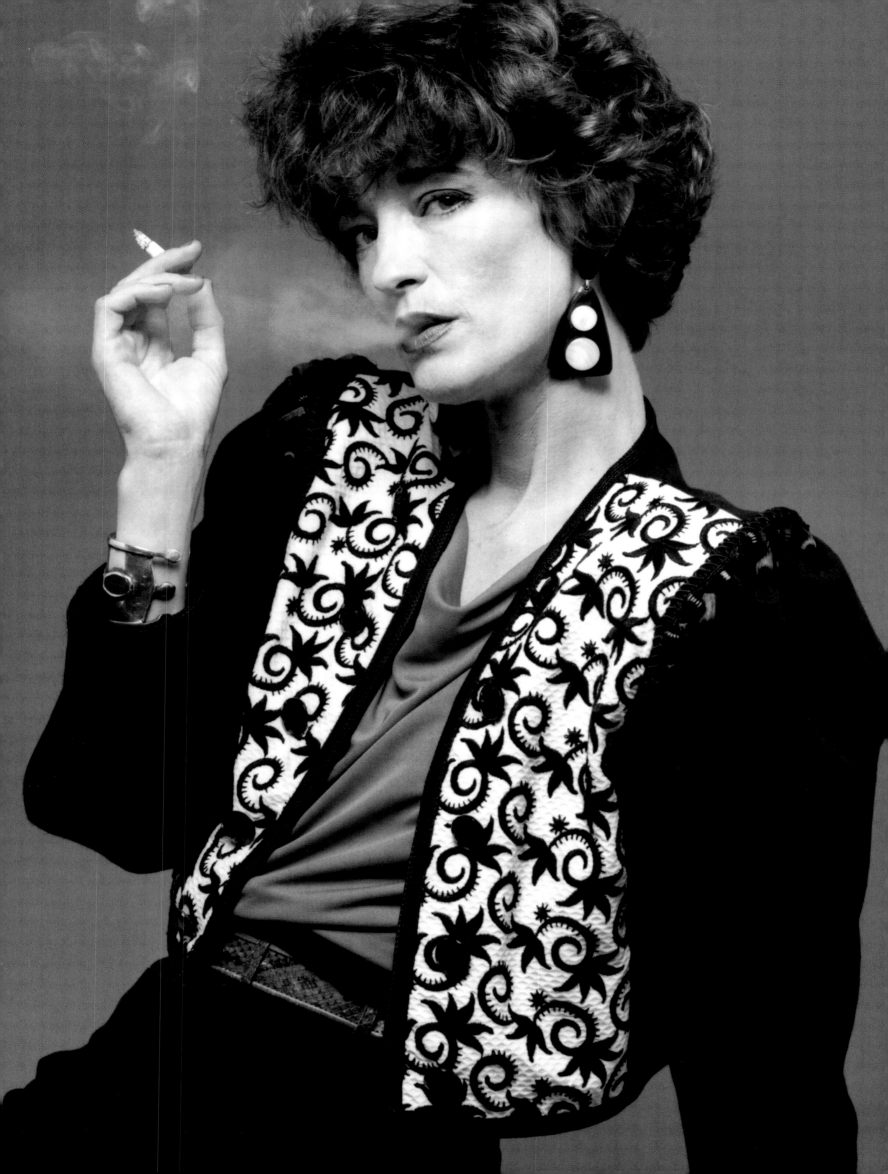

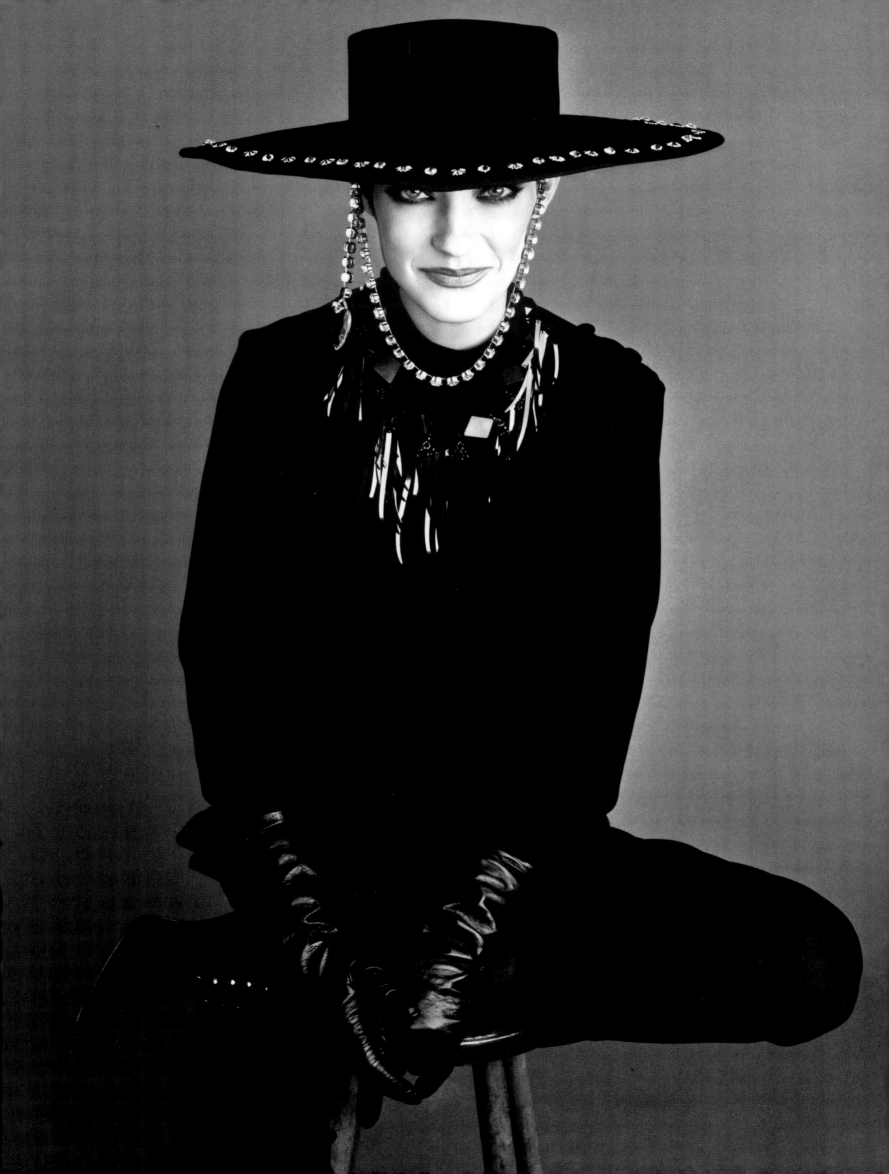

"I always loved the photo of Loulou at her wedding party with a starry shawl wrapped around her head and a shot of her on a sofa with Yves Saint Laurent and Betty Catroux. She seemed like the epitome of a grown-up chic Parisian woman – elegant and fun!"

— Sofia Coppola

"She was infinitely elegant, she was infinitely English, typified by that fantasy and eccentricity and also that reserve, that disguised distance that hides intense feelings."

— Catherine Deneuve

"I knew Loulou all her life, we had a lot of fun together. She was a great icon and everyone adored and admired her."

— Marianne Faithfull

"Surprisingly, this woman who incarnated chic was a tomboy. She had broad shoulders, that way of swinging her arms and a streetwise attitude that made you feel that she could talk to anyone."

— Ines de la Fressange

"Loulou had amazing creativity and it's wonderful that she lives on in so many beautiful photographs."

— Diane von Fürstenberg

"With grace, creativity, innate glamour, and free spiritedness, Loulou imparted fashion to the world with a signature elegance."

— Pamela Golbin

"Loulou was a fascinating woman, whose imagination and taste influenced so many."

— Carolina Herrera

"Loulou was a combination of Colette, Coco Chanel, and all things French and chic."

— Anjelica Huston

"On first sight of Loulou, you knew she was one of a kind, a rare evolutionary wonder."

— Lauren Hutton

"Effortless elegance? Loulou was just born that way, it was in her blood."

— Grace Jones

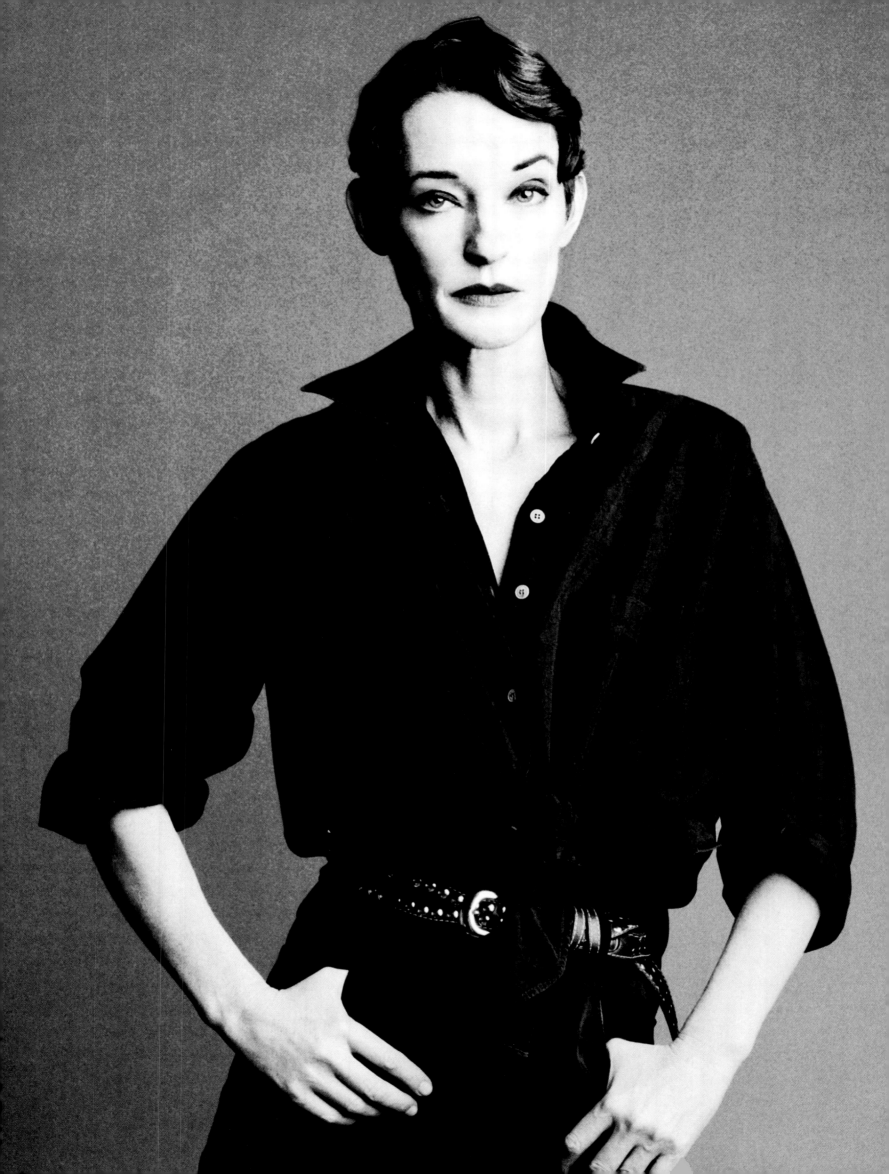

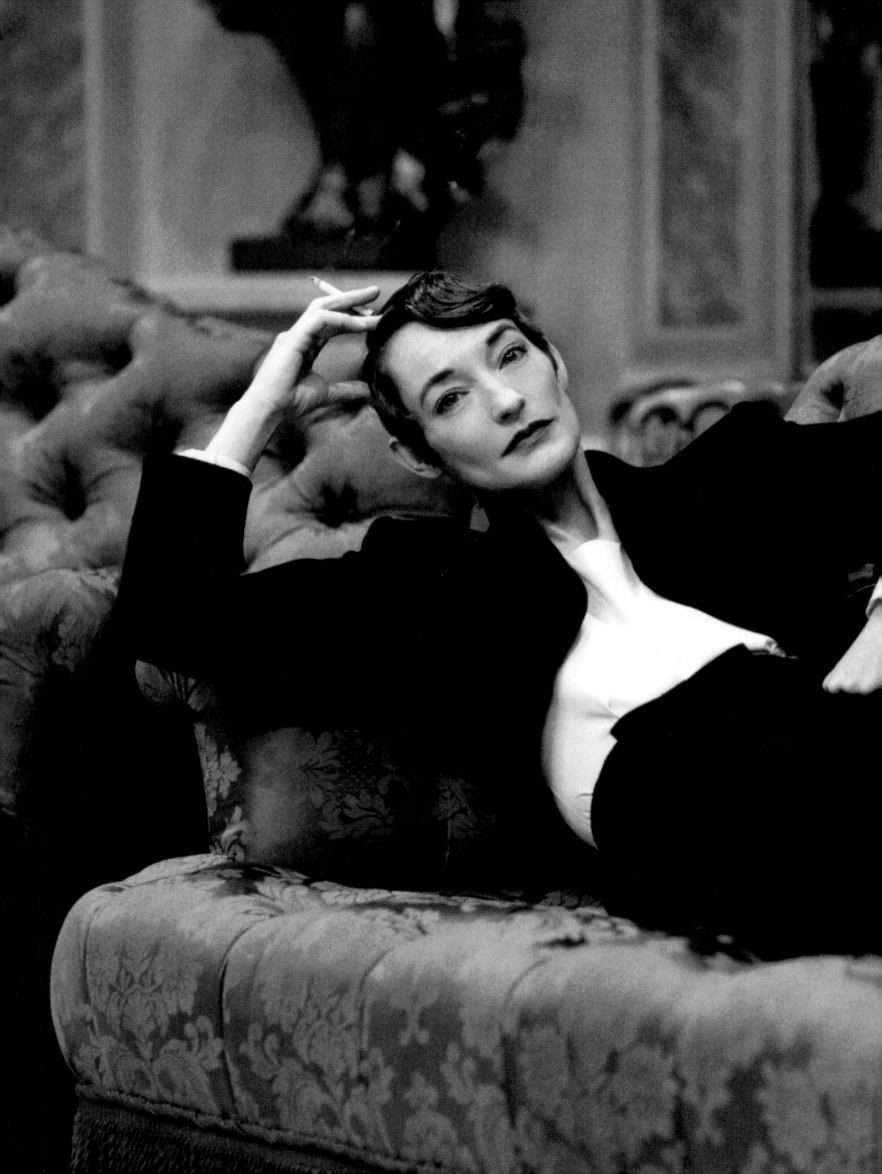

*"I did a Saint Laurent campaign with her when I was about eighteen and she took me under her wing.
The last time I saw her, we hung out all night and had such good fun."*

— Kate Moss

"I always admired Loulou, she could put herself into clothes like magic."

— Elsa Peretti

"Loulou was in her own category, like no one else."

— Paloma Picasso

"Loulou was a lesson in elegance. We all shared different moments with her. She laughed a lot, but she worked so hard. It was delicious being with her."

— Bettina Rheims

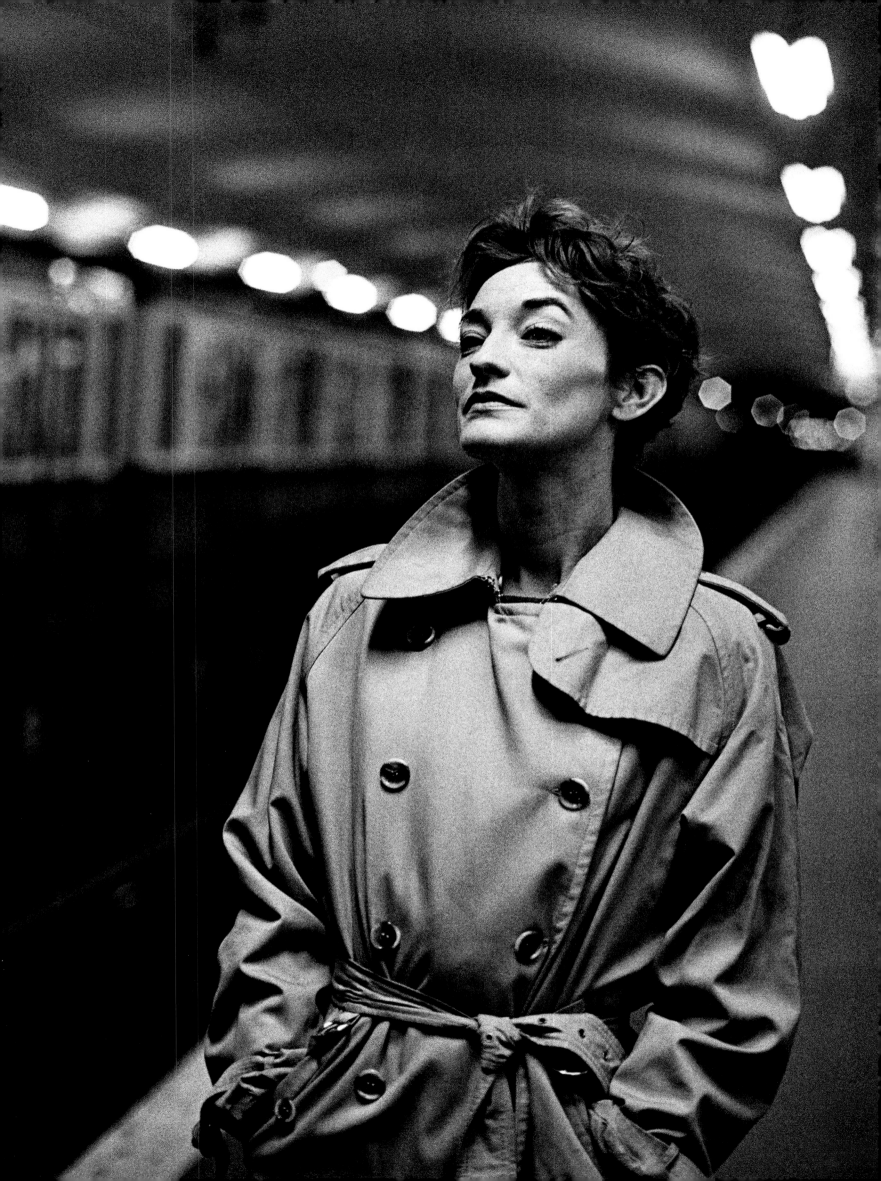

CONTENTS

Loulou photographed by Pierre Bergé in Marrakech circa 1970.

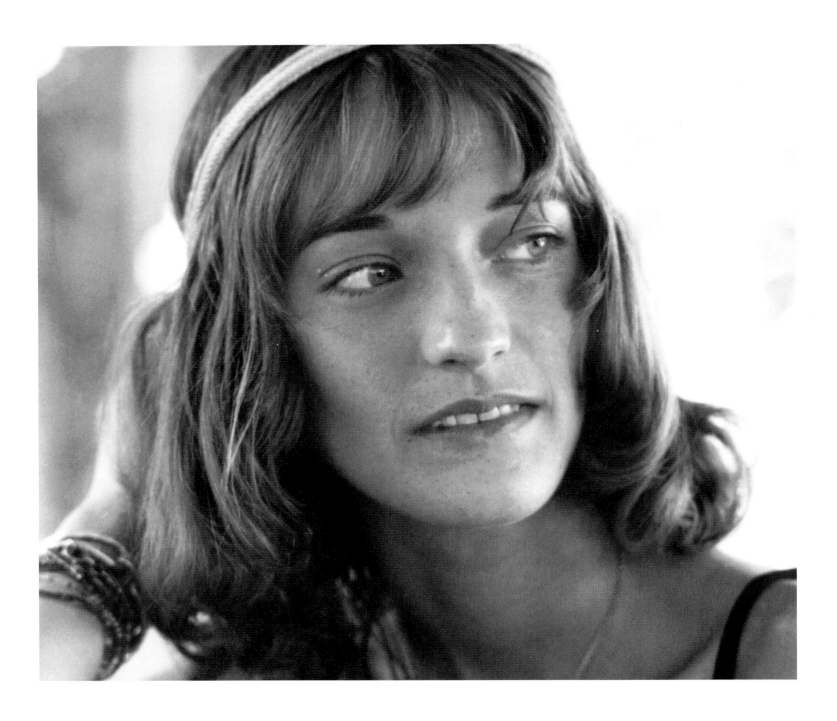

Loulou de la Falaise

Such a French name for a British woman who was... so British.
Her father, the Marquis de la Falaise, was a member of the Jockey Club. She resembled him, and yet it was from her mother, Maxime, and her grandmother, Lady Birley, that she acquired the eccentricity and boldness that served as her passports in life.

Yves Saint Laurent and I met her through Fernando Sanchez, a fashion designer from New York. He had been seduced by her charm; we soon succumbed as well. Yves hired her to work alongside him, fulfilling the same role that Mitzah Bricard had held beside Christian Dior. Her striking personality and talent quickly led Yves to designate her as the creative force driving jewelry and accessory design at the fashion house.

We were delighted when she married Thadée Klossowski. They seemed to emerge from a Burne-Jones painting, which fascinated Yves and me, ardent admirers of the Pre-Raphaelite artists. They became part of our family. The real family, the one we choose. Yves, without hesitation, became godfather of their daughter, Anna.

Above all, I should speak of Loulou the designer. Like her mother before her, fashion was in her blood. She had a sharp and exacting eye. Worn by her, clothing appeared as a second skin. Jewels appeared wondrously from her hands, those of a magician. Loulou's mysterious character was reflected in her enigmatic, otherwordly hats. She had a passion for life, and when she died, many among us knew we had lost someone unique. She bravely and defiantly confronted her illness. She hated gossip, lies, and unmannerly people. Loulou maintained her dignity to the end. She fought her last battle with courage, and if I dare say so, *avec chic*. Chic, the French word that describes her so well, and which she so marvelously personified.

May this book be more than a homage; may it be a source of inspiration for those who never knew her. When seeing these photos, may Thadée, who so loved her, remember the many joyous moments we were blessed to share with her.

— Pierre Bergé

A Remarkable

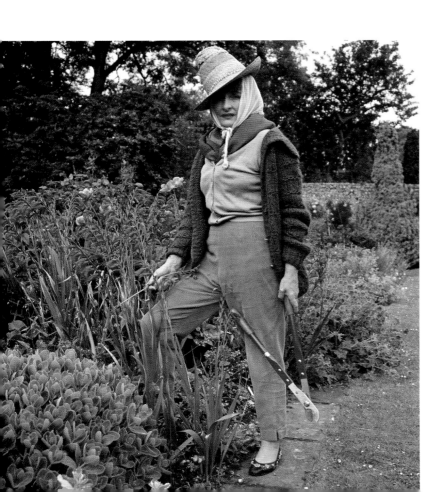

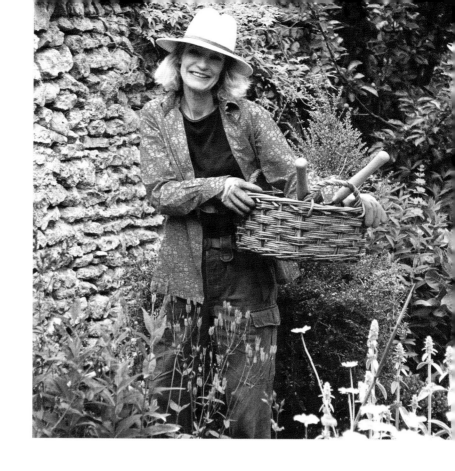

DYNASTY

"Rhoda, Maxime, and Loulou were three beautiful women who each had their own character and style."

— Hubert de Givenchy

Loulou, christened Louise Vava Lucia Henriette Le Bailly de La Falaise, was born in London on May 4, 1947. Even as a child, she was enchanting. "There was something so surreal about her beauty that people used to stare at her in the street," recalls her aunt Lady Annabel Goldsmith. Brilliant and armed with "the best sense of humor," little Loulou was also extremely creative. "She used to do endless drawings of dresses and was a very good draftsman."

Loulou's family connections were equally exceptional. Her mother was Maxime Birley, a renowned English model in Paris, and her father was Alain de la Falaise, a French count who was a publisher and whose brother Henri was married to Gloria Swanson and Constance Bennett. Her maternal grandmother was Rhoda Pike, the charismatic Irish hostess who became noted for her cooking and gardening, and her grandfather was Sir Oswald Birley, the Court of St. James portraitist who was considered the John Singer Sargent of his day due to the wide scope of his subjects.

Sir Oswald passed away when Loulou was five years old and, in spite of having a distinguished career painting prime ministers and heiresses, he was a peripheral figure in her life. Instead, the center stage was taken up and unwillingly shared by his wife Rhoda, Lady Birley, and daughter Maxime. "You cannot imagine how competitive they were," says art historian John Richardson — to such an alarming degree that they could not even agree on the hour of Loulou's birth: Rhoda insisted that it was teatime, while Maxime stood firm on cocktail hour. What is sure is that Loulou was born on a Sunday, making her "bonnie, blithe and gay," according to the English nursery rhyme, and she possessed an astrological chart implying that she was creatively charged, intuitive, stubborn, and feisty — all qualities that would serve her well her entire life.

In spite of all Loulou's eventual achievements, society costume jeweler Kenneth Jay Lane points out that "it's impossible to talk about Loulou without referring to her family." He is one of the rare people to have been friendly with Rhoda, Maxime, and Loulou. "They were extraordinary but so mixed up with some good elements, some strange," he explains. "Loulou really was a branch off Maxime, who was a branch off Rhoda." And whoever met each character was likely to be marked by the occasion, not just due to their charisma and appearance but also because they were "great crack," an Irish expression meaning that they were tremendous fun.

Sir Oswald Birley with his wife Rhoda and daughter Maxime, photographed in his studio by Cecil Beaton in 1935.

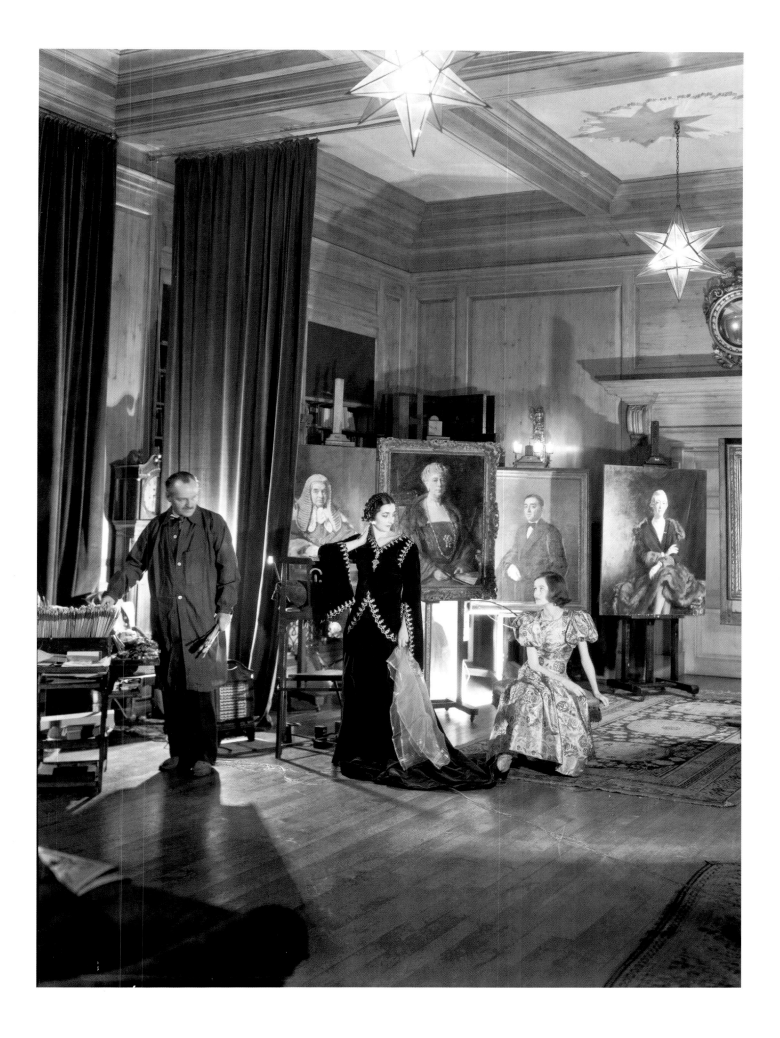

Rhoda was born in County Carlow to an old Irish Quaker family. Her father Robert Lecky Pike was the high sheriff and her mother Vavarina was a dashing figure described by *Vogue*'s Hamish Bowles as sporting "ivory fedoras and beige cardigans acquired at the gentleman's departments of the London stores." Resembling an Augustus John painting—Rhoda had dramatic looks, with her mass of thick, dark hair — she married Sir Oswald, her senior by twenty years. Admirers like Hubert de Givenchy were transfixed by her pale gray-greenish eyes "that held such force and seductive powers" and her look that "channeled gypsy with her necklaces, belts, and gathered skirts." A client of Schiaparelli and Balenciaga, she was referred to by de Givenchy as "a gypsy-like Millicent Rogers." "Clothes came naturally to her and her chic came from within," the iconic designer says.

Displaying dash and determination, Rhoda would appear in Palm Beach, staying at the home of the heiress Alice De Lamar. "She looked quite different from everyone else," notes de Givenchy. "Out of her suitcase, Rhoda would produce all these necklaces that she had made and organize exhibitions selling them." Considering most people in Palm Beach favored Cartier and Van Cleef & Arpels, the sales of the colorful, eye-catching trinkets were a testament to Rhoda's flair and charm.

The midsummer garden and arts festivals that Rhoda organized at Charleston Manor, her house in East Sussex, were more whimsical. In her 1970 book *The Beautiful Fall: Fashion Genius, and Glorious Excess in 1970s Paris*, Alicia Drake describes Rhoda serving up "violet cake and violet-colored ice-cream shakes to accompany a Christopher Lloyd lecture on clematis and violets." Unique for both the period and her social stature, Rhoda was an inspired cook. Givenchy remembers her always "being in the kitchen, baking bread for the likes of Cecil Beaton, the actor John Gielgud, and art director Oliver Messel." According to Lady Annabel Goldsmith, who married Rhoda's son Mark Birley in 1954, "She invented as she went along." Her outfits were as memorable as the meals she served. Lane attended one of Rhoda's gastronomic symposiums that included Beaton and two other notables of their day, the artist Derek Hill and the cartoonist Osbert Lancaster, where she sported "banana curls hanging from her head," a bright saffron-colored blouse held together with a couple of nice Chanel brooches, and a Spanish shawl wrapped around her waist with a Chanel skirt underneath.

Rhoda was also admired for her green thumb. Having sought the advice of her pals Gertrude Jekyll and Vita Sackville-West, she created Charleston's garden from scratch. Noted for her razzmatazz of hats, veils, and layers, she was lauded for her formal, garden-room style and practical approach.

"Like her grandmother, Loulou was passionate about her garden; it was peaceful and radiated with her sense of fantasy."
— Louis Benech

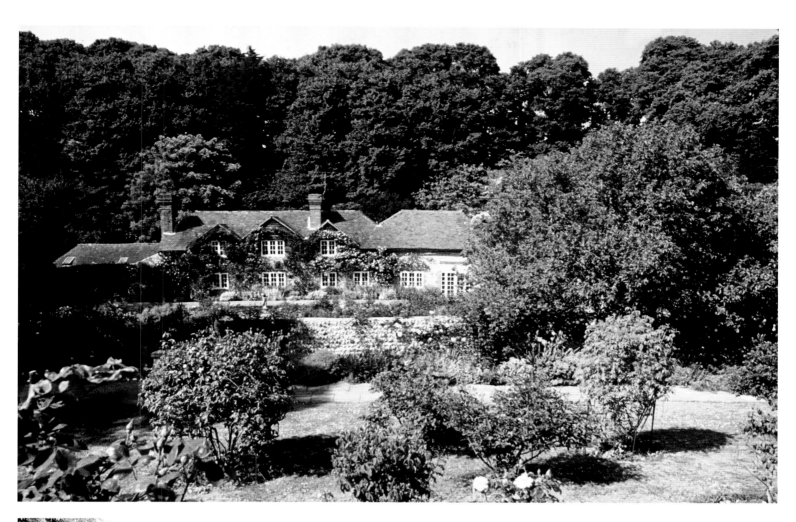

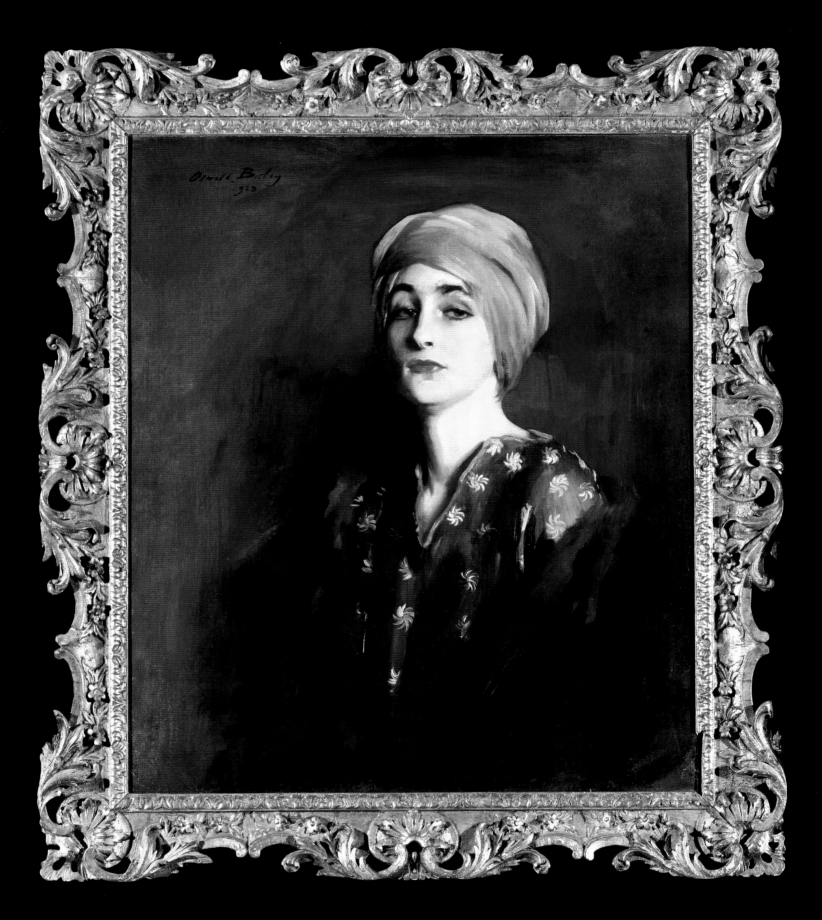

A portrait of Rhoda Birley in a Chinese-silk shirt and turban, painted by her husband in 1923. Inspired by her ever-evolving appearance, Sir Oswald painted her several times.

Although universally popular — "Rhoda was flamboyant but individual and bohemian in the best possible way," says the historian Antonia Fraser — she was unaffectionate to her own children. "She hated to be touched," Loulou later remarked. But concerning her only son, Rhoda took it even further. "I think she thought Mark was the devil and every time he turned his back she would make the sign of cross," Lady Annabel recalls.

Boundaries were not part of the Birley household, but style and presence were. When the newly married Maxime arrived in Paris after the war, jaws dropped. "She was this great beauty with the most magnificent eyes," says Bettina Graziani, the top model at Jacques Fath, "and she could really laugh at herself." Employed as a house model at Schiaparelli, Maxime quickly caught the eye of Hubert de Givenchy, then the assistant designer. "She was a dream to sketch," he says. "And being all neck and leg, everything looked sensational on her. . . . And she had this wonderful, unselfconscious way of walking through the salons that was so unique." He was also fascinated by her fearlessness ("One night she encouraged me to cut her hair really short and then put Kiwi boot polish to make it shine," Givenchy remembers) and impressed by her ideas and taste. "Maxime designed a series of children's organza dresses embroidered with snakes, toads, and poisoned toadstools. Schiaparelli thought they were wonderful!" he recalls.

If Maxime and the equally spectacular-looking de Givenchy entered a cocktail party or ball together, it was followed by a stunned, appreciative silence. And when Cecil Beaton photographed Maxime, he admired how she hunched her shoulders and curved her spine. "You are the only English woman I know who manages to be really chic in really hideous clothes," he once told her.

During this period, Maxime's husband was barely in the picture. "Alain was nice but rather overshadowed by her," says Frank Giles, who ran the office of the London *Times*. An old-fashioned roué who was a member of the Jockey Club, Alain had a weakness for English-speaking women, while "his beautiful legs" had seduced his wife. Still, it was a mismatch and a few years after the birth of their second child, Alexis, in 1948, the couple divorced.

"Rhoda was striking, Maxime was beautiful." — Sir John Richardson

Clockwise from top left: Maxime holding baby Loulou - Maxime in a Schiaparelli suit designed by Hubert de Givenchy in 1949 Loulou with her mother and brother - Loulou playing with her brother Alexis, 1950 - A bronze bust of Loulou's father, Alain de la Falaise (center).

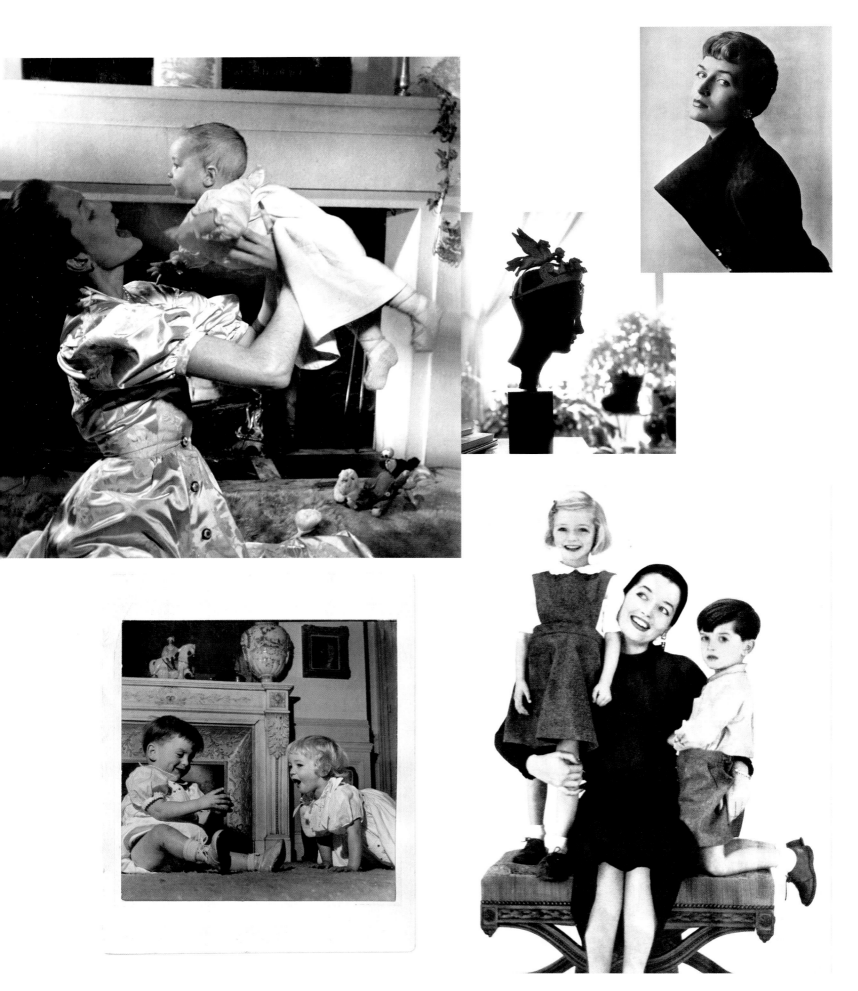

Due to conducting an extramarital affair, Maxime was judged *une mère indigne* by the French courts and lost all her rights as a mother. Alain informed her that she could have one child but not both. Since she could not stand the idea of separating them, Loulou and Alexis were farmed out to a foster family in Seine-et-Marne. At the tender age of four and three, they were essentially abandoned to live in the French countryside with a couple that Alain's mother only vaguely knew. Even during the early 1950s, when privileged children saw more of their nannies than parents, the decision staggers. Later, Loulou condemned the period as "too painful to talk about."

Demonstrating admirable inner resources, Loulou found solace in the countryside. "She created this whole imaginative world talking to trees and rocks," says her husband, Thadée Klossowski. Her main goal, however, was to protect her little brother, whom Thadée describes as the person whom Loulou loved most deeply in her life. Later, when they were sent to boarding schools in England and Switzerland and shuffled between family members, their bond only strengthened further. Indeed, from an early age, Loulou refused to be a victim. "She and Alexis never put their crap on the table, which is so admirable," says Lucie, Alexis's daughter. "They proved it's not what you are dealt, it's what you make of it." Viewing them as "optimistic and happy creatures," she describes them as having "this very sweet, nurturing side, which is quite rare if someone hasn't shown it to you."

Loulou's attitude towards Maxime was admirable. "She was so kind and forgiving," says Robin Birley, the son of Loulou's uncle Mark Birley. "She never delved into the sadness of her childhood and I was really impressed by that. It would have been very easy to have been chippie about Maxime but she wasn't." After Maxime lost her second husband, John McKendry, in 1975, Loulou would call close friends like André Leon Talley and ask if he could visit her lonely mother. "Loulou cared in the way that British people take care of their kin," he says. "She would get exhausted with Maxime but she really loved her." In some ways, Loulou reminded the Southern-born Talley of characters from Eudora Welty's novels. "Loulou and Maxime were authentic," he says. "They were exotic, vulnerable but survivors. In the same way that people in the South survive."

Bettina Graziani admired how, when Maxime was broke, which was often, she nevertheless gave the impression of being rich. "Physically she dominated," she says. "She had that 'show must go on' spirit that never changed." Talley was amused by the tales of Maxime's dinners, given in her cramped Paris apartment that led to her laying out dinner on the ironing board. "When you're chic, you can get away with that," he says. "Loulou had the same quality." And so did Rhoda. "She understood attitude," says Hubert de Givenchy, "and started a dynasty of glamour and chic."

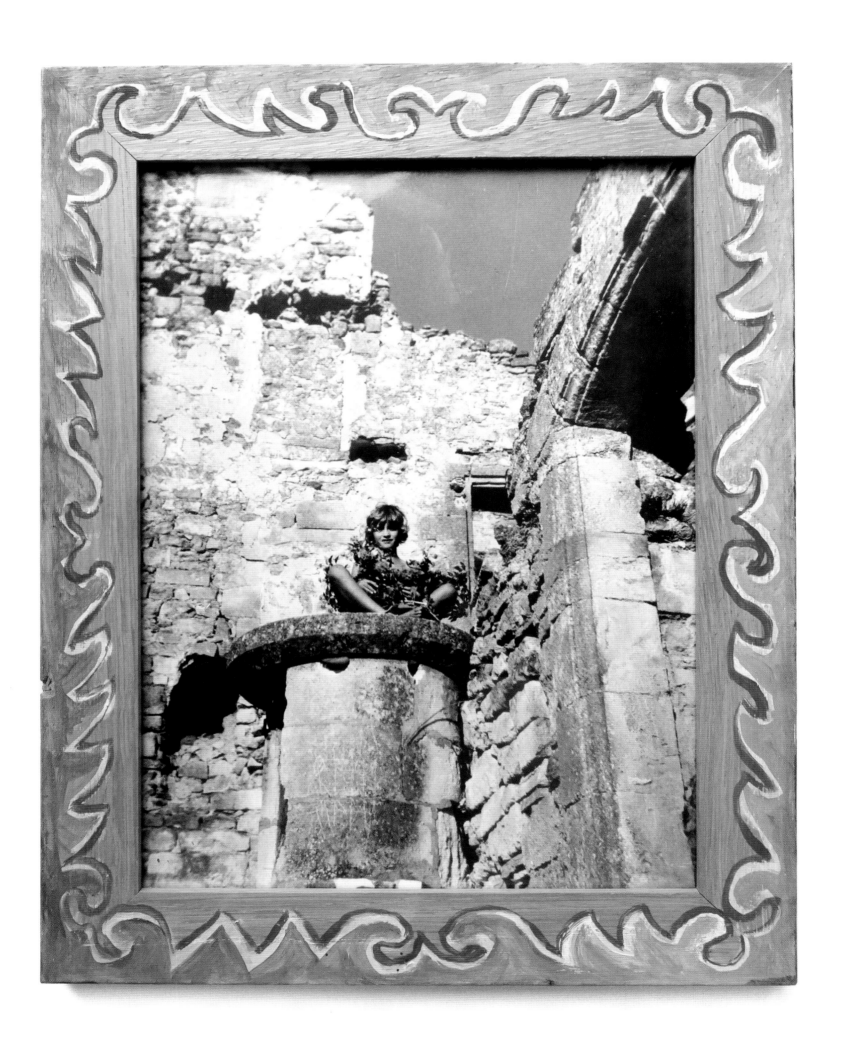

OPPOSITE — Loulou at Lacoste, the Marquis de Sade's château (picture frame created by Maxime).
BELOW — Clockwise from top left: Standing on Alexis's shoulders in Majorca - Snapped on the beach - Swimming with her father - With Maxime and Alexis - Already stylish in her sweater.

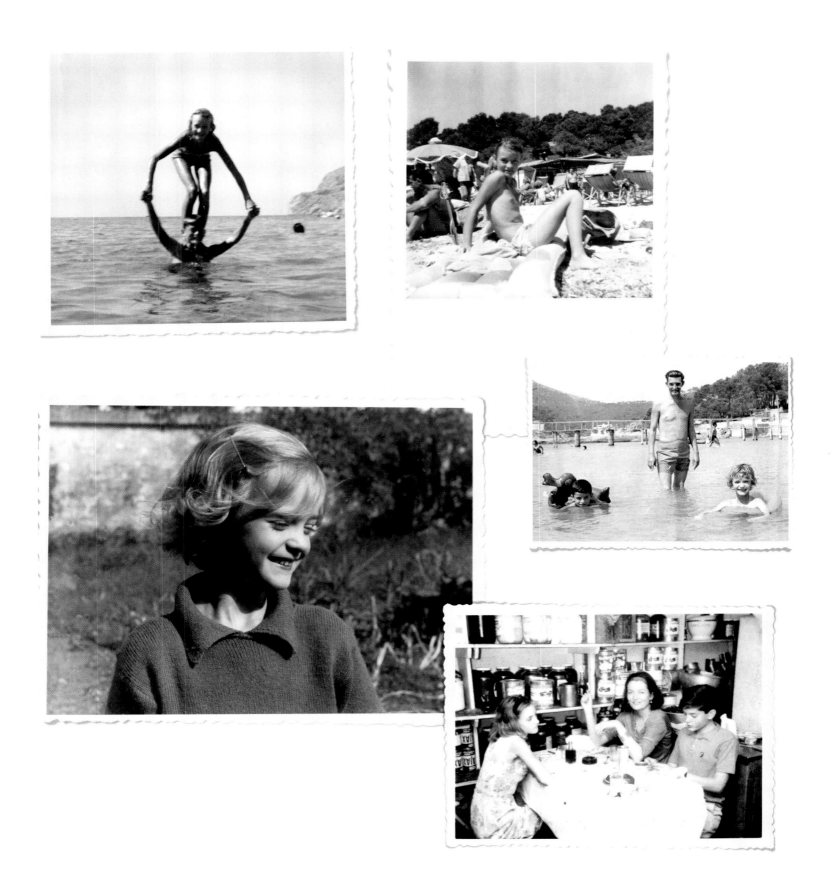

"I cannot say if Maxime was bad or good but she was a very special mother."

— Kenneth Jay Lane

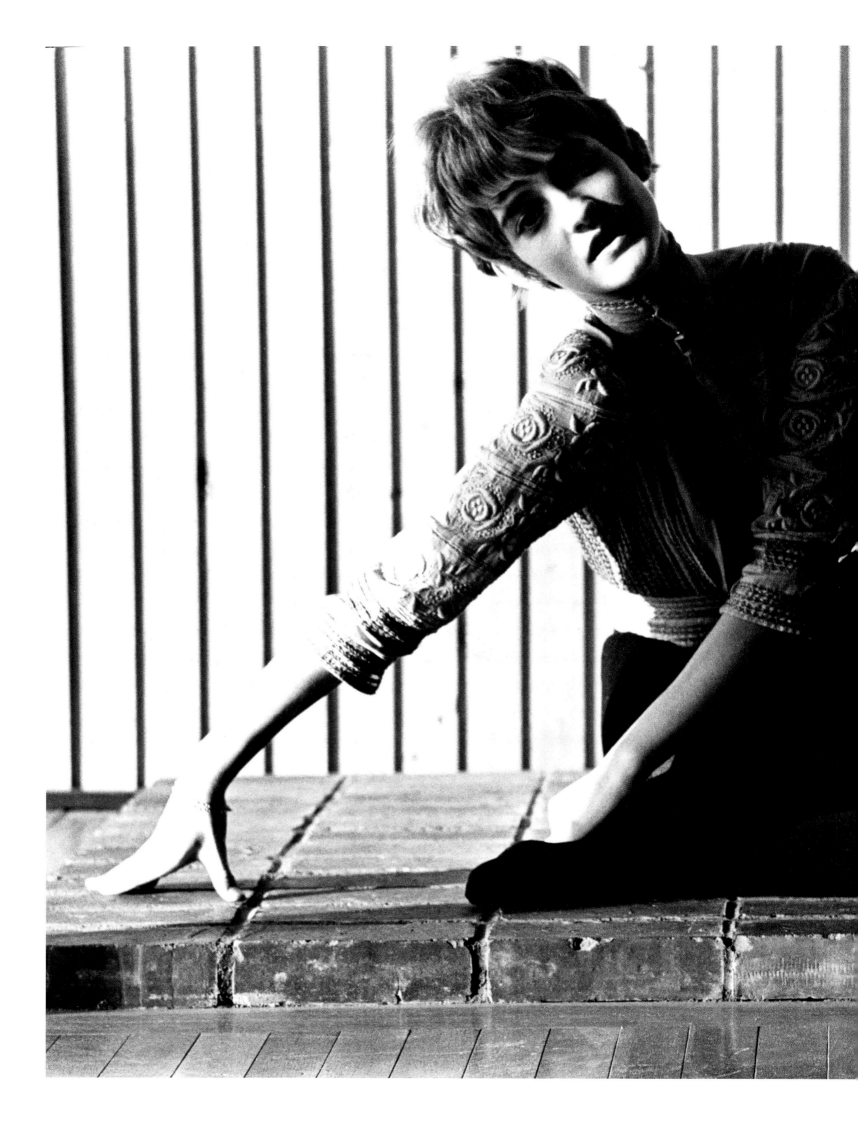

Sixteen-year-old Loulou's first try at modeling. Photographed by Hans Namuth in Watermill, Long Island, 1963.
FOLLOWING – Maxime in Schiaparelli, photographed by Gordon Parks for Vogue, 1949 (left) - Loulou photographed by Hans Namuth in 1963 (right).

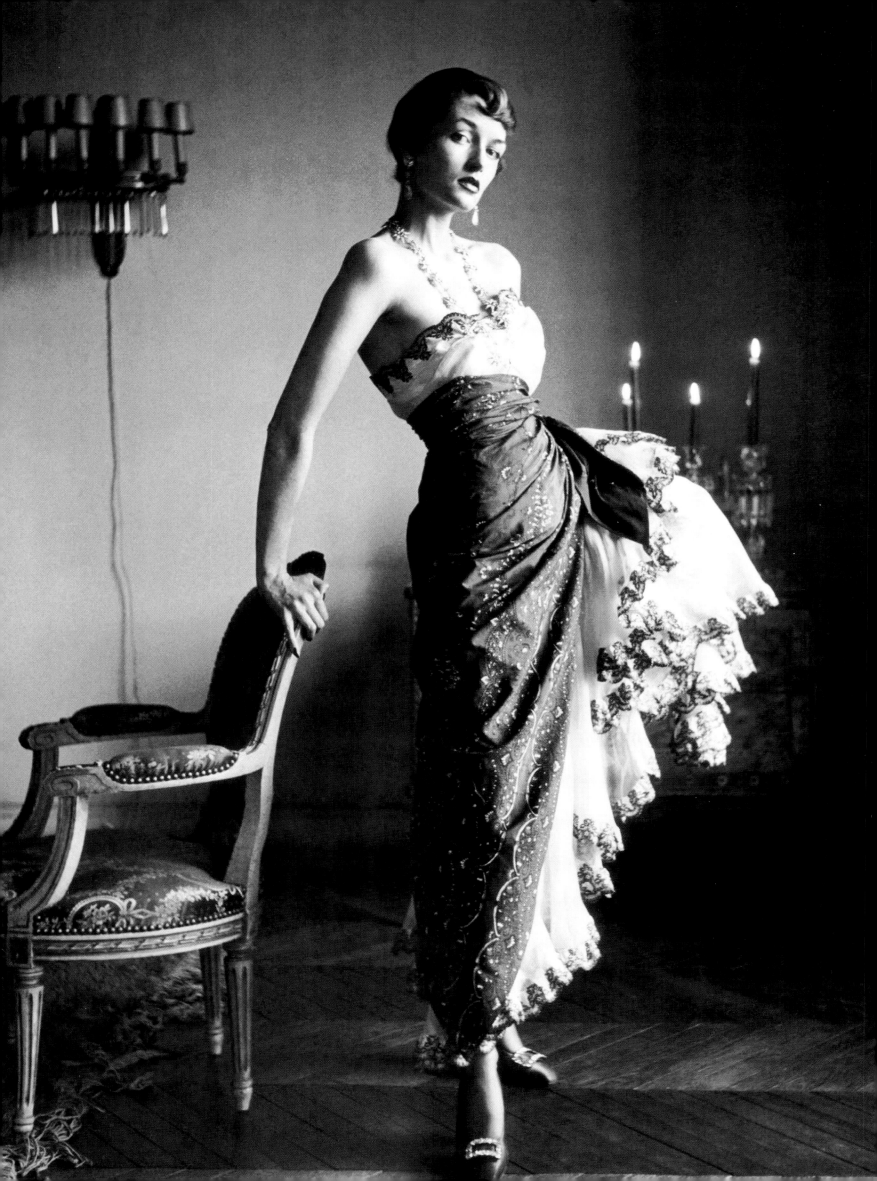

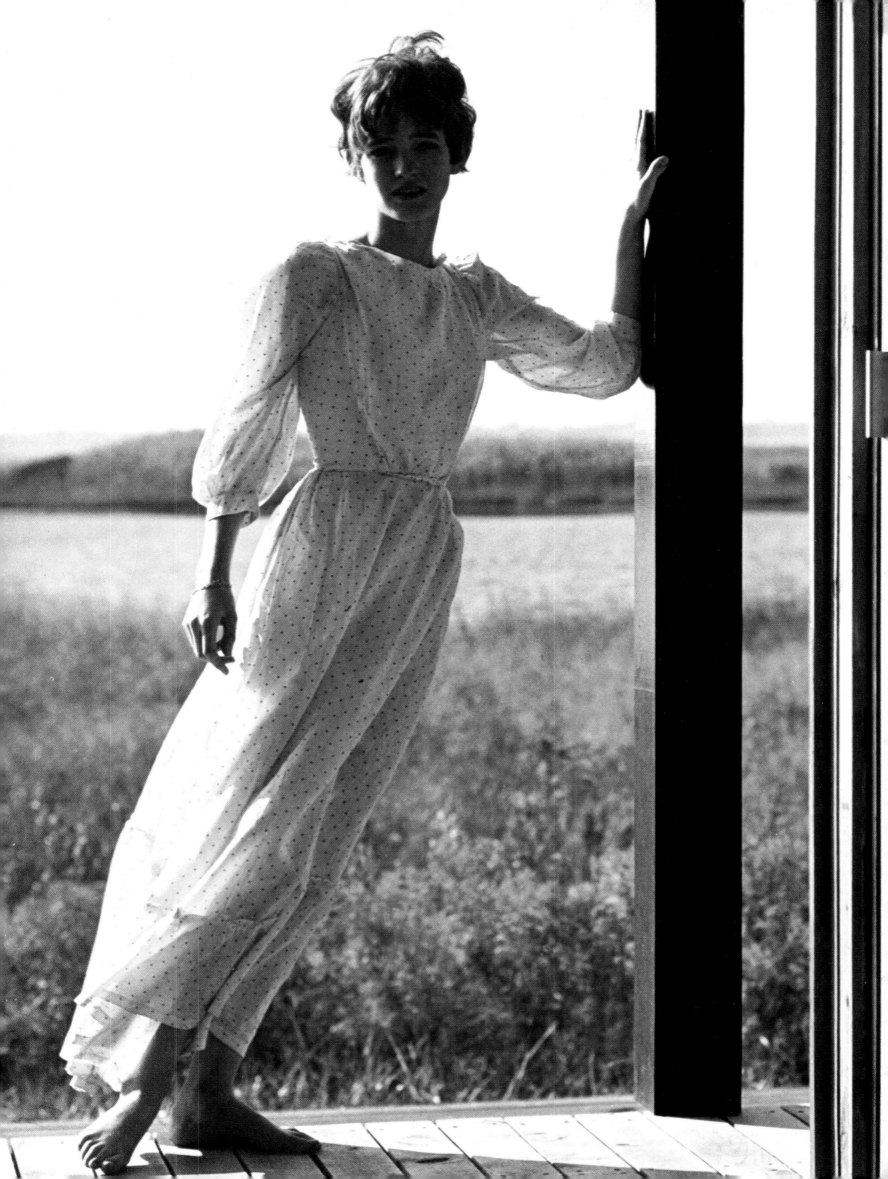

BELOW — Maxime wearing a black and white striped taffeta fishtail gown by Paquin,
photographed by Cecil Beaton for *Vogue Paris* in January, 1950.
OPPOSITE — Loulou relaxed at sea.

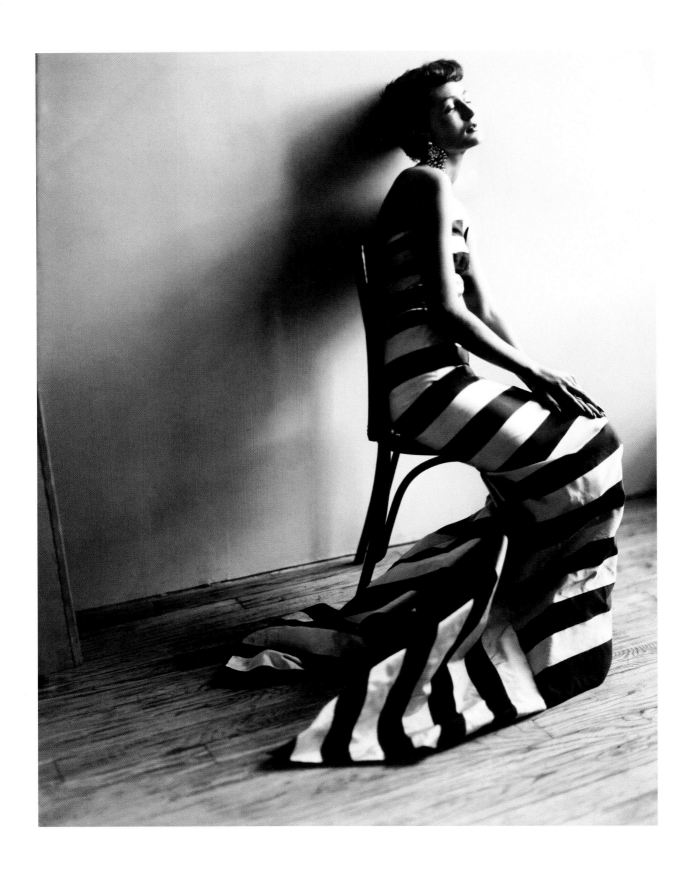

*" Like Maxime, Loulou was not bourgeois which is so great in Paris.
Both were so feminine with this unexpected beauty."*

— Bettina Graziani

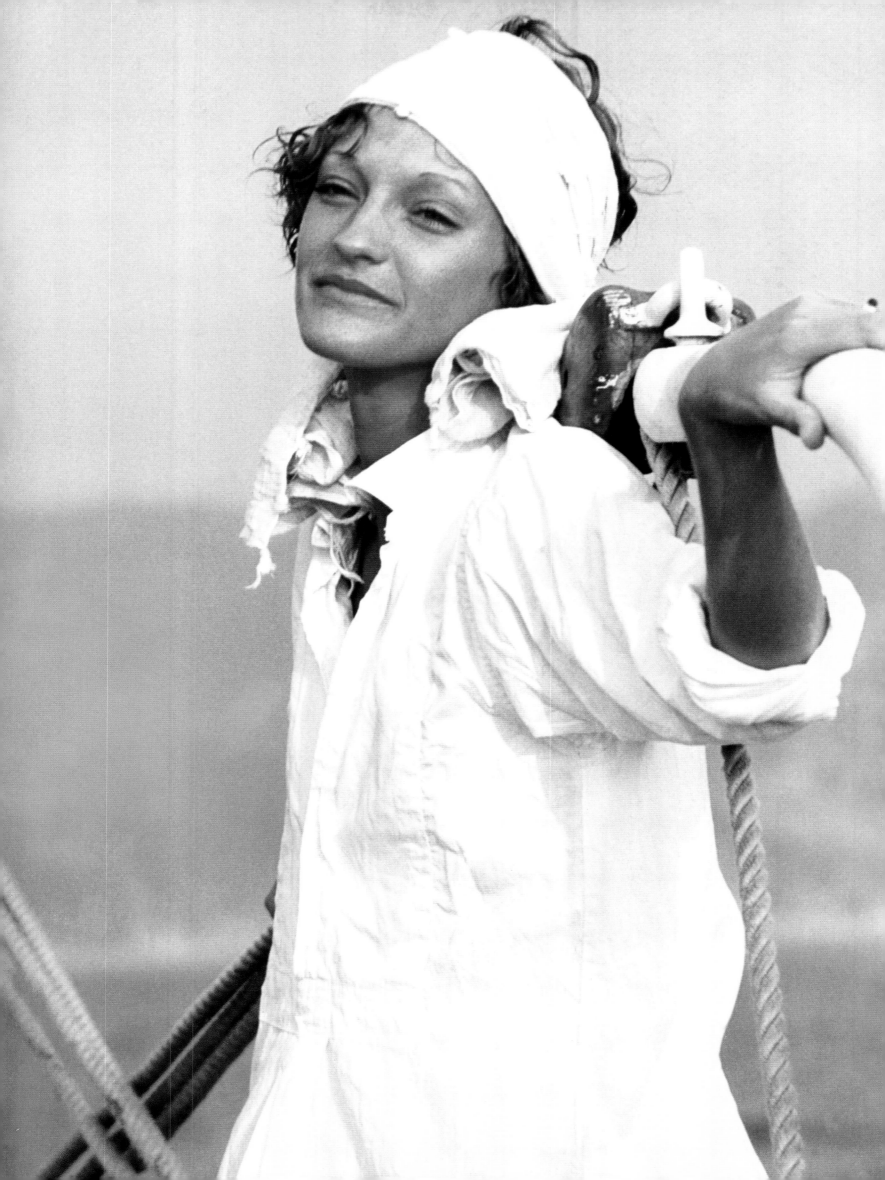

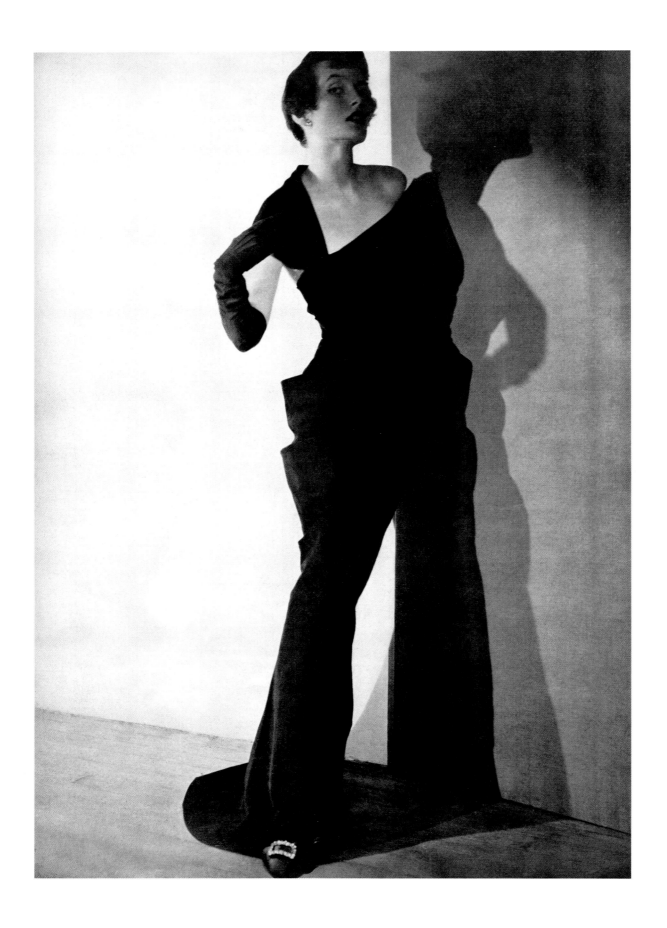

" That picture taken by Helmut is one of his best. You can see Loulou's attitude and way of being."

— Elsa Peretti

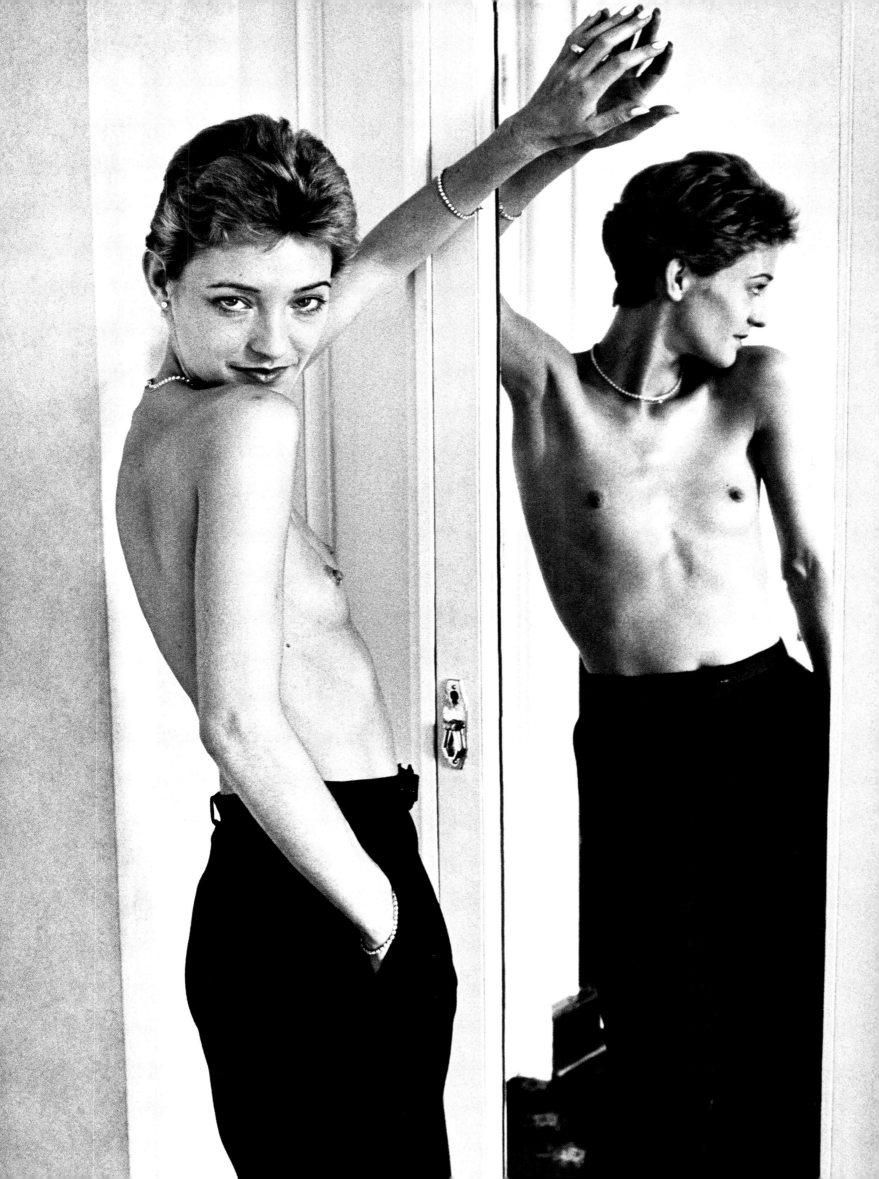

BELOW – A self-styled Maxime wearing a dress she designed for Paquin's boutique, photographed by Horst in 1950.
OPPOSITE – Thirty years later, Loulou also dazzles in a self-styled Saint Laurent look in a photograph by Roxanne Lowit.

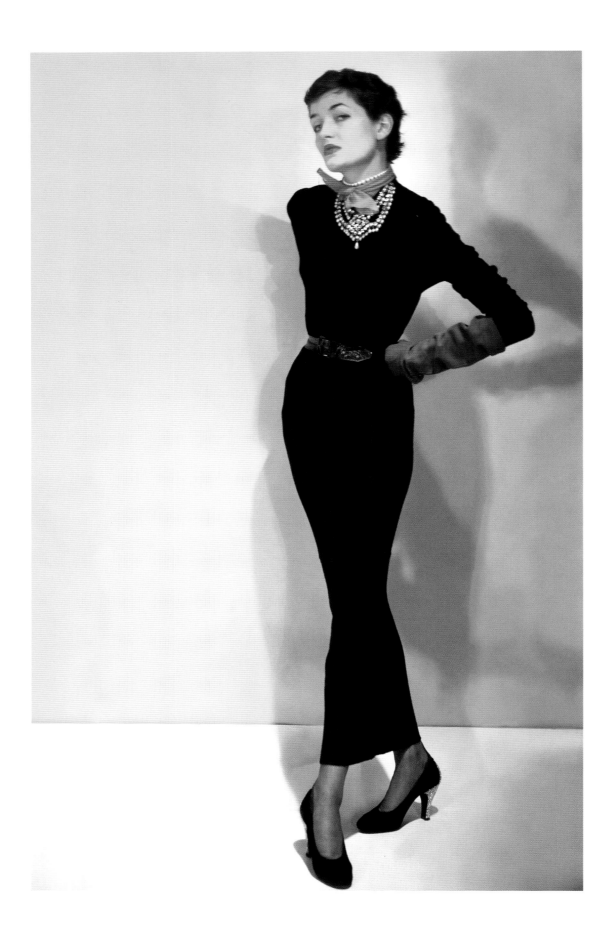

" What Loulou achieved with her accessories could transform a sweater and a skirt, she was amazing in her choice."

— Hubert de Givenchy

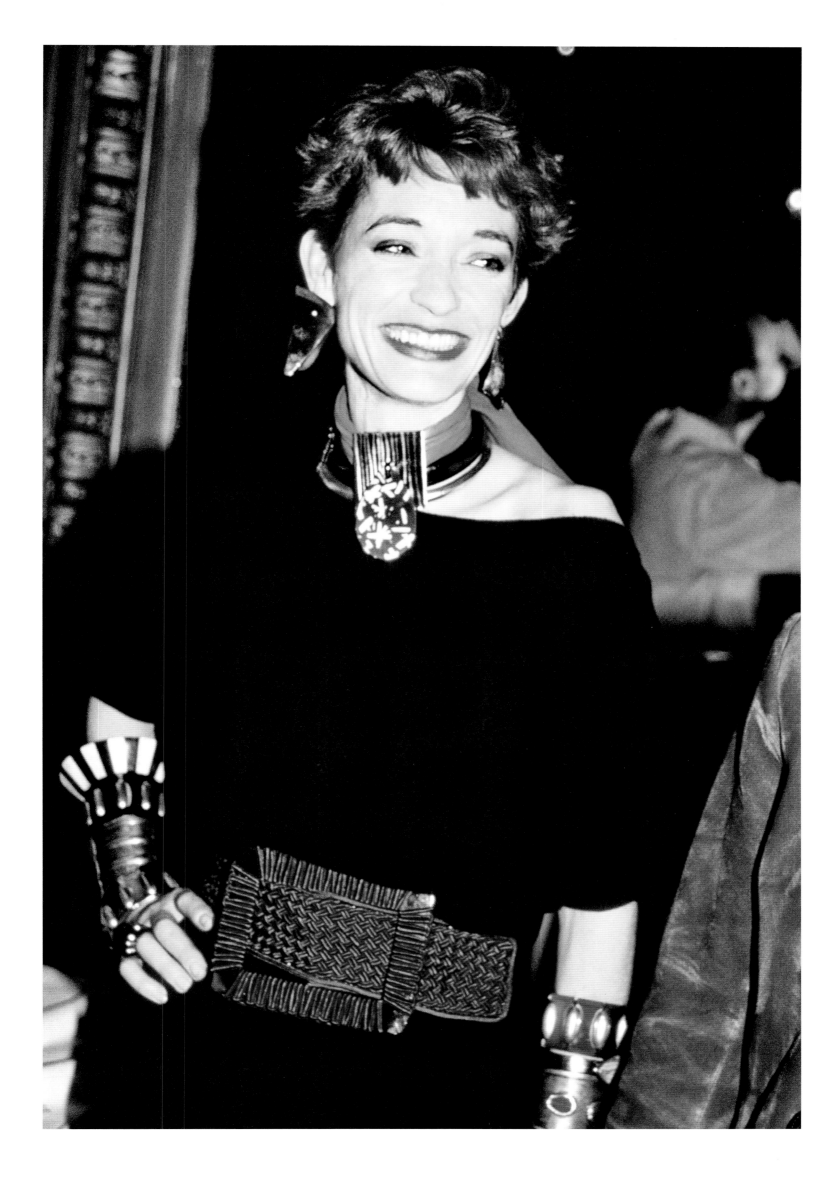

"Andy [Warhol] liked Maxime because she was a force and could be quite formidable and demanding."
— Vincent Fremont

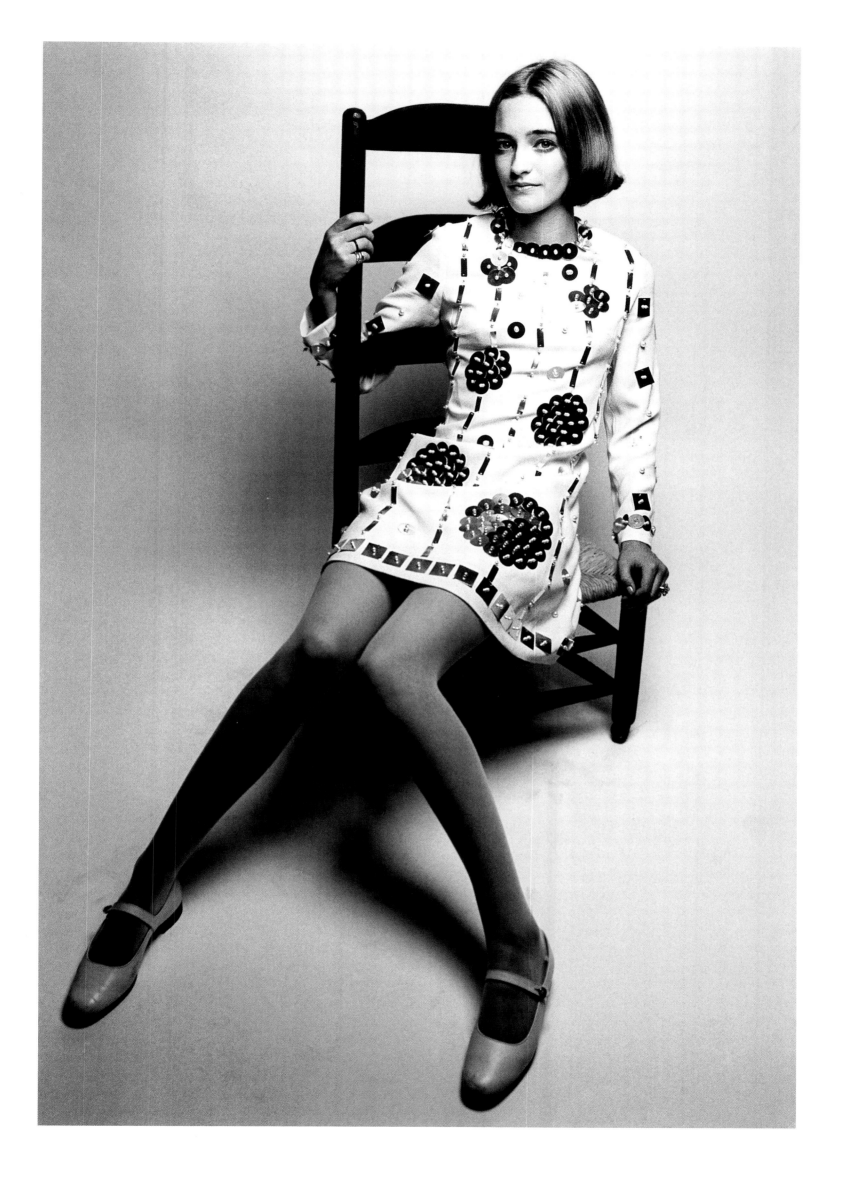

BELOW – Top from left: Kenneth Jay Lane, Maxime and Boaz Mazor on Fire Island in 1976 -
Bottom from left: Javier Arroyuelo, Bianca Jagger, Loulou and Silvia Serra di Cassano in New York.
OPPOSITE – Top from left: Loulou and Maxime in New York, photographed by Joël Lebon in 1971 -
Bottom: Alexis's children Lucie and Daniel de la Falaise photographed by Arthur Elgort, *Vogue Paris*, 1988.

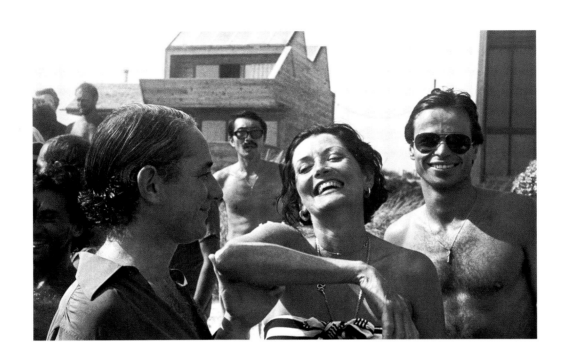

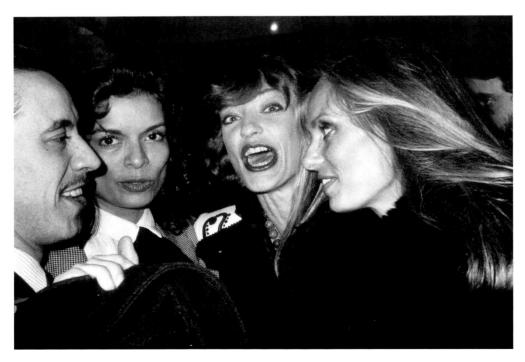

" The way Loulou and Maxime held their cigarettes, laughed out loud…
It was genetic!"

— Boaz Mazor

" Balthus loved the fact that Loulou and her family were so beautiful."

— Setsuko Klossowska de Rola

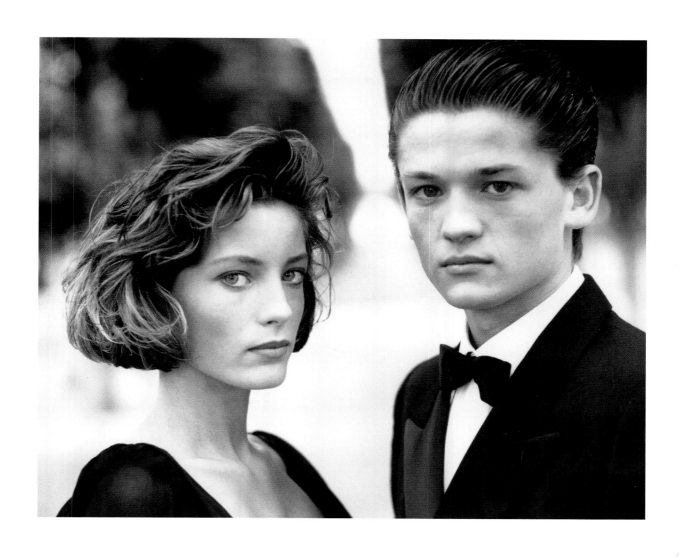

Siblings Loulou and Alexis de la Falaise photographed by Richard Avedon.

"All the girls fell madly in love with Alexis, he was so handsome and romantic, living in a farm in Wales."

— Grace Coddington

Irving Penn's Velasquez-like portrait for the March 1992 issue of *Vogue*, featuring Maxime, Anna, Lucie, and Loulou in Yves Saint Laurent *haute couture*.

"Maxime was a magnificent Amazonian bird and all her offspring were superstars."

— Robin Birley

LONDON NEW YORK

and lots more

Loulou at her first wedding in 1966, when she was nineteen. Photograph by Patrick Lichfield.

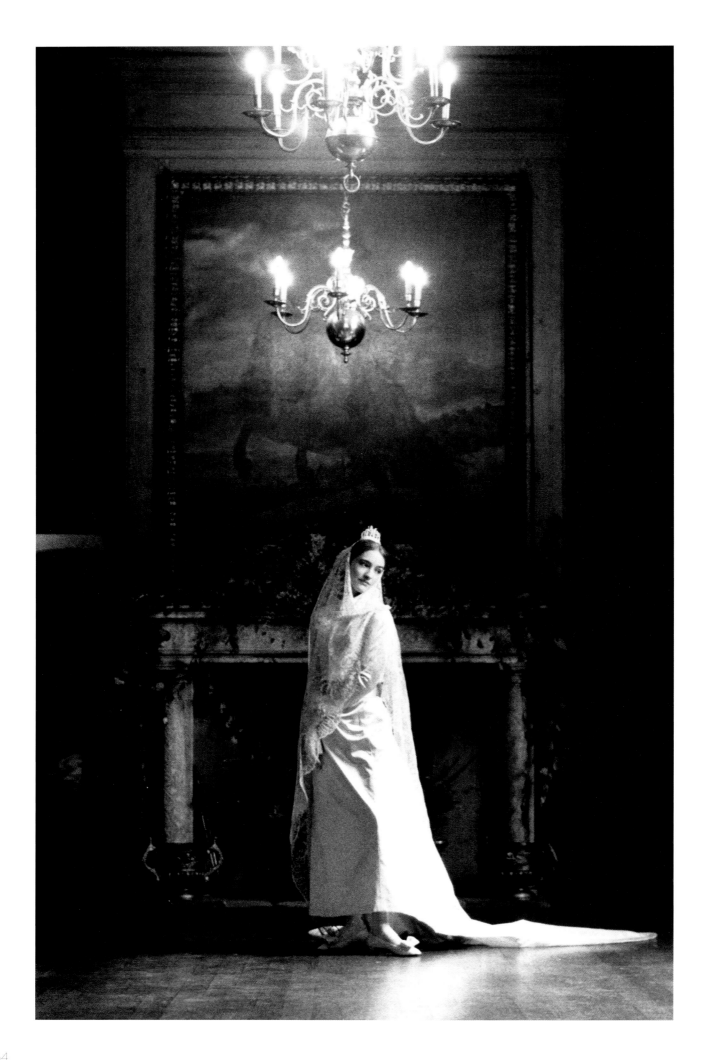

" When young, nothing could touch Loulou. She was like an exquisite butterfly flitting here and there."
— Paloma Picasso

In the mid-1960s, Loulou lived at a breakneck pace, never failing to strike others with her appearance. She attended her first Parisian couture show with her aunt Gloria Swanson and on the professional front, she was assisting an unknown Helmut Newton, was discovered by *Vogue*'s Diana Vreeland, modeled furs for Richard Avedon, and designed prints for Halston. According to David Croland, the Mapplethorpe model and fashion illustrator who met her at Andy Warhol's Factory, "Loulou never just entered a room or space; she flew into it." And it was "'Loulou!' with an exclamation point," he continues. "The smile was electric. Her body and face, a study in motion."

Peter Schlesinger, the California artist, had been taken to a party in London that Loulou and her first husband were giving. "We walked up the stairs, passing Mick Jagger coming down," he recalls. "Loulou was holding court in the bedroom [and] I saw a vision that burned in my memory. She was cross-legged on the bed wearing Ossie Clark's black-and-red satin dragon-printed pantsuit. I had no idea that we were basically the same age. She was so much more sophisticated than I was." According to the photographer Eric Boman, "When [she was] young, Loulou wanted action and fun all the time.... She was in a hurry."

This period in her life had actually begun rather badly. Having been living in a Manhattan loft with her mother — "Her bedroom was up a little ladder and she wore knee socks and curtsied," says Kenneth Jay Lane — Loulou had been banished to her grandmother's house in London after being expelled from New York's Lycée Français. Living with Rhoda, Lady Birley, in 1965 had been a nightmare. Obsessed with Loulou's virginity, she tried to force her rebellious granddaughter into becoming a debutante. That said, it was Rhoda who introduced her to Desmond Fitzgerald, the 29th Knight of Glin, in May 1966. They married five months later at St. Mary's Cadogan Church. A society event that was photographed by Patrick Lichfield, the queen's cousin, it was also referred to in one English newspaper as "the most fascinating wedding of the year."

Clockwise from top left: Alexis - Loulou *en famille* - And alone in London, 1968.

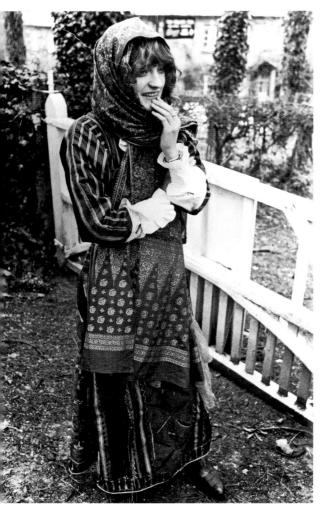

Then working as a curator at the Victoria & Albert Museum, the knight was a catch. Handsome and erudite, he possessed an ancient Gaelic title and a ravishingly pretty castle called Glin, in Ireland. He had a reputation for hating "vulgarity and sameness," according to his friend Christopher Gibbs, the aesthete. And Loulou, his nineteen-year-old bride who resembled a vivacious Edward Burne-Jones painting was to surprise him at every turn, whether by wearing a large linked chainmail that barely covered her nipples to his place of work, or by appearing naked at one dinner where she shimmied and danced the whole length of the table. John Stefanidis, the interior designer, first spotted her in the packed drawing room of Lindy, the Marchioness of Dufferin, wearing "a tall pheasant feather" that "was bobbing above the crowd." Said Stefanidis, "The following day, I rang Willie Landels, the art director of *Harper's & Queen*, and said I had met Loulou Fitzgerald, who had innate chic and should be employed by the magazine." Loulou was hired as a fashion assistant. Then run by Jocelyn Stevens, the magazine rarely featured fashion clothes unless the designers advertised. "So we would club together to buy a small five-pound advert for Ossie Clark, who didn't have a penny," Loulou told *Harper's & Queen* in 2005. "There would be screaming in the office and I would hold up the advert and say, 'Look, he's an advertiser!'"

Loulou worked on several shoots with Helmut Newton; the first took place on abandoned railway tracks and the second was in a basement of a London pub. Since the senior fashion editor had called in sick on the second shoot, Newton dominated the juniors. The shoot, according to Loulou, had "a decadent thirties feel," in which Newton's large-breasted models "spilled out all over the place."

It was London's Swinging Sixties, which often meant three parties a night and an exhilarating breaking of social barriers. "Those years melted into one," says Manolo Blahnik. "But every day was an adventure." Captivated by Loulou's appearance — "She had that refined British aristocratic quality that is impossible to imitate," the shoe designer says — Blahnik remains unsure where they met. It was either at the house of Julian Ormsby-Gore, the dandy son of David, Lord Harlech; or the gallery of the influential art dealer Robert Fraser. John Pearse, however, clearly remembers Loulou from her appearances at his King's Road boutique Granny Takes a Trip, which dressed Jimi Hendrix, George Harrison, and all the cool rock stars of the period. "In the morning, she and Talitha Getty — these incredible-looking beauties — would turn up looking rumpled but rumpled in the best possible way," says Pearse.

"I greatly admired Loulou's early looks which were very Anglo-Irish and gave a sense of finding a dressing-up box in a rambling country house." — Hamish Bowles

Although Desmond was madly in love with Loulou, he was never part of her decadent rambles. And in spite of the fun and games at the couple's Pont Street flat, in 1967, Loulou ran off with Donald Cammell, the writer and co-director of the 1970 cult classic *Performance*. "Desmond was devastated when Loulou left him," says John Stefanidis. But according to Robert O'Byrne, Desmond's biographer, they were totally incompatible. Albeit social, Loulou's husband "was committed to scholarship, to learning more about Ireland's cultural heritage and to proselytizing on its behalf," he writes. Indeed, the knight became a leading figure in the Irish Georgian Society and the Irish Architectural Archive. It was obvious that he wanted and needed to spend more time at Glin, his ancestral home. "And the role of chatelaine of a country house overlooking the Shannon estuary proved not to Loulou's taste," concludes O'Bryne. Glin was much too isolated. "She used to go up the nearby hill and scream," Desmond told the *Times* in 1990. Loulou recalled the experience as "quite fun but then I thought this is not my life, I can't do this forever." Despite their divorce, they remained on the best of terms. "Desmond was always impressed that Loulou didn't demand anything and left all the family jewels," says Thadée Klossowski. "And when we got engaged, she insisted that we ask for his approval."

One of Loulou's many appealing sides was her total lack of venality — "With her style, she didn't need money," reasons Kenneth Jay Lane — and strong belief in earning her own keep. To a certain extent, Paloma Picasso feels that Maxime was responsible for "Loulou's amazing work ethic," pushing the fact that it led to freedom for her.

Later, Loulou blamed her "scandalous affair" with Cammell as her reason for leaving London. "I thought it very inelegant to move into someone's flat and instead I went to New York," she told Bettina von Hase from Warhol's *Interview* magazine in 1984. By this time, Maxime had married John McEndry, the curator of prints and photographs at the Metropolitan Museum of Art, and the couple had quite the salon on the Upper West Side. They entertained Andy Warhol, Fred Hughes, Diana Vreeland, Kenneth Jay Lane, Oscar and Françoise de la Renta, John Richardson, and Robert Mapplethorpe, and sometimes organized poetry readings with an unknown Patti Smith.

" The knight was devastated when Loulou left him but she was so undemanding and good natured that they remained friends for the rest of their lives."

— John Stefanidis

Desmond and Loulou Fitzgerald at home on Pont Street, photographed by Rhoda Birley's great friend Cecil Beaton in 1967 for *Vogue*.

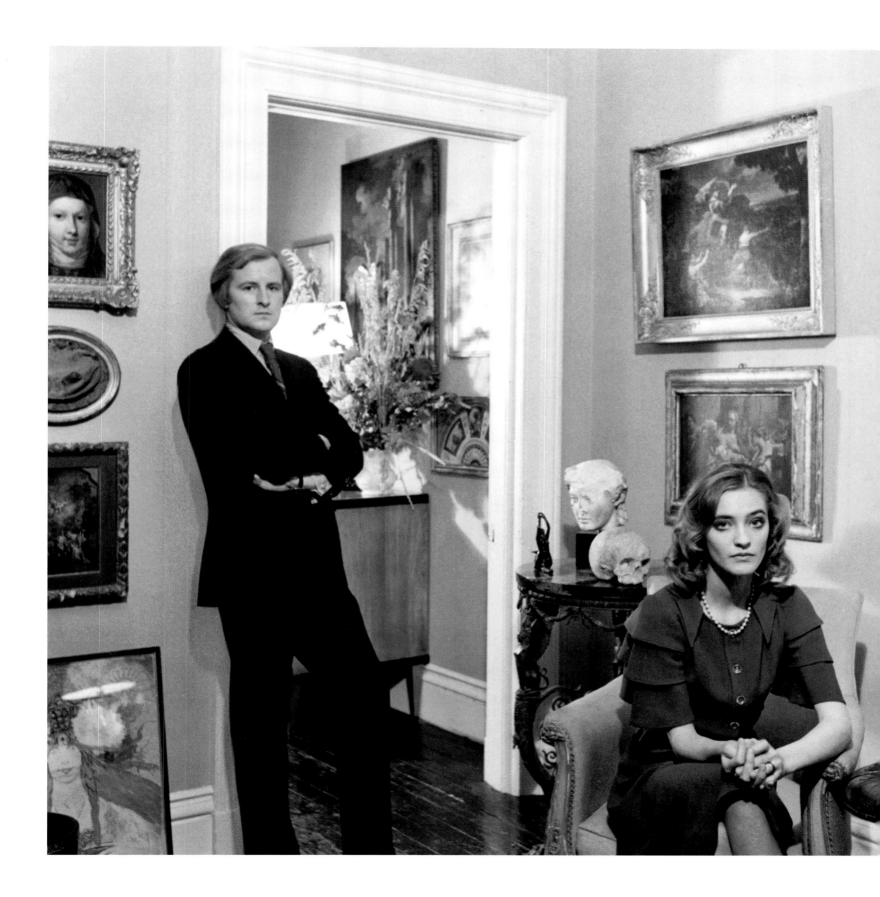

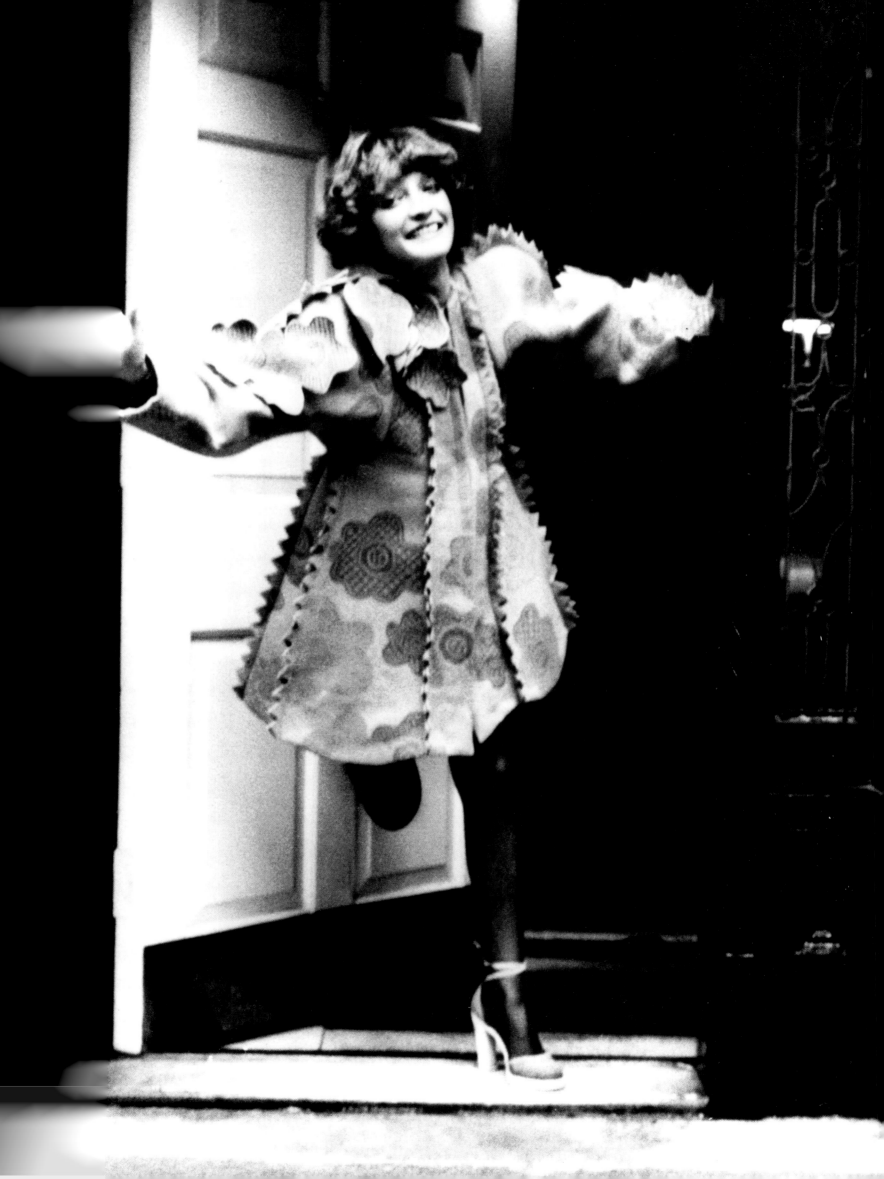

"There was this huge sense of freedom around Maxime," says model Bettina Graziani. "It allowed her to create the most beautiful things." Much as everyone was fond of Loulou's mother; however, she was a terrible cook who insisted inflicting her food on everyone. She had become *Vogue's* food columnist, and often tried out menus on her friends for her eventual book *Seven Centuries of English Cooking*, which was published in 1994. "Since she didn't fuss over detail, the results were disgusting." says Richardson. Nevertheless, he attests that she put together lively dinners with chic Parisians like Kim d'Estainville, Hélène Rochas, and Cristiana Brandolini. "Maxime was much maligned as a cook, but she did have a profound knowledge and instinctive understanding of food," Eric Boman says, in her defense. "Her accompanying lapses in hygiene had more to do with her vanity of not wearing eyeglasses."

Loulou, who was sharing an apartment with the illustrator Joe Eula (whom she credits with teaching her how to draw and express her visions on paper), added a youthful contingency to her mother's gatherings, bringing along friends like sisters Berry and Marisa Berenson (granddaughters of fashion designer Elsa Schiaparelli), Paloma Picasso, Diane von Fürstenberg, and André Leon Talley. "In many ways, she and Maxime had a sisterlike relationship," Lane explains. One of Loulou's favorite stories was walking in after one of her mother's feasts and finding Diana Vreeland and other guests fast asleep, like Sleeping Beauty's courtiers, making her wonder what her mother had put in the food. Loulou later moved in with the photographer Berry Berenson. "We had great fun living in a messy loft," recalled Loulou. They kept a menagerie of animals to keep them company, such as a rabbit named Beluga (named for his constant droppings) and two lovebirds called Ike and Tina.

Loulou and Berry worked for the legendary designer Halston at the same time as Elsa Peretti. "Halston was then on Sixty-Eighth Street and it was the best," says Peretti. "Berry took photographs and Loulou was so talented at doing fabrics with little bees and pigs." Peretti, a style icon who became one of Tiffany's most successful jewelry designers, admired Loulou's grace and style. "She was like a little elf with this big laugh and the very powerful voice of a smoker," she says. "Her laugh and voice were snobby in a good way." The two women often had lunches and dinners where Loulou "smoked like a chimney and ate nothing." Peretti describes Loulou as being able to wear clothes "like magic." "Being small boned, Loulou could afford to put a lot of things on," she says. Halston was also fond of Loulou. "He loved to have young people around, admiring their spirit and fun," says Peretti. Marisa Berenson remembers their tie-dye sessions at Halston's country house. "We'd do it in huge basins at the weekends," she says.

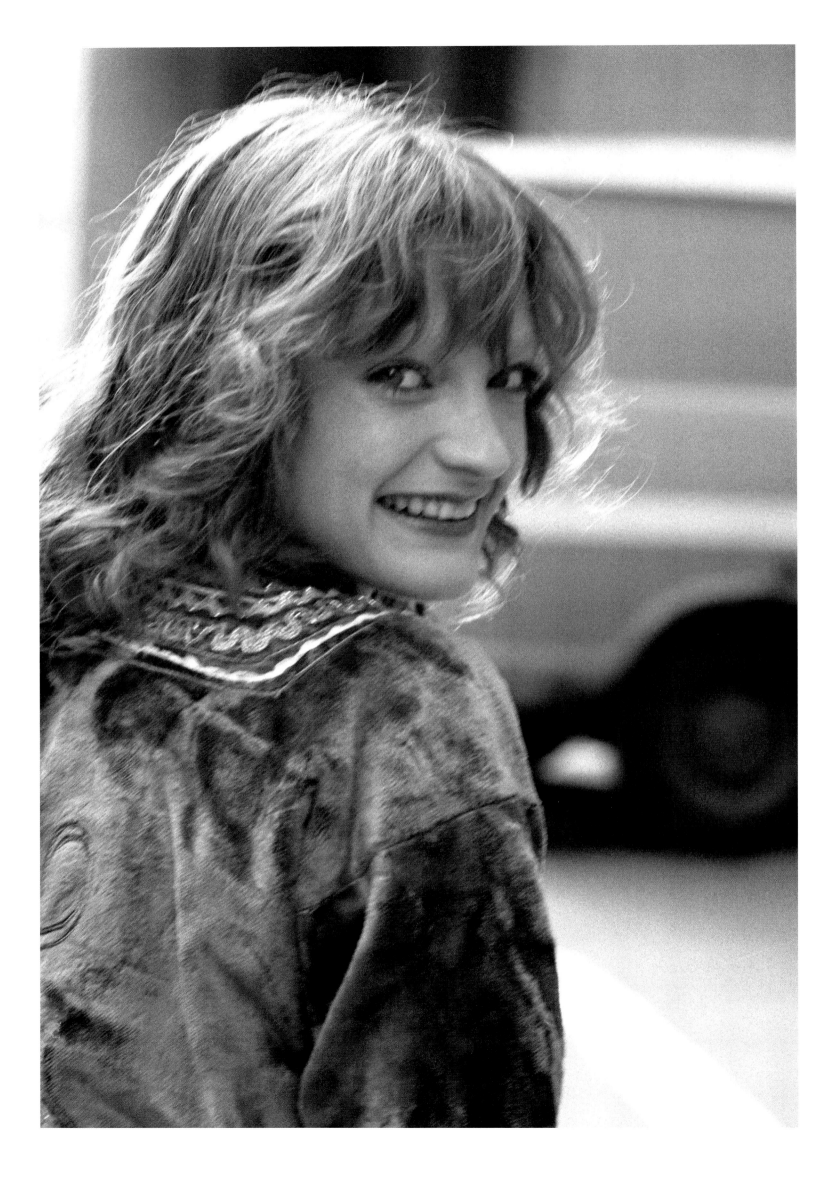

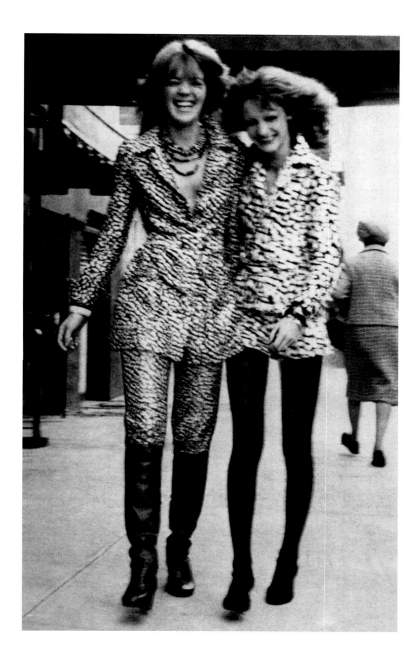

" Berry and Loulou adored each other and would fly about the town.
I was always struck by Loulou's energy, aura, and charm."

— Marisa Berenson

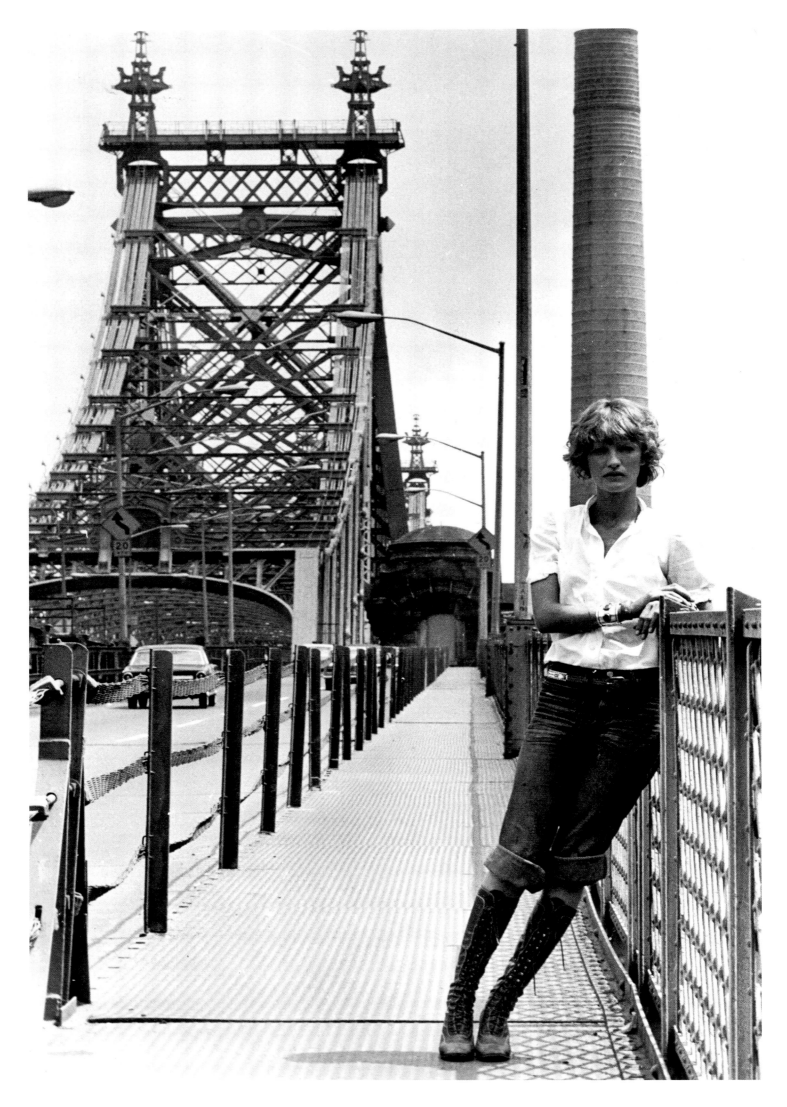

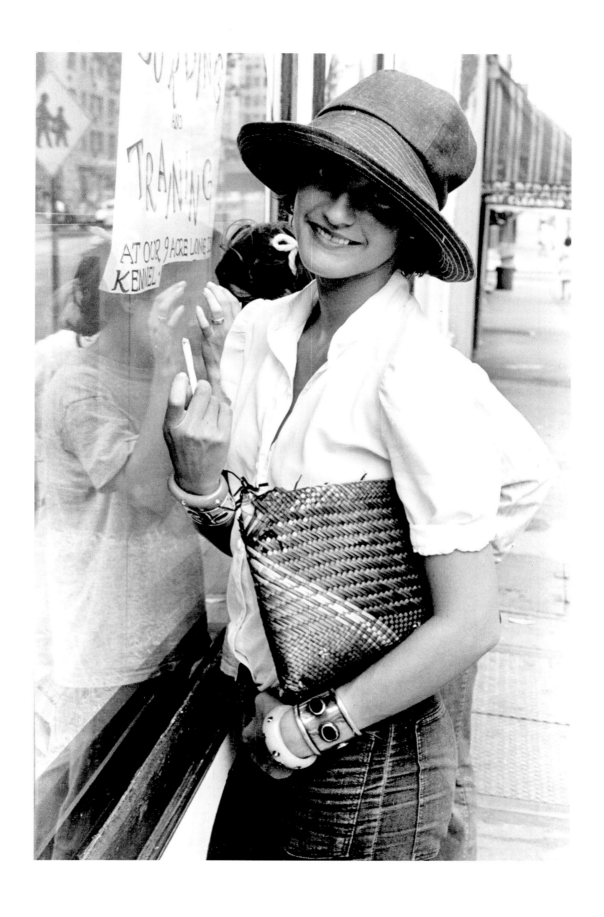

"Loulou's gift was that she knew what was right on her." — Paloma Picasso

Clockwise from top left: Loulou with Fernando Sanchez in his New York studio - With Dimitri Srovoravdis in Plaka, Athens, Greece - Photographed for *Vogue* by Berry Berenson in Giorgio di Sant'Angelo's studio - With Jay Johnson in Paris.

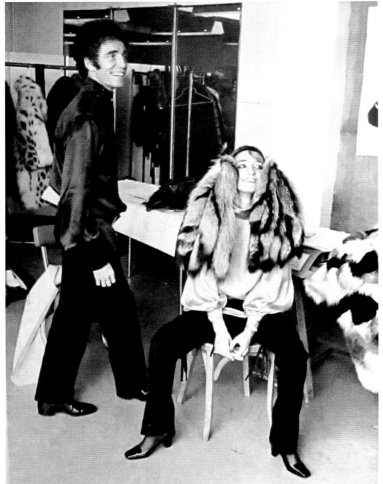

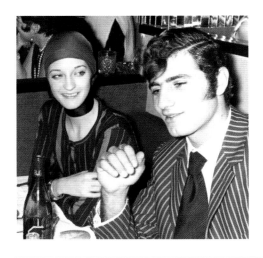

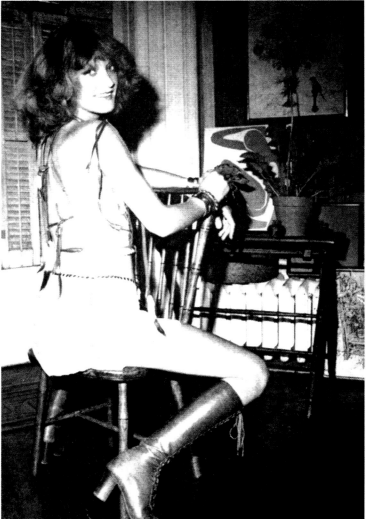

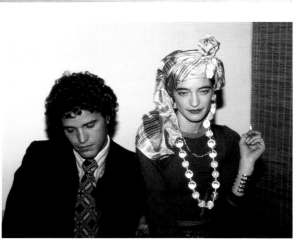

"All we had were rags, but Loulou could turn them into riches and create a new look."

— Maxime de la Falaise

When Diane von Fürstenberg first introduced her iconic wrap dresses to Mrs. Vreeland at *Vogue's* offices in 1970 — a milestone in the designer's career — she remembers meeting Loulou. "I had a big suitcase with my dresses in it and [Mrs. Vreeland] called two girls to try them on — one was Pat Cleveland and the other was Loulou, who had no makeup on and resembled a waif." They became great friends — "We misbehaved and became close," she says. Later, Boaz Mazor, Oscar de la Renta's PR honcho, recalls Loulou and Diane doing an erotic dance one night at a Fire Island disco. "It was to Donna Summers's 'Love to Love You Baby' and it even got all the gay boys heated up," he remembers. "But what was fascinating about Loulou is that she was androgynous. She wasn't Marilyn Monroe, but there was something magnetic about her. She also had that French accent, beautiful jawline, and long neck." Marisa Berenson wonders if Loulou's appeal came from a need "to seduce and flirt" and her being "free with no inhibitions." Richardson recalls her as "a bit of bad girl" who enjoyed kissing the boys and making them cry. Corey Grant Tippin, then a stylist, was wowed by Loulou's attire — he remembers a turban "allowing cascading ringlets" and scarves cinching a peasant skirt — and her social ease that allowed her to fit in wherever she went.

Tippin describes New York's exciting nightlife at the time as being divided between the entourages of Andy Warhol, the illustrator Antonio Lopez, and designers like Stephen Burrows, Giorgio di Sant'Angelo, and Fernando Sanchez. Although the groups mixed, there was an unspoken possessiveness — yet Loulou managed to cut right through the boundaries. "Loulou was independent yet part of the whole family," Tippin says. "She had alliances with everyone." He was also amazed by Loulou's discipline and her "intelligence and instinct that steered her back from any loss of control." She lived with "all the distractions, false temptations, and complications that inhabit 'the world of fashion' and accepted them as nonthreatening issues." With Tippin and Berenson, she collaborated on a *Life* magazine shoot in 1971 called "The Veil Returns." Loulou had styled it "and the millinery confections that she promptly concocted were glorious. She was a pro."

Jay Johnson, the former model and twin brother of Jed Johnson, was in awe of Loulou's sense of uniqueness and privilege. "I never thought of myself as powerful or beautiful and was simply amazed that others were attracted to me," Johnson says. "Loulou, on the other hand, was raised very differently." Like many, Johnson was astounded by her late-night stamina. "I could endure quite long but her powers were even more than mine," he says. There was also her kindness and tenderness, "even when I was very badly behaved." "Once, I was asleep and Loulou jumped into bed with me, cuddled, and fell asleep," he says. "It was just so unexpected and so sweet. I went along for the ride and it was one of those wonderful times when you don't question things and are completely spontaneous and in the moment."

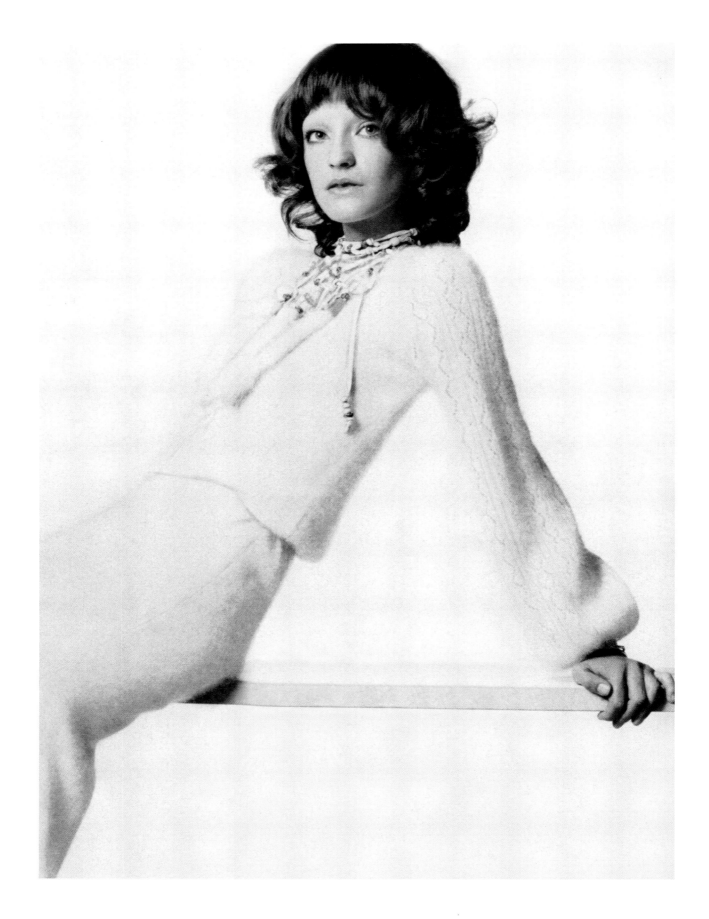

"The first time I ever laid eyes on Loulou was at a ball given by some Duchess. There we all admired her youthful, dazzling beauty."

— Stash Klossowski de Rola

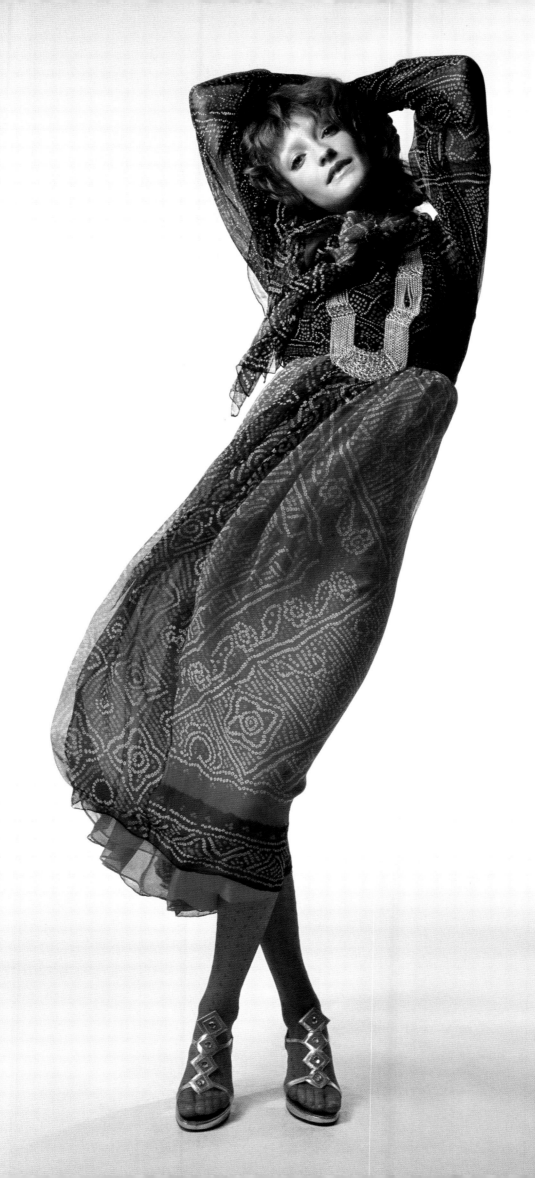

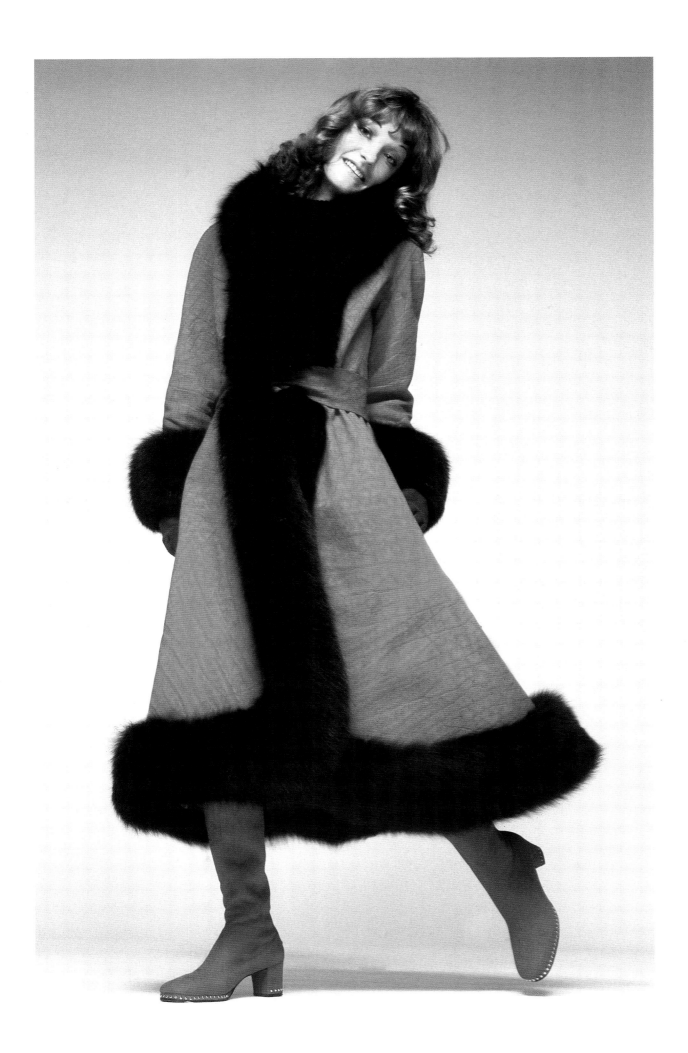

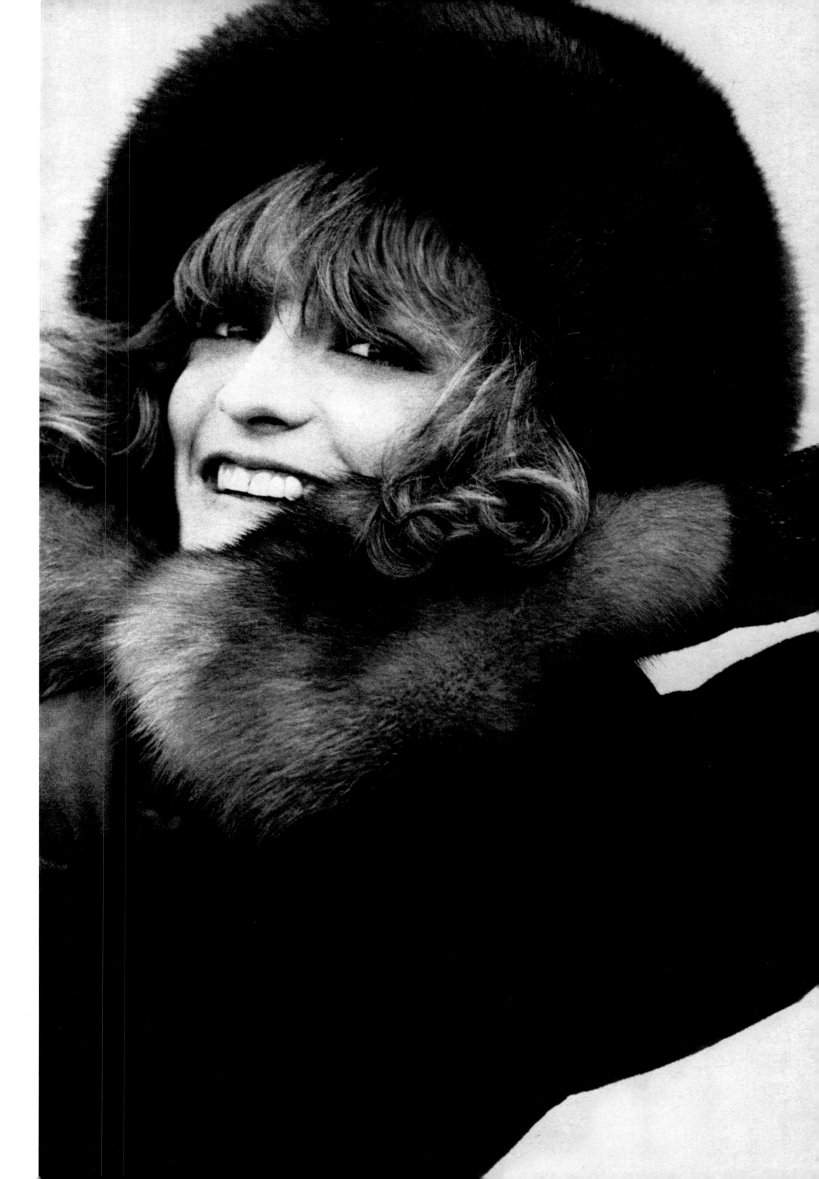

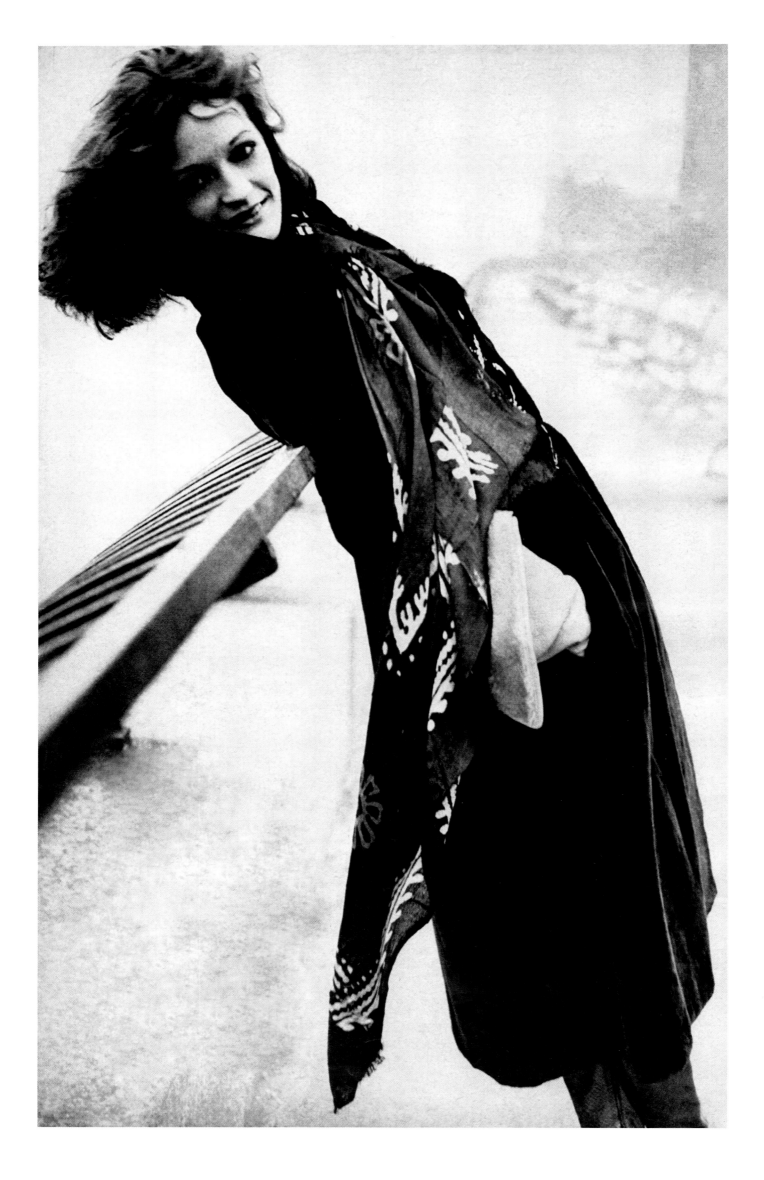

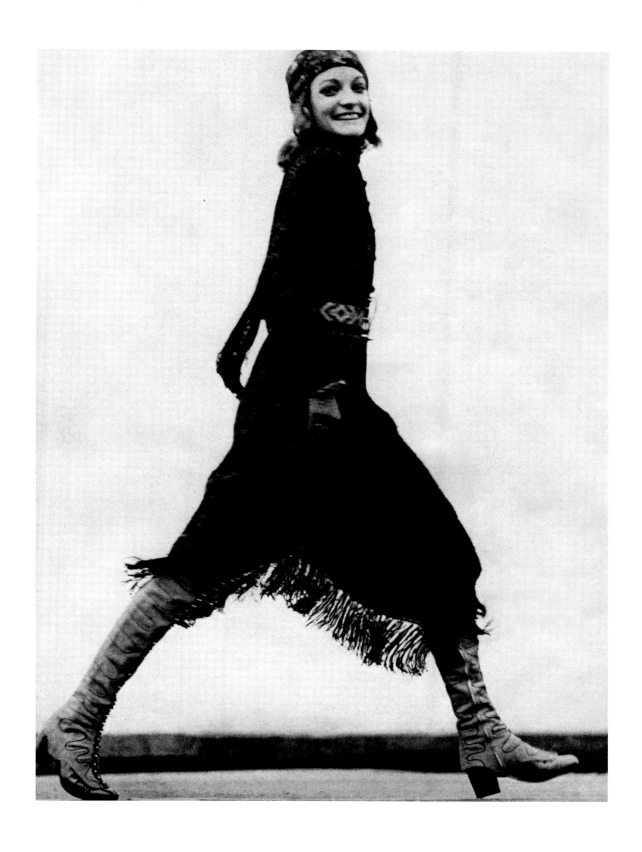

"Loulou, Berry, Marisa, even Anjelica Huston — what Halston and I called the children. They wound up at Mrs. Vreeland's and were coming from these exotic places called home."
— Frances Stein

A series of Robert Mapplethorpe Polaroids of Loulou, Paris 1971.

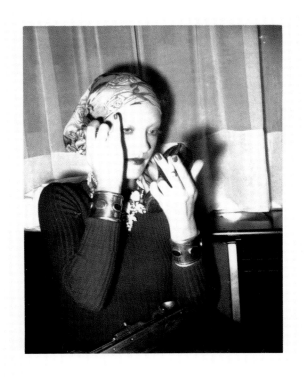
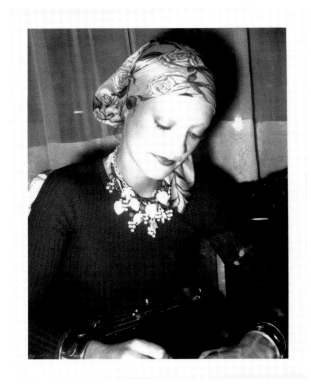

" When Robert went to Paris for the first time, Loulou took him in hand.
She brought him to wonderful houses and seedy strip clubs. The haute and the hot.
They had genuine love and admiration for one another. Both kindred spirits in
appreciation of all things refined, decadent, sweet, and cool."
— David Croland

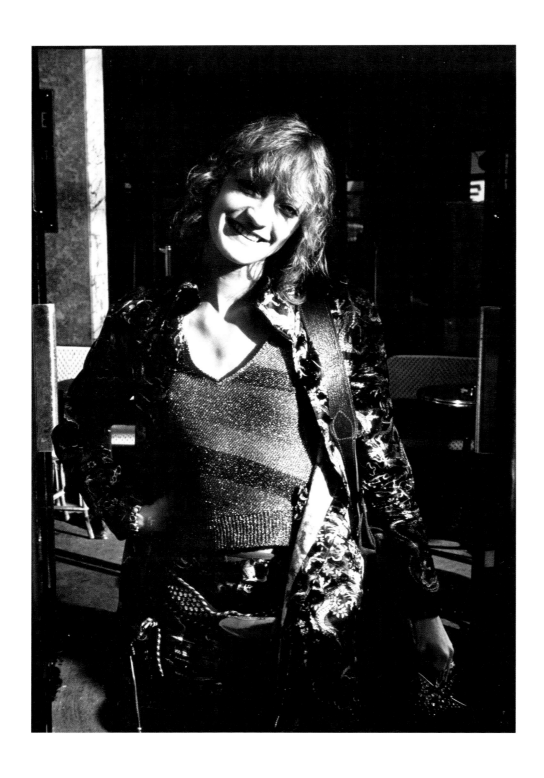

*" In the late '60s, Loulou was adorned in gypsy skirts, turbans, wild hair,
vintage treasures from Chelsea Antique market in London, Les Puces in Paris,
bangles and beads from Morocco."*

— David Croland

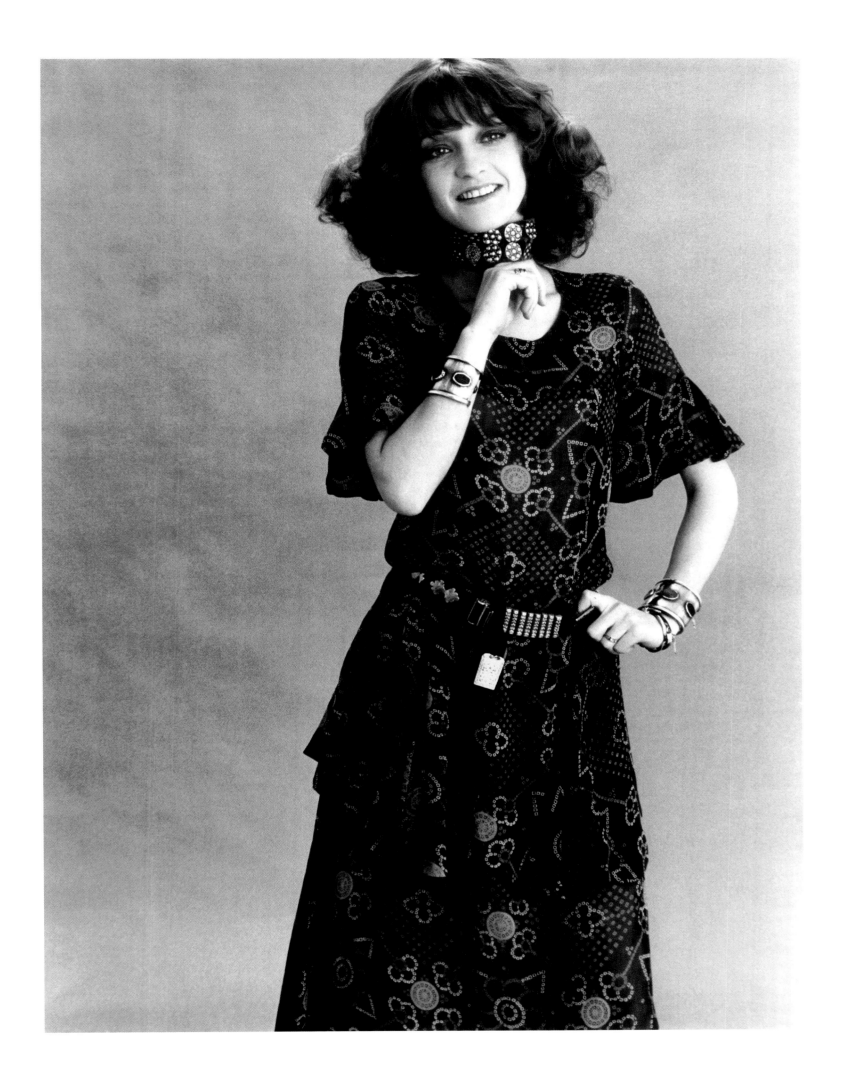

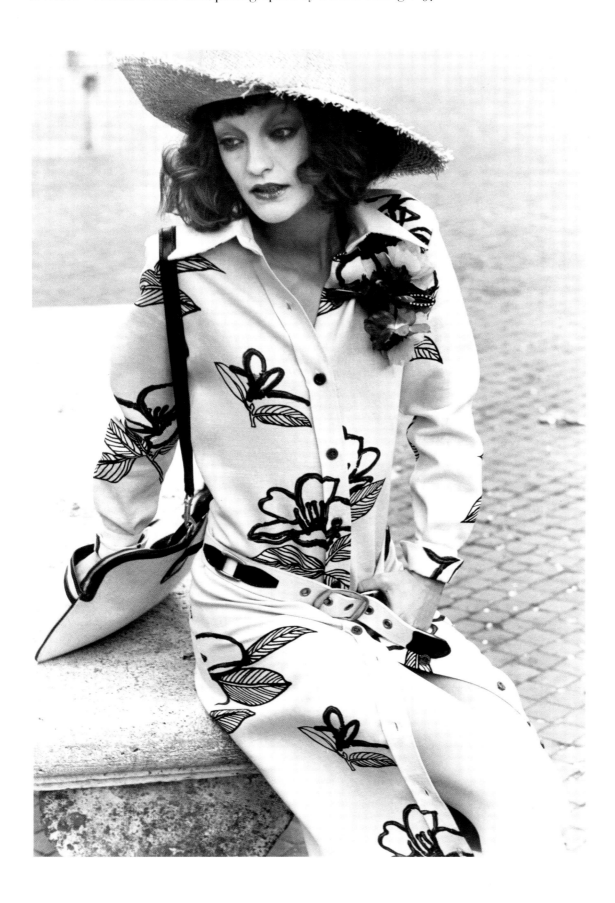

"Loulou really had incredible class and allure." — Diane von Fürstenberg

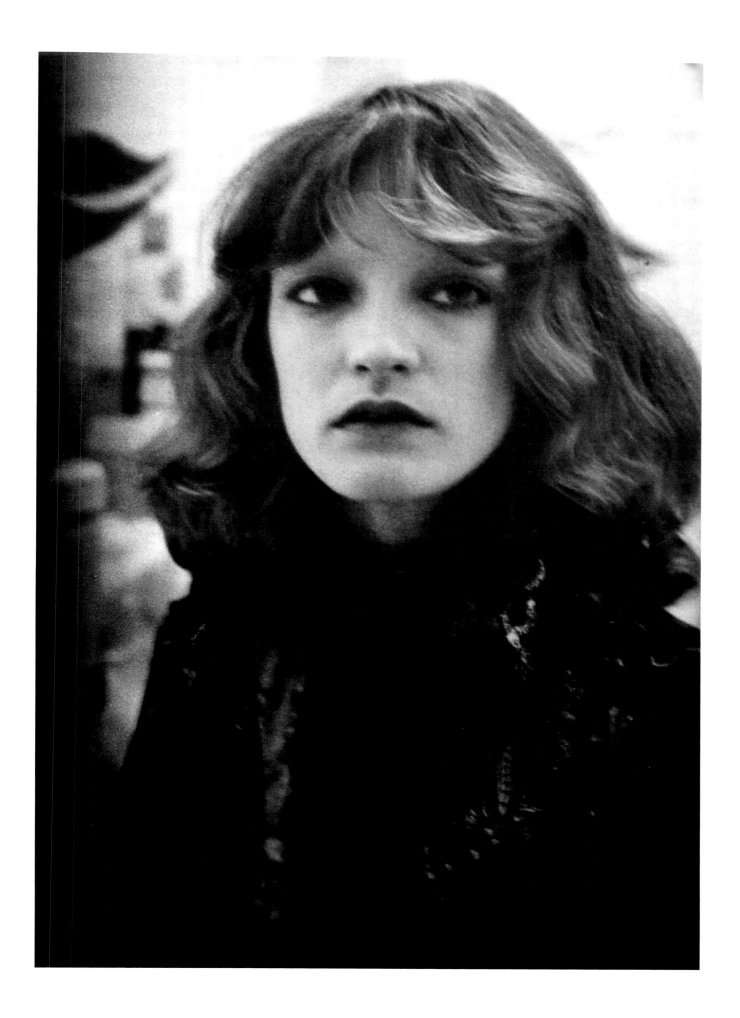

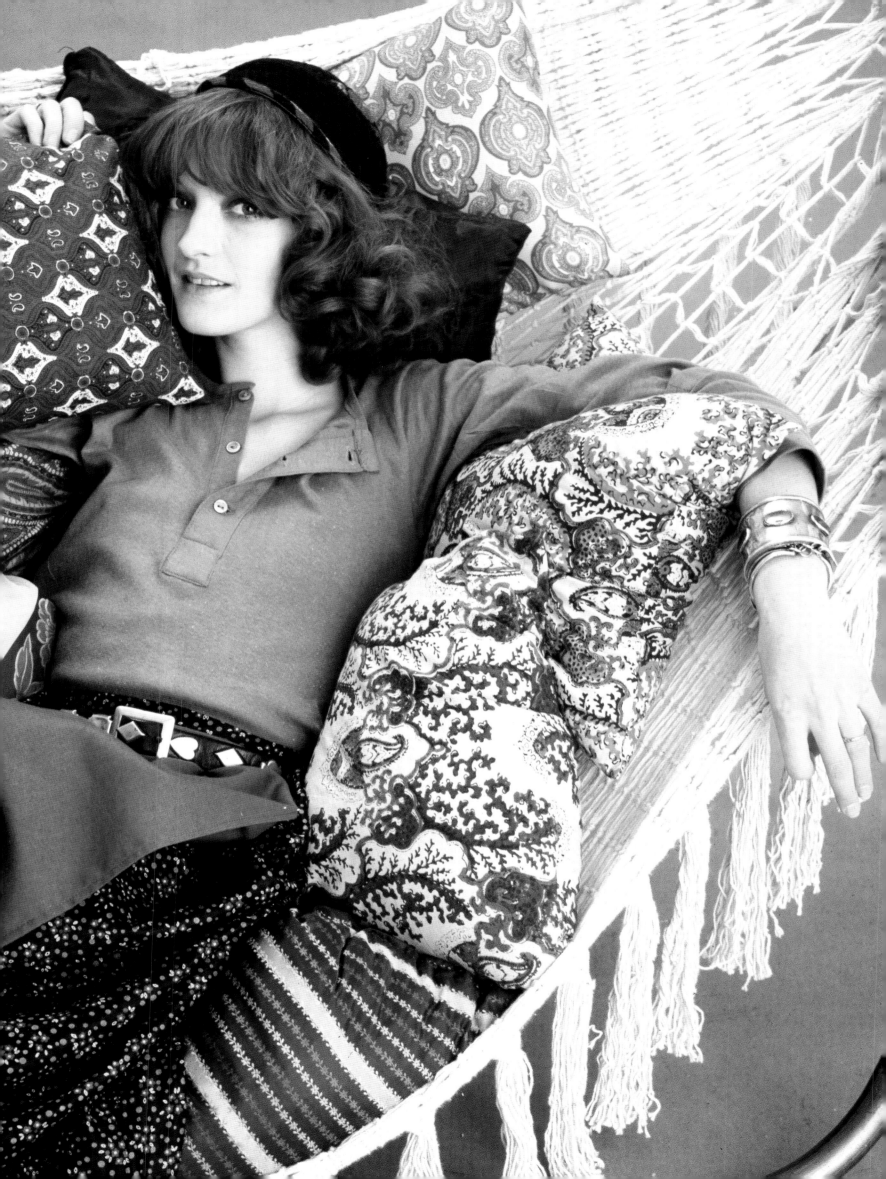

BELOW — Arriving at the Yves Saint Laurent couture house, 5 avenue Marceau. Photograph by Hélène Bamberger for the September 1983 issue of *Vogue*.
OPPOSITE — Loulou with Pierre Bergé and Yves Saint Laurent at Paloma Picasso's wedding in 1978.

YSL
the GLORIOUS

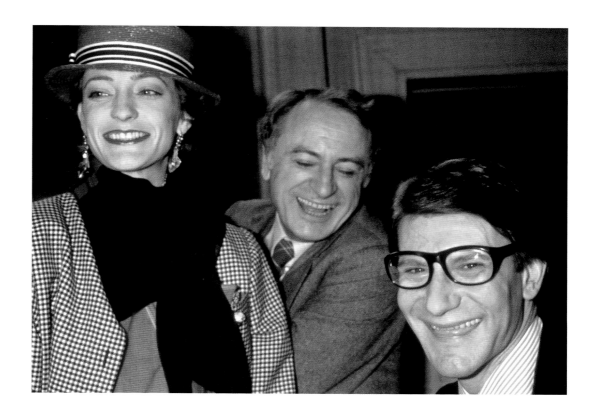

YEARS

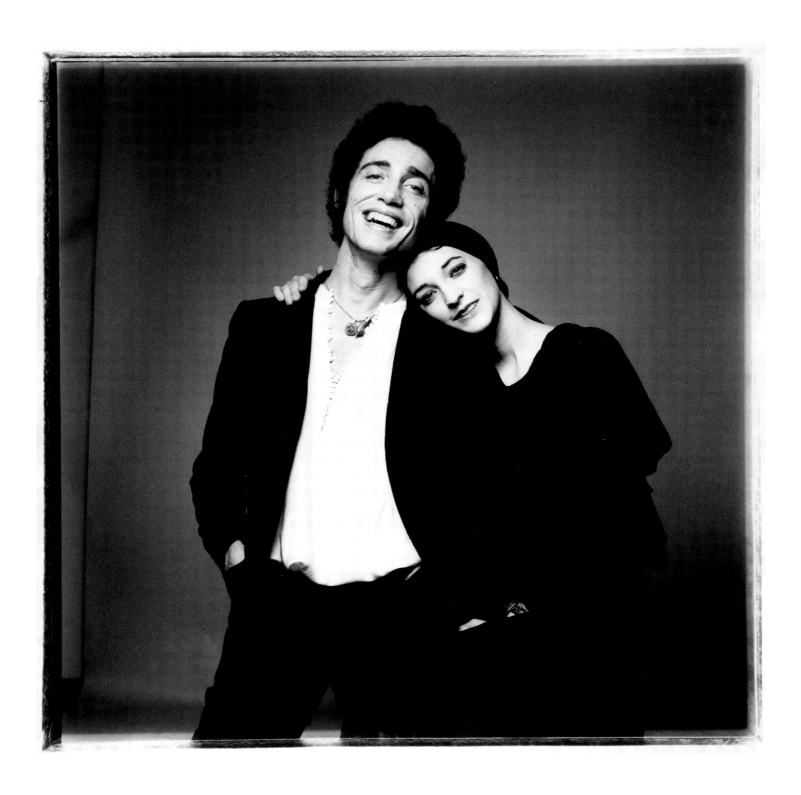

In the summer of 1968, Loulou met fashion designer Fernando Sanchez in Tangiers. Weeks later, she appeared on the doorstep of his Paris apartment. "I opened the door and there was Loulou, standing on her head," he recalls. "This crazy girl from London was wearing purple velvet pants, gold shoes, and a flower crown." Sanchez quickly fell under her charm and told her that he would introduce her to "Yves and Pierre." Loulou knew Yves to be Saint Laurent, but admitted later to *Interview* in 1984 that she erroneously imagined that he was living with Pierre Cardin. "I had worked for *Harper's & Queen* as a junior editor in London. But we had never covered French fashion — too stuffy we thought."

Too stuffy indeed! And what better way to first meet Yves Saint Laurent than through Sanchez — the hippie prince of the Place de Furstemberg and *le tout Paris*. Hard to believe but in the late 1960s, the fashion capital was way behind London and New York. "Paris was not swinging," explains Alicia Drake, the author of *The Beautiful Fall*. "It was tight and coiled like a spring and Fernando was key for bringing that whole hippie vibe in." Sanchez, who later became known as a lingerie designer, "opened it all up" with his tea parties, where he mixed the likes of Elsa Peretti, Jack Nicholson, and Talitha Getty, "and poured the tea with his Afro hair, kohl on his eyes, and pierced ears." When he had lit a joint in front of the Saint Laurent crew in 1968, they had been appalled, viewing him as someone "about to be taken to rehab." But Sanchez, whom Drake describes as "tripping out in North Africa, living between New York and Paris" would stir something deep within Saint Laurent, who had been his classmate at L'Ecole de La Chambre Syndicale, the French fashion school. Sanchez also introduced him to Loulou, who, in his cosmopolitan estimation, was "one of those extraordinary creatures who could invent herself with two or three safety pins and four scarves."

The encounter with Saint Laurent that happened over Sunday tea in the month of July was to change Loulou's life. Wearing an Ossie Clark tunic and matching pants and holding a little ball of hash in her hand, she had a headscarf tied around her head and bangles clanked at her wrists. "Like a child, she had her legs stretched out in front of her and resembled an *Alice in Wonderland* illustration," says Charlotte Aillaud, the writer and sister of the singer Juliette Gréco. "She didn't speak but laughed at everything we said." And Betty Catroux, Saint Laurent's blonde muse, also present, was charmed: "I thought she was terribly nice." However, Saint Laurent just stared. "Loulou de la Falaise came as a shock to Yves's thoroughly French taste," Drake wrote in *The Beautiful Fall*. "There was fantasy and color and daring to her style that was truly original."

LES BOUTIQUES
DE VOGUE
L'ART DE MÉLANGER LES TROUVAILLES OU COMMENT DEVENIR SON PROPRE COUTURIER

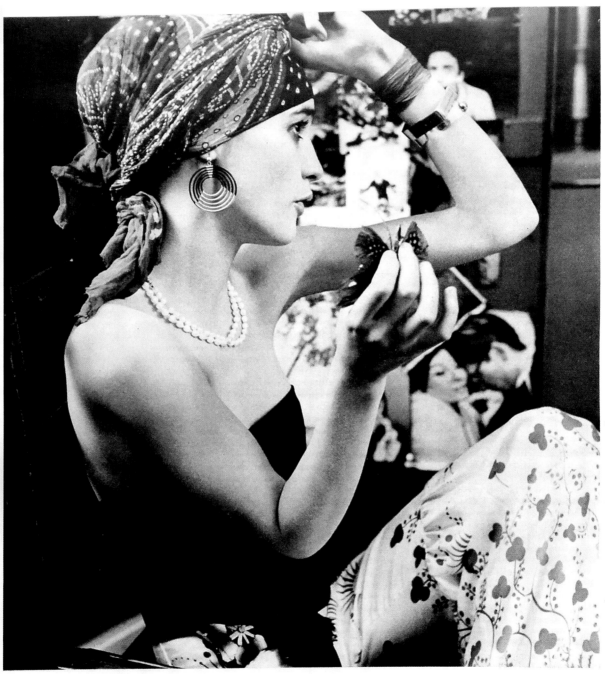

- "Ma mère voulait que je sois poète... alors elle m'a appelée *Louise*."

- "J'aime le présent, la jeunesse de maintenant... je me sens en accord avec la jeunesse anglaise... pas la française..."

- "L'atmosphère de Londres, c'est ce que je préfère... J'aimerais vivre six mois à la campagne en Angleterre, dans une grande maison, et six mois au Maroc, peu importe le temps de l'année..."

- "Ce qui m'amuse, c'est de prendre une fille mal habillée mais jolie, et de lui dire ce qu'elle doit faire. J'aimerais réaliser quelques idées que j'ai depuis longtemps..."

- "IL FAUT CROIRE AUX FANTÔMES POUR EN VOIR... J'EN AI VU..."
"Je n'aime pas tellement le rouge, le bleu marine..."

- "On a toujours eu des complexes envers nos mères..."
Louise se trouve moins jolie que sa mère, qui se trouve moins jolie que Lady Birley, qui se trouve moins jolie que ne l'était sa mère.

Louise Fitz-Gérald de la Falaise *est la petite fille du peintre Oswald Birley. Grands yeux écartés des rêveurs, longues mains des poètes. Seule loi : la fantaisie. Plus intéressée par les accessoires que par la mode elle-même,* **Louise** *s'habille de "riens" dénichés au cours de ses voyages. De tempérament artiste, elle a le talent de savoir les choisir, une manière à elle de les réunir. Avec habileté, elle sait comment draper n'importe quel tissu en turban, y fixer un dragon, un papillon (ci-dessus). Sa beauté est romanesque, chaque jour différente. Imitez son génie du colifichet.*

138

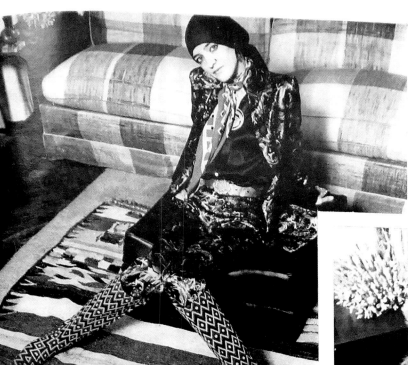

Ses goûts? Rossetti, Burn Jones. Beardsley. Klimt...

Elle est elle-même un Gustave Moreau, un Odilon Redon. Ensemble-pantalon en tissu japonais moletonné, imprimé de dragons et de bouquets de violettes. **Ossie Clark.** Quorum, 52, Radnor Walk. Londres. Sur la tête, une soie noire enserre les cheveux. Au cou, écharpe 1930 du Antique Market, Kingsroad. Londres. Ceinture d'argent du Marché aux Puces. Paris. Bottes de Saint Laurent-Rive Gauche.

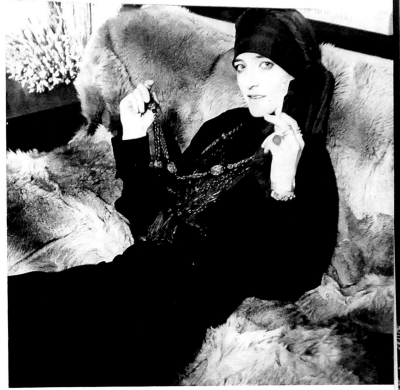

... n peu fée

...1930... "comme tout ce" Ossie Clark". Mis ...ur par **Louise** dan... ...r son lit, ensemble ...en, absolument extra... ...e de légèreté, d'impré... ...jamais vu.

... colliers

...ui ne servent pas sont ...lus au mur. Douée du ...es couleurs, **Louise** mé... ...ambre, corail de Téroua... ...haine victorienne et pier... ...ques. Au poignet, serre... ...volé au "Petit Saint-... ...! Turban bleu-vert et ...piqué d'un dragon ...aux Puces.

Le noir, je ne le porte qu'à Paris...

... Paris, pour moi, c'est six personnes et la place Furstenberg..." dit **Louise** dans une tenue subtile où contrastent tous les noirs. Velours de l'ensemble-pantalon évasé de Saint Laurent-Rive Gauche, soie du turban drapé à la manière des femmes du sud marocain, colliers de jais, perles d'acier et passementerie de perles grises que portent les gondoliers à Venise.

139

PATRICK SAUTERET

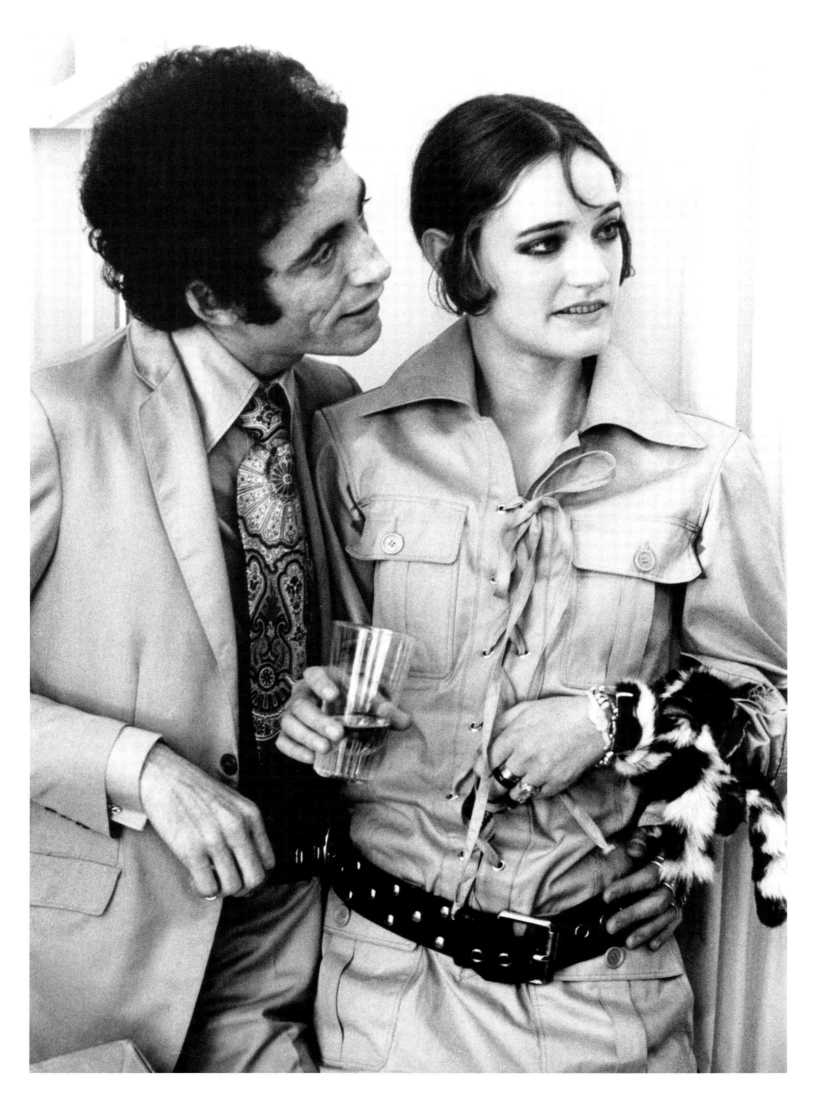

Saint Laurent was as intrigued as Sanchez, who ultimately fell in love with Loulou. She was fearless and audacious, but also vulnerable. It was obvious Loulou needed a creative home. "Both Halston and Fernando decided that Paris was right for her," says Elsa Peretti. And what better fashion designer than Saint Laurent, who was hailed as a genius? "On every level, there was nothing that Yves couldn't do," says John Fairchild, who dominated the fashion world in the 1970s and 1980s as editor in chief of *Women's Wear Daily* and founder of *W* magazine. "And Loulou, well, she was the real McCoy."

When asked about Saint Laurent's brilliance in *Interview*, Loulou replied, "It's the sense of being right. He takes a peasant dress and makes it look superb on the contemporary woman's body." And when questioned about her role, she said, "I think he asked me to join him because I had a less formal quality that he wanted to learn about." However, Loulou's friend Marisa Berenson casts her as "Yves's Tinkerbell," an opinion shared by Paloma Picasso, who was struck by Loulou's "ethereal energy" and her way with color. "It was as if someone took a brush and painted a color around her — it was magic," Picasso says.

The courtship took time. First, Saint Laurent began sending her clothes. "He loved how Loulou mixed couture with her own wardrobe and never stopped changing styles," says Clara Saint, an essential figure at Saint Laurent's fashion house. Then he invited her to the presentation of his legendary 1940s collection in 1971. "We were posted in the room to see how the press and clients would react," says Picasso. "It was fun being with Loulou and she was terribly good at talking up the collection that became such an influence on fashion." A year later, Saint Laurent decided that he wanted Loulou in his studio and Clara Saint was sent searching for her. "At the time, she was living in Wales with her brother, Alexis, who was raising sheep," Saint says. According to Eric Boman, who was then designing textiles for Saint Laurent, "personal style was a prerequisite for Yves," but he senses that "it was Loulou's upbeat person that impressed him the most — he needed to be lifted from his morose depths and Loulou could do that by just being herself." There was also her general attitude. "Loulou understood that you have to amuse yourself with fashion, otherwise it's unbearable," says Hubert de Givenchy.

"After Loulou ended her relationship with Fernando Sanchez, he said 'It's like having no flowers in my home.'"
— Elsa Peretti

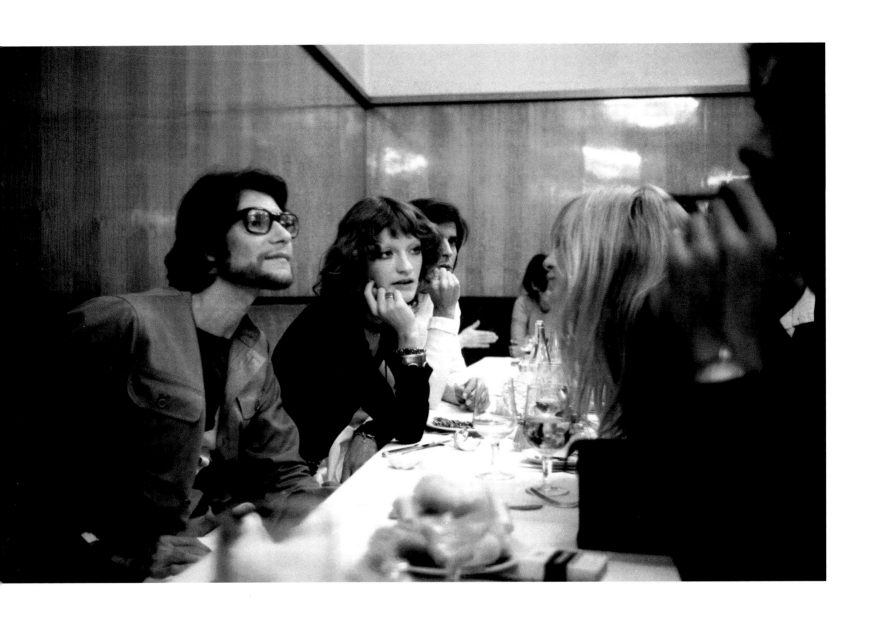

" Loulou understood and loved fashion, yet kept her personality and unique style. She was so free."

— Betty Catroux

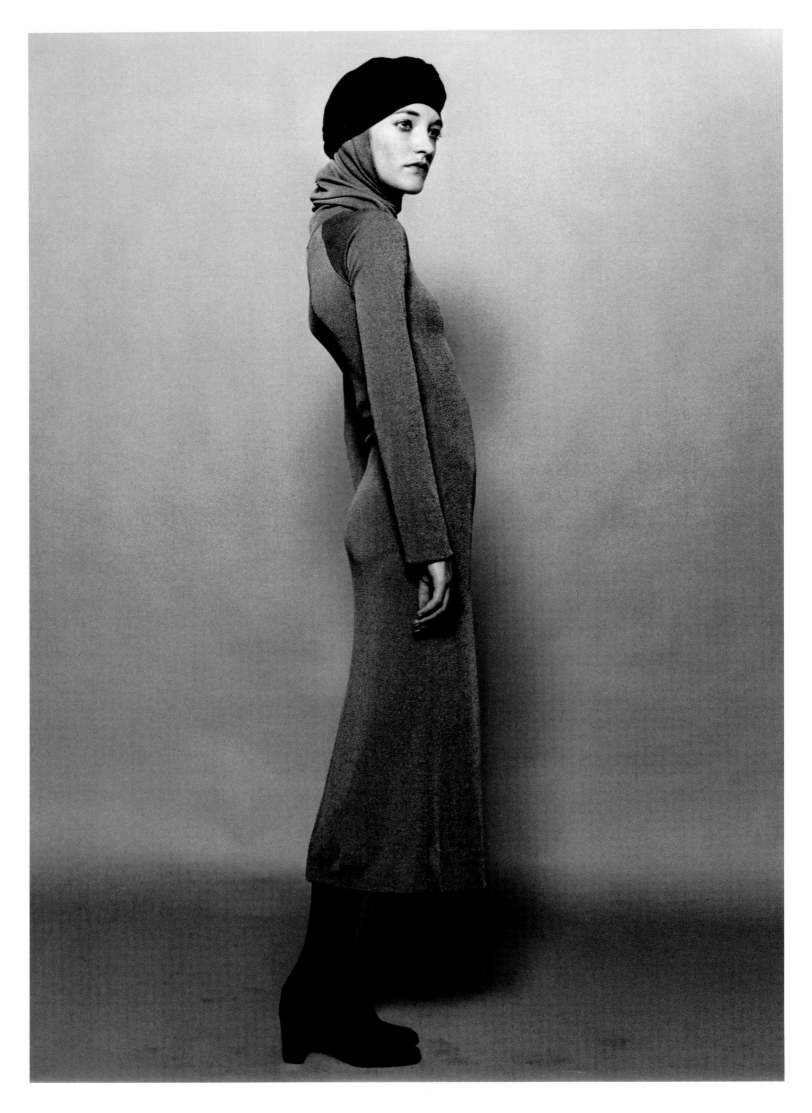

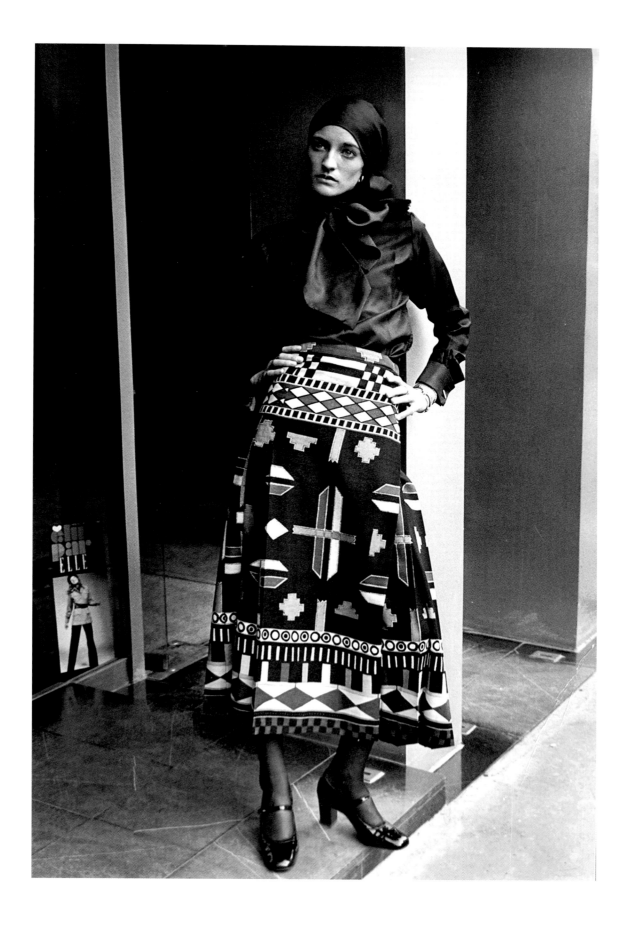

OPPOSITE — Loulou posing for *Elle* in a knit dress from *rive gauche* Autumn-Winter 1969. Photograph by Peter Knapp.

"Born with grace and a slightly melancholic elegance, everything looked good on her. She was a princess — but of what galaxy?"

— Gilles Bensimon

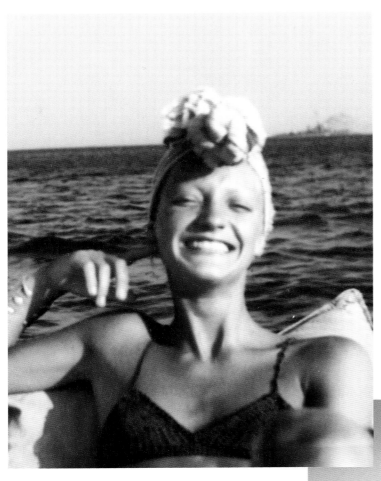

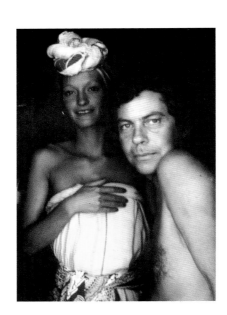

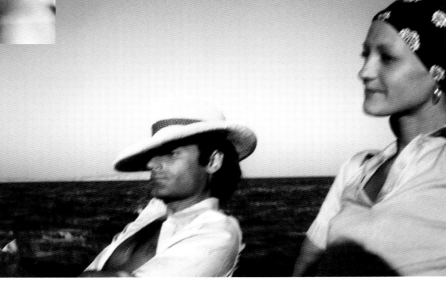

"On Patmos, Loulou displayed an unsuspected sportsmanship.
She dove around the rocks for sea urchins, which she opened with a knife carried
in her bikini bottom and devoured them on the spot."
— Eric Boman

Loulou had the summer to think about Saint Laurent's offer. "She was somewhat hesitant," said John Stefanidis, who had invited her to stay with him in Patmos, Greece. "She wanted her freedom." The interior decorator Verde Visconti, who was with them on this holiday, recalls Loulou constantly playing Lou Reed's "Walk on the Wild Side." "She listened to it again and again and again," Visconti says.

Eventually, Loulou accepted the position, with some trepidation. She showed up at her first day of work at the house of Saint Laurent wearing her old Lycée uniform (a decision that later became one of her favorite fashion faux pas tales). "Yves was a little scared that I wouldn't want to include Loulou," says Anne-Marie Muñoz, who ran the studio and knew the designer from his days at Christian Dior. "But I was thrilled." The soberly chic Muñoz was struck by Loulou's spontaneity, love of bright colors, and gifts as a stylist, as well as how she created gaiety around her. The two women were quite different in character. "Muñoz was strict but loyal to a fault; without her the ship would have sunk many times over," explains Boman; Loulou was viewed as the cool sister. Their approach to the designer was also dissimilar. Muñoz worshipped Saint Laurent, whereas Loulou was more detached and less fawning.

That said, despite their contrasting roles, Muñoz insists that they shared the same goal. "We wanted to seduce Yves with our work," she says, stressing that everything revolved around him. "They were so lucky to have her," says Fairchild. "Not only was Loulou bubbly and hardworking but she inspired Yves." Marian McEvoy, who worked for *Women's Wear Daily*, compares Loulou and Saint Laurent to an old couple: "Calm, aware of each other's moods, and courteous; there were no lengthy discussions or debates," she says. "But lots of communication through gestures and glances." Though she was Saint Laurent's great friend and muse, McEvoy stresses that "Loulou challenged Yves and Yves challenged Loulou. But the results are historic."

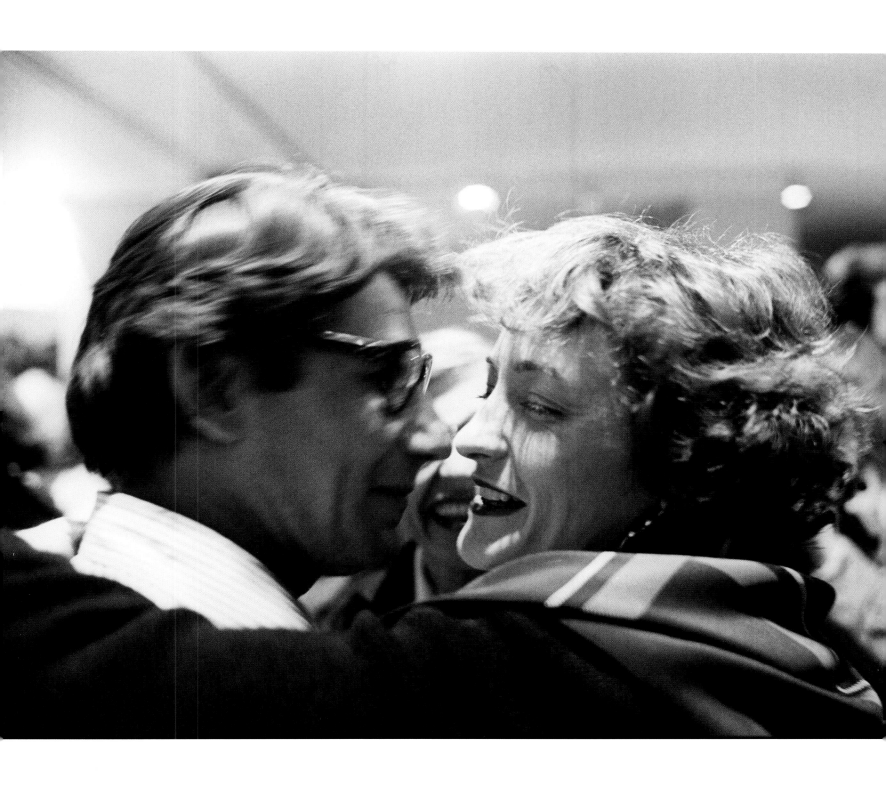

" Yves and Loulou complemented each other. Yves loved Loulou like a sister."

— Manolo Blahnik

Louise de la Falaise dite Loulou. Un nom qui pourrait être celui d'une favorite de Louis XIV, un surnom qui évoque une heroïne d'Alban Berg.

C'est en résumé tout ce qui émane d'elle. Elle n'est que facettes multicolores et brillantes. Nymphe au corps d'hermaphrodite elle imprime à tout ce qu'elle fait ce jeu des contrastes les plus opposés mais qu'elle seule sait faire se rejoindre.

Son élégance devient exhubérance et s'encanaille. L'Aristocratique et hautain dessin de son corps n'entrave en rien ce parfum de trouble sensualité qui étonne, intrigue, accapare, dérange. Cette réserve lointaine est un appel plein de mystères. Ne nous y trompons pas: sous le voile impudique de dentelle noire se cache une petite fille qui est une vraie femme.

Yves Saint Laurent

Louise de la Falaise, known as Loulou. A name for one of Louis XIV's favorites, a nickname evoking a heroine by Alban Berg.
It is the essence of everything that radiates from her. She is composed of brilliant and multicolored facets.
Androgynous nymph, she stamps everything she does with a caprice of clashing contrasts which she alone can harmonize.
Her elegance is transfigured by exuberance and revelry. The haughty and aristocratic lines of her body leave unfettered the fragrance of sensuous tumult which astonishes, intrigues, conquers, disturbs. Her aloof reserve is a summons full of mystery.
Let us not be deceived: under the unchaste veil of black lace hides a little girl who is a true woman. — Yves Saint Laurent

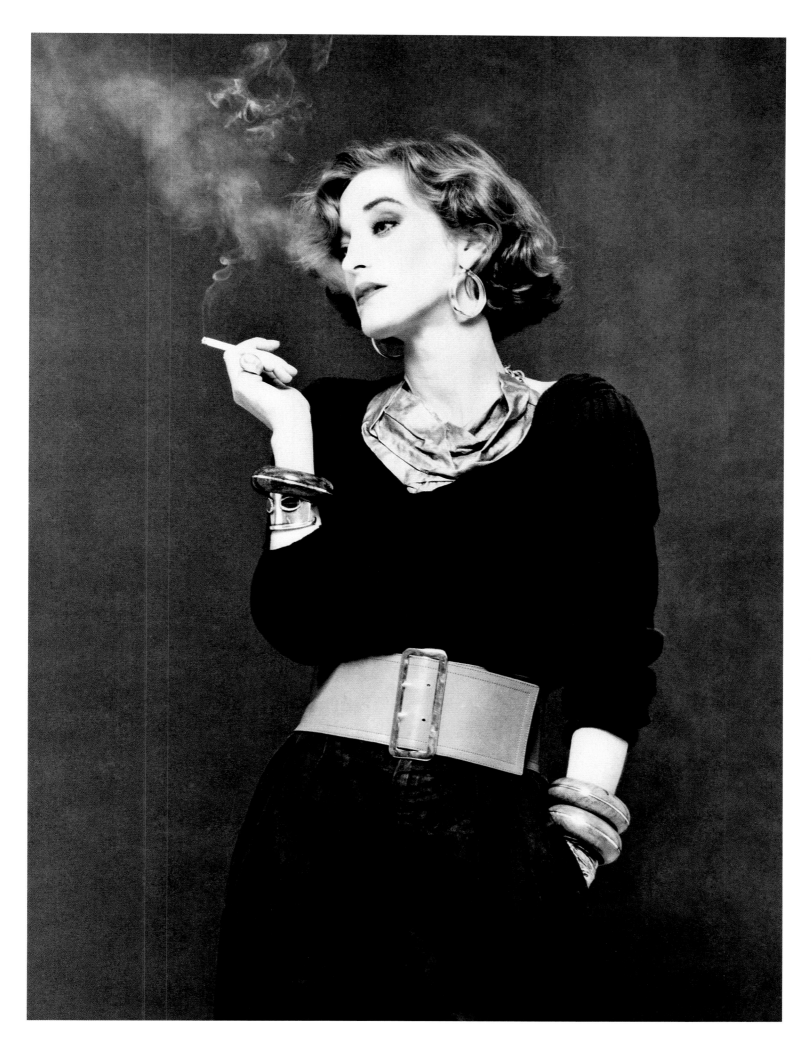

Few could carry off flamboyant costume jewelry like Loulou, as evidenced by this 1992 Pascal Chevallier portrait from *Vogue*, where she mixes a Saint Laurent *rive gauche* jacket, necklace, and belt with *haute couture* earrings.

There was also the fact that no one wore Saint Laurent like Loulou. Landscape designer Madison Cox, then a student at Parsons, recalls her entrance at a downtown loft resembling "the Tartar prince from Virginia Woolf's *Orlando*." "She had an enormous fur hat on her head, a fox dangling across her chest," he says. "It was the height of Yves's Russian peasant look but there was nothing 'babushka' about Loulou. She initially intimidated then immediately charmed." Loulou had worn the same outfit when having a "showgirls' lunch" (Campbell's soup served out of a can and a bottle of whiskey) with the Irish poet Patrick O'Higgins and the fashion editor André Leon Talley. "All dressed up, she was very 'countess madam,'" says Talley, then at Warhol's *Interview* magazine. "On her, Saint Laurent took on another dimension and that's what Yves loved." A few years later, Loulou in his *haute couture* Smoking with "enormous white revers on the black jacket" had left David Croland, speechless. "Everyone was chic" but "not quite as chic as Loulou."

Her appearances were so breathtaking that Fairchild and McEvoy once discussed the idea of staking a photographer outside Loulou's front door on a daily basis for a year. "It would have been a documentation of a brave and constant style," McEvoy says. Loulou also dared to tease Fairchild, a "feared and revered" figure in Paris. "He was deeply impressed, and probably somewhat in love with Loulou — everyone was," McEvoy recalls.

Whatever the circumstances, Loulou was socially comfortable. "In a place based on hierarchy, she made herself exempt from politics," recalls Gabrielle Buchaert, in charge of the fashion house's press office; whereas in the opinion of Hélène de Ludinghausen, the director of the couture salon, "Loulou could charm a wall." And all that counted to Saint Laurent, who was calmed by her protectiveness and closeness to Betty Catroux, his best friend and his female equivalent, physically. "Loulou was the positive one in the trio," says Catroux. "Yves and I tended to darken everything black. But Loulou was the opposite and kept up the morale."

"Loulou's accessories were the defining exclamation mark on an Yves Saint Laurent look."

— Hamish Bowles

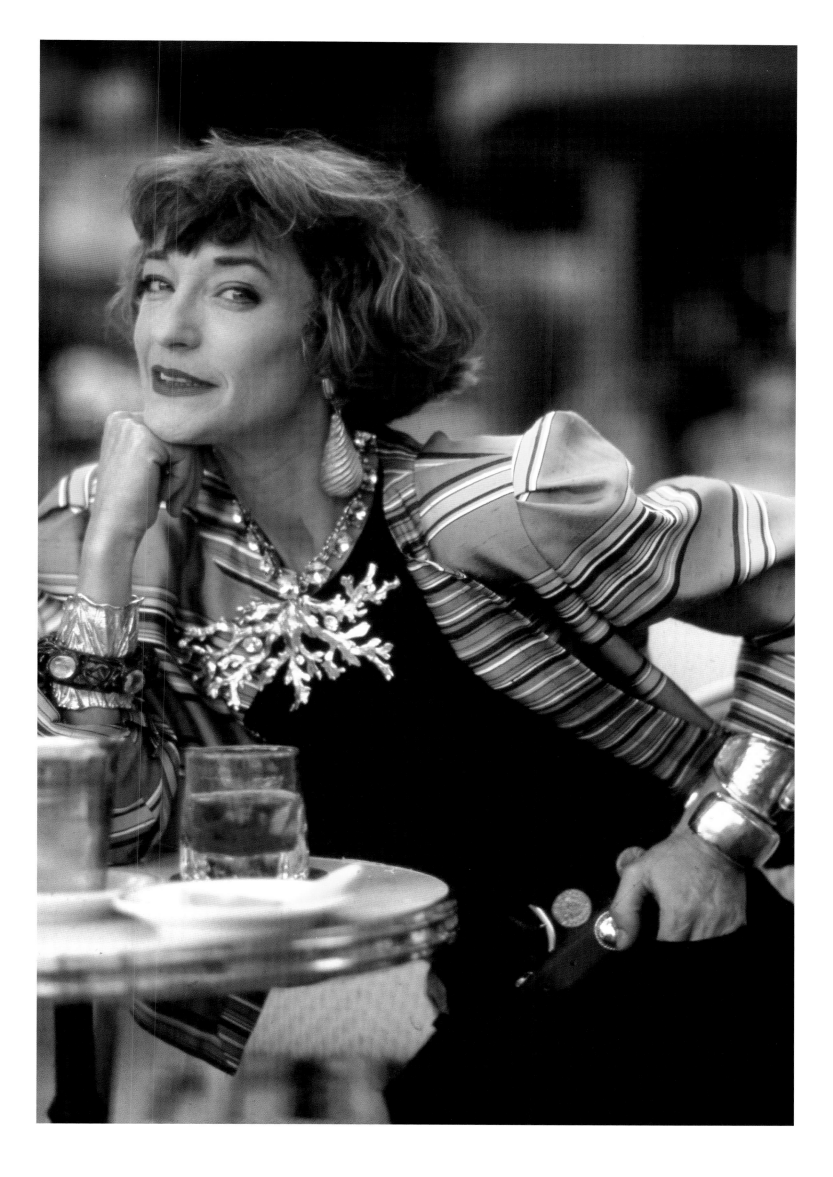

Nevertheless, Mademoiselle de la Falaise was too curious just to belong to one gang. She liked to swim in different crowds. She would travel to exotic places with Ricardo Bofill, the Spanish architect. She would stay at Château Lafite with Eric de Rothschild, one of France's most eligible bachelors; or start a food fight at Bofinger with Fred Hughes, Warhol's business partner; or kick back with the illustrator Antonio Lopez, his boyfriend Juan Ramos, and his outrageous gang of models including Pat Cleveland, Donna Jordan, Corey Grant Tippin, and Jay Johnson, fresh from New York. "It always amazed me how Loulou could be at the Club Sept every night dancing away with Grace Jones and then be able to work in the morning," says Johnson. "I think her job and friendship with Yves were her foundation. She certainly was devoted and loyal to an extreme."

In the opinion of Kenzo Takada, both Saint Laurent and Pierre Bergé were possessive of Loulou. "She often received calls wanting to find out what she was doing, but she was hard to pin down," he remembers. "Loulou was the type to kick off her shoes to dance, as if it was the most normal thing in the world." Kenzo, with his shop Jungle Jap, was one of the new fashion talents, but he was designing ready-to-wear, not couture. "We used to meet at the bar of the Cloiserie des Lilas," he says. "I was really shy and it was thanks to her that I met chic Parisians." Loulou dared to take the rival designer to the home of Charlotte Aillaud, a noted Rive Gauche hostess who was Bergé's best friend and a Saint Laurent client. In the opinion of Eric Boman, Loulou's relationship with Kenzo confirmed how Loulou "was totally nonconformist." "If she thought one person was divine, that was enough," the photographer says. However, Alicia Drake senses that Loulou's open-mindedness captured "a time of glorious freedom" and "the possibility to experiment with your sexuality and to do so without the fear and shame of extreme censure," which, Drake notes, "is so hard now to imagine."

The only area where Loulou truly lacked control — an excess typical of the period — was her alcohol and drug intake. When Loulou had a brief abstinence from alcohol, Marie-Hélène de Rothschild, Paris's social queen, had congratulated her, enthusing "It's so good for you not to drink." (Loulou greeted that remark with a speedy reply of "Yes, apparently cocaine is wonderful for your liver.") But whatever Loulou did the night before, "she was always at her desk in the morning," says de Ludinghausen. This won Pierre Bergé's eternal respect. "She was there and left after everybody else," says Madison Cox, Bergé's boyfriend at the time. "She rolled up her sleeves and got to work. Loulou could not do it any other way" — even if her professional discipline occasionally led to crazy circumstances. "Once, after a very long night, Loulou slipped into the *rive gauche* boutique that was below my apartment and changed," says Kenzo. "She was so quick — like boom, boom — and always chic."

Loulou at Maxim's, December 14, 1974. From left: Jaime Clausa, Clara Saint, Kenzo Takada, Loulou, Pablo Mesejean, Thadée Klossowski, and Delia Cancela.

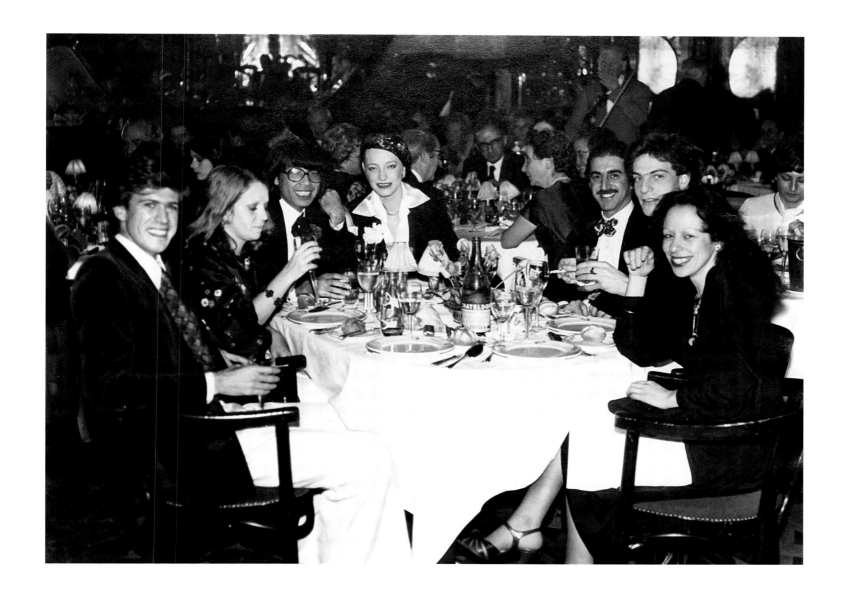

" In the evening, Loulou looked spectacular. She loved to shine." — Clara Saint

BELOW — In the studio, Loulou and Saint Laurent taking their calls.
Bottom from left: Accessorizing Willy van Roy for the *Opéras et Ballets Russes* Collection -
Fitting a model with Saint Laurent in 1978.
OPPOSITE — Pierre Bergé and Loulou photographed by André Perlstein in the studio, 1977.

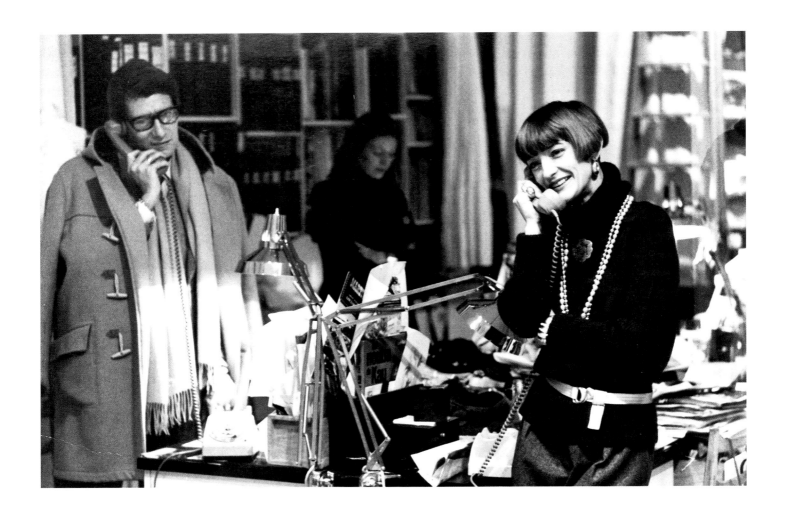

" Loulou had natural grace, was very cute, and loved what she was doing."

— John Fairchild

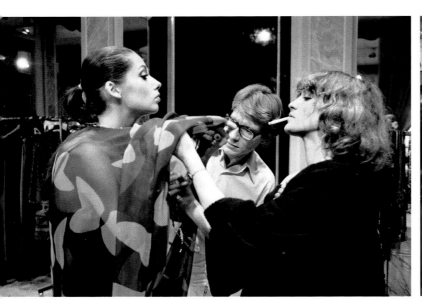

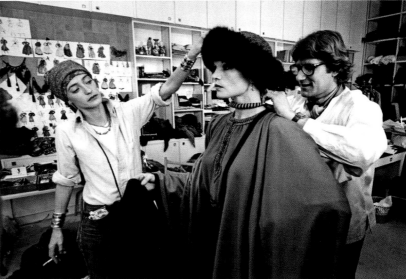

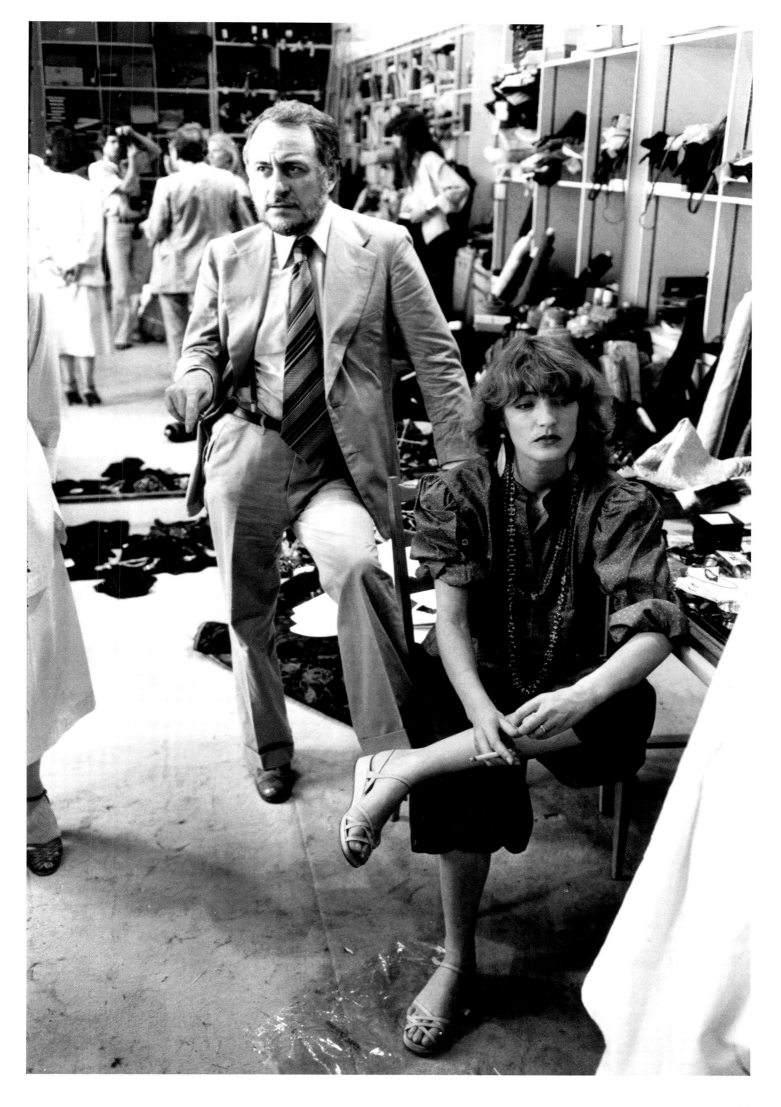

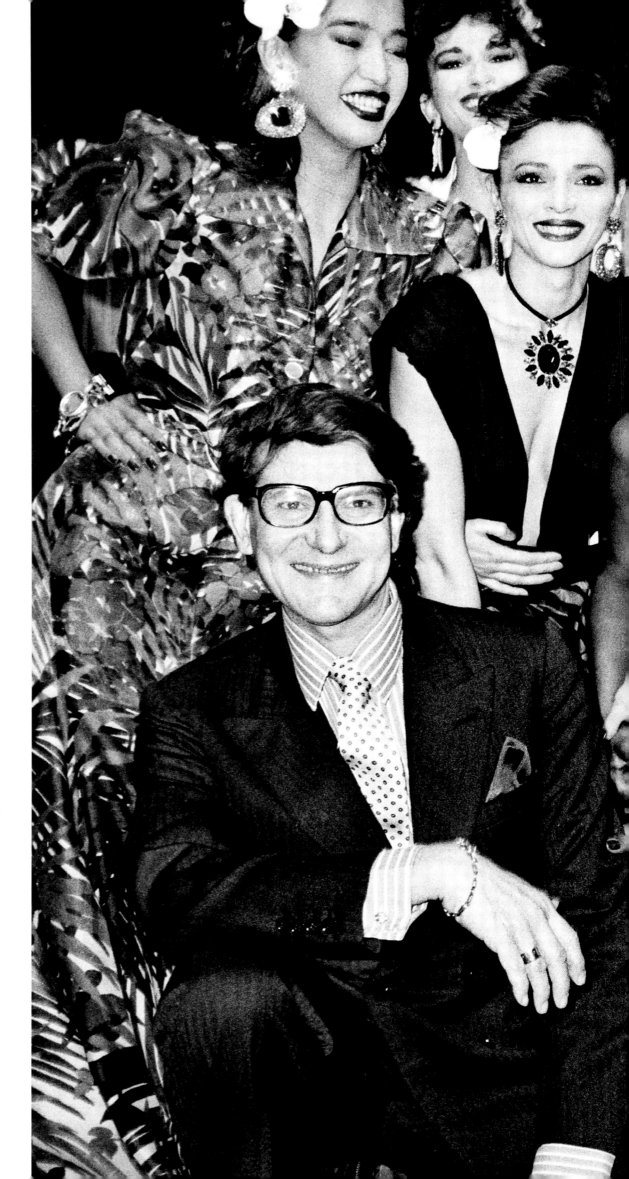

Saint Laurent and Loulou pose with their models for Roxanne Lowit after the Spring-Summer 1985 *rive gauche* show. Back row from left: Anna, Betty, Dalma, Kirat, Vania, Mounia. First row, from left, Madeleine, Rebecca, Edia, Amalia, and Nicole.

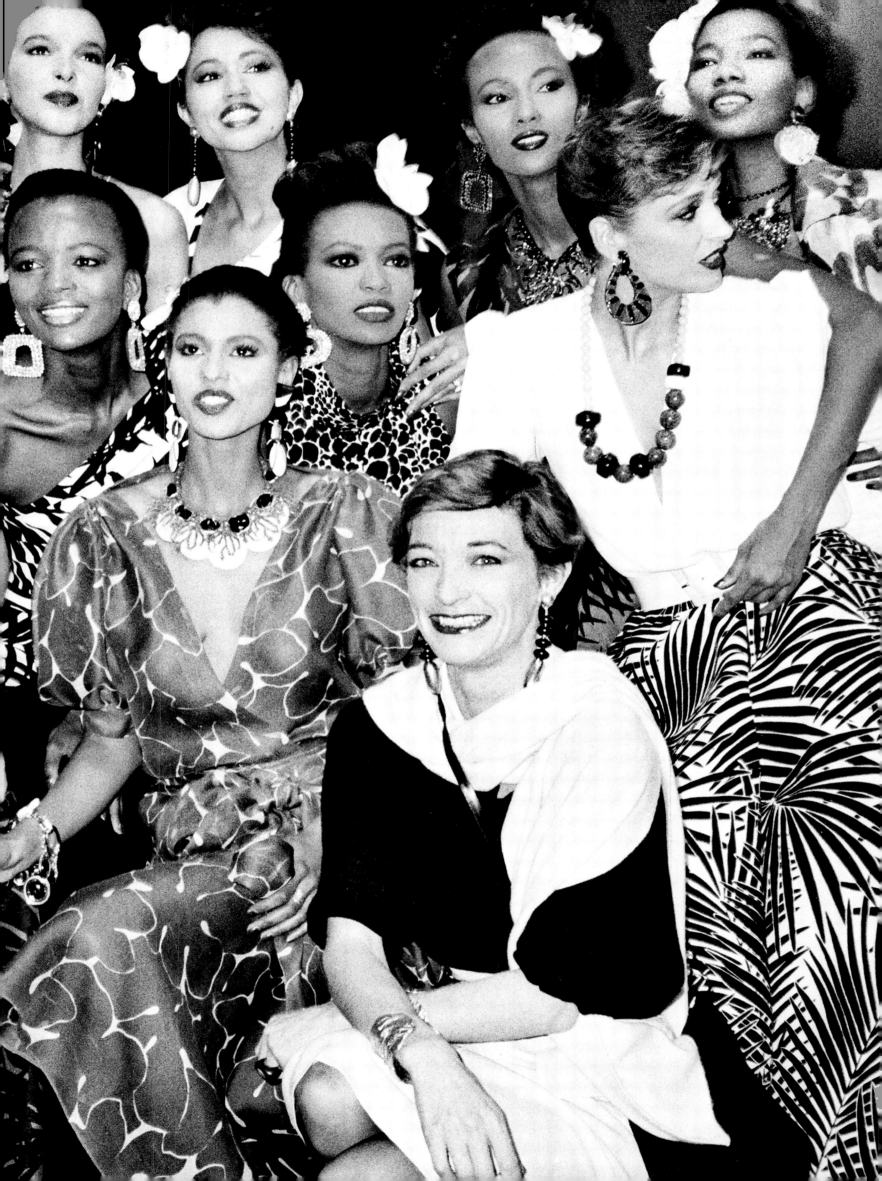

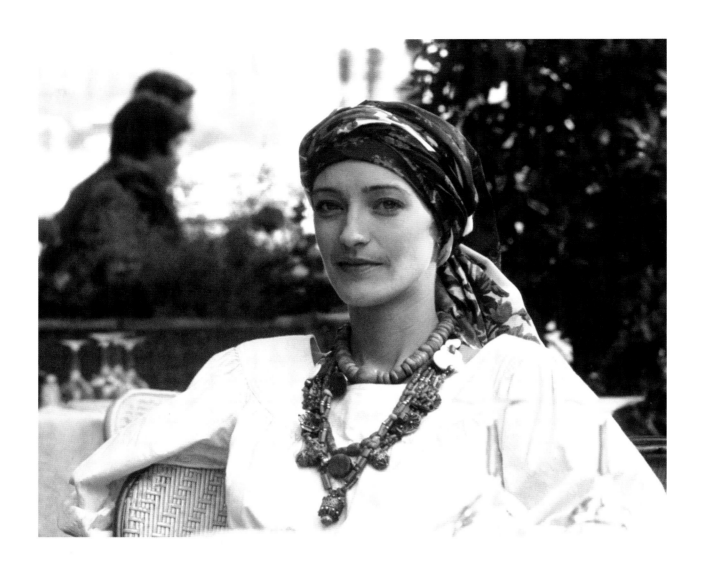

"I was hit by her beauty and fragility and how romantic she was. When Loulou moved, there was a lot of noise around her because of all the necklaces, bangles, and cuffs."

— Clara Saint

Dominique Deroche, then working in Saint Laurent's press department, remembers the excitement of Loulou's daily arrival at the avenue Marceau office. "We'd hear her run up the stairs; she made so much noise for a tiny person," she says. "And it would be 'what's she going to wear today?'" Meanwhile, Deroche describes her as "a godsend." "A genius stylist, she could choose the right dress for Romy Schneider or help if there was an article on Catherine Deneuve in Marrakech or propose the best outfits needed for a film," she says. "Loulou was like the in-house fashion editor and always available to help us." Fun and never arrogant, Deroche describes Loulou as being equivalent to four people. "It was incredible because she was also working on six collections a year, plus licenses," she says.

As for Loulou's iconic costume jewelry, which was further forging her international reputation, she thought up two thousand different creations a year. "Loulou would have meetings with Robert Goossens, Gripoix, and all the other artisans," says Danielle Vinmer, her assistant in the studio. "She had so much respect for creativity and inspired them via her enthusiasm, often pushing them to use things that they hadn't thought of before." Vinmer recalls her patience and thoughtfulness. "If an artisan was down on their luck, she tried to help," continues Vinmer. "She really felt for others and it was really appreciated. All the artisans wanted to work with her." And in spite of being very confident in her taste, she was interested in the opinion of others too.

Loulou's designs were inspired by Saint Laurent's sketches of each collection. "Sometimes he implied jewelry with big pearls or large tears and Loulou would take it from there," says Vinmer. In general, she avoided anything obvious and conventional, using huge gold balls and combining semiprecious stones, and was "mad for rock crystal." When pieces appeared, Loulou immediately tried them on. Loulou was also skilled at introducing new faces to the fashion house. "Yves always wanted to work with the same girls like Amalia and Mounia, and Loulou, with Clara Saint, pushed him to think differently," says Anne-Marie Muñoz. It was due to Loulou that Kirat Young hit the catwalk and began a successful modeling career. "She'd seen me at a party and presented me to the house," says Young, whose first show was the *Opéras et Ballets Russes* collection. Describing her as "a fairy with bracelets all up her arms and merry blue eyes," Young was bowled over by her playfulness with accessories. "Even if it seemed haphazard, it was not."

Hélène de Ludinghausen was a fan of Loulou's accessories — "They were bold and had movement" — and her trooper spirit. "Yves could be funny and humorous but he was severe in his judgment," she says. "Loulou's big expression was 'let's de-dramatize the situation' and it was a helpful attitude."

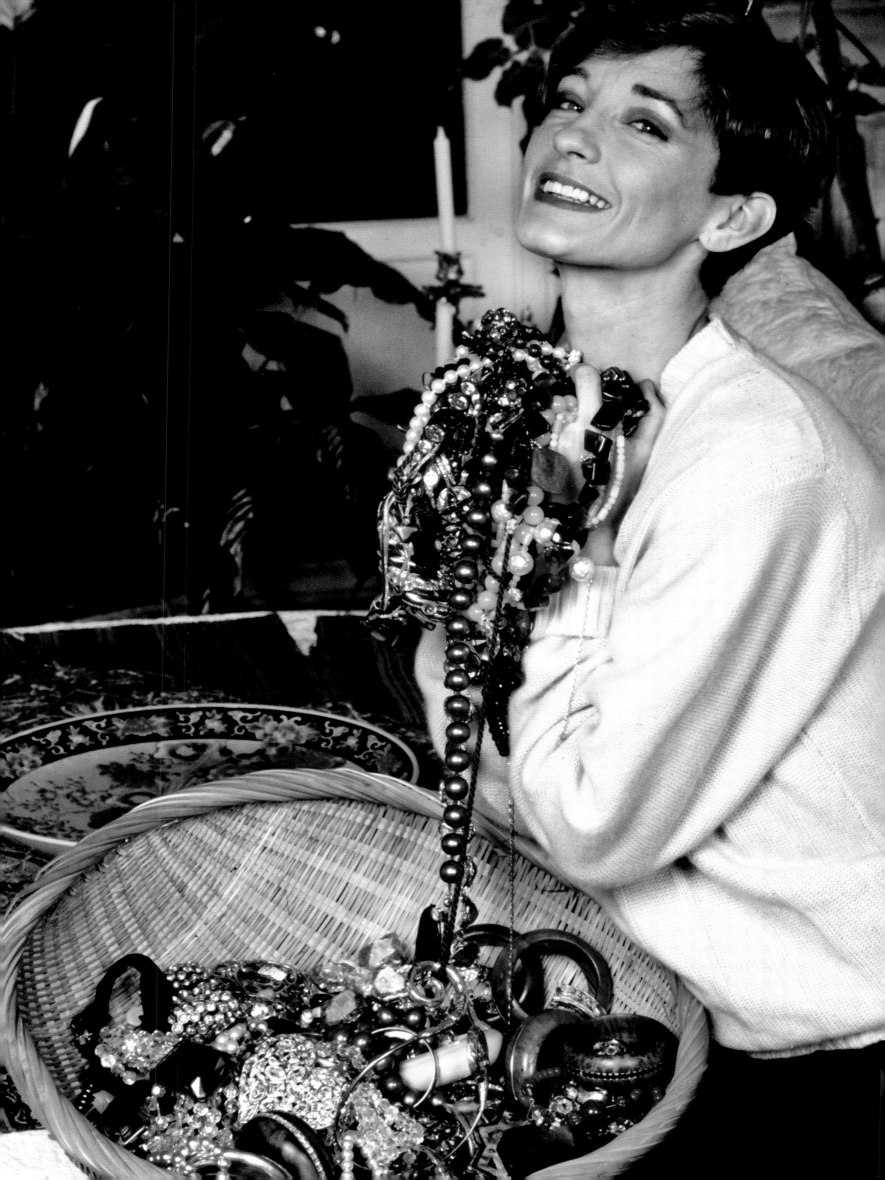

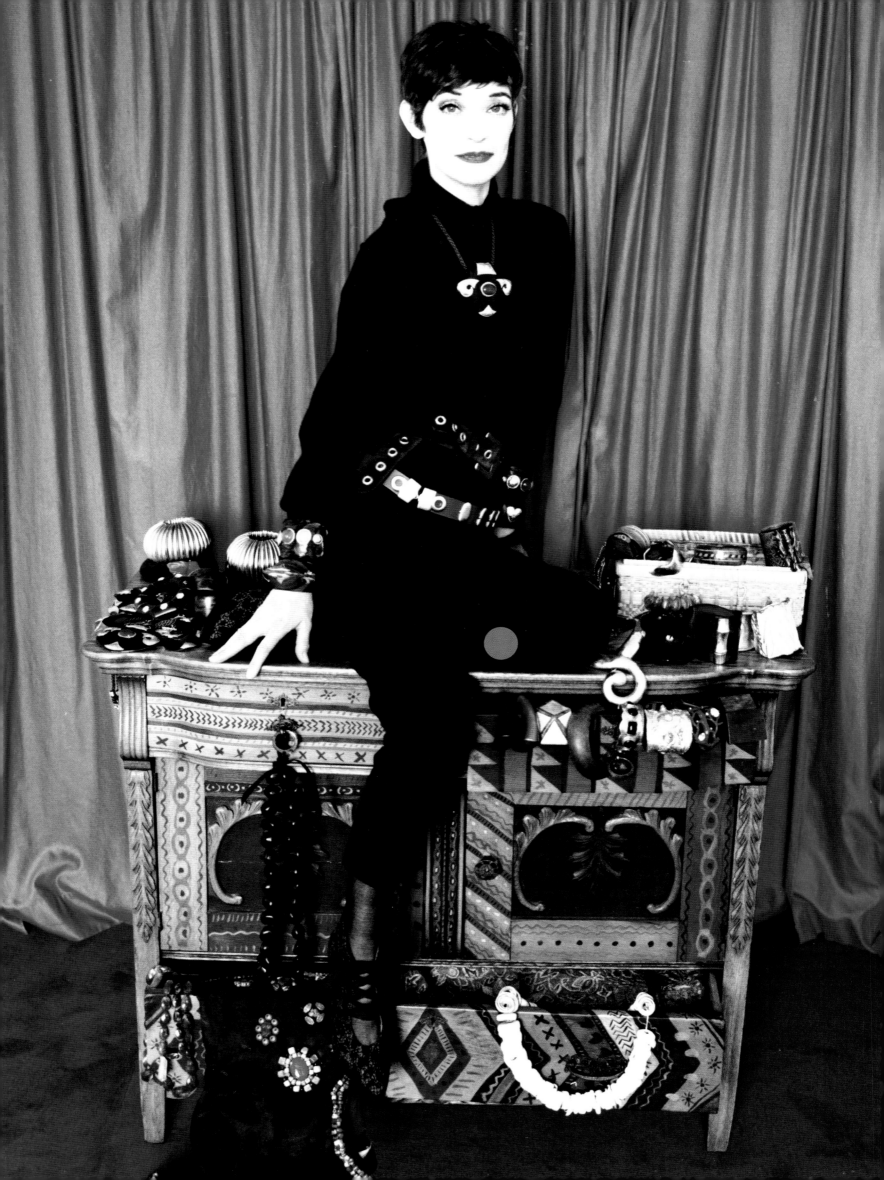

OPPOSITE — Loulou sitting on a chest of drawers painted by her mother Maxime de la Falaise,
photographed by André Rau for *Elle*.
BELOW — Loulou loved natural elements, like those that inspired these carved Saint Laurent *rive gauche* shell cuffs.

*" Being profoundly unconventional, Loulou was very brave with her hair
and used it to change her look. She was always game to changing her color or
cutting it really short."*

— Valentin Mordacq

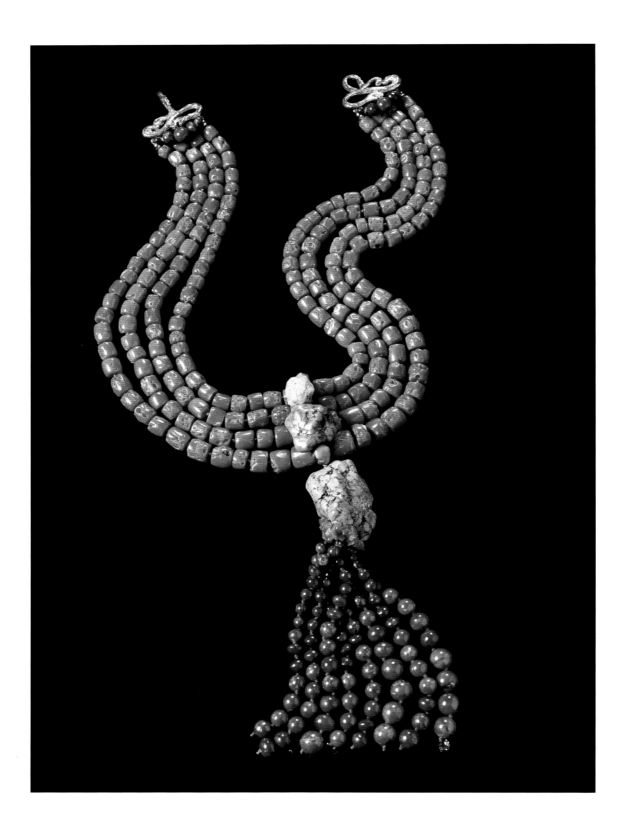

"Loulou was the chichest person on two legs. She had that built-in elegance."

— Grace Coddington

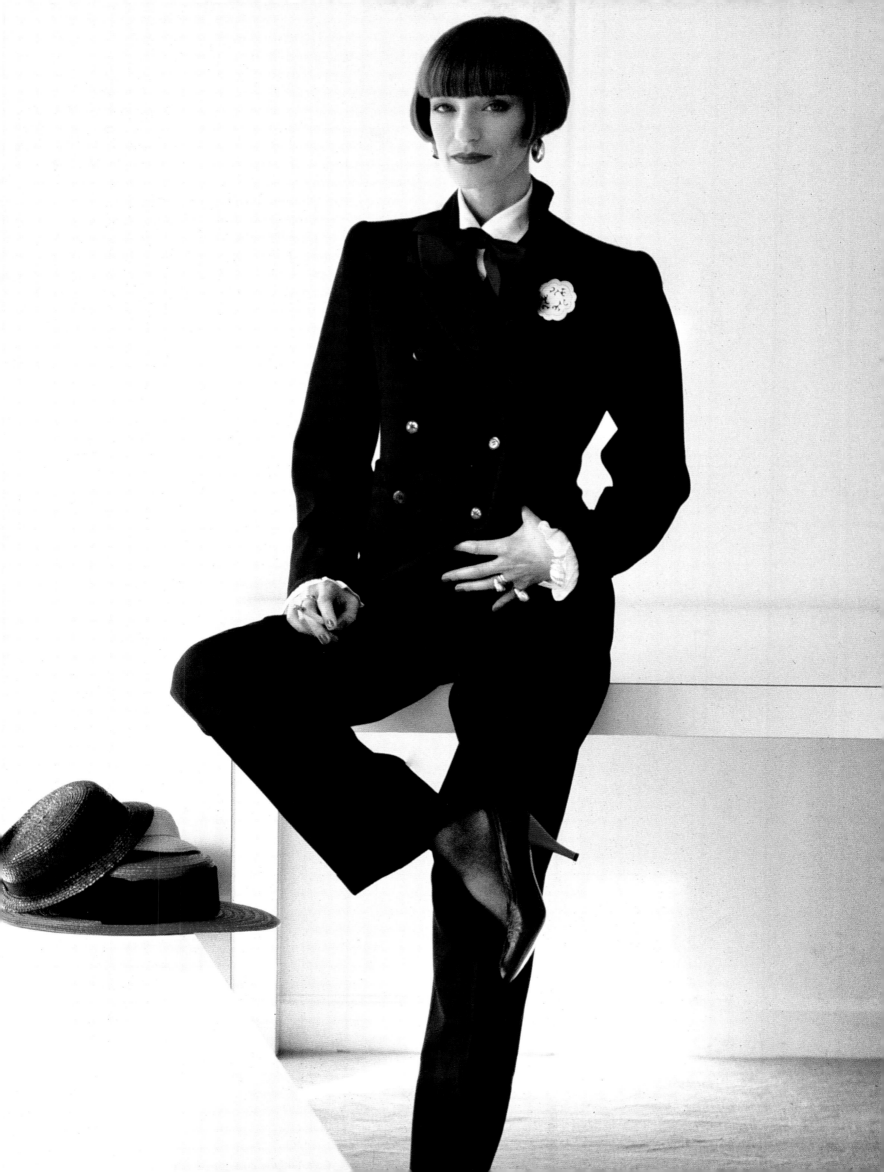

BELOW – Some of the knits and accessories Loulou created for Saint Laurent *rive gauche*.
OPPOSITE – Loulou sporting a pair of her tasseled earrings and a 1990 Yves Saint Laurent *haute couture* jacket.
Photographed by Oberto Gili for the September 1990 issue of *Vogue Germany*.

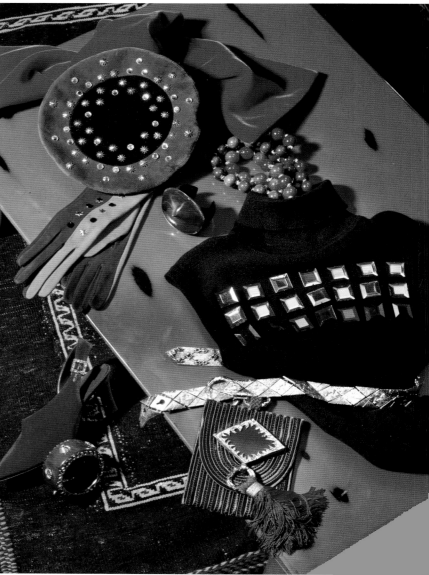

"One Loulou story I love concerns a trip she took to New York. When she arrived at JFK, a customs official asked her to open her four suitcases filled with hundreds of pieces of outsize jewelry and sparkly shoes and bags. Astounded and perplexed, he looked up and asked, 'Hey lady, are you in the circus or something?'"

— Marian McEvoy

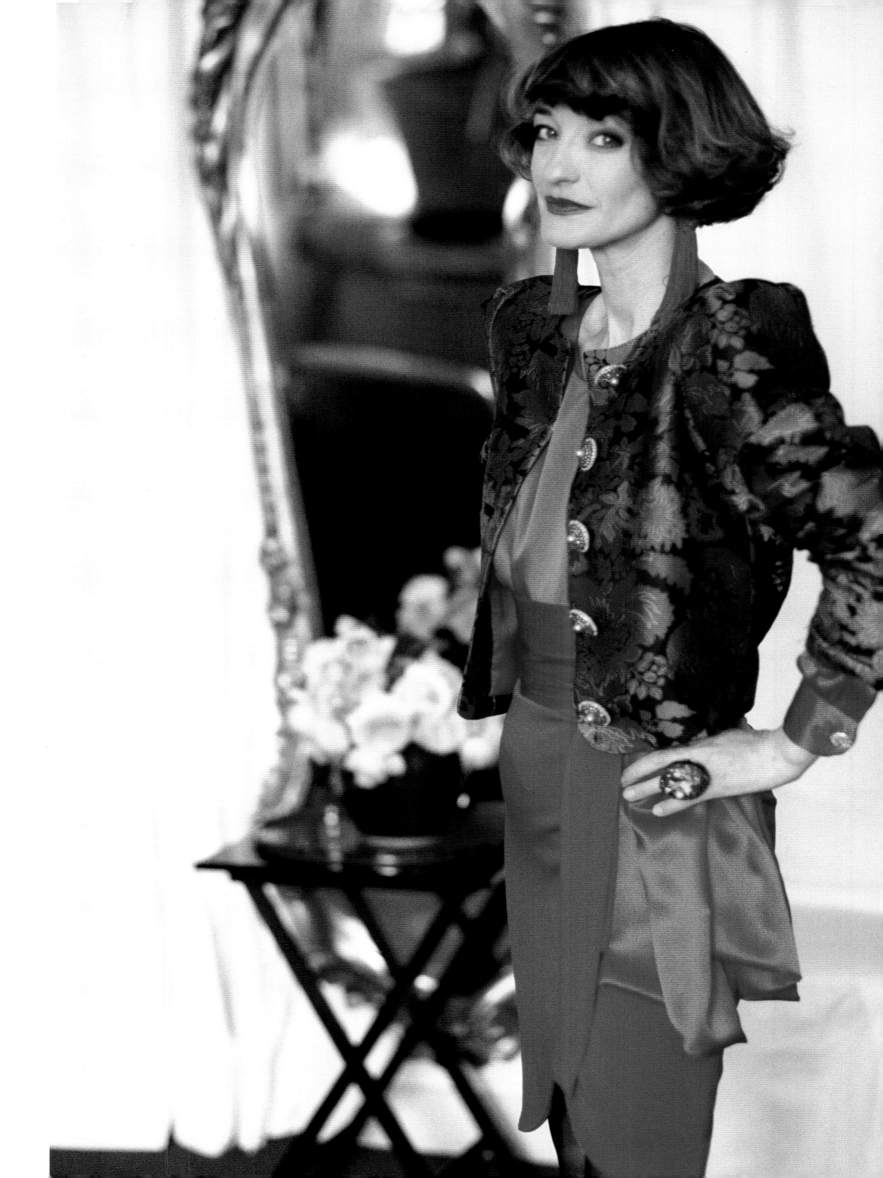

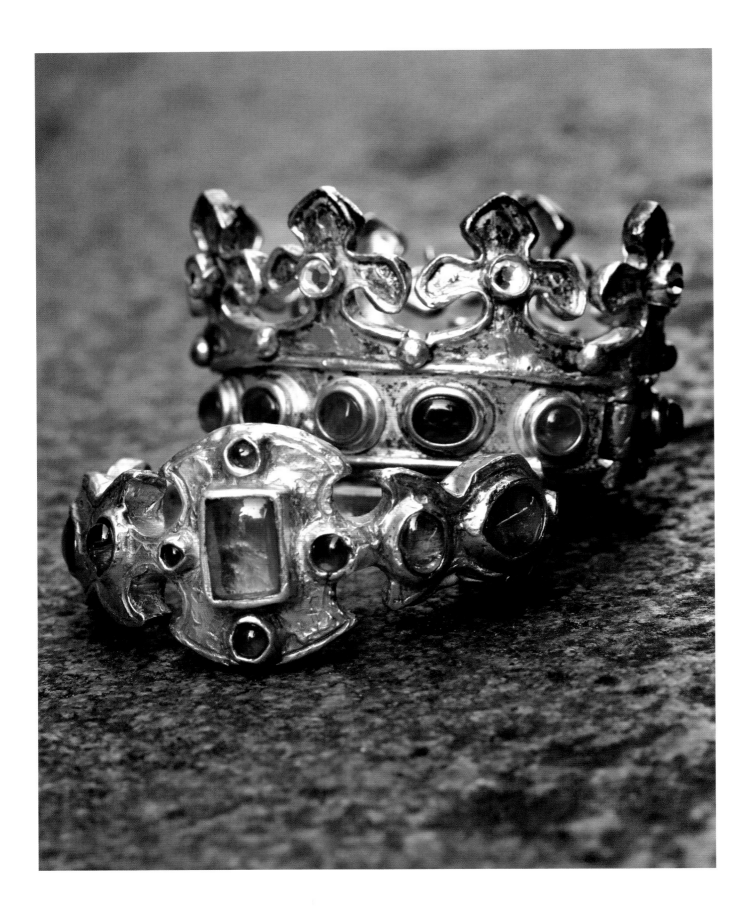

"Loulou knew what she was in the mood for. She needed no reference. There was spontaneous confidence that comes with that." — Lucie de la Falaise

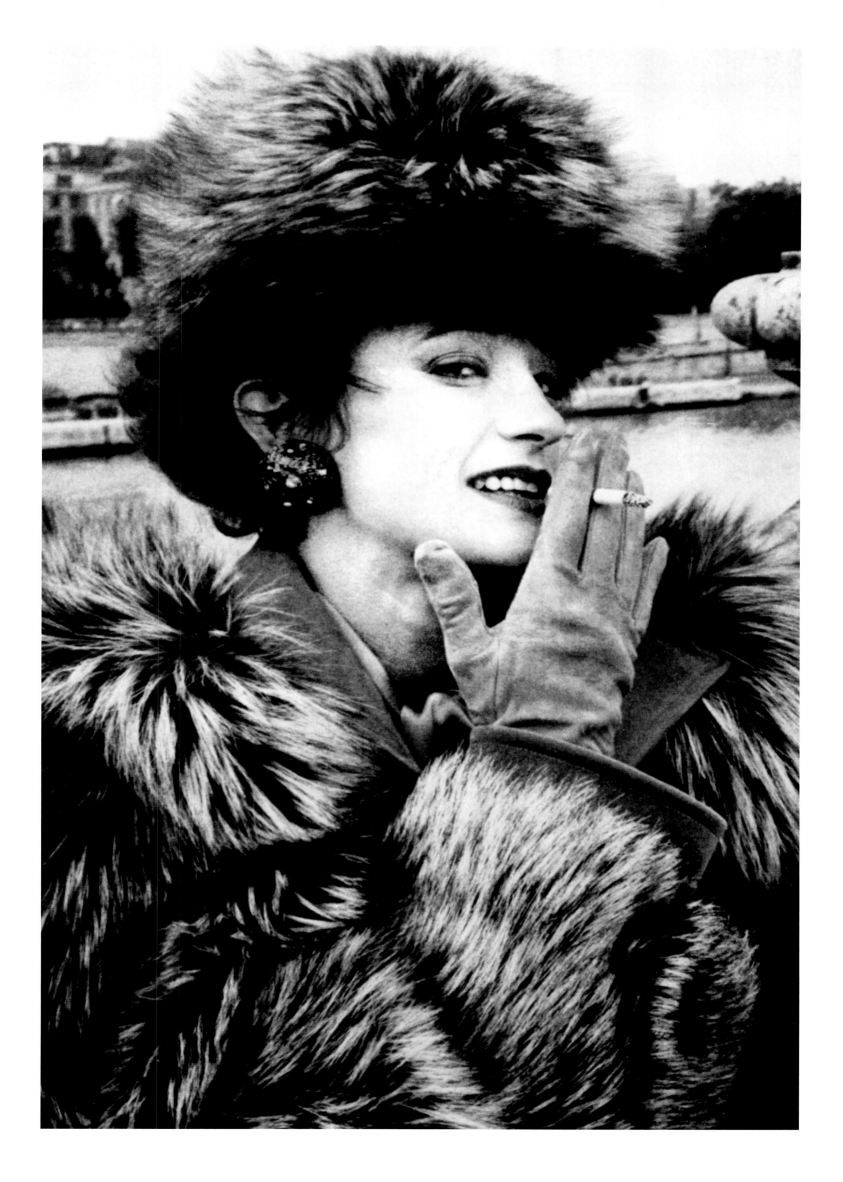

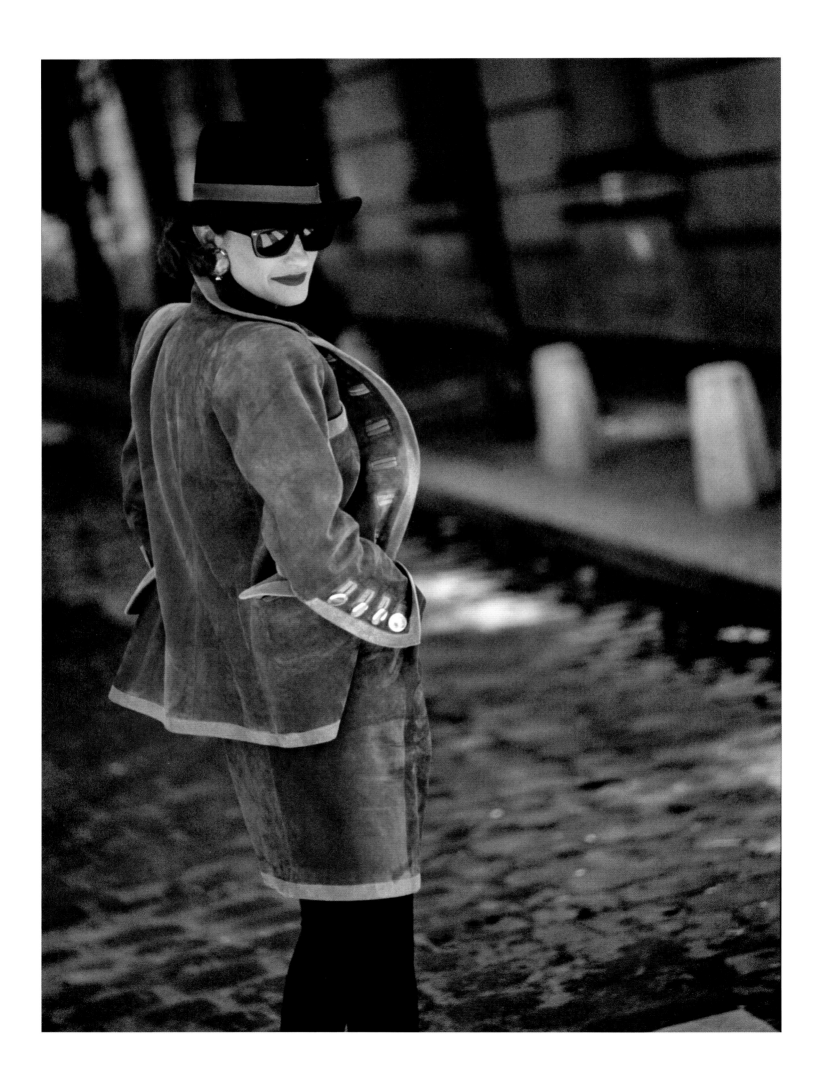

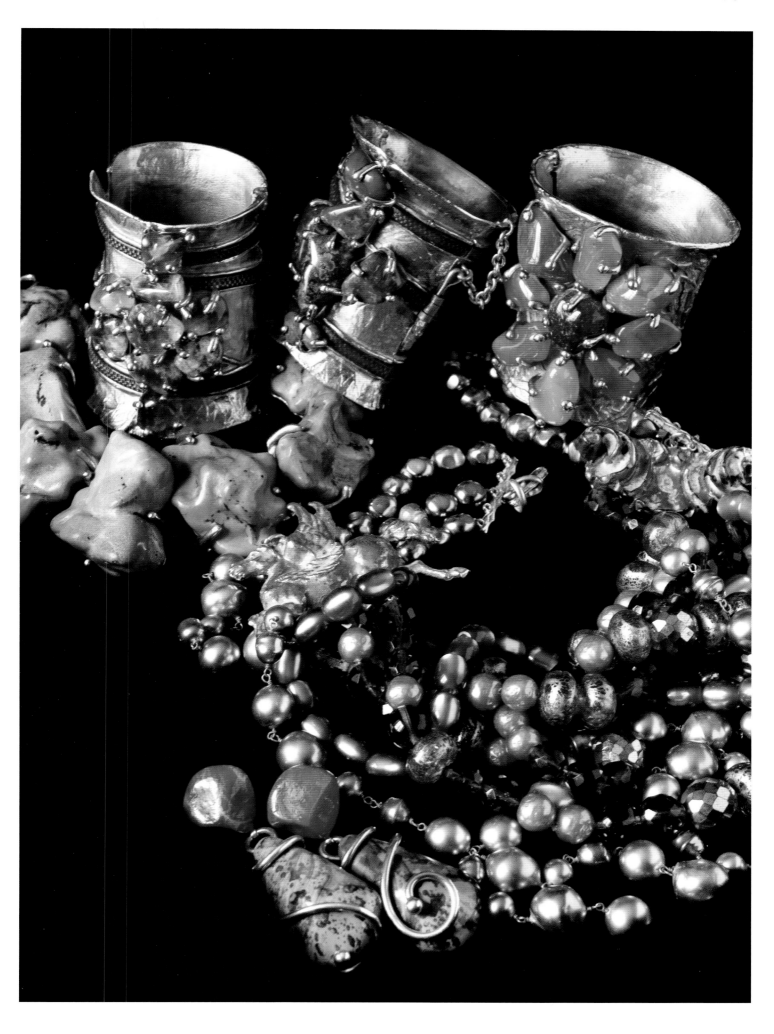

BELOW — This *haute couture* bangle with rock crystal, from Autumn-Winter 1988 is a perfect example of Loulou's collaboration with the revered jeweler Robert Goossens.
OPPOSITE — Loulou wearing one of Yves's favorite pieces, a gold wheat brooch.

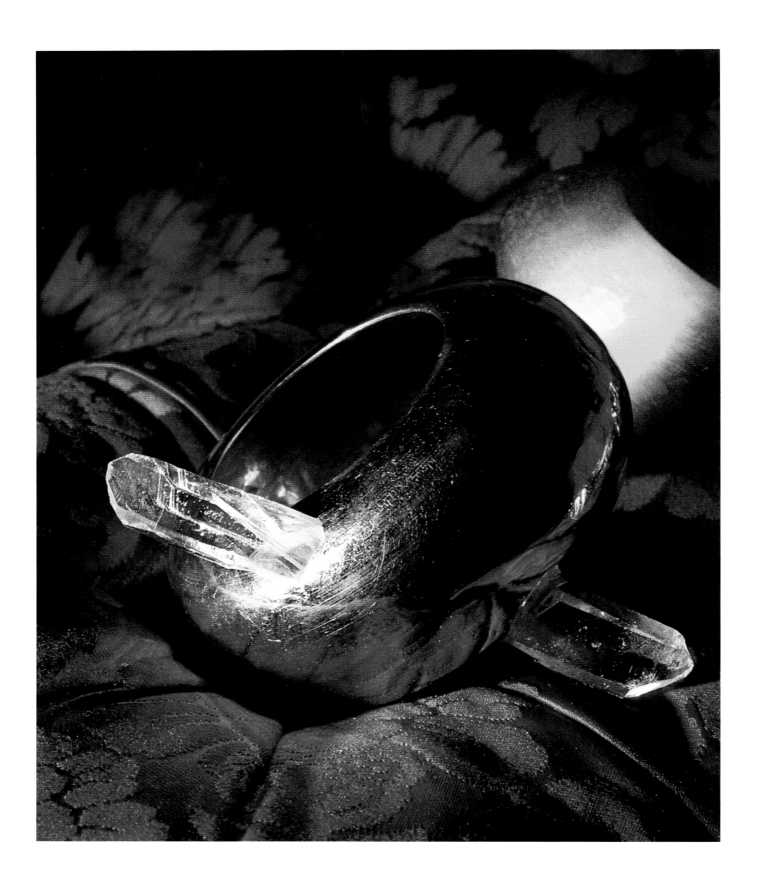

"Loulou had a modern aesthetic and made things with terrific refinement."

— Christian Louboutin

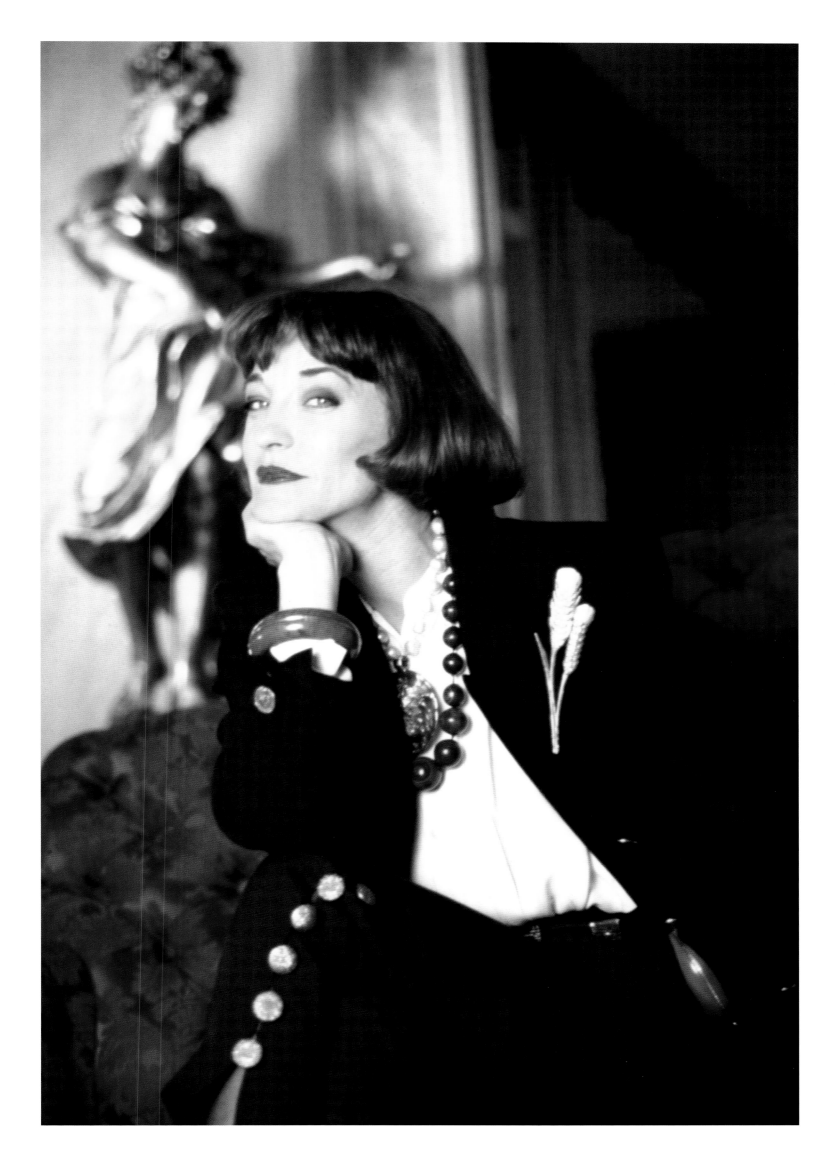

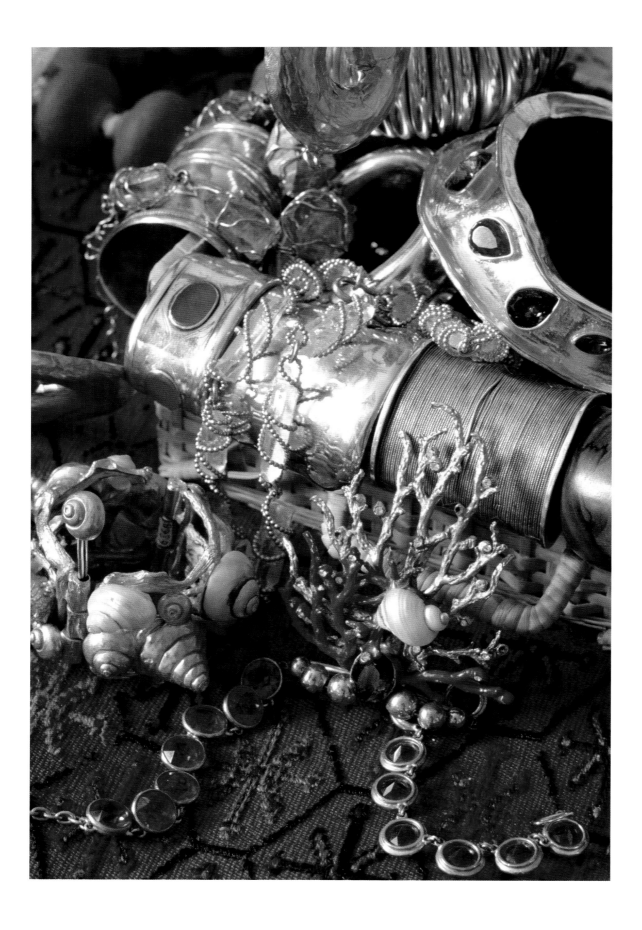

*"Loulou's influence was pretty profound on Yves Saint Laurent,
the most influential designer of his generation."*

— Hamish Bowles

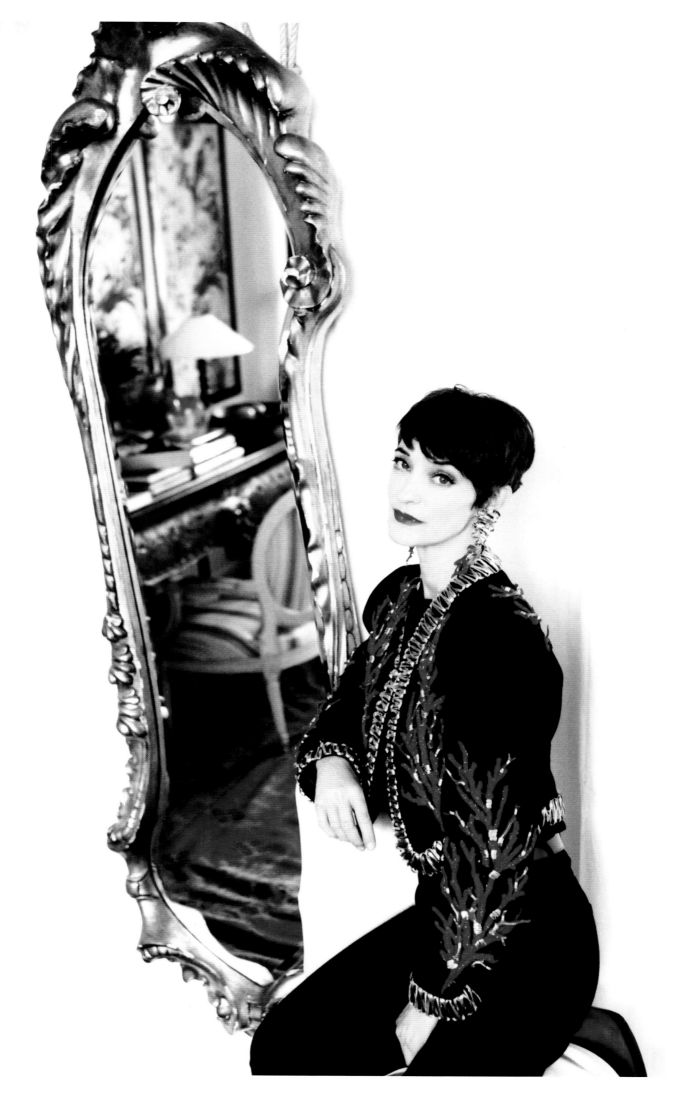

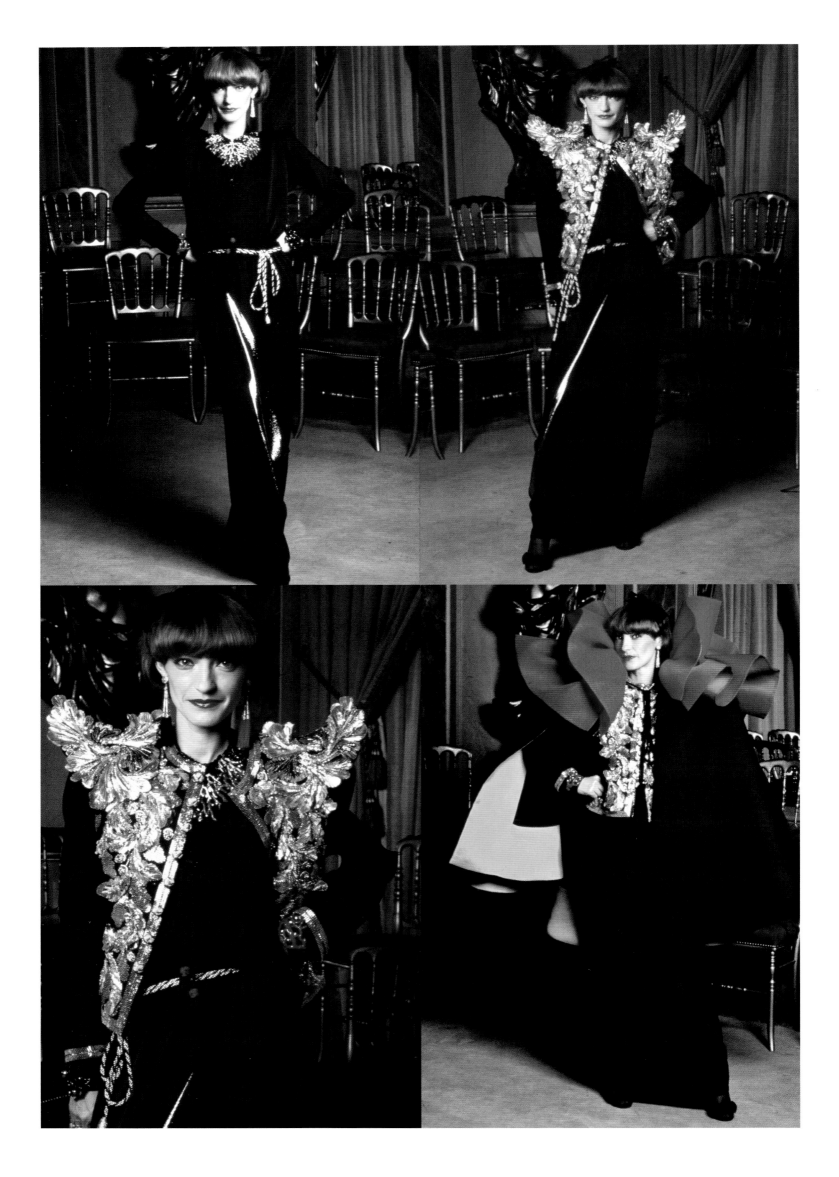

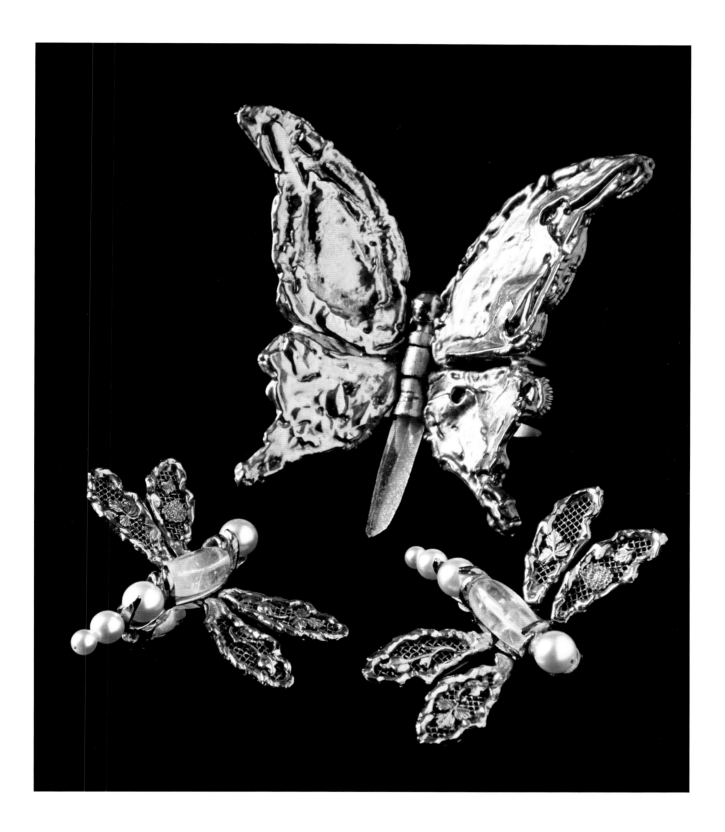

"Loulou and Yves belonged to the same planet and she acted like a light at his side."

— Violetta Sanchez

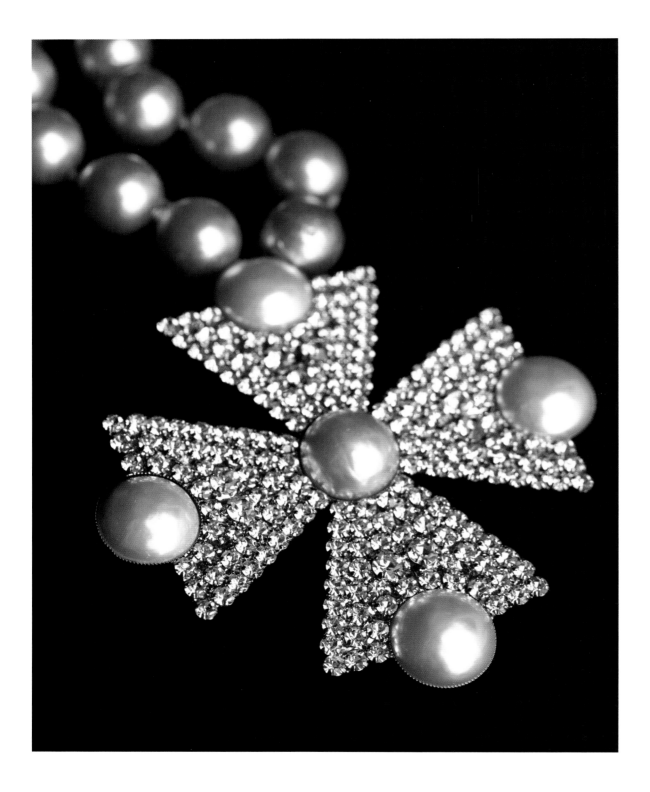

"Loulou had that way and manner that all clothes looked light on her, it was so unique."

— Michel Klein

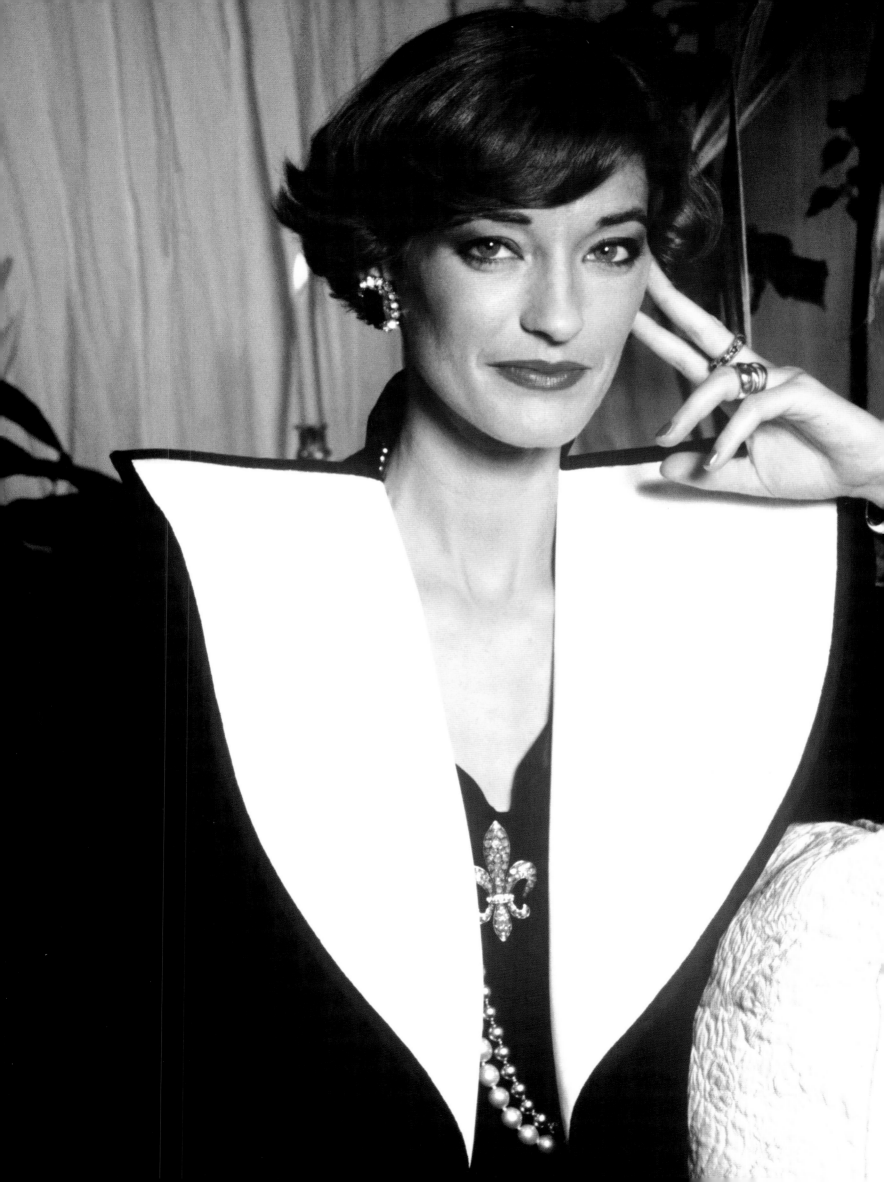

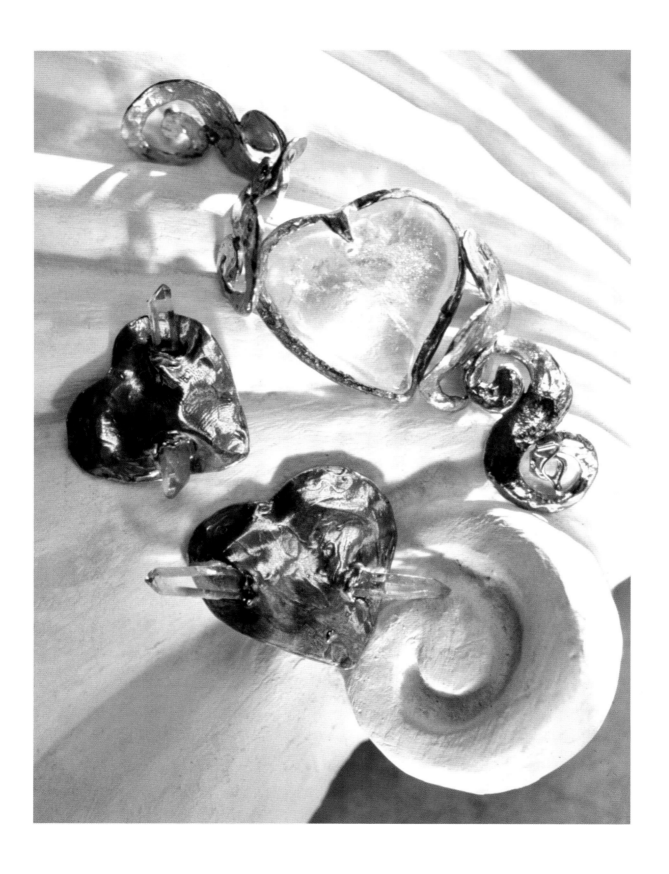

"Looking at photographs of Loulou, you can see that she was such a chameleon, but because of her personality, it was always her."
— Michel Klein

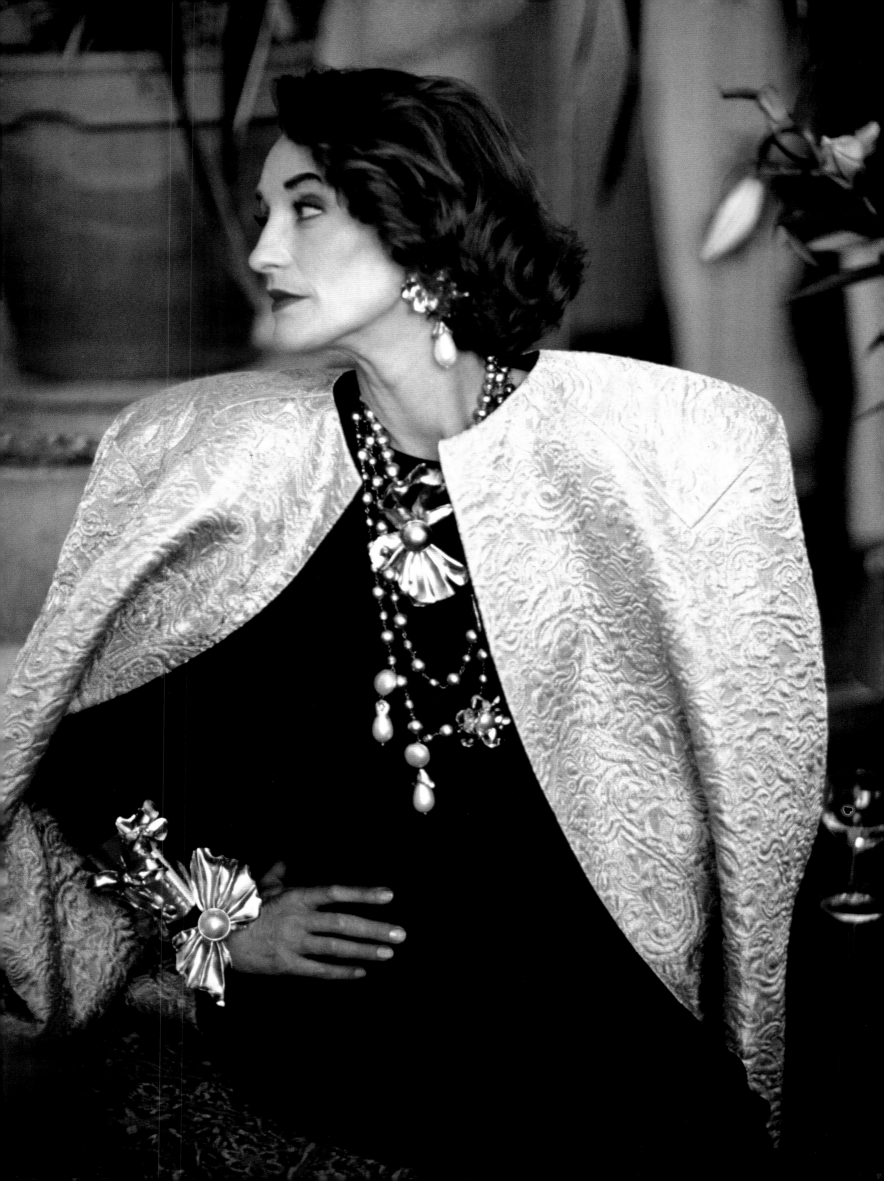

BELOW – Yves Saint Laurent on Loulou for *L'Insensé* magazine, Spring 1984.
OPPOSITE – Loulou in crystal splendor, photographed by Gilles Bensimon for March issue of *Elle*, 1990.
FOLLOWING – More crystal splendor from the same issue of *Elle*.

Loulou de la Falaise, Trade secrets

*Louise de la Falaise. In a word, Loulou. The divine and glamorous Loulou.
In the world of fashion, she is a star. Her hats, which accompany my collections,
are whimsical, elegant, modern and on the mark. She is the true* croqueuse de
diamants *because she creates fabulous jewelry by skillfully mixing plastic,
mica, glass and straw together with ivory and precious woods like Makassar
ebony. But her true passion is for rock crystal, vermeil, pearls, lapis-lazuli,
jade and coral.*

*When I see the fruits of her imagination nestling in their red velvet trays –
the crosses, the hearts, the braided pearls, the necklaces, the "saint esprits", the
golden fleeces, all the 18th century baroque, the passementerie belts embroidered
with gemstones, the tsarina sets, the Diane de Poitiers crescents, the African queen
amulets, the wheat sheaves, the wild flowers of splintered mother of pearl and
so many other splendors – I tell myself that I am truly fortunate to have had
Loulou at my side all these years because there isn't a day that goes by when she
doesn't fill me with wonder.*

Yves Saint Laurent

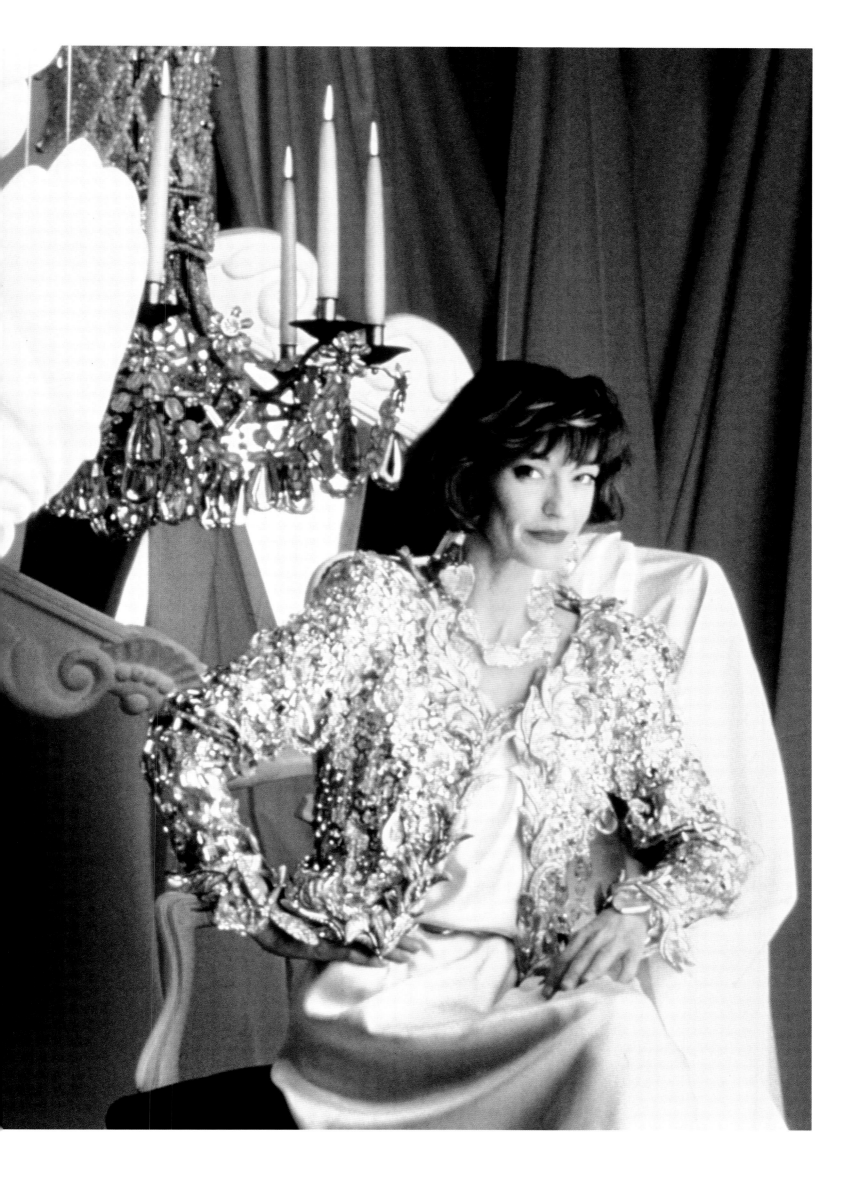

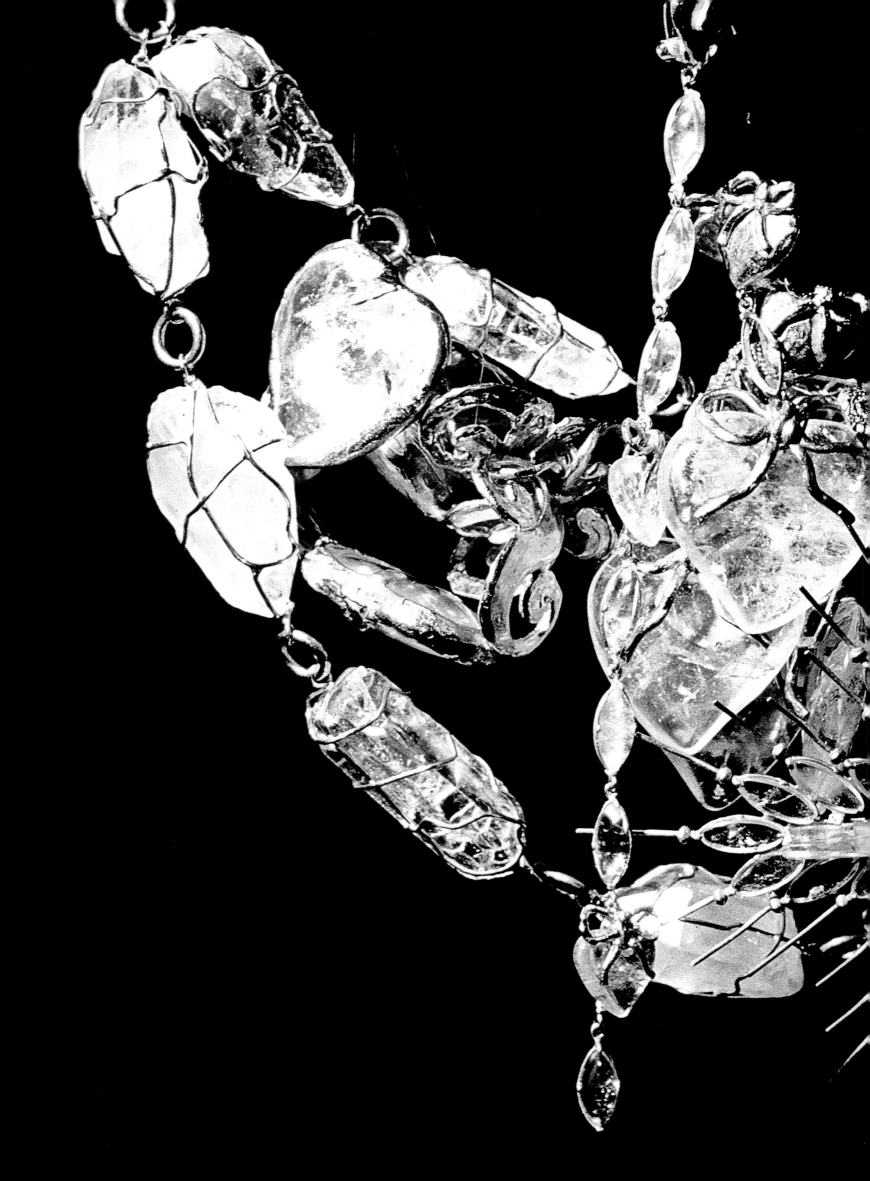

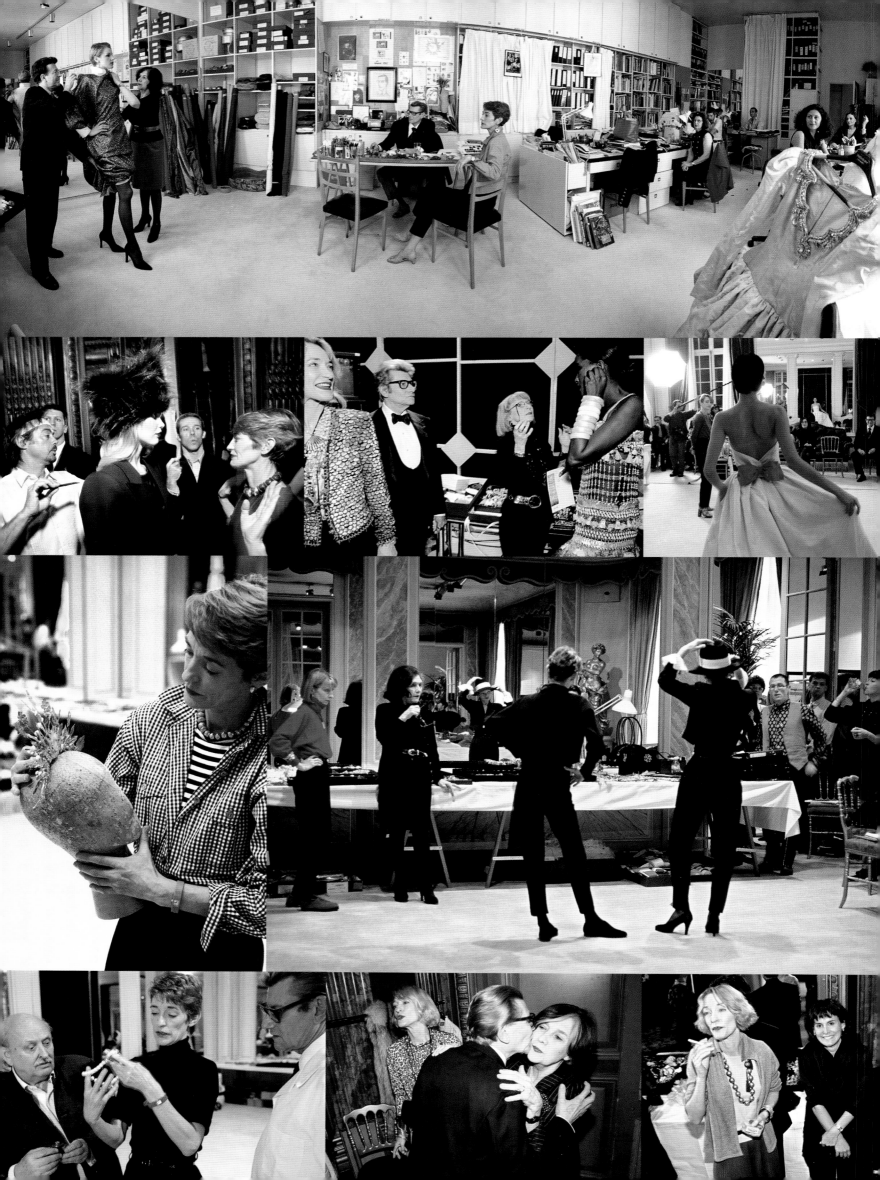

At the end of the 1980s, the atmosphere in the house changed. Having shaken the fashion world with memorable collections like *Opéras et Ballets Russes* (Fall-Winter 1976), *Les Chinoises Opium* (Fall-Winter 1977), and *Broadway Suit* (Spring-Summer 1978). Saint Laurent was creatively exhausted and thoroughly depressed. "Yves's vulnerability began to eat at him; he became withdrawn and demanded an ivory tower existence," says Paloma Picasso. "Being unconventional and sympathetic, Loulou could handle it." The rumors were that Saint Laurent was still designing couture but that Loulou was responsible for ready-to-wear, leading to the frequently used nickname Yves Saint Loulou. Loyal as ever, Loulou was infuriated by such rumors and kept a discreet silence. When the atmosphere in the studio became too tense, Loulou and Muñoz would escape to Galeries Lafayette, the department store. "One time we found a 1940s style skirt that had four panels," recalls Muñoz, still amused by the experience. "And Loulou and I fell upon the sales assistant and asked a ton of questions, ignoring the fact that it was getting really late."

Meanwhile, Loulou brought two members of her family into the Saint Laurent fold. Maxime was given Saint Laurent's domestic licenses in New York. ("She was nuts but a stitch," comments Connie Uzzo, in charge of the American operation.) Loulou's niece Lucie, the beautiful daughter of Alexis, became the face of Paris, one of Saint Laurent's perfumes, and was the bride at the end of several shows.

In 2000, Loulou designed the clothes, costume jewelry, and accessories for the new Yves Saint Laurent couture boutique on rue Faubourg Saint-Honoré. "De la Falaise will offer fancy blouses, tailored blazers, sensual knitwear, seductive lingerie, colorful scarves, and her famous chunky jewelry," enthused Suzy Menkes in the *International Herald Tribune*. Viewed by Menkes as "a deliberately provocative gesture" against Tom Ford's regime, which had taken control over the ready-to-wear line, Loulou described the boutique as "the flea on the back of the herd of corporate elephants." "And why not?" she declared. "It makes things more fun." Indeed, in her case, it was a way to express herself and be recognized for the limited editions. Elie Top, who now designs jewelry for Lanvin, had worked with her on the project. "We did outrageous vitrines," he recalls.

Charles Sebline, then an assistant in the Saint Laurent couture studio, was awed by "the breadth of characters that Loulou could drum up — she could be a Jacobean punk, Shakespeare's Puck, or bring to mind the portrait of a Spanish king." Comparing her to a wonderful painting, he says, "You were never bored of looking at her." He recalls a cobalt-blue top and pair of emerald-green pajama-like pants: "I was reminded of the Sistine Chapel."

Loulou and Anne-Marie Muñoz watching the Spring-Summer 1998 couture show in the Salon Imperial at the former Hotel Intercontinental. Photograph by Carlos Muñoz-Yagüe.

" My favorite Loulou look was a black sweater, black trousers, a belt, and a great necklace."

— Anne-Marie Muñoz-Yagüe

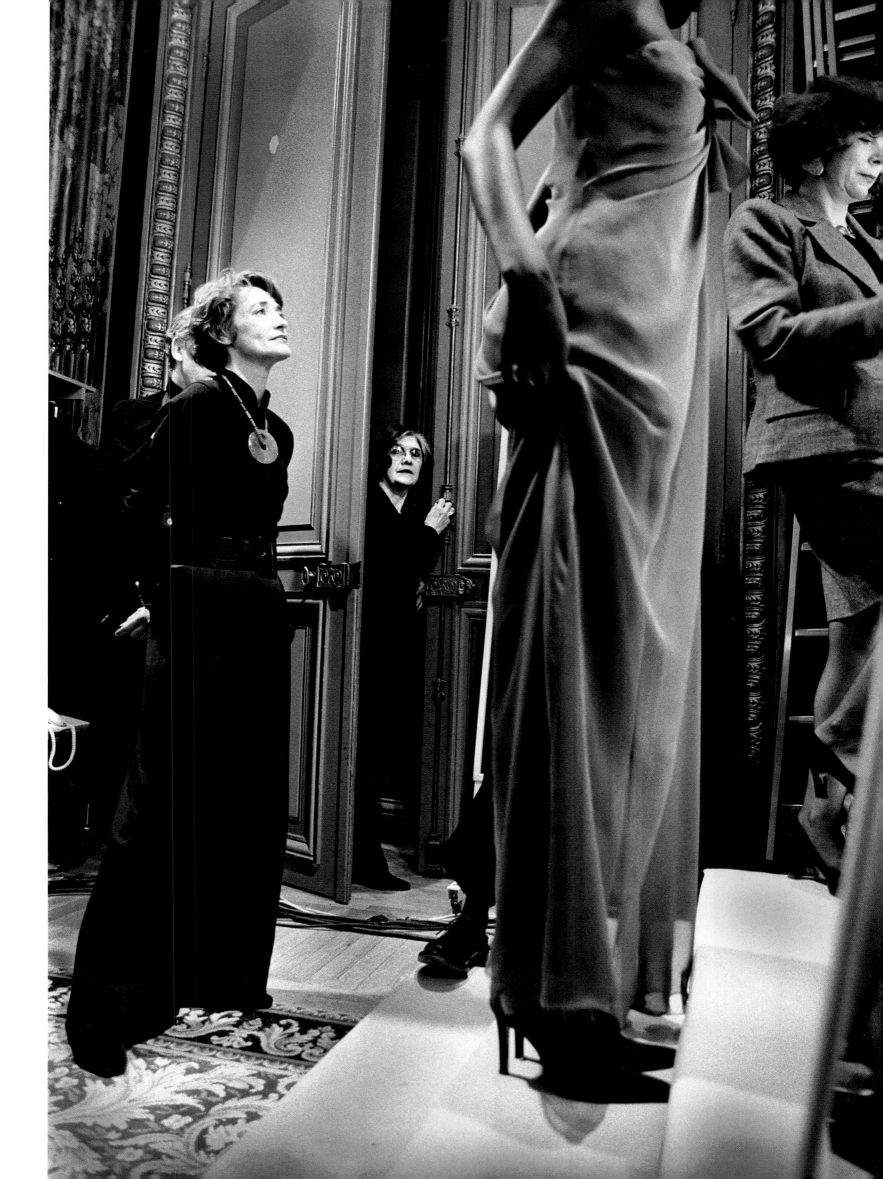

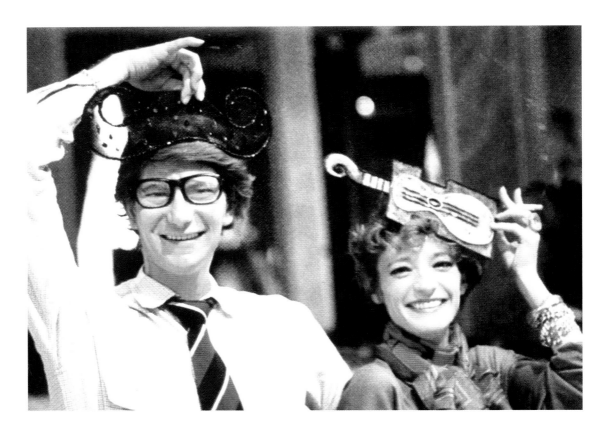

"The atmosphere in the studio could get very silly and jolly and we all had loads of fun. We loved to dress up and dress others up and shared many memorable fits of giggles."
— Loulou de la Falaise

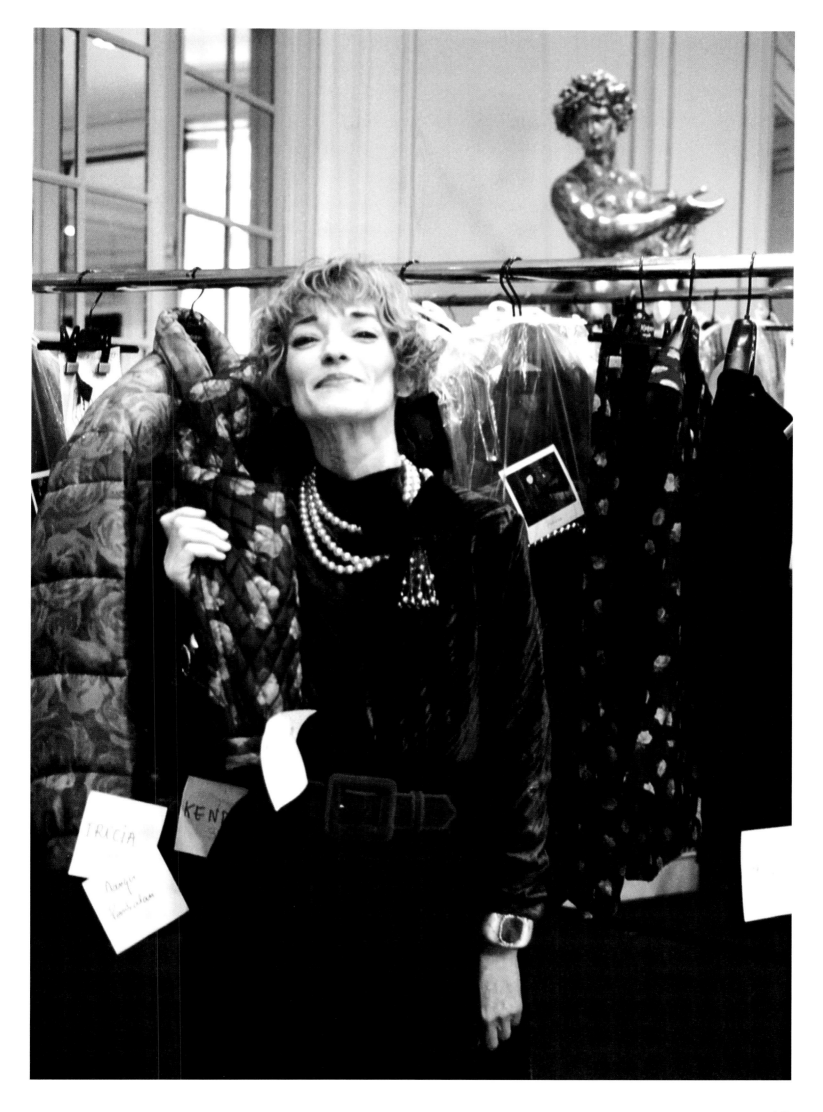

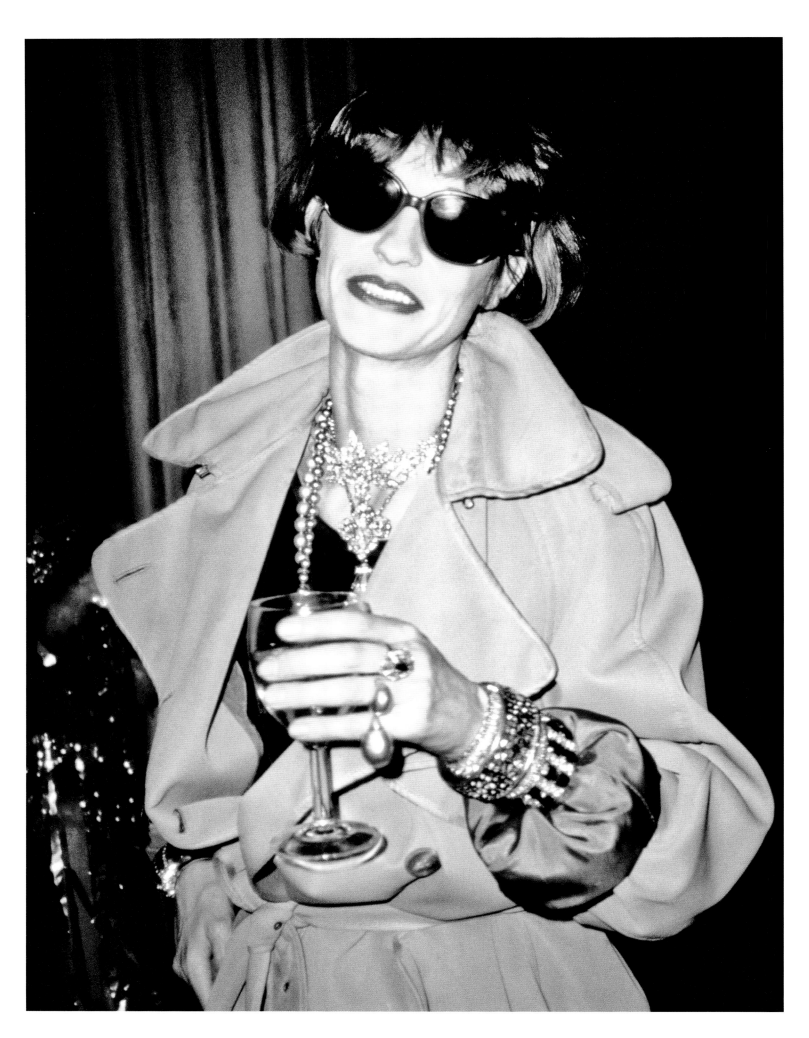

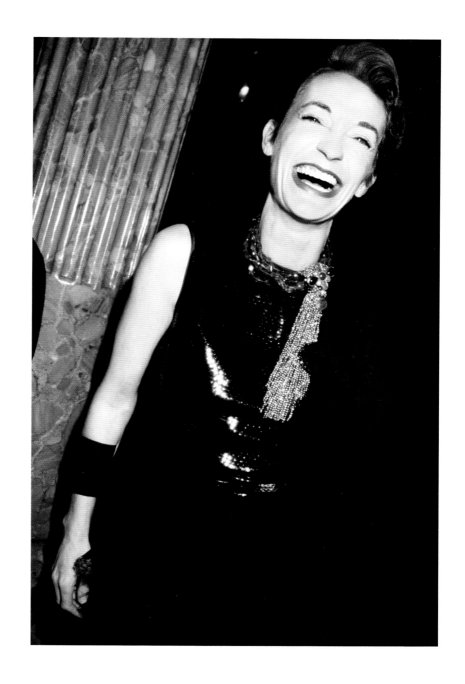

" The moment I met Loulou I was captivated by her charm. She was dancing on the table at Club Sept. Her energy was contagious and she was sweet and lovely."

— Roxanne Lowit

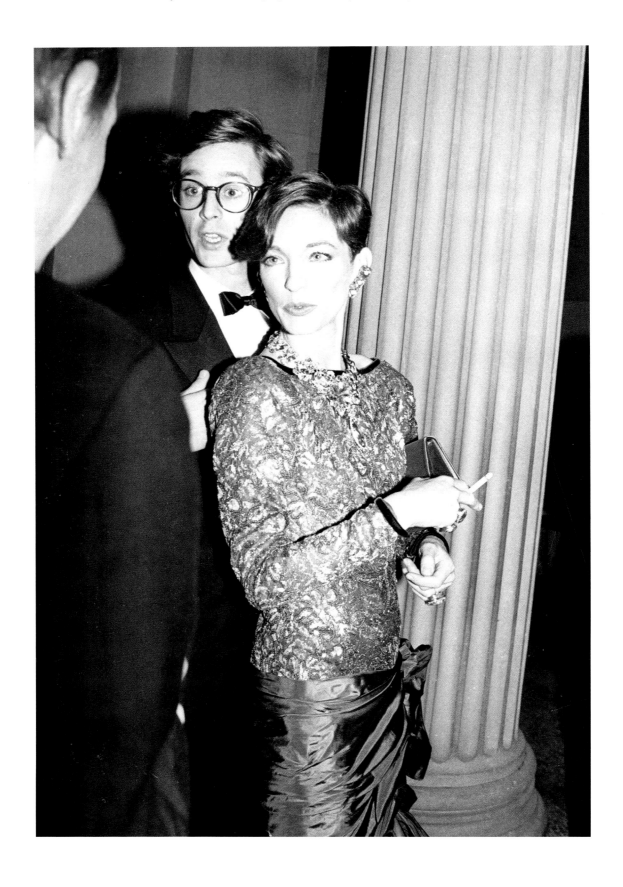

"Loulou made stunning entrances in New York. She was the star in the YSL crowd."

— André Leon Talley

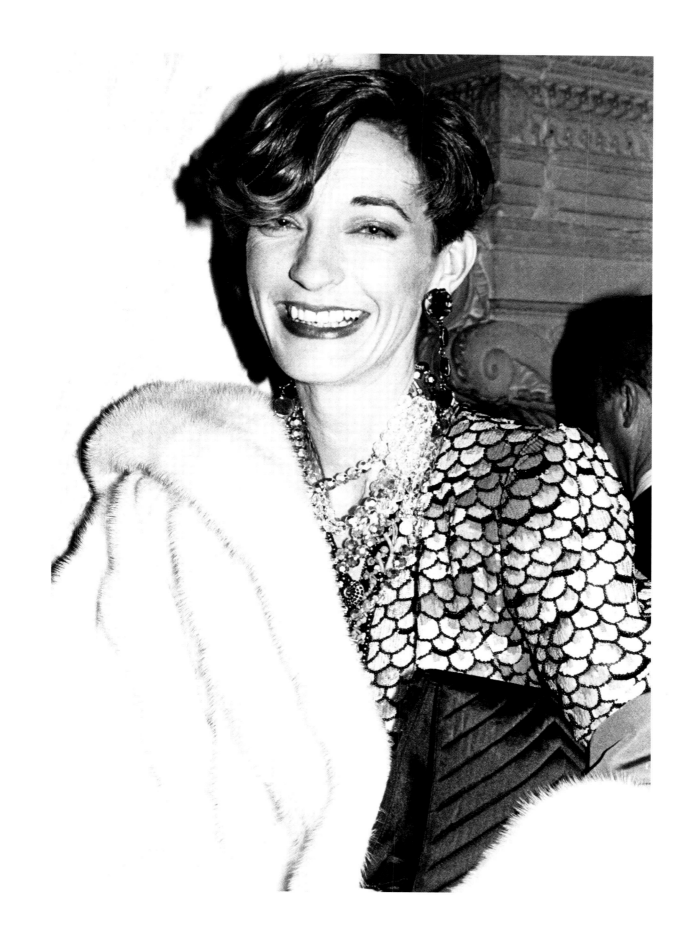

" When wearing a jacket embroidered by Lesage, Loulou had the attitude of someone wearing jeans."

— Ines de la Fressange

Yves with his irreplaceables in a portrait by Annie Leibovitz for *Vogue*, September 2000. Below: The ateliers, tailleur and flou.
Back row: Alain, Colette, Jean-Pierre, Philippe, Georgette (sitting) and Frederique (sitting) with Pierre Bergé.
Opposite: Amalia a favorite model, Catherine Deneuve, Anne-Marie Muñoz, Betty Catroux, Loulou and Moujik, Yves Saint Laurent's
French bulldog.
FOLLOWING – Yves and Loulou photographed by Dominique Issermann backstage at the Centre Pompidou during the final
Yves Saint Laurent *haute couture* show January 20, 2002.

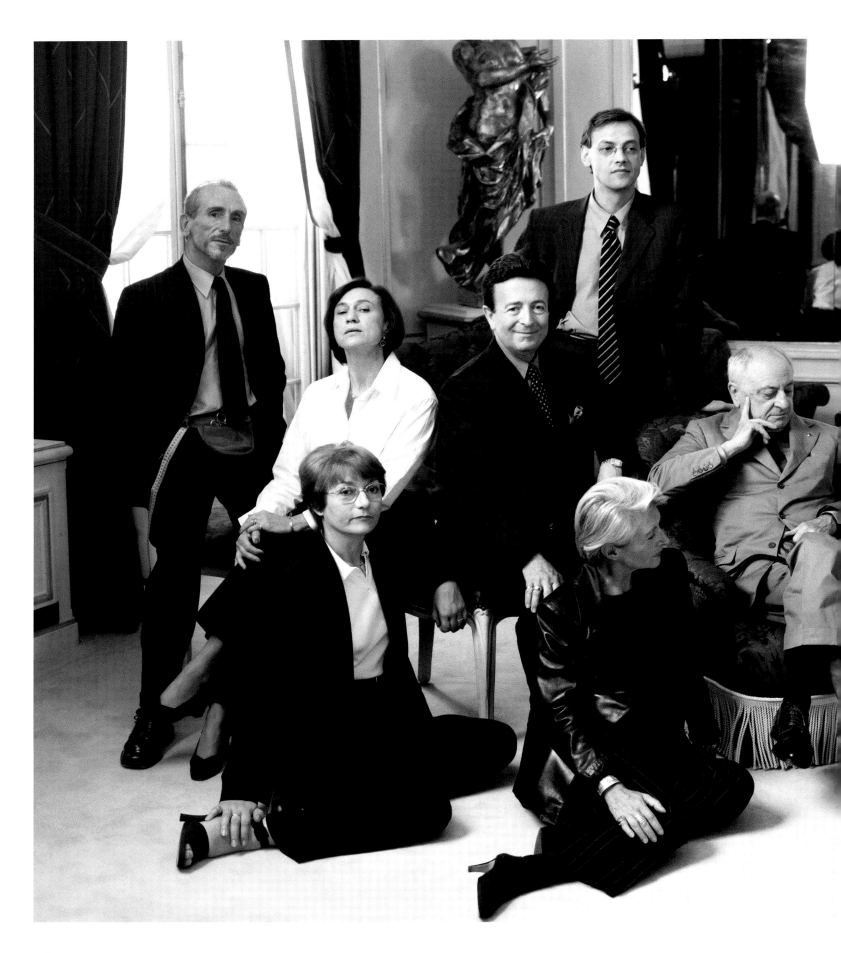

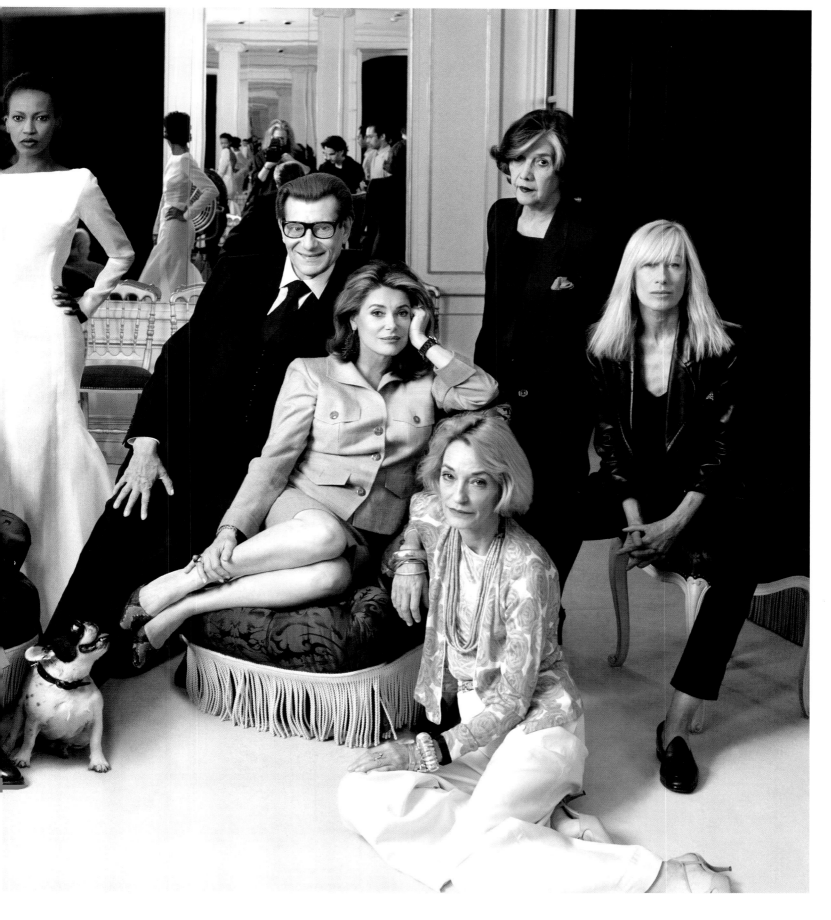

RIGHT — Anna Klossowski playing at home in Paris, rue des Plantes.
BELOW — Loulou, Anna and Thadée in Montecalvello, Italy.
OPPOSITE — Loulou with pals in Cadaques, Spain.

FAMILY FRIENDS

and *MAGIC* *Moments*

"My favorite memory of Loulou? That is very easy. It is the famous night of her wedding."

— Pierre Bergé

"Their wedding was absolutely fantastic, I had never had so much fun in my life. I brought my brother, Ruy, as a date."

— Leonello Brandolini d'Adda

"When Loulou got married, all of us at Saint Laurent were invited to her wedding. With Loulou, there were no social barriers, it was part of her great charm."

— Gabrielle Buchaert

"I love the story of Loulou and Yves decorating the place for the wedding and realizing that they hadn't made her dress. . . . That dress took two minutes and yet has become so iconic."

— Vincent Darré

The Wedding

"It was incredible, mad and extravagant."

— Bettina Graziani

"I came to look upon Loulou as a rescuing angel, so I was super happy when the cable arrived that they were getting married. Enfin!"

— Stash Klossowski de Rola

"The small civil wedding took place on the Left Bank and the lunch afterwards was given by Bernard and Ginette Camus, at their 7ᵗʰ arrondissement apartment. The lamb and root vegetable main course was delicious, it was Loulou's favorite dish. – Later in June, we all went to the Bois de Boulogne party and what a ride it was! Rothschilds, rock stars, royalty, and dozens of the world's best artists, decorators, architects, writers, and fashion designers attended. That incredible secluded island, the boat rides to and from, everything draped in vines and flowered garlands, lots of wild dancing."

— Marian McEvoy

"We all arrived on little boats, lit up like a fairy tale. It was so pretty to do that and such fun. A baroque night, someone took off his clothes and threw himself in the water."

— Kenzo Takada

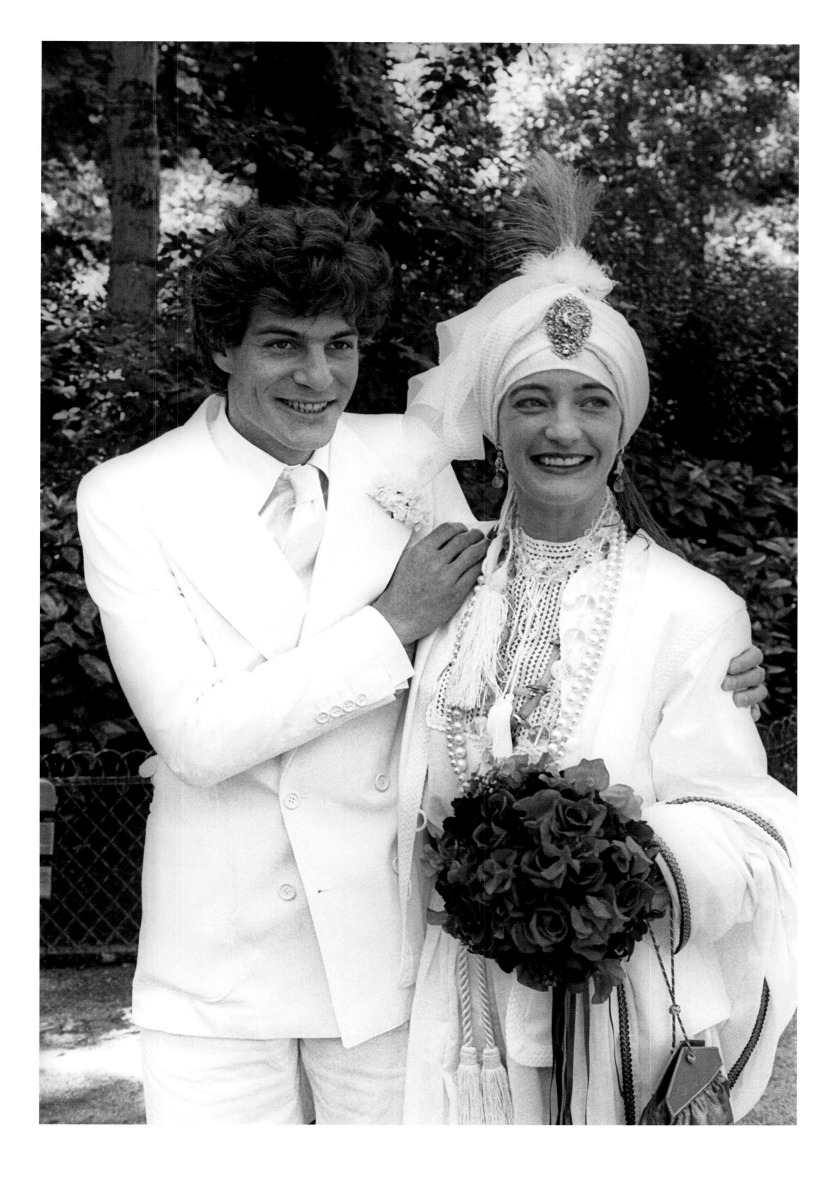

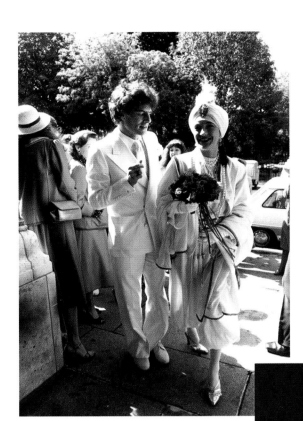

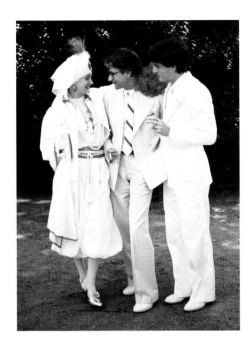

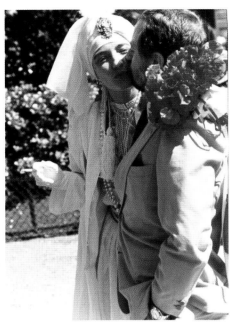

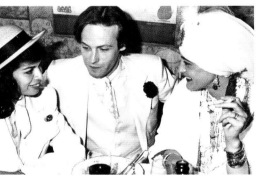

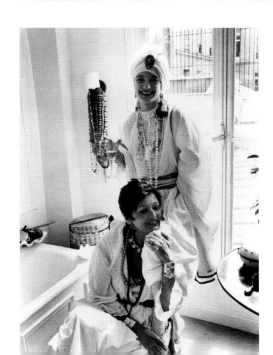

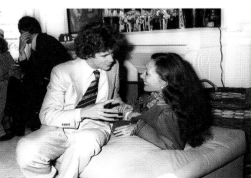

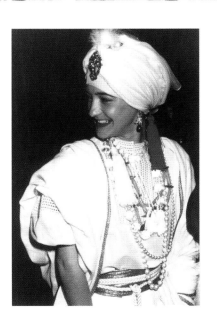

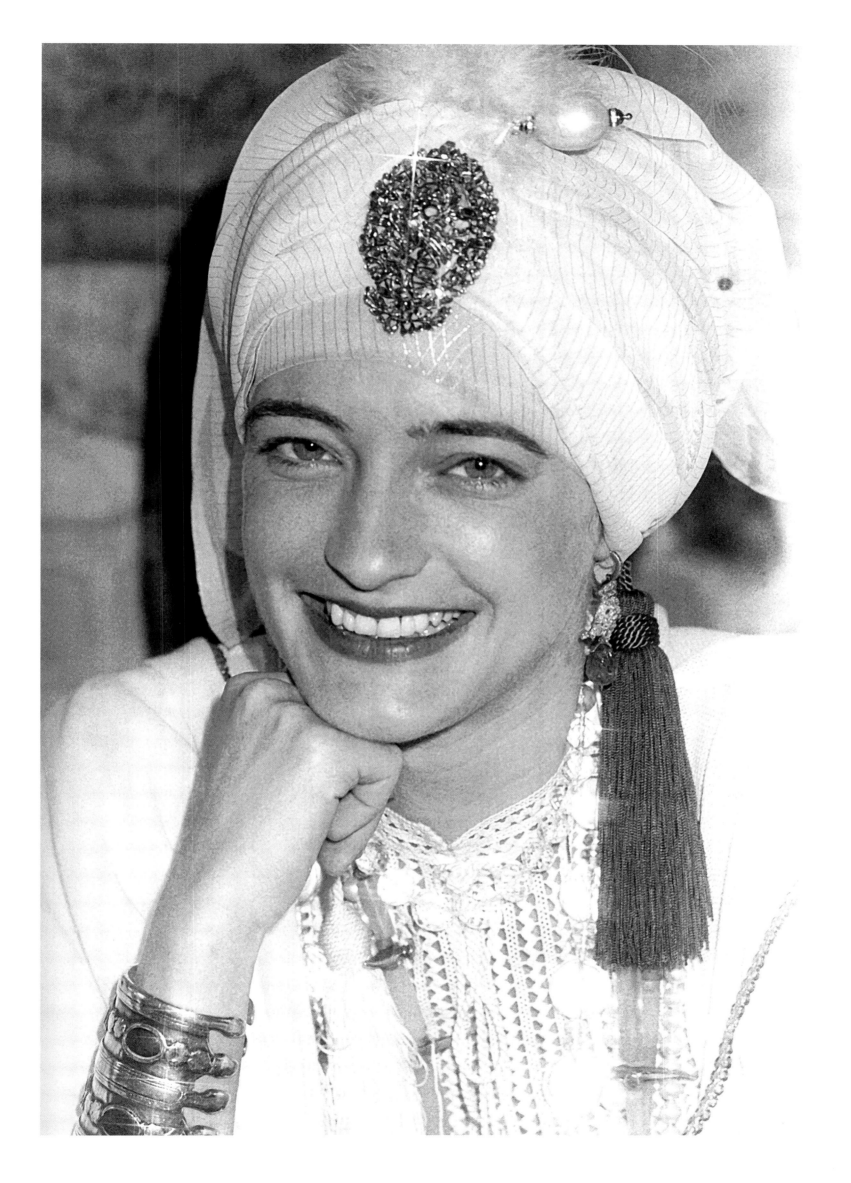

BELOW — From left: The Chalet des Iles, where the Klossowski wedding party was held - Loulou being welcomed by Pierre Bergé dressed for her wedding ball in an indigo sari dress shot through with silver, wearing a glittering crown of moons and stars that she made herself with cardboard and paste.
OPPOSITE — The Klossowskis walking into their wedding party with Yves Saint Laurent.
FOLLOWING — The party.

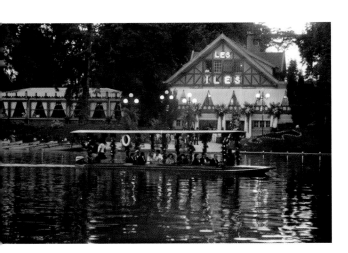

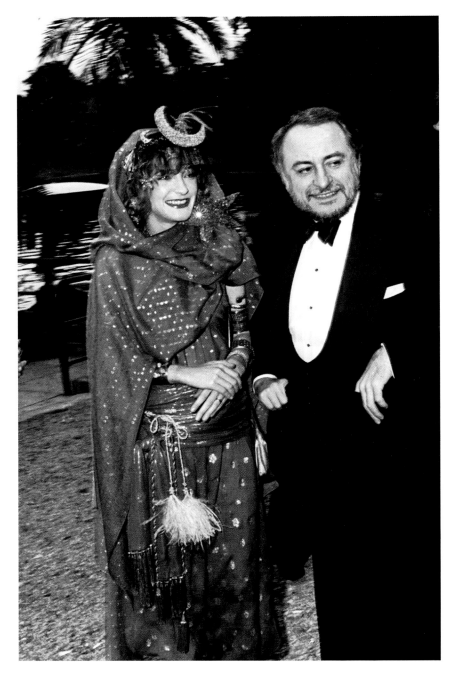

"Our wedding party was hosted by Yves Saint Laurent and Pierre Bergé, and among the five hundred guests were my English life, my New York life, Thadée had a Roman life, we had a Parisian life. It was the first time in Paris there was such a mixture of age, class, activities, a jumble of character and everyone adored meeting each other, looking at each other."
— Loulou de la Falaise

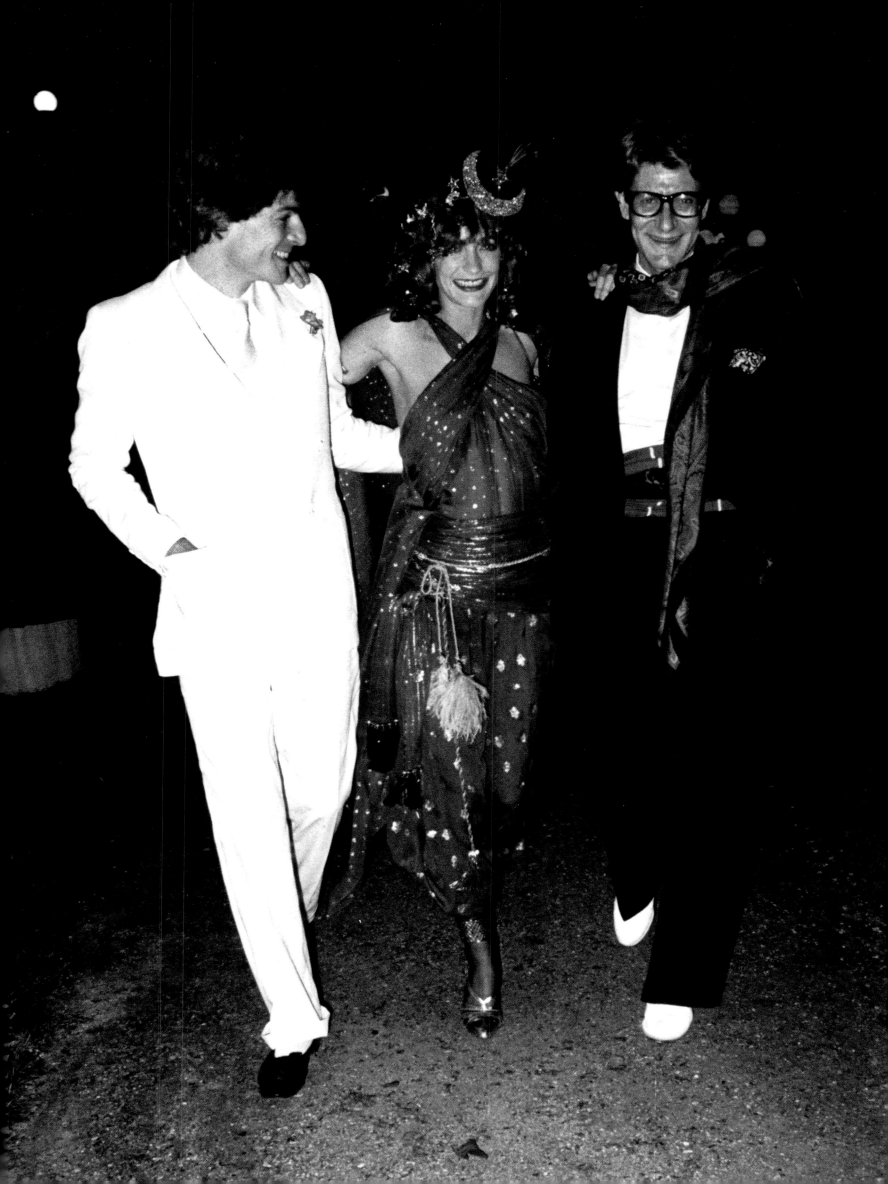

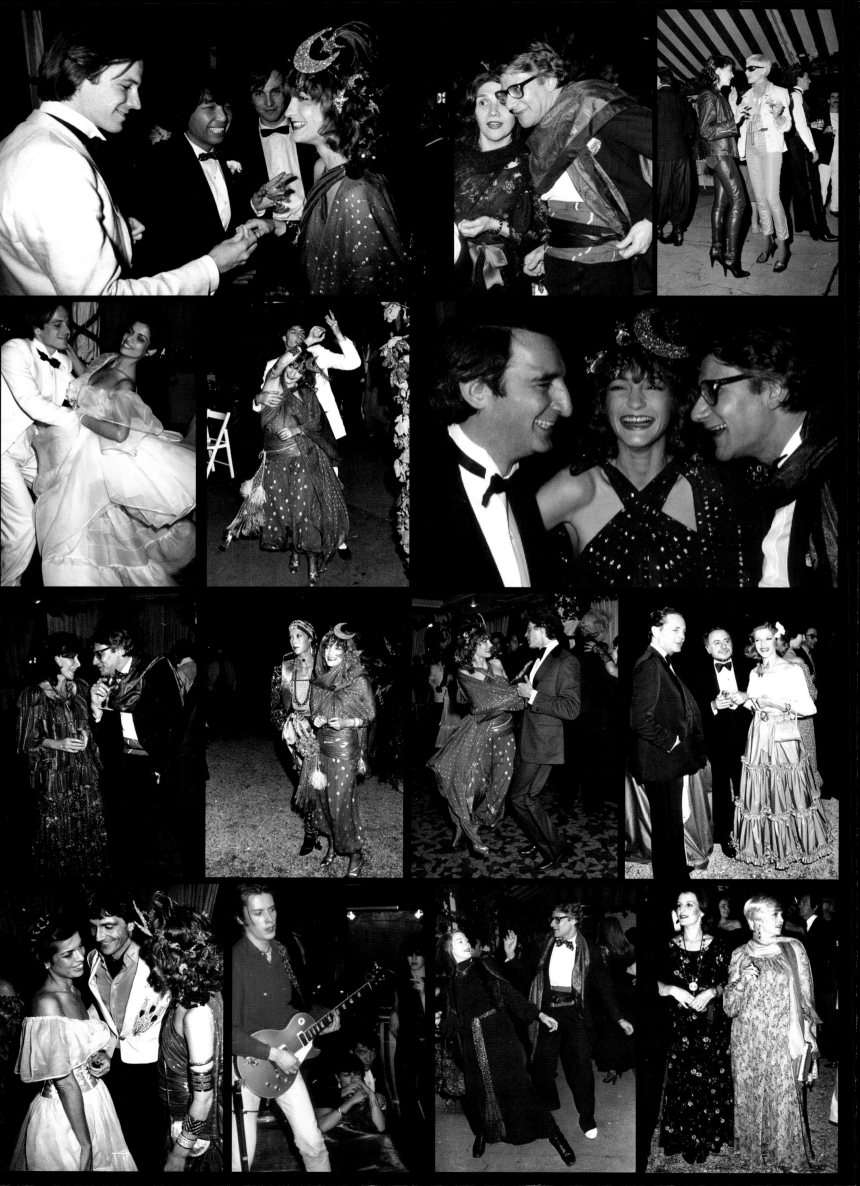

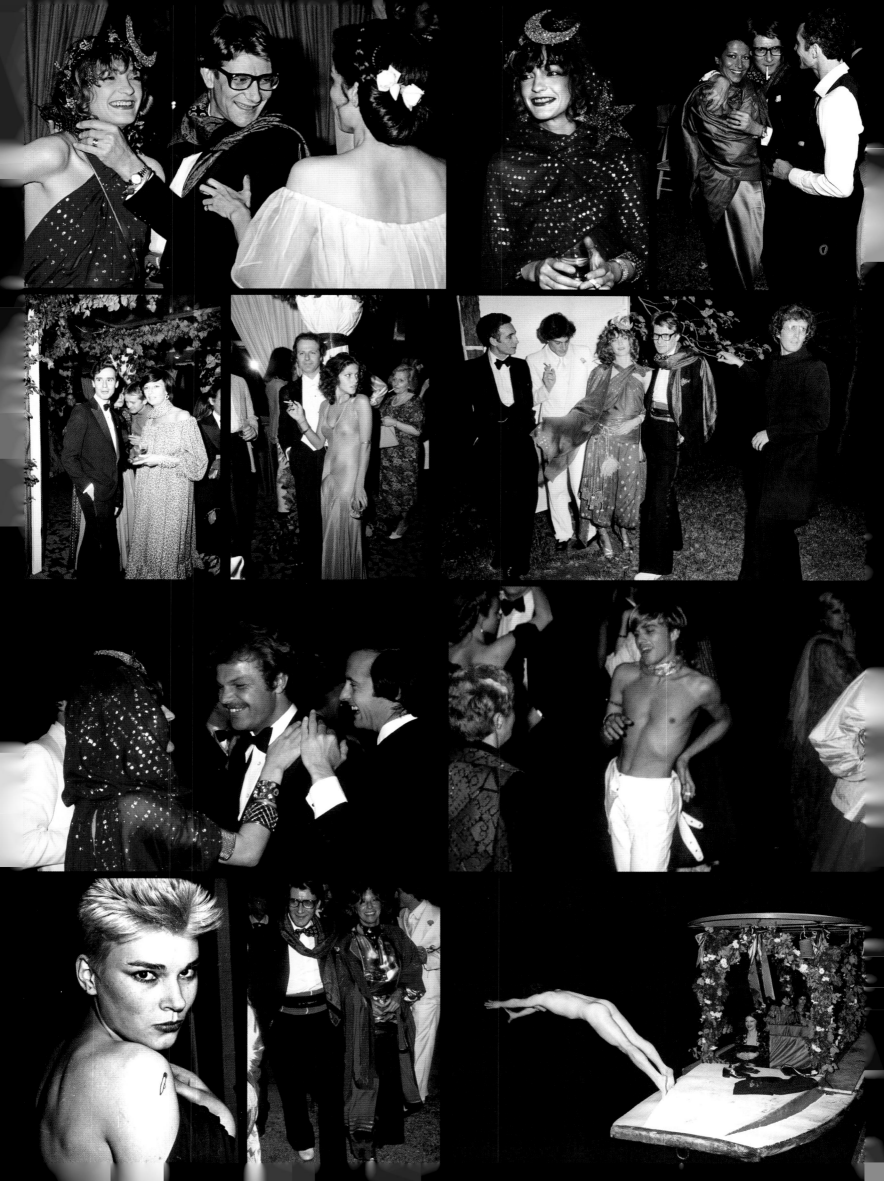

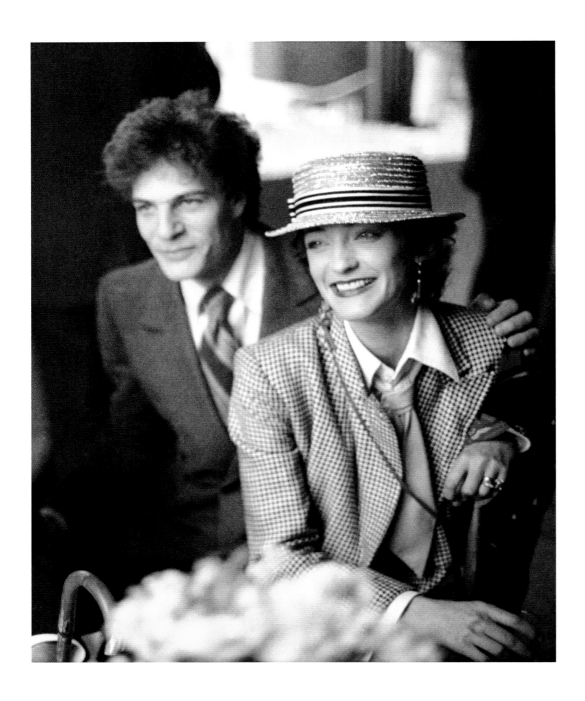

" When I was growing up I often asked Maman: 'How did you know Papa was the one?' – they got married a long time after having met – and she always answered: 'I never didn't know, we just waited a long time before taking off together for a new life'."

— Anna Klossowski

" Thadée and Loulou were glamorous inherently, intuitively and incredibly so."

—Madison Cox

Loulou and Thadée's 1977 wedding was an incredible, memorable social event, after which they were viewed as a golden couple. "They put a stamp on Paris," says Manolo Blahnik. Paloma Picasso sensed that marrying Thadée "grounded Loulou" and "was the right match because they had been friends forever." Describing them as "exotic and extremely poetic," Madison Cox found them "protective and inclusive." "They were like my older siblings," he says. When each was questioned on the other's appeal, Thadée mentioned his wife's "*gaîté* and love of life" while she admired his lack of competitive edge and how he was "met with universal approval."

According to Thadée, after their legendary wedding party and the Angels & Devils Ball at the Palace nightclub — Paris's Studio 54 — hopes were high that they would turn into an "out every night," seamlessly social couple. They then realized that "*la vie mondaine* was the last thing we wanted," Thadée says.

They led a charmed bohemian existence that was divided between a romantic rented studio apartment in the arty 14th arrondissement and Montecalvello, a medieval castle outside Rome, owned by Balthus, Thadée's father. It was the moment of big balls and important parties in Paris and the couple were sought after by Marie-Hélène de Rothschild and Charlotte Aillaud, two of Paris's key hostesses of the 1970s and '80s. "Loulou and Thadée were the perfection of a dream," says Aillaud. "I loved his tenderness and how she was at ease everywhere, like a bird on a bench." Still, if there was any hint of mixing with the stiff or bourgeois members of Parisian society, the Klossowkis fled.

Noted regulars of the Palace, their friends were a mixture of the erudite, the chic, and the sophisticated: the publisher Leonello Brandolini, the model Wallis Franken, the inventor Jacques de Gunzburg, the designer Michel Klein, the fashion editor André Leon Talley, the photographer Bettina Rheims and her journalist husband Serge Bramly, the banker Eric de Rothschild, and Nicole Wisniak, *Egoïste*'s founder and editor. "It was Loulou's intelligence that was so remarkable," says Wisniak. Loulou's determination to make "people be happy" rarely ceased to astonish Brandolini. "I have never seen anyone as generous," he says. "In fact, the two things that defined Loulou were her generosity and her courage." He also admired her mental elegance. "She thought some things were petty and they were not worth paying attention to."

Thadée with Loulou in full Saint Laurent regalia in a New York lobby. Photographed by Priscilla Rattazzi for the April 1984 issue of *Interview*.

" The motor in the marriage was Loulou and she was better than a Rolls-Royce."

— Charlotte Aillaud

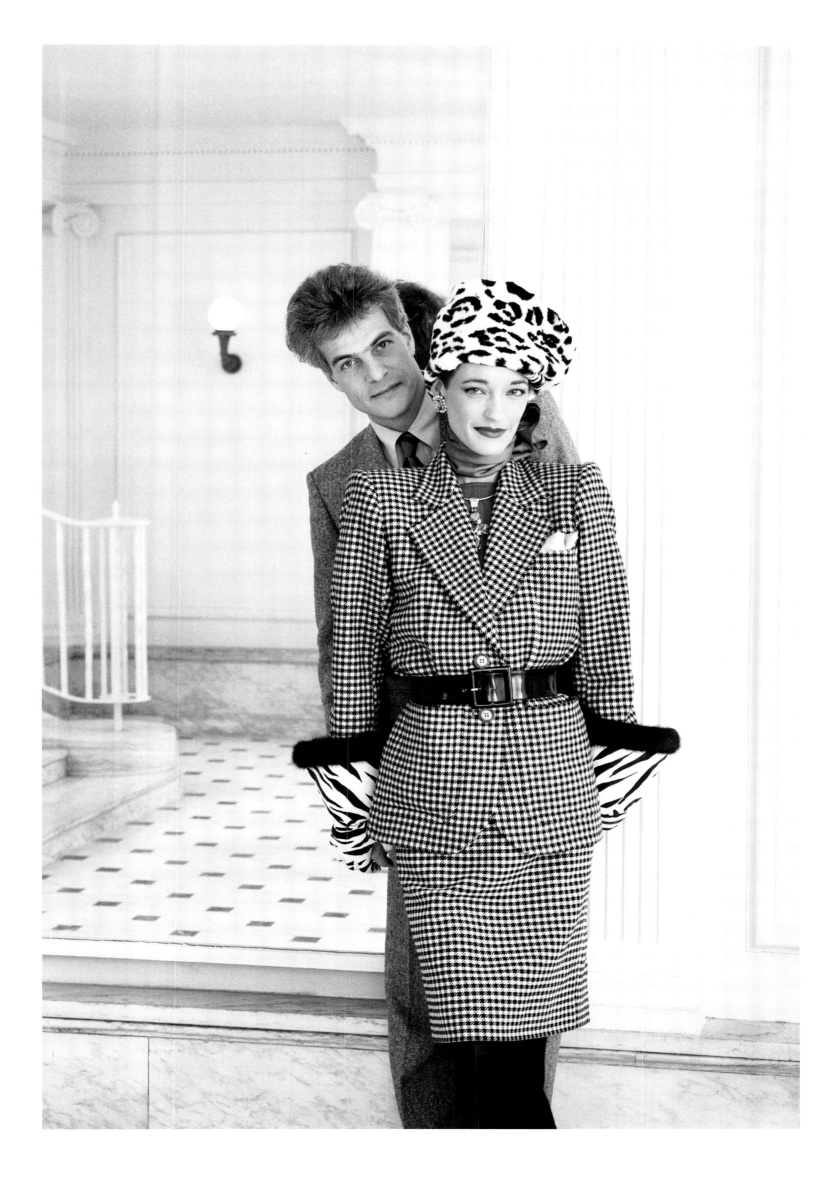

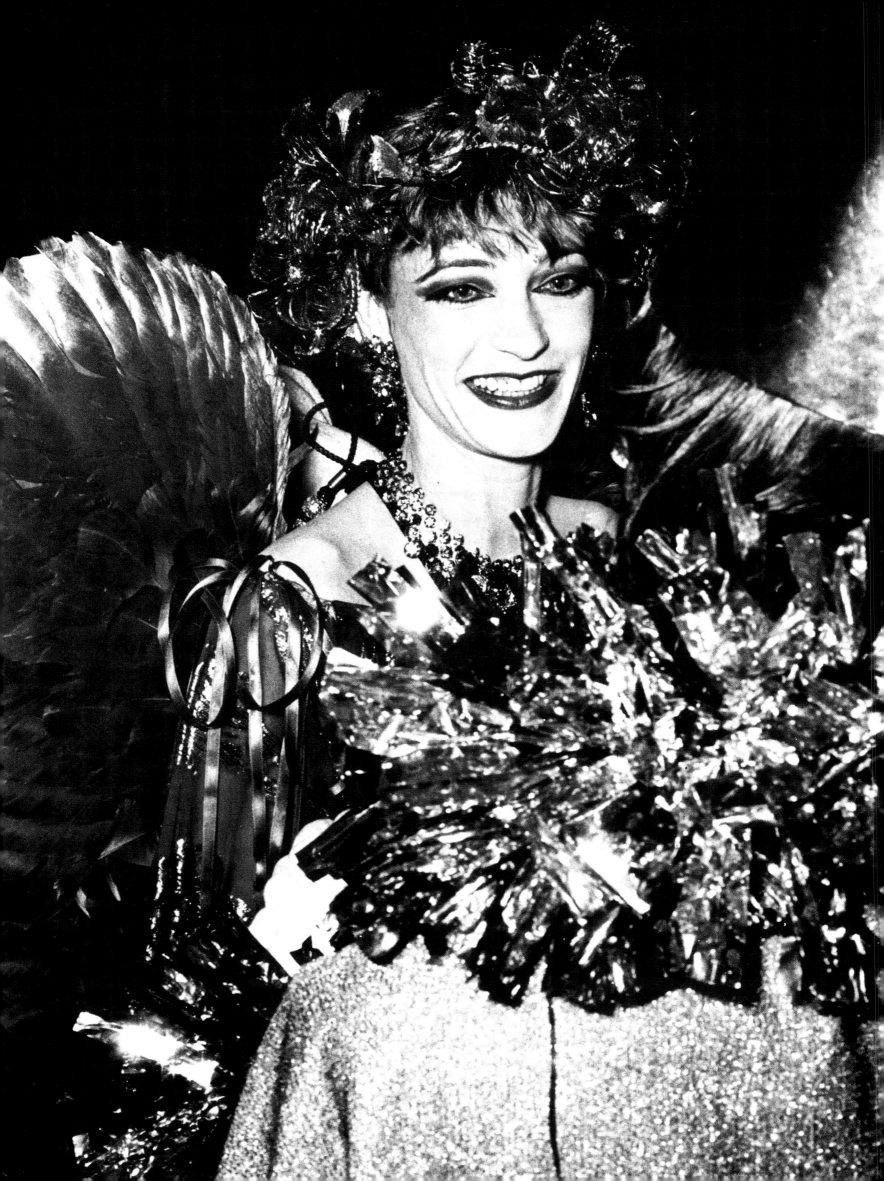

OPPOSITE – Loulou as an enchantress at the Angels and Demons Ball that she and Thadée hosted at Le Palace in 1978.
BELOW – From top: The invitation to the ball - Loulou and Thadée dressed as an angel - The Klossowskis dancing - Kirat Young as Krishna and Mounia as an African queen - Frédéric Mitterrand on stage with Loulou and Thadée.

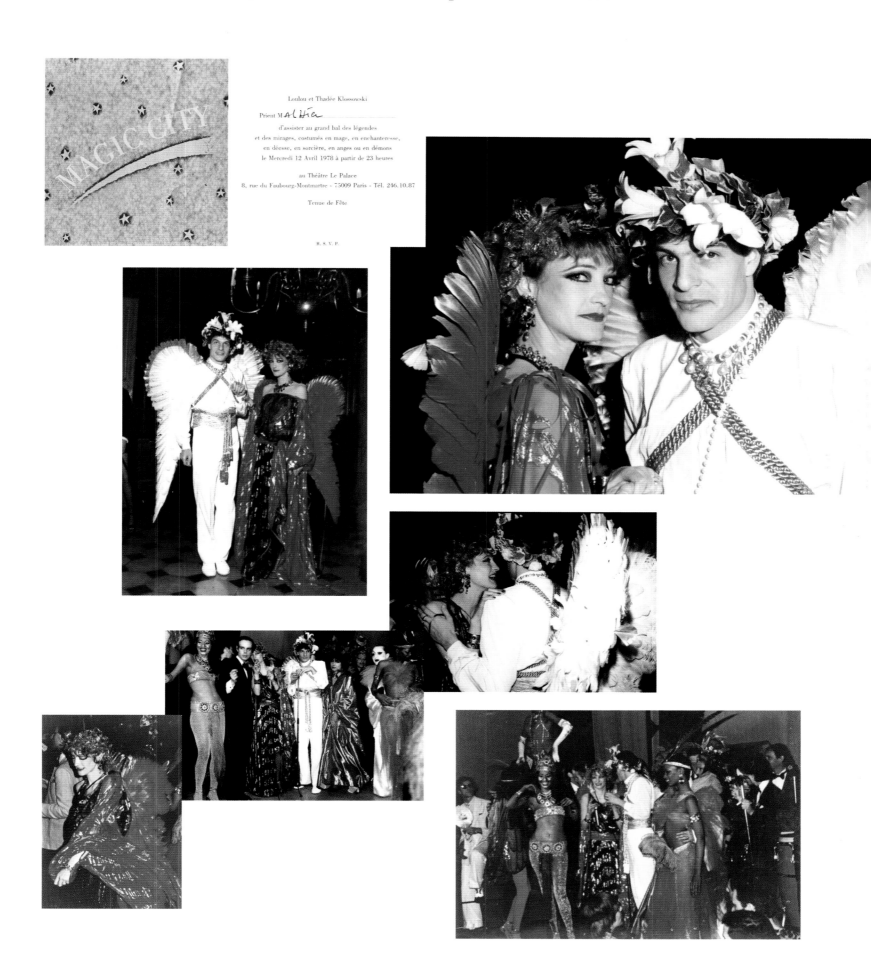

"Paris was so carefree and vibrant then — and Loulou was the Pied Piper."

— Kirat Young

Loulou and Yves arriving for a party at Le Palace in Paris, 1980.

"Loulou was like the sun coming up in the morning." — John Fairchild

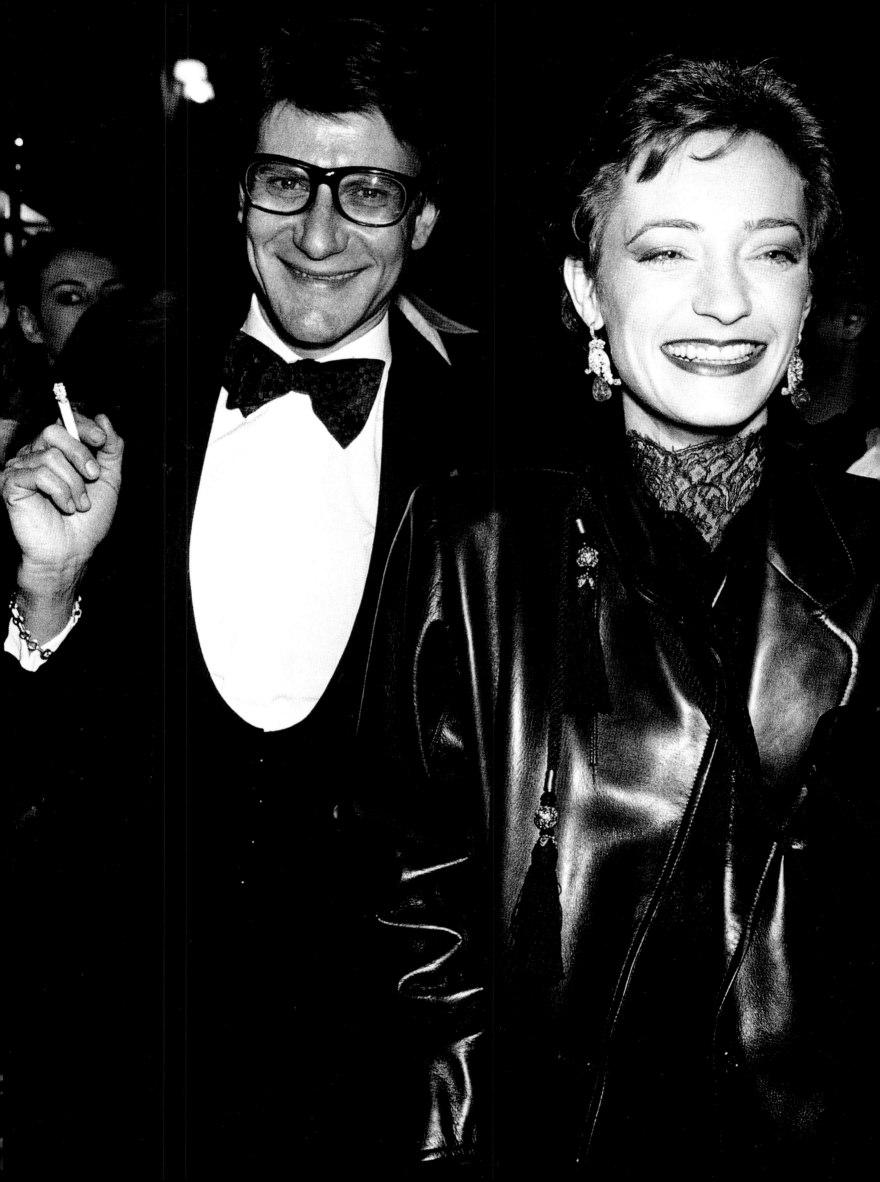

Paris nights at Le Palace, photographed by Dominique Lauga, Guy Marineau and Philippe Morillon.

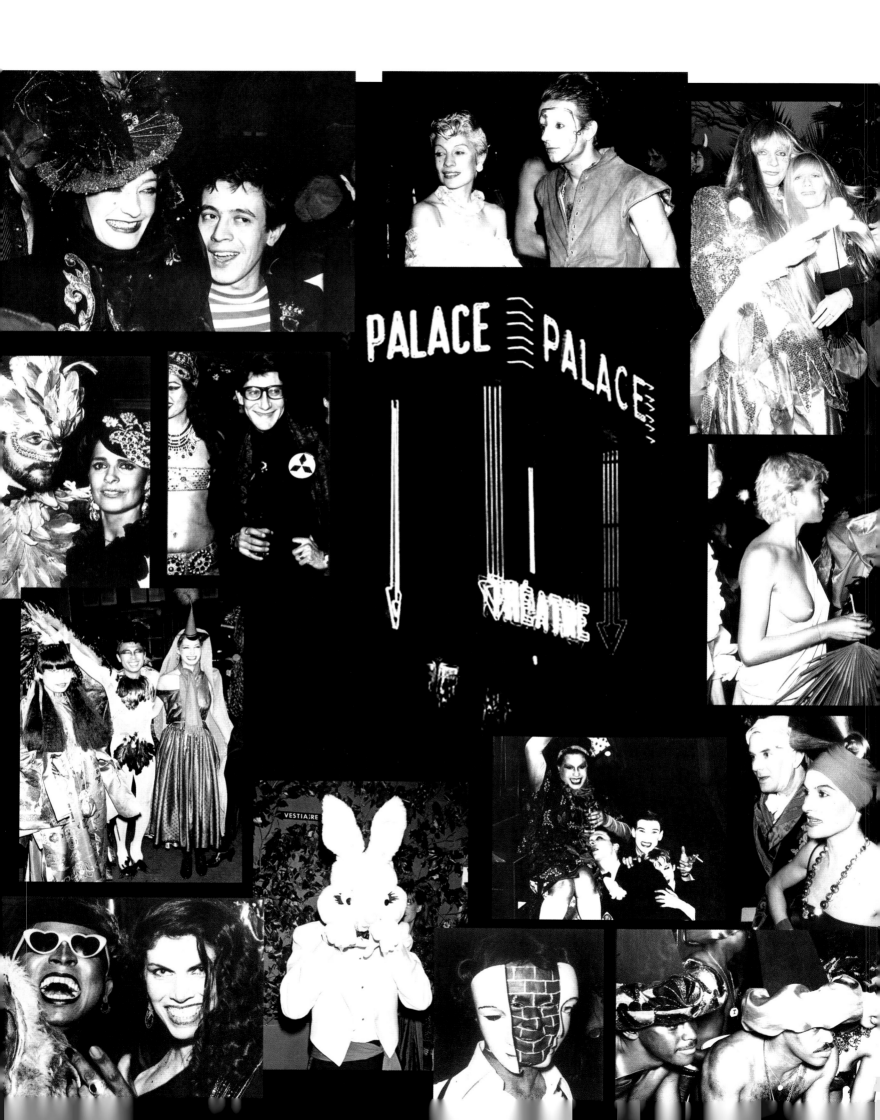

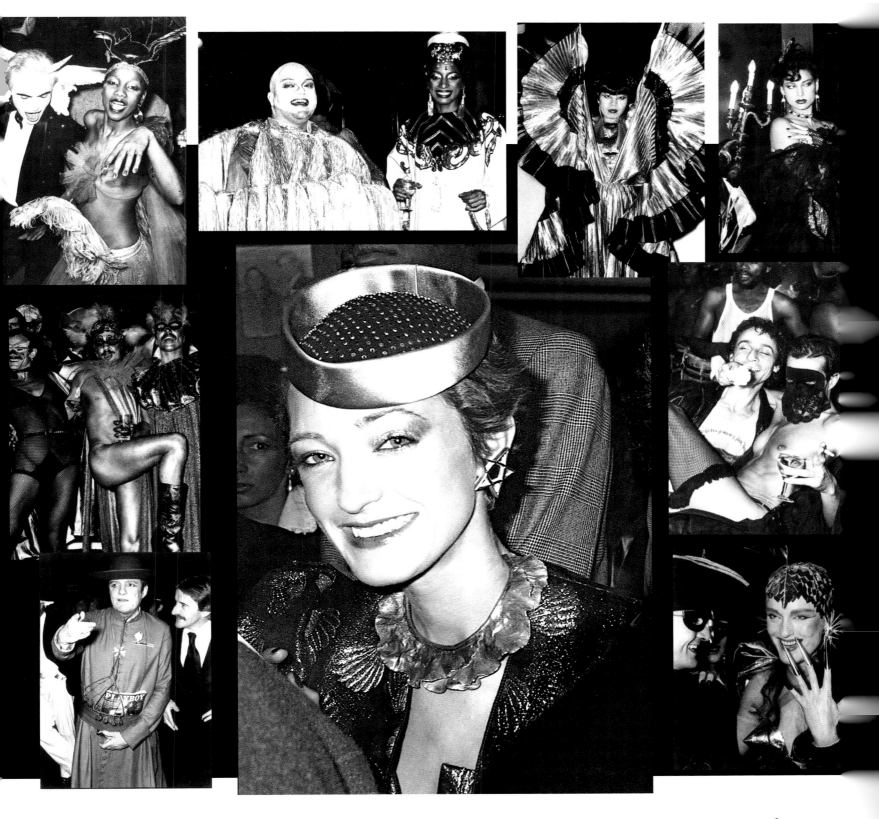

"All the underground people in Paris loved Loulou, she was very important to them. It was why Yves loved her so much."

— Pierre Bergé

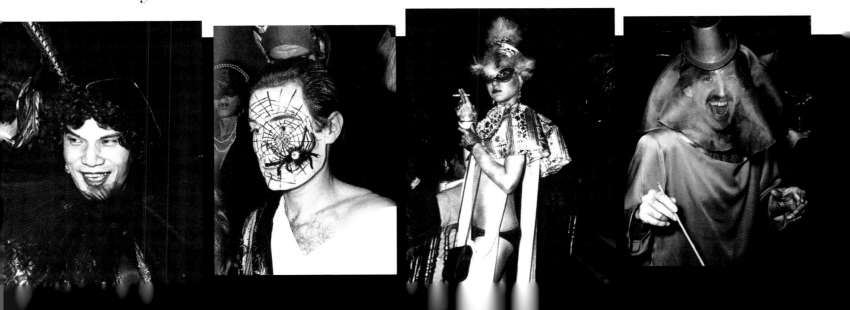

" Loulou was considered the most elegant woman in Paris but she was also quite rock 'n' roll. She loved flirting with Edwige who was the queen of the punks and sort of Marilyn Monroe-like."
— Vincent Darré

" Late at night when we were all kicking back, Loulou would suddenly leave and say, 'I have to be beautiful for my boss.' It was the only time that she ever referred to Yves as her boss."
— Michel Klein

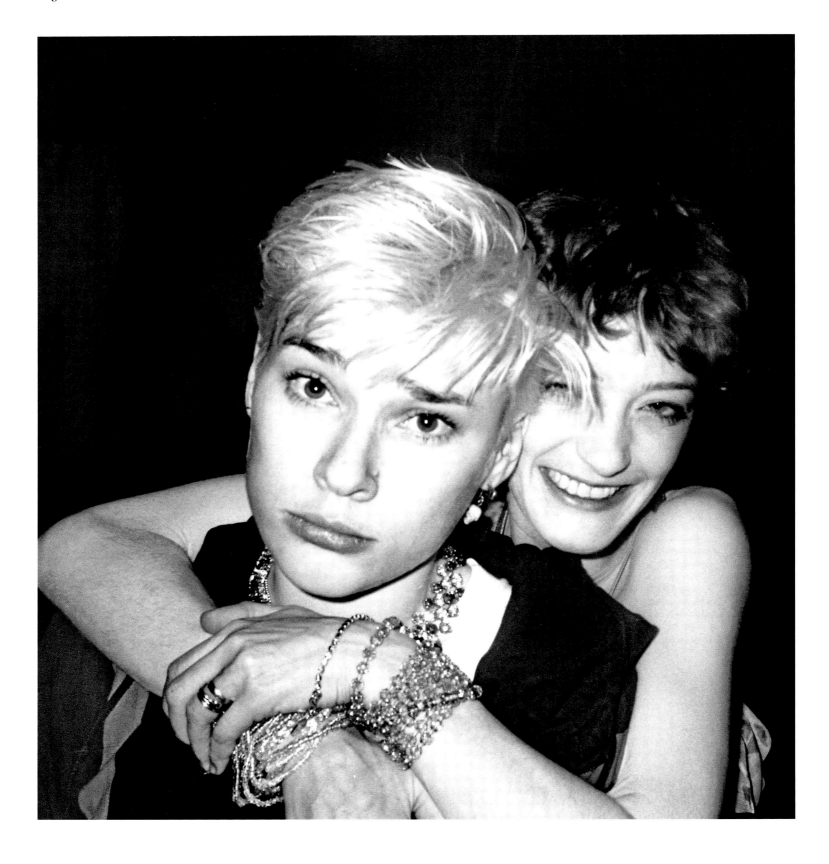

" Dancing with Loulou, she was in Saint Laurent and I was in Claude Montana. She was very light on her feet and I would trash her around on the dance floor. We would end up in the wee hours of the morning with our outfits completely destroyed! "

— Grace Jones

" She and Fred Hughes? I'd say they were soul mates."

— Bob Colacello

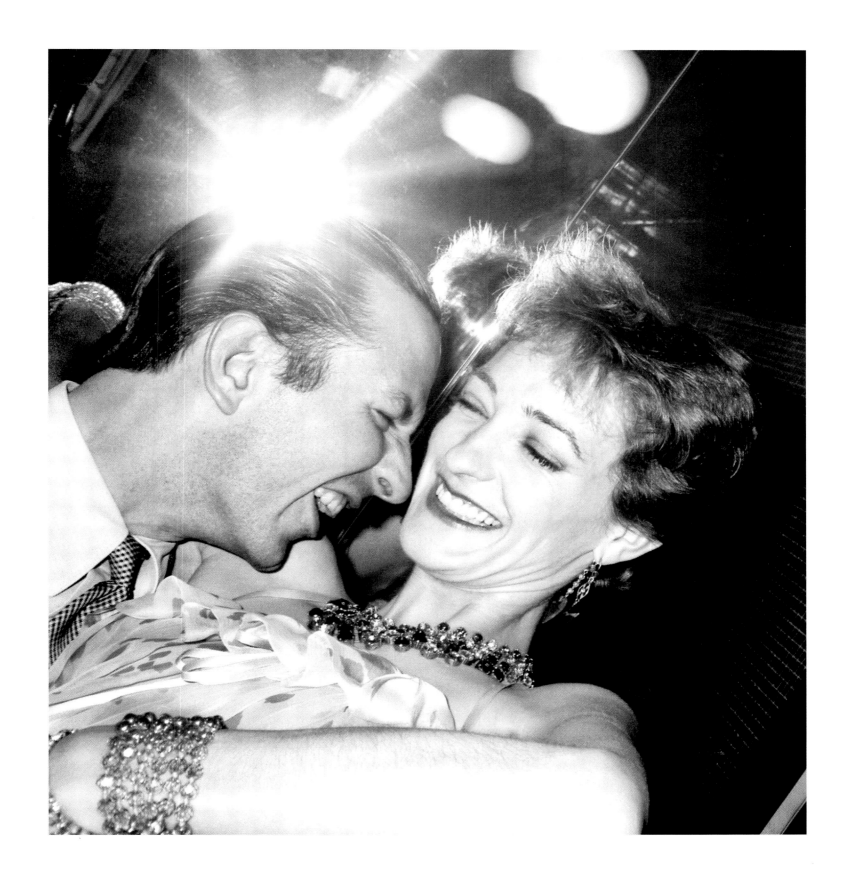

Loulou and Betty with Yves at his Place Vauban apartment, photographed by Guy Marineau for *Women's Wear*, 1978.

" *Yves is perfection, my fashion school, the longest anyone has been to! He taught me equilibrium and proportion. He has the sharpest eye I have ever known.*"

— Loulou

"*Loulou is charm, poetry, excess, and extravagance all in one blow.*"

— Yves Saint Laurent

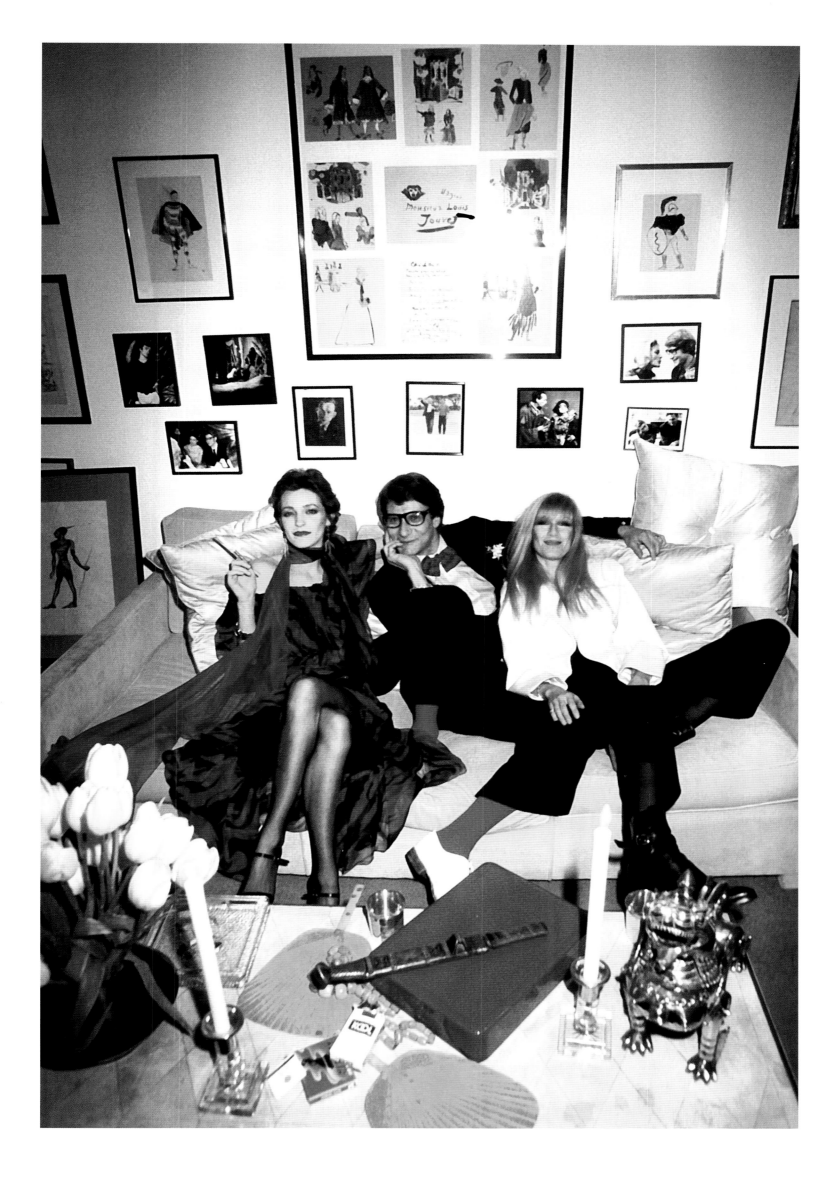

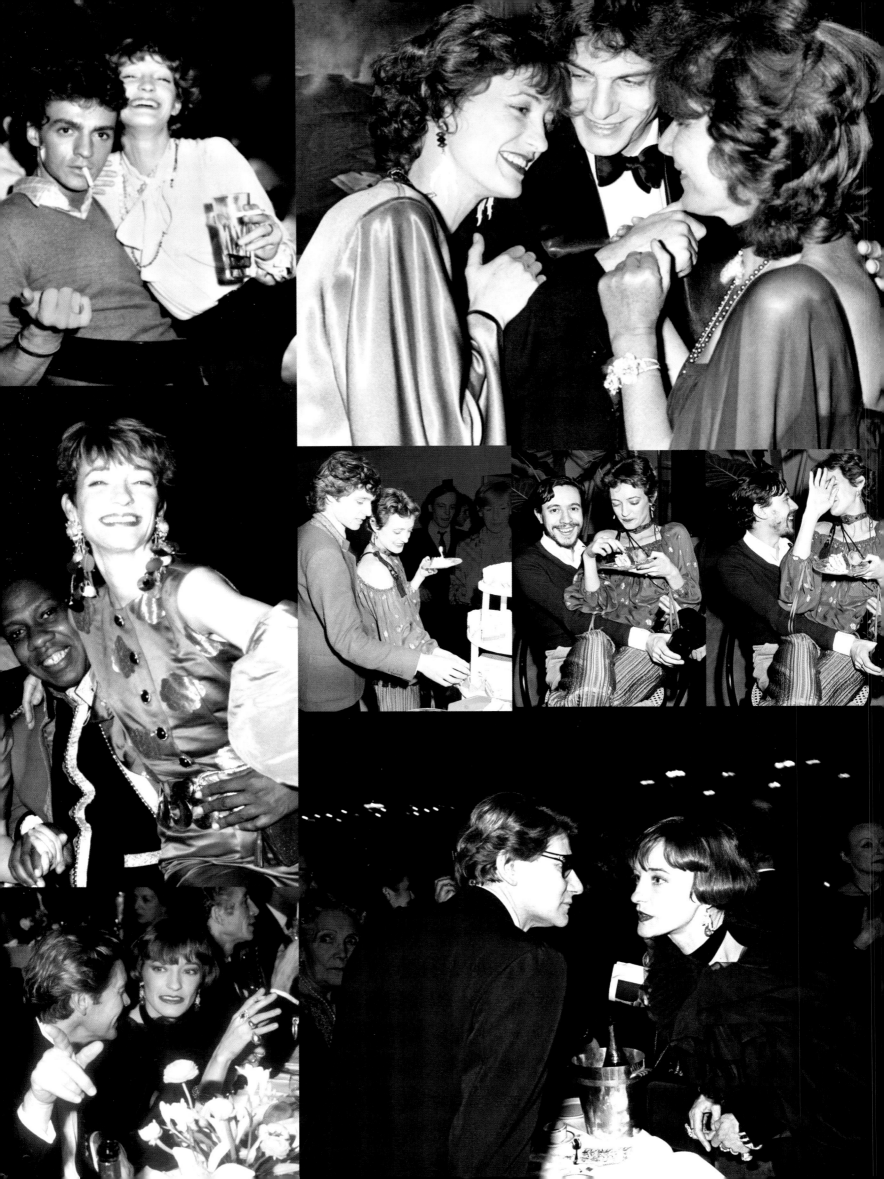

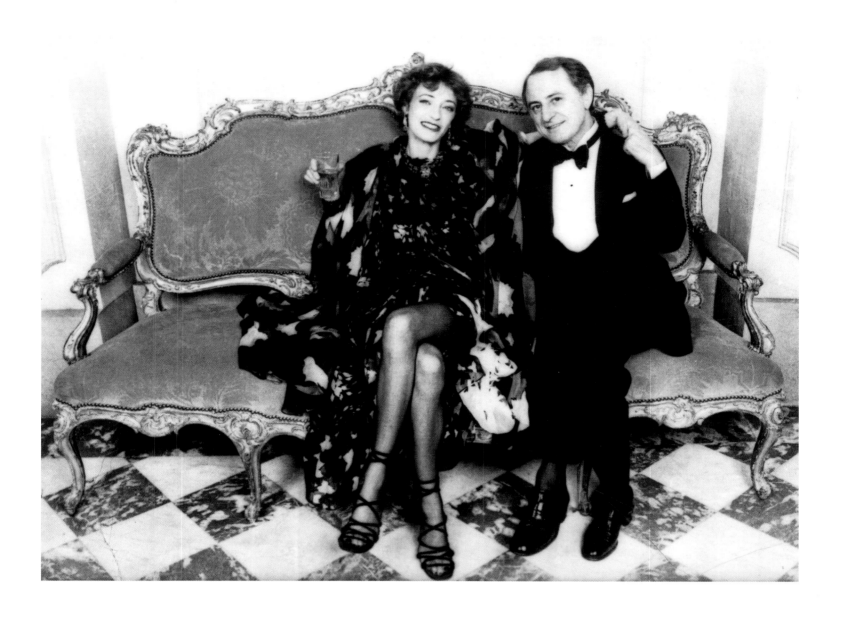

" Loulou was naughty and nice, her hooting laugh and distinctive annunciation added to her seductiveness."

— Marian McEvoy

BELOW – Relaxing in Marrakech with friends at Yves and Pierre's home Dar es Saada. Clockwise from top: Loulou with Fernando, Yves, and Thadée - Posing with Omar and Aziz - As an Orientalist portrait.
OPPOSITE – Posing with Thadée - With Yves - With Fernando Sanchez, Betty Catroux, and Jacques Grange.

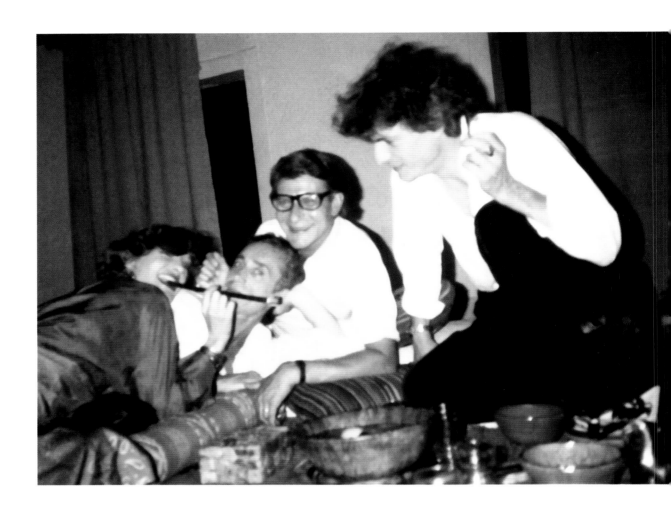

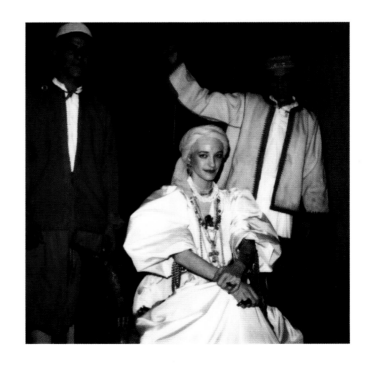

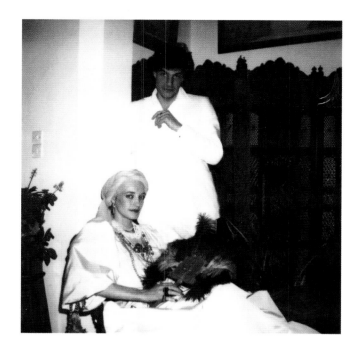

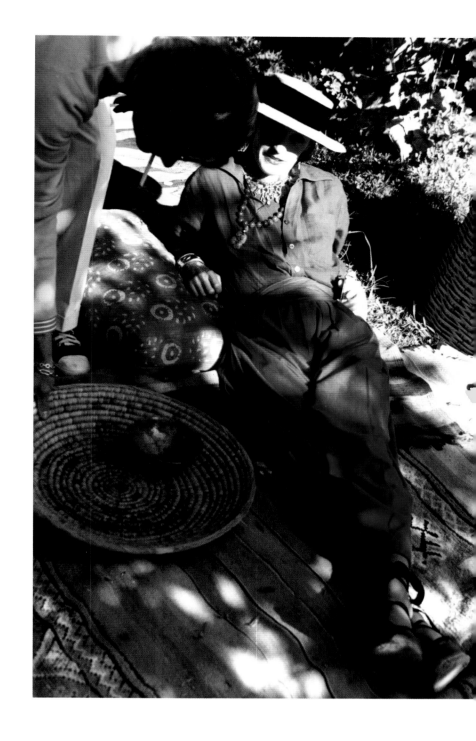

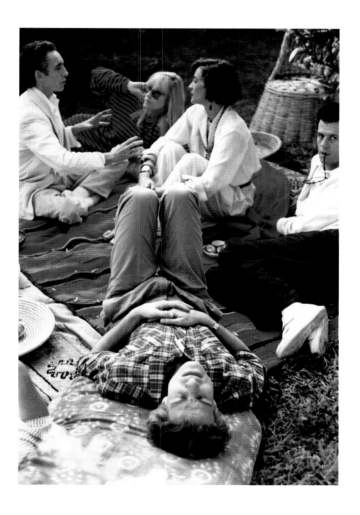

" Loulou came to Morocco with us very often, she loved to wear the turban.
It was the time to smoke joints and to spend a night on the terrace, during the
summer time and it was fantastique."
<div align="right">— Pierre Bergé</div>

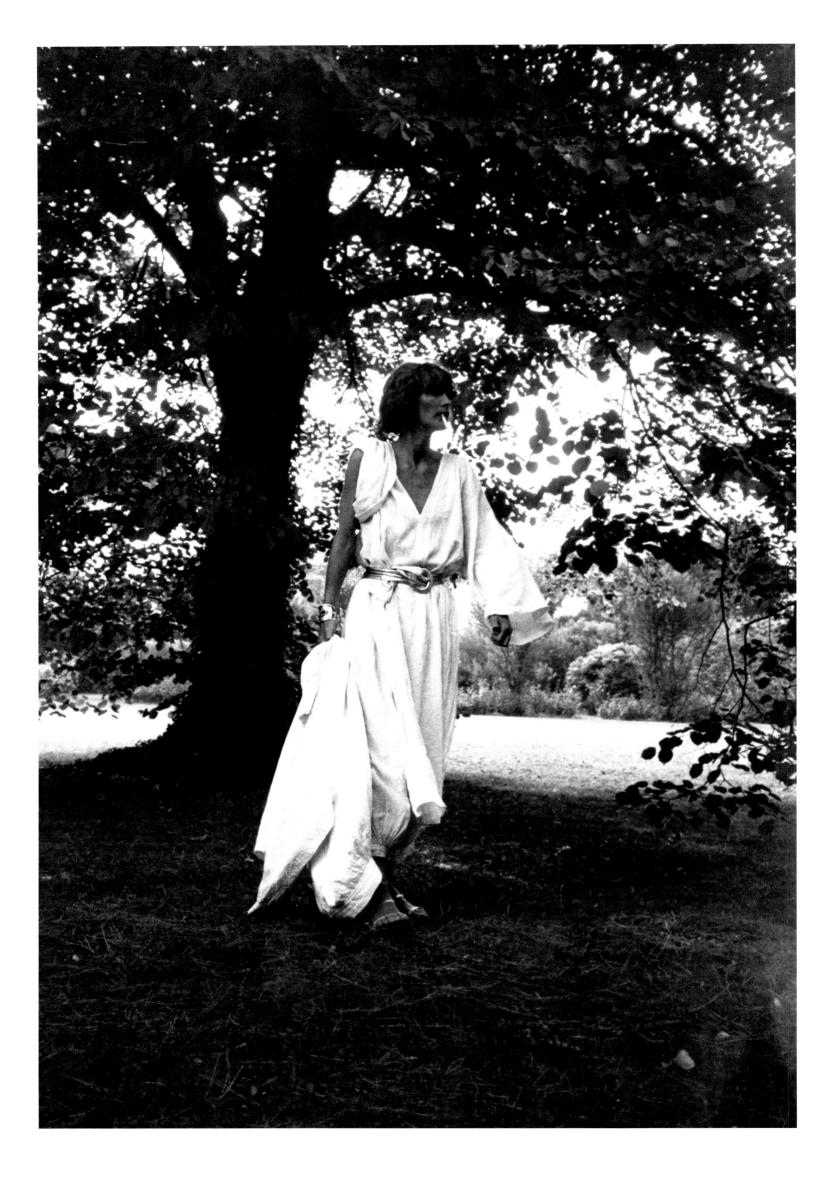

OPPOSITE — Loulou in Italy, photographed by Gwendoline Bemberg in 1980.
BELOW — A weekend party at Eric de Rothschild's Chateau Lafite photographed by Helmut Newton. From top left: Nicole Wisniak and Loulou - With Eric de Rothschild - The weekend party (from left), Antonio Recalcati, Antoinette Seillière, Jenny Capitain, Régine Deforges, Ernest-Antoine Seillière, June Newton, a guest, Nicole Wisniak, Léa Deforges-Wiazemsky, Pierre Wiazemsky, Frédéric Mitterrand, and Thadée Klossowski.

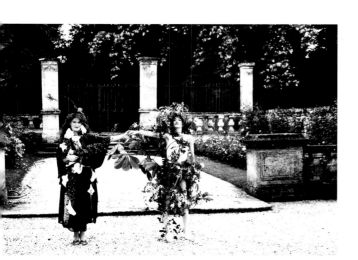

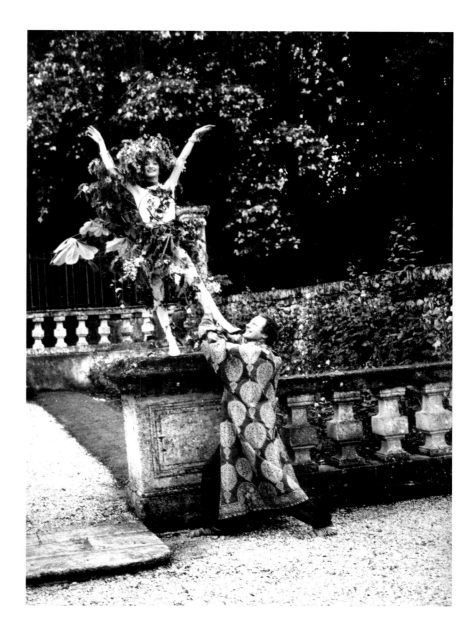

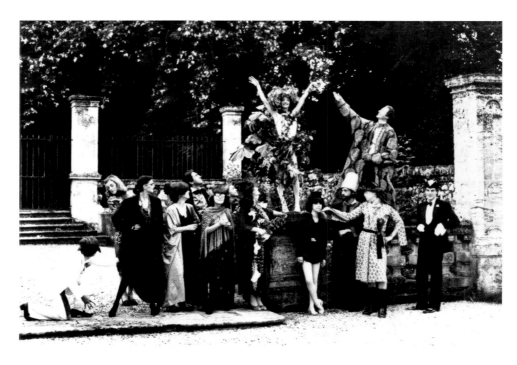

" Balthus's birthday was in the Grand Chalet. It was 'saltimbanchi' like a village fête and masked ball but not really. It was charming, the mix of masquerade and the atmosphere of the owner."

— Verde Visconti

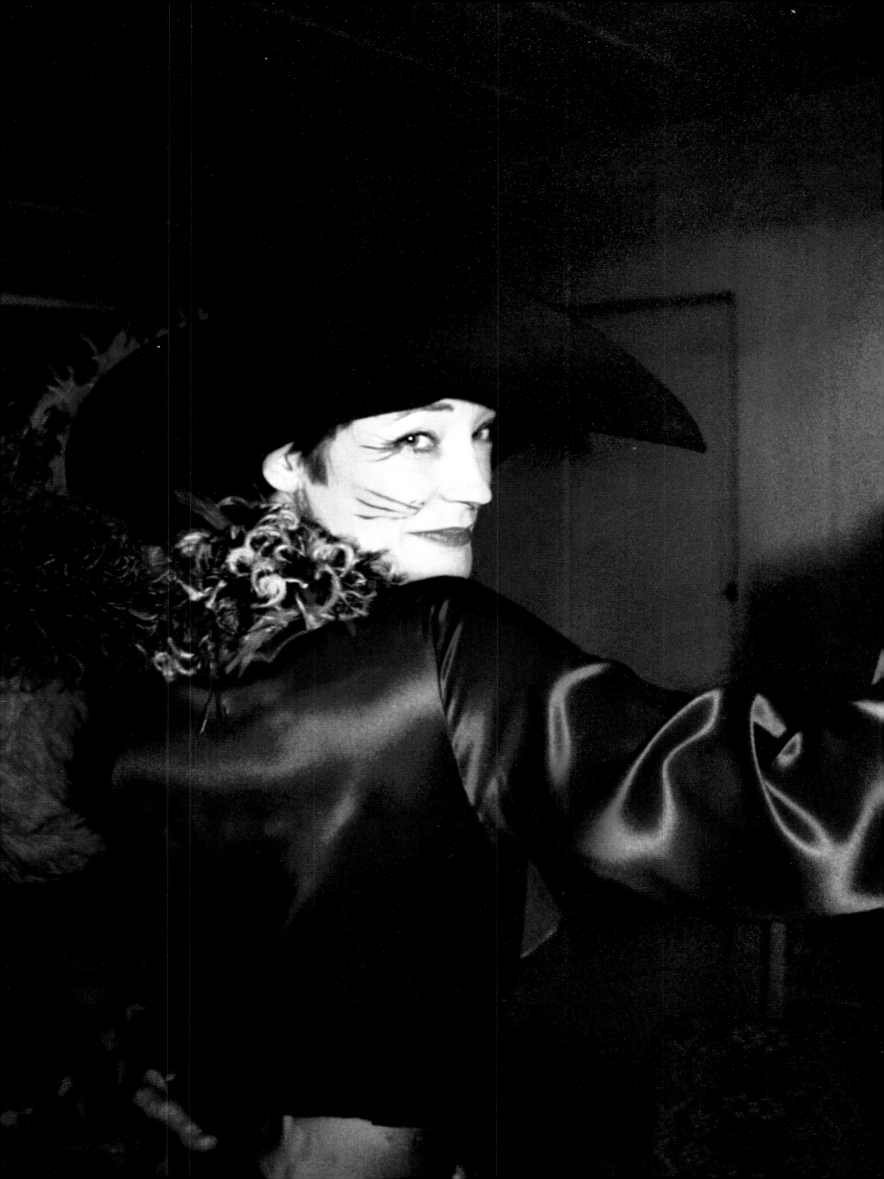

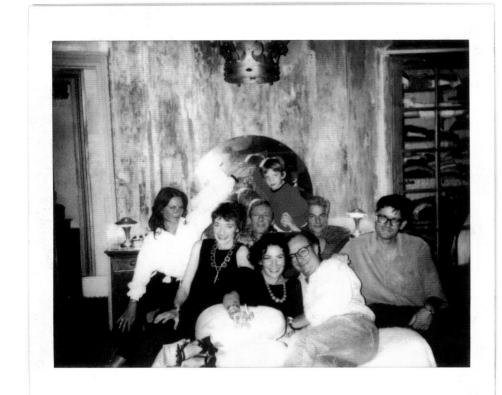

" Loulou was instinctive and gave a lightness to whatever surrounded her. "

— Leonello Brandolini d'Adda

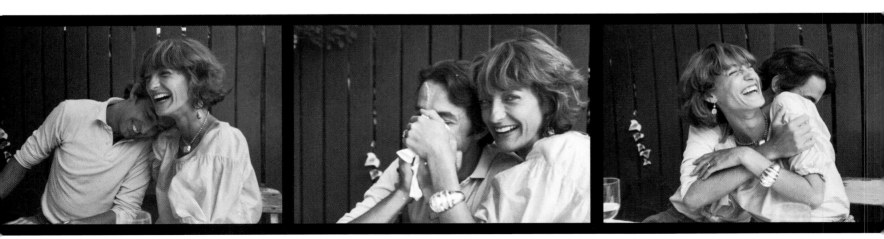

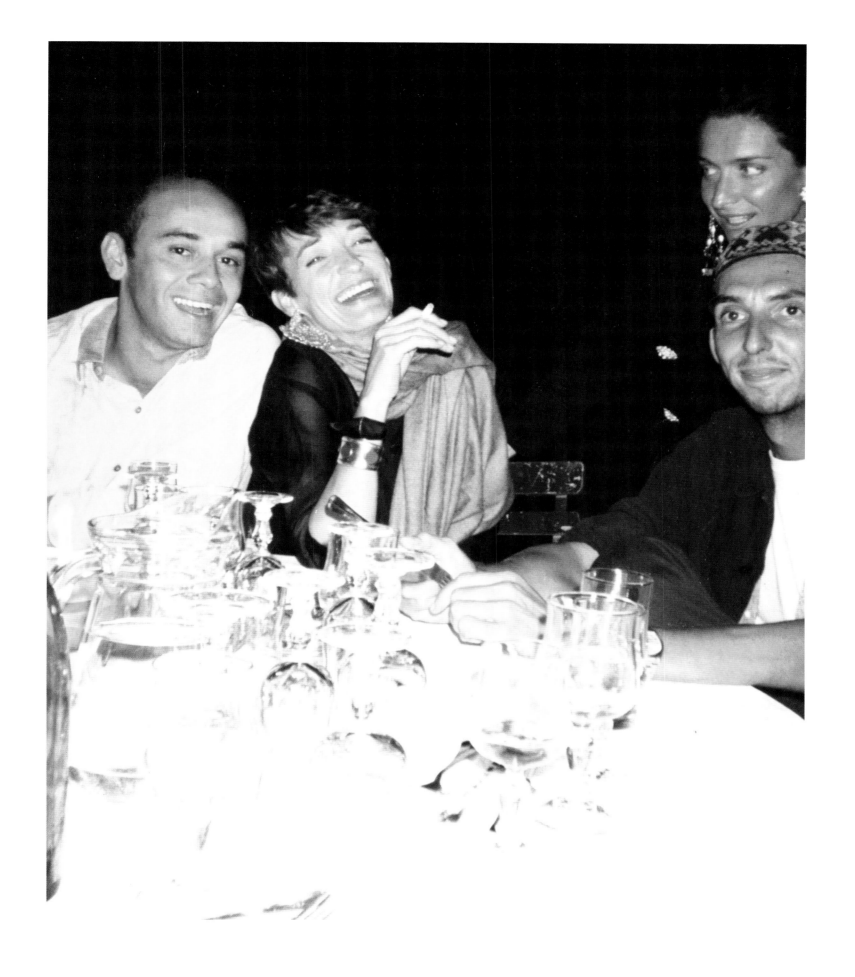

"Nothing was forced with Loulou. Her love of laughing and sense of humor created friendships."

— Christian Louboutin

Most Saturdays, Loulou and Thadée would entertain at their home on the rue des Plantes.
Many of their guests recall the vast eighteenth-century chandelier hanging in the salon, a wedding present from Saint Laurent. (It lay in its box until being hooked up by a pale man whom Loulou described as being "fish-like with a massive, rounded back that rolled into his neck," either revealing or omitting the fact that he was the boyfriend of a popular cocaine dealer, depending on who she was talking to.) "The decor of that apartment was the chic of the poor with the highest, poetic moments," says André Leon Talley. "That Louis XV chandelier, the apple-green sleigh bed, the batiks and Irish linen cloths." The decor was pepped up by her imaginative bouquets. "Loulou treated flowers in the same free way that she dressed: very quick and all at once," says Beatrice Caracciolo , the artist wife of Eric de Rothschild.

The soirées were cozy and fun. "Loulou was the perfect hostess by never being pretentious or grand," Manolo Blahnik recalls. "There was always a dinner for someone from out of town, which led to the best parties," says Caracciolo. Guests of honor ranged from the writer Bruce Chatwin to the photographer Robert Mapplethorpe to Andy Warhol's business partner, Fred Hughes. "It was a carefree period, before AIDS," says Bettina Rheims. "Apart from Loulou, most of us were broke and starting out." Little attention was paid to food, and "we drank more than we ate." As the night progressed, all the women would disappear into Loulou's closet. "It resembled Ali Baba's cave and Loulou would dress us up like dolls," she says. The goal was always to hit the night scene afterward, "but most of the time, we took too long, ended up staying in, and that was the fun." Regarding Loulou's relationship with her male friends "both straight and gay," Bella Freud, the designer and daughter of the artist Lucian Freud, compares her to Titania, the Fairy Queen in *Midsummer's Night Dream*. "They looked to Loulou to lead the way and she set the pace and theme," she says. "There was nothing that she wouldn't do herself yet she had a sense of the rules of the game."

" She sparkled like no one I'd ever seen — it was a kind of charge that went through her and radiated out."
— Joan Juliet Buck

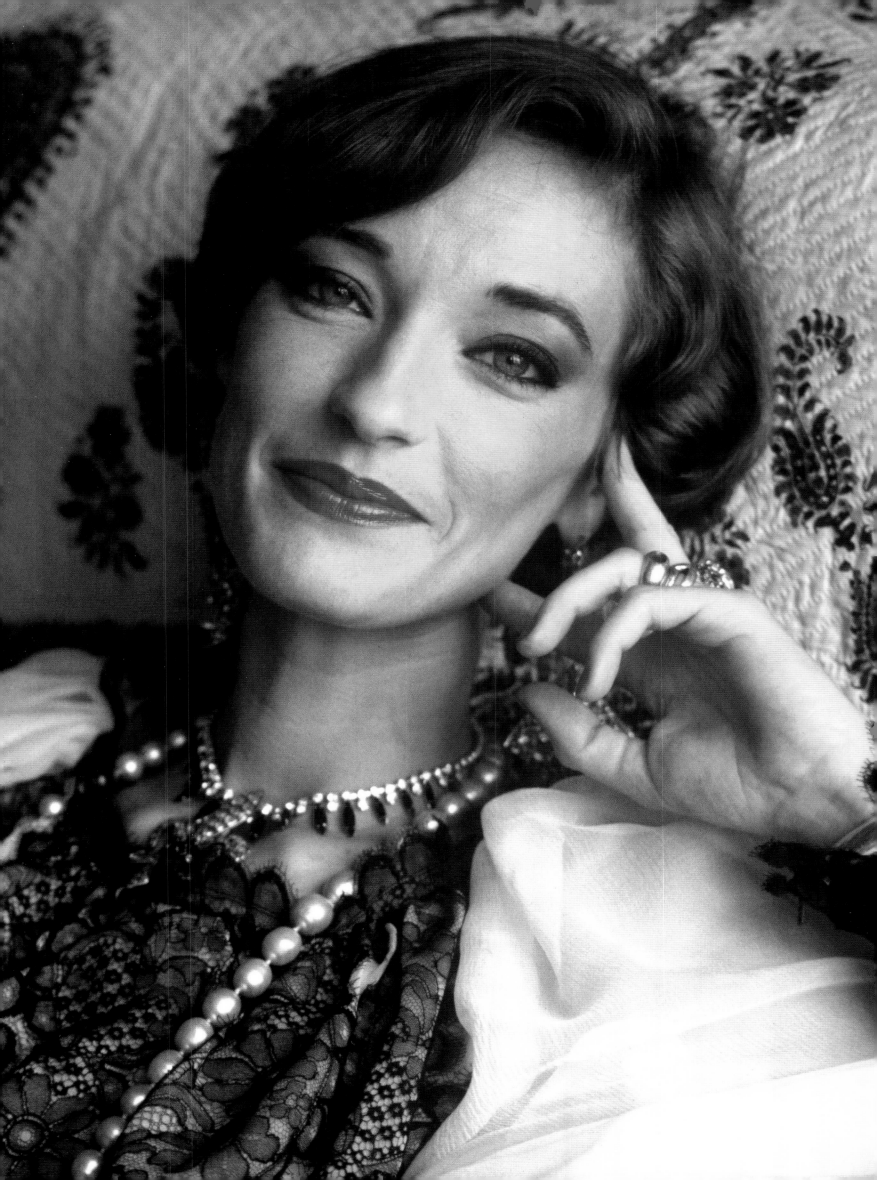

During the holidays, the couple would take off to the Klossowski family castle in Italy. "Loulou really loved Montecalvello," Thadée recalls. "The place had been burgled and it was completely empty and full of light." All that remained were "rather good beds and bathrooms" and an enfilade of refined rooms that brought to mind "Beauty and the Beast" and other fairy tales. "Seeing Loulou in those empty rooms was wonderful," says Verde Visconti. Marvelling at Loulou's talent for picking wild flowers — "finding teeny ones growing under moss" — and creating bouquets of all sizes, Visconti was reminded of "a little wood fairy."

Ines de la Fressange, the style icon and second wife of Luigi d'Urso who was one of Loulou's best friends, recalls Loulou's sense of humor and explosions of laughter. "A lot of teasing went on but it wasn't mean," she says, "just a way of creating childlike complicity among pals." Like her maternal grandmother, Rhoda Birley, Loulou cooked with everything she could find — "and it was always delicious," notes Beatrice Caracciolo. "Cooking cèpe mushrooms, Loulou threw in large grains of salt in the same way that she covered her shoulders with a silk shawl or shoveled earth in her garden: it was effortless," says de la Fressange. Once, when John Stefanidis appeared from Salzburg bearing painted Easter eggs, Loulou immediately hung them from the dining room's iron chandelier. "And just before we sat down, she darted into the courtyard, picked some lemons with their branches, and threw them on the table — a perfect and festive centerpiece," he says.

Spontaneous and in the moment, Loulou was also thoughtful. "When we were living in Wales, she'd arrive with wonderful Bonpoint clothes and little French frocks," says her niece Lucie. Her brother Daniel once received a Swiss army penknife for a birthday. "Loulou and I went off, caught a rabbit and then skinned it," he recalls. When they were sent to boarding school in France in the mid-1980s, the children would stay with Loulou and Thadée every weekend. "I have a memory of her wearing dirty 501s with Thadée's shirt tucked inside and her saying, 'Grab the potatoes, I'll get the courgettes' and we'd have the greatest chats peeling the veg," Lucie says.

All of Loulou's friends continued to be impressed by her attentiveness to her family. "She seemed quite fragile but she really took care of her brother, Alexis, her niece, and her mother," says Paloma Picasso. "She was organizing everyone." In the opinion of Leonello Brandolini, "Family and friends were the two things that Loulou took seriously."

"One of my best friends was always fascinated that every time my parents passed by one another they touched the other, if only with their eyes." — Anna Klossowski

Loulou and Thadée, photographed by Richard Avedon in Paris, January 1978.

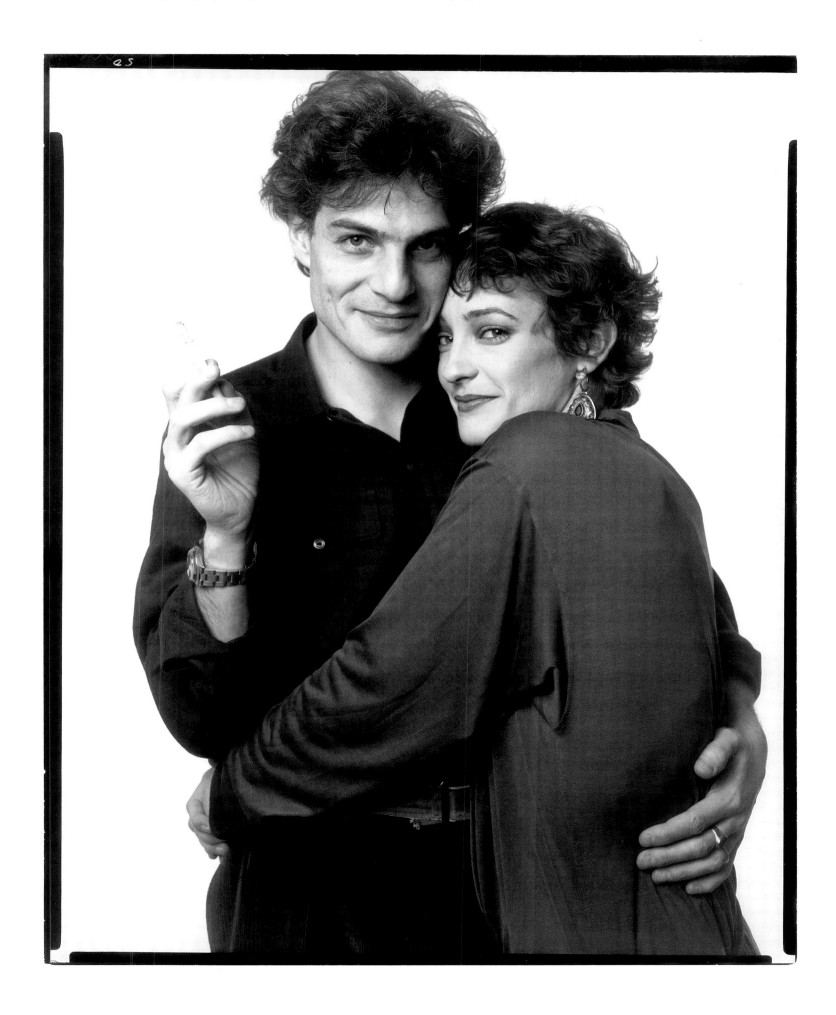

Although Loulou's public appearance defined sophisticated, in private she was still a country girl who relished being practical and grounded. "If you didn't know Loulou, you'd fantasize about her look and how she was the Greta Garbo of the fashion world," says Christian Louboutin, the shoe designer. "But you soon discovered that she was a tomboy who was more interested in planting potatoes and how best to cover them." He noticed that Loulou's various abodes were more likely to be littered with garden magazines and plant catalogs than *Vogue*s. "Loulou lived fashion but, when away from work, she didn't like talking about it," says Ariel de Ravenel, her friend and eventual business partner. A voracious reader of biographers and novels, she preferred conversing with intellectuals like John Richardson, Picasso's acclaimed biographer. The feeling was mutual. "I loved having Loulou to myself because she was like a sprite who was always roaring with laughter," he explains. "She didn't behave like a great beauty and never stuck her looks down your throat." In Sicily in the late 1970s, Madison Cox witnessed how Loulou transformed a modest hotel room by "moving the lamp and covering it with a scarf." "With nothing, she made it comfortable," he says. And when joining Saint Laurent on press trips to Australia and Japan, Loulou taught him to make the most out of any situation: "She'd say, 'Come on, the Kabuki drag queen park is only twenty minutes way, let's go.' Loulou pushed with her warmth and amazing spirit."

In many ways, she was the ultimate bohemian who avoided being spoiled in spite of being endlessly admired. "I loved how simple Loulou was," says Verde Visconti. "When she went to the grocery store to buy butter in Viterbo, it was as if she was buying the most sophisticated thing in the world." That she took every experience to be an adventure is illustrated by a drive she took one afternoon into the country with Christian Louboutin. "Her job was to map read and check the petrol," he says. "Well, we ended up lost, without petrol, and needing to flag someone down on the motorway. It took seven hours for an hour-long trip. Anyone else would have freaked, but Loulou was very amused. She was never bourgeois." For Brandolini, it went hand in hand with Loulou's "incredible lightness of being."

For years, Loulou was convinced that she could not have children. Then to her shock, she became pregnant in 1985. "She and Thadée burst into tears when the doctor confirmed the pregnancy," says Stefanidis. Viewed as "a miracle" by Thadée and a true turning point, motherhood changed Loulou. "The birth of Anna became the most meaningful thing in her life because finally, Loulou could turn her back on her sad childhood," opines Diane von Fürstenberg.

After Anna's birth, October 26, 1985. Her godparents were Beatrice Caracciolo de Rothschild and Yves Saint Laurent.

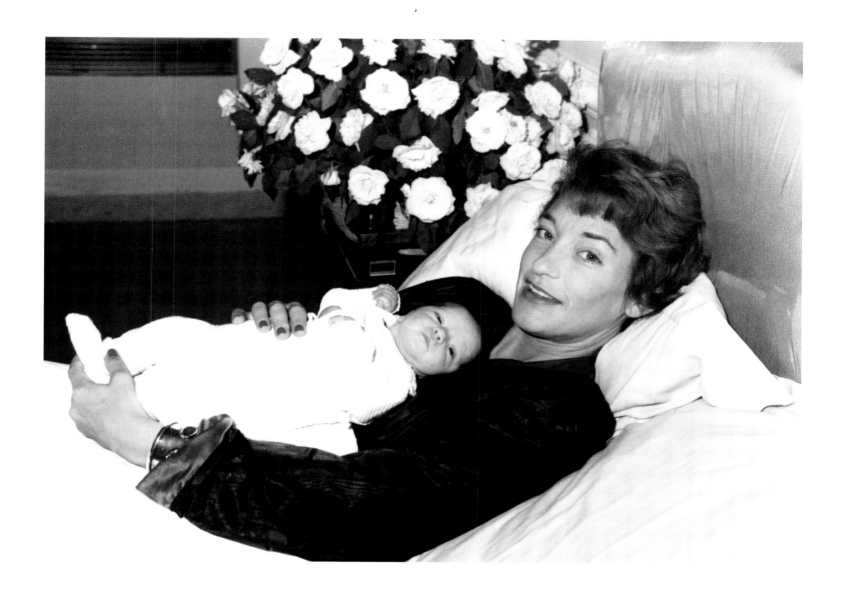

" When Anna was born our father was so happy he hit his head; Loulou had had a baby and he had had a glass of whisky! He was so proud his sister had become a mum."

— Lucie de la Falaise

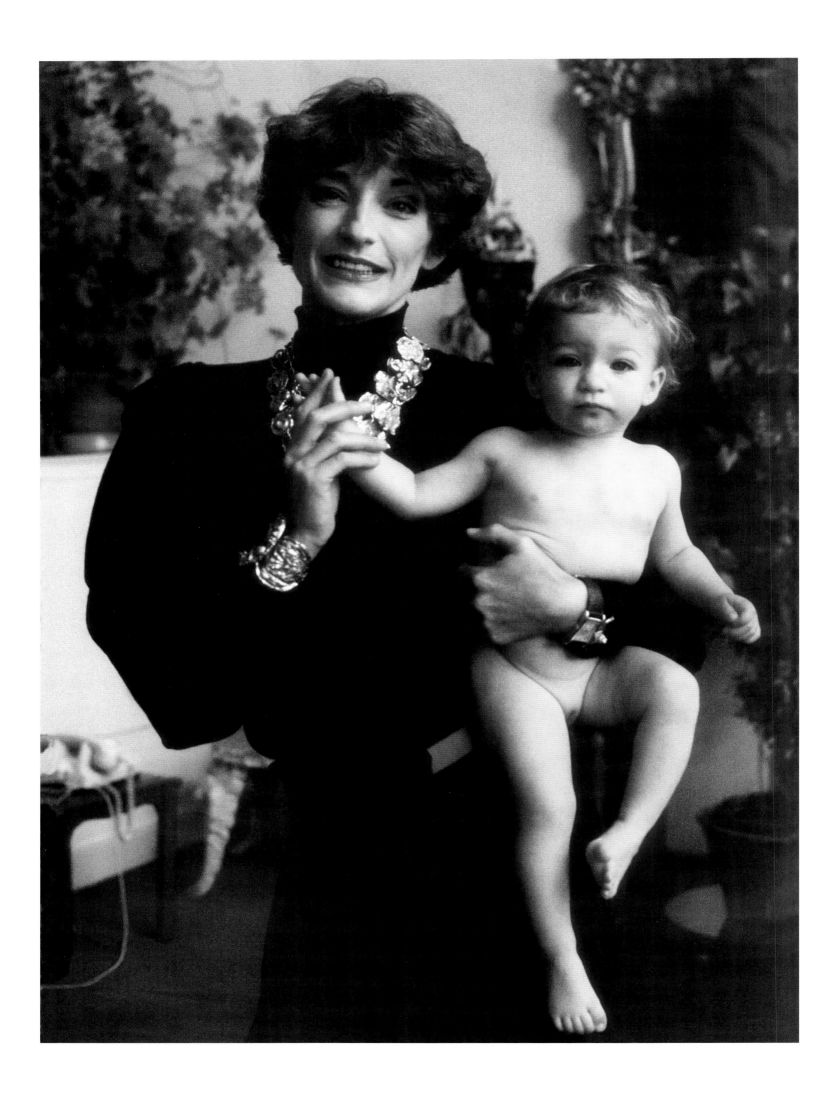

"The turning point in Loulou's life was the birth of our daughter Anna."

— Thadée Klossowski

"Anna was a light in Loulou's life." — Marisa Berenson

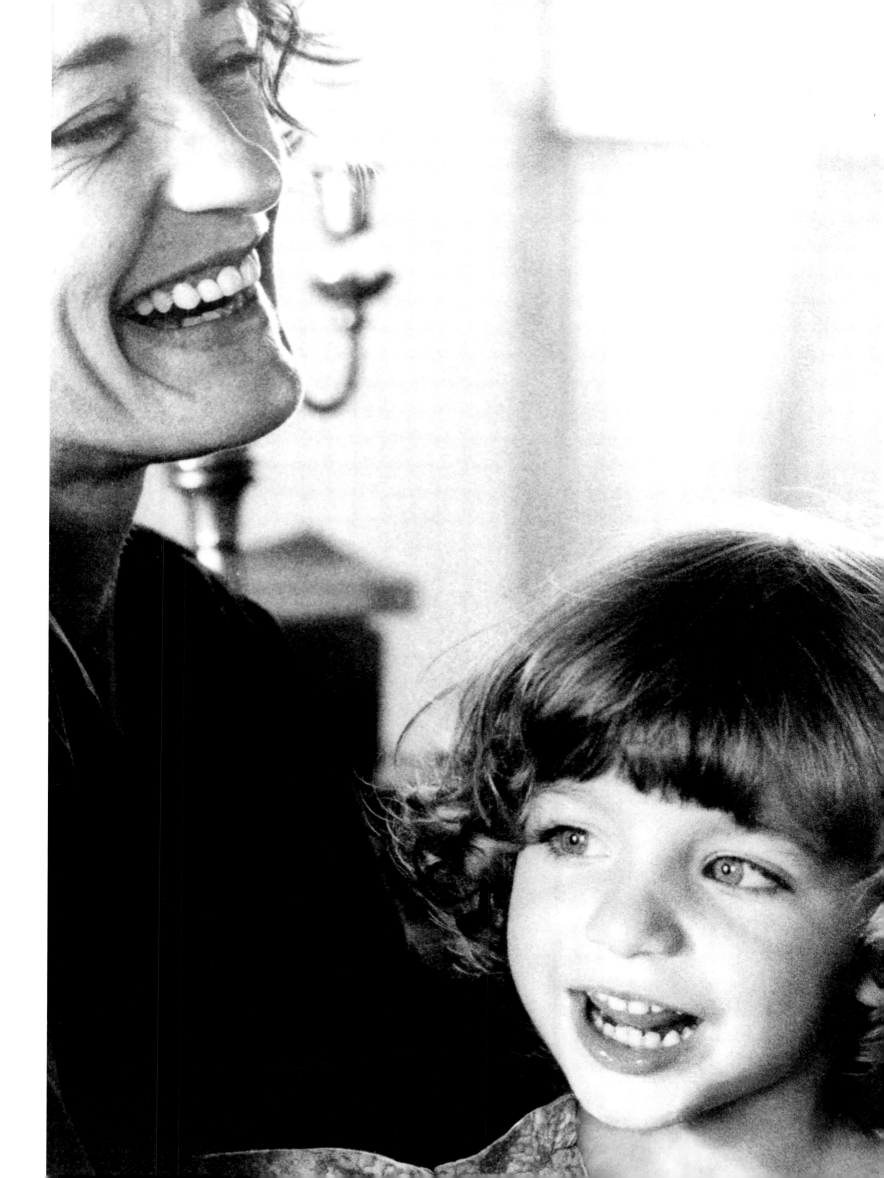

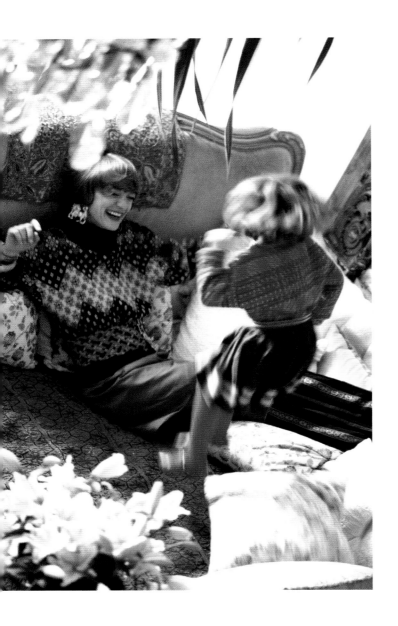

"Maman wanted me to speak English. I remember being in bed when she was reading 'The Wind in The Willows' in French and was trying to translate it spontaneously into English. She would suddenly yell, 'Thadée, how do you say marguerite in English?' She said that it was due to her that his English had improved since they had been together."
— Anna Klossowski

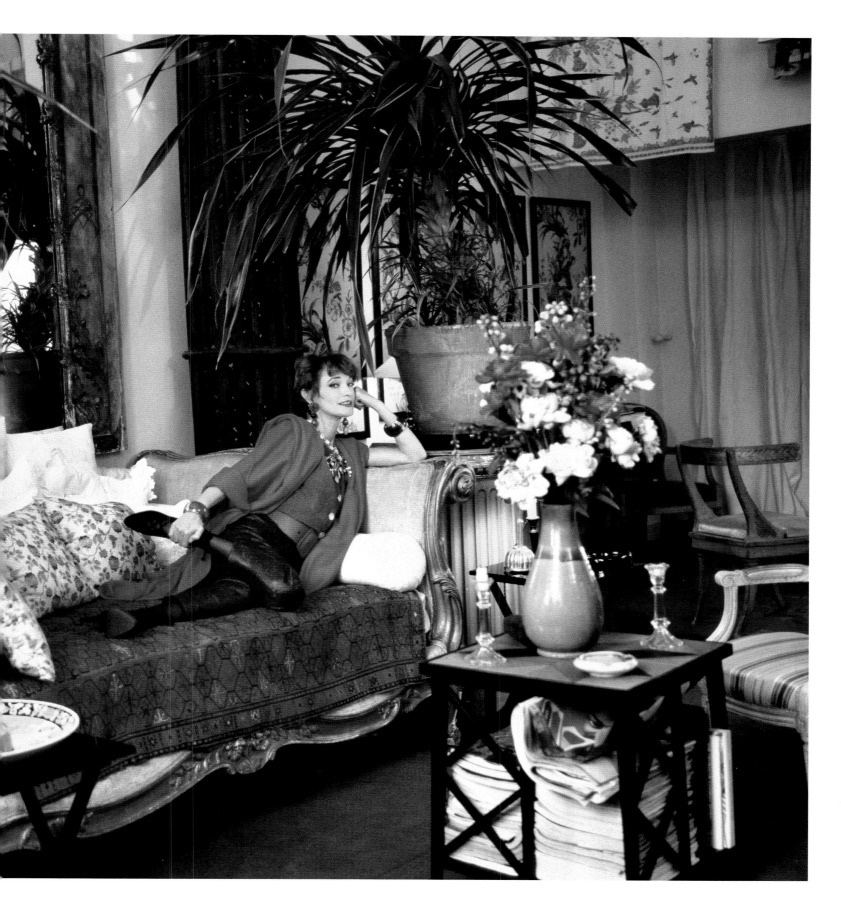

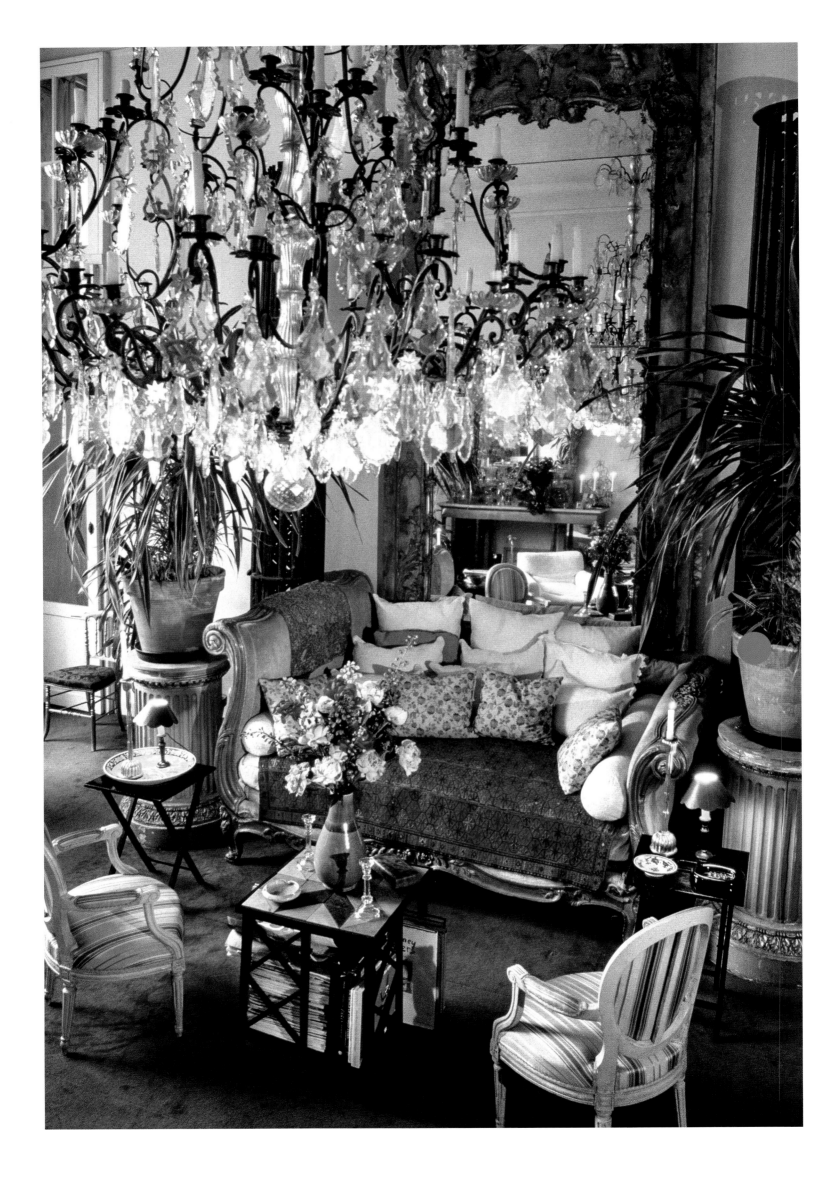

OPPOSITE — The salon and its 100-candle chandelier, a wedding gift from Yves Saint Laurent and Pierre Bergé.
Photograph by François Halard.
BELOW — Loulou photographed at home by Guy Marineau, 1984 - Details of her belongings.

"Maman's bouquets reflected her sense of volume and love of color. She paid attention to all the different sides and placed them close to mirrors so you could see everything."
— Anna Klossowski

BELOW – The frescos in Montecalvello's salon featuring the coat of arms of the Giustiniani Monadelschi family, the former owners, reflect its grand and romantic history.
OPPOSITE – Loulou upstairs in the corridor - A guest bedroom.

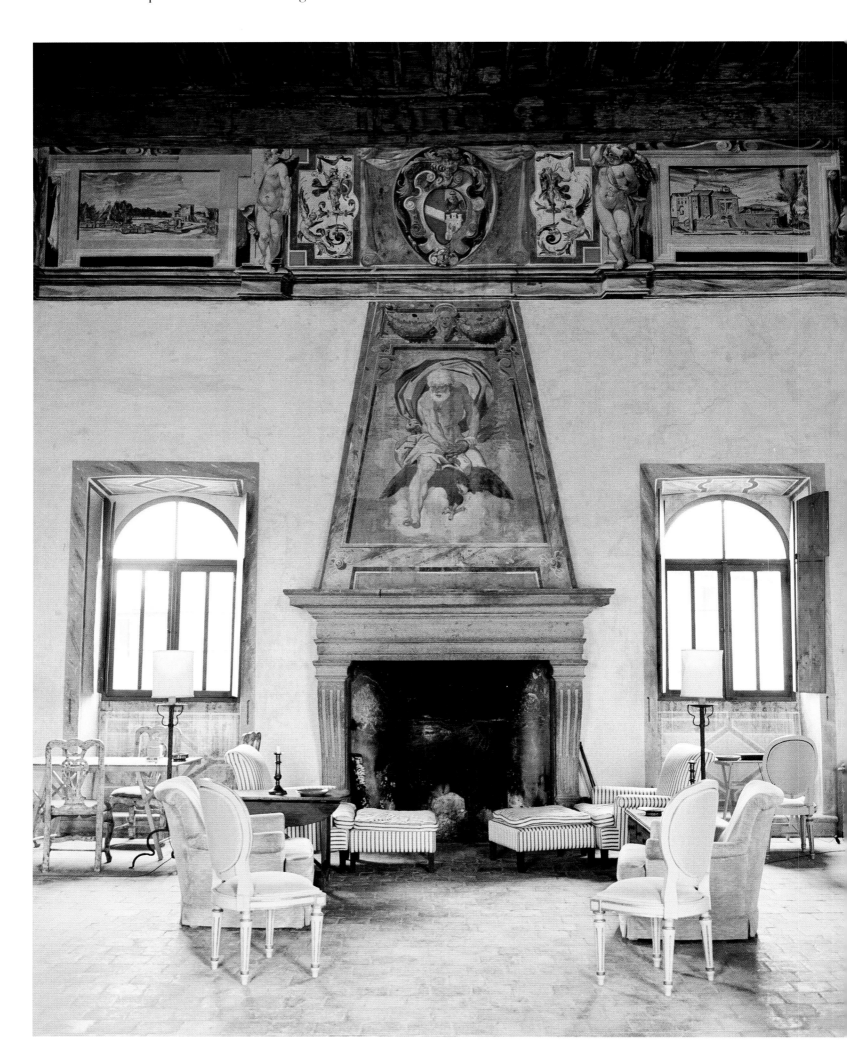

"*There is strictly nothing to do at Montecalvello besides keeping warm or getting rid of your hangover. Loulou would curl up with a book. She always had a dog-eared copy of something.*"

— Madison Cox

OPPOSITE — Loulou and Anna photographed on the balcony of Montecalvello.
BELOW — Clockwise from top left: Thadée - The castle's façade - The view from the terrace that inspired Balthus's painting *La Vue de Montecalvello* (1979) that includes the nearby hills and distant valley that runs from Viterbo in the North to Rome in the South - A view of the Montecalvello chapel.

"*Loulou's eyes were the clearest blue, and though it's an overused term, they truly sparkled.*"
— Stewart Shining

BELOW — An archway at Montecavello, a castle that had been abandoned in the early eighteenth century. It served as a granary until Balthus became the owner.
OPPOSITE — Clockwise from top left: Loulou at Montecavello - The couple's red VW beetle, a honeymoon gift from Bergé and Saint Laurent - A family moment in the field.

" When visiting Thadée and Loulou in Montecalvello, I felt I had never seen Loulou so happy."

— François Catroux

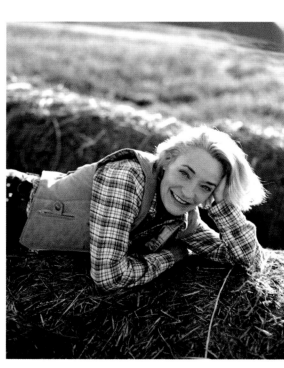

207

Loulou's own childhood remained a forbidden subject. "She never, ever talked about it," says Brandolini. And when her own daughter asked, Loulou always said, "When you're older, I'll tell you." But even after the years passed, Anna never did broach the subject. "I could tell from looking at her eyes that it would upset her." Anna wonders if the early traumas gave energy and strength to her mother and "the power of loving that few had." Loulou and Anna formed an incredibly strong mother-daughter bond. From the word go, cooking together became one of their favorite activities. "Wearing an apron, I would have my little plastic casserole," Anna recalls. And when her parents bought Boury in 1988 — an eighteenth-century country house in the Ile-de-France — Anna would follow her mother around in the garden with plastic watering can in hand. Many pansies were planted "because I think that was an easy flower for a little girl to plant," she says.

Few of Loulou's friends were not charmed by Boury. "It was the perfect match of Thadée and Loulou's talents," says Brandolini. "Thadée gave the structure and she gave the imagination and the colors." Loulou liked to tease that "John Stefanidis would faint." Indeed, Beatrice Caracciolo had exclaimed "What courage!" when shown the bright green library for the first time. "But that was Loulou," says Caracciolo. "She always went for an amazing assembly of colors." Carolina Irving, the textile designer who styled the house for various magazine shoots, compares Loulou's mix of colors to being equivalent to David Hicks, the interior designer. "She dared but everything was in total harmony," she says.

It was Boury's back door leading into "fields of nothing" that sold Loulou on the house, allowing her to walk for two hours without seeing a soul. "She'd vanish into the garden, pick the beans, and deliver a lunch of amazing efficiency and no fuss," Richardson remembers. "It came as a surprise considering her extraordinary glamour." As the years passed, Loulou became a country girl, nursing a growing passion for traditional gumboots and sturdy outerwear. "She loved it when it rained and she could wear them for long walks in the woods and fields" says Ariel de Ravenel. Meanwhile, Boury's garden with its "Halloween" willow tree, iron cast gazebo, and poetic layout became Loulou's haven. "There was nothing that made my mother more happy," Anna says. "It's what she waited for, all week."

"In a huge green field, Loulou could see the four-leaf clover." — Verde Visconti

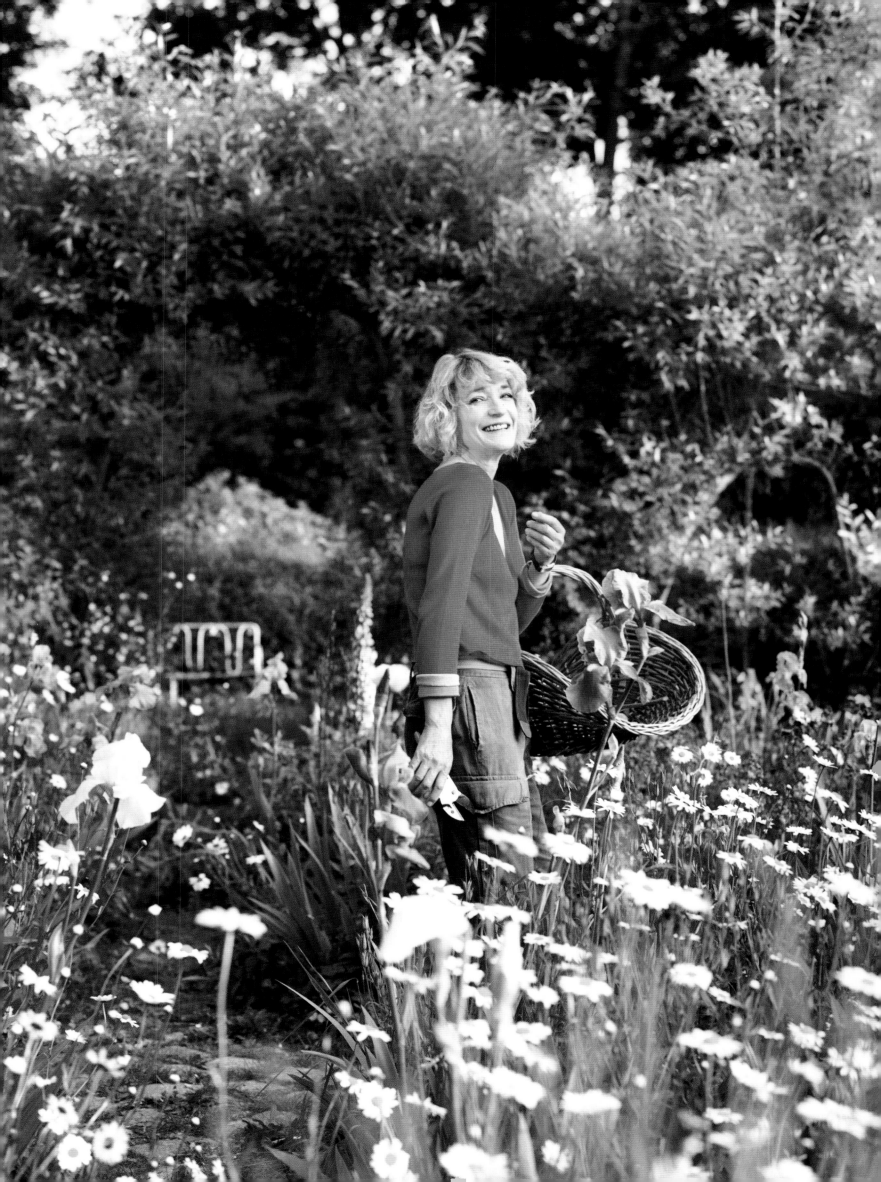

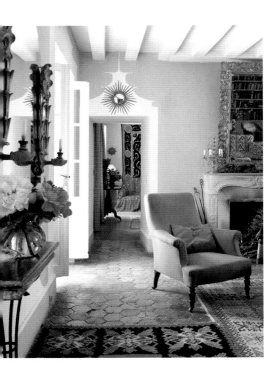

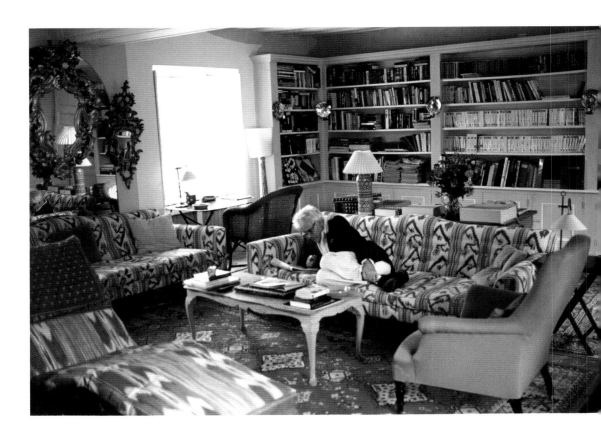

" When we were in Majorca, we went to the well-known fabric maker where Loulou went mad buying ikats that, years later, ended up on Alexis's sofas."

— Leonello Brandolini d'Adda

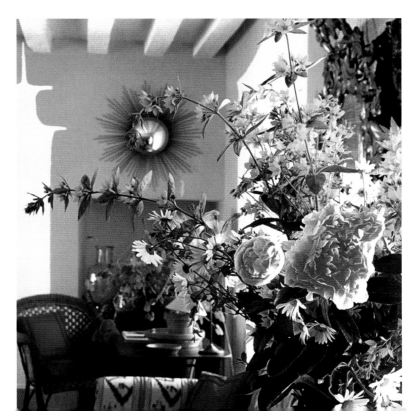

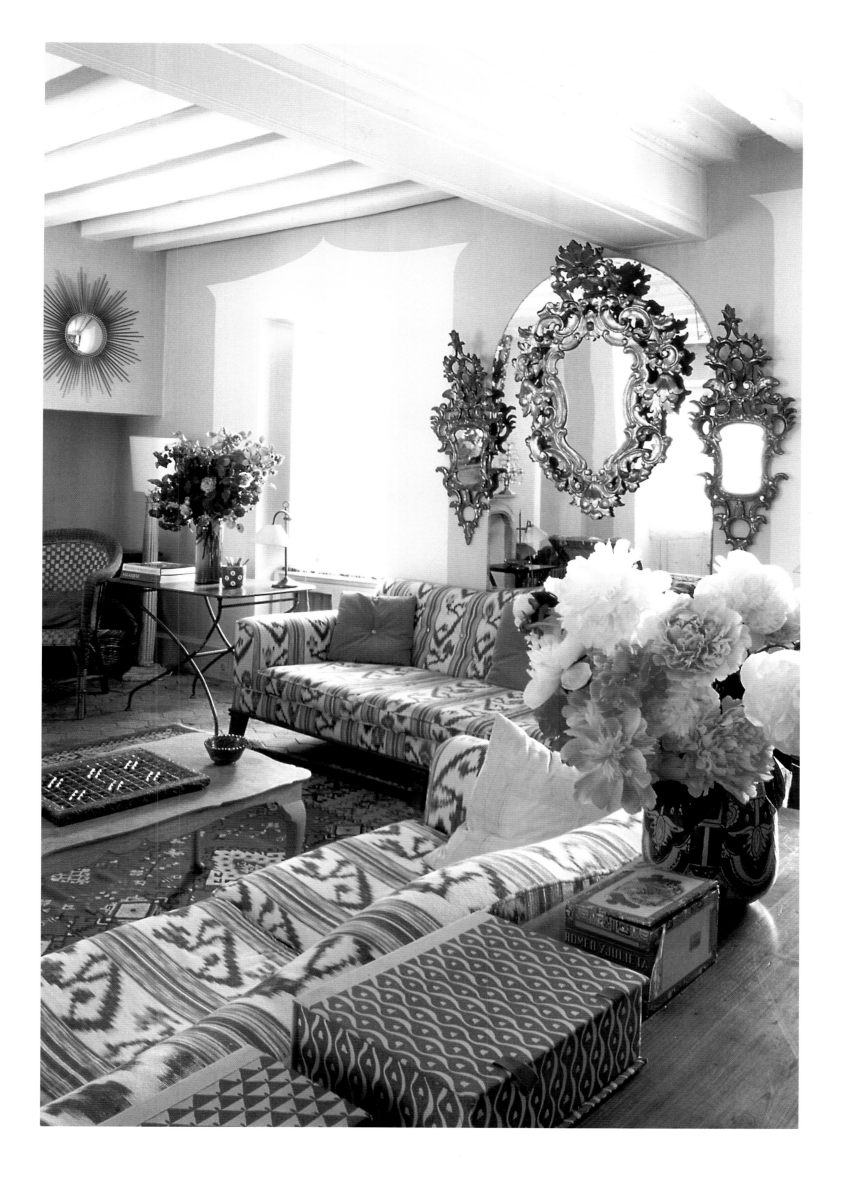

BELOW – Fireplace in Loulou's bedroom decorated with Anna's drawings.
OPPOSITE – Four views of Boury. The plates on the wall are French, and the blue-and-white tiles come from Farnese, a celebrated shop in Rome

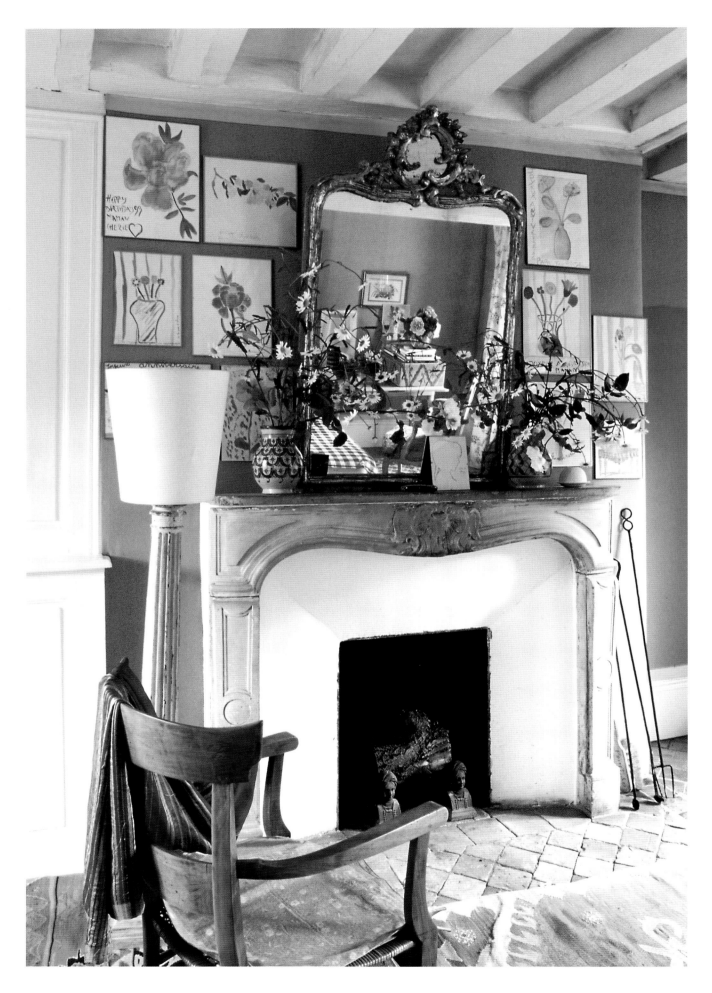

"Loulou treasured all of Anna's drawings and had them hanging on her bedroom wall."

— Ariel de Ravenel

"Loulou's way of doing a garden was pure poetry with many references to literature."

— Madison Cox

An ENGLISH HEART

Mon rêve de
toujours se réalise
une Maison Anglaise
dans le coeur du beau
Paris

HOUSE in the of PARIS

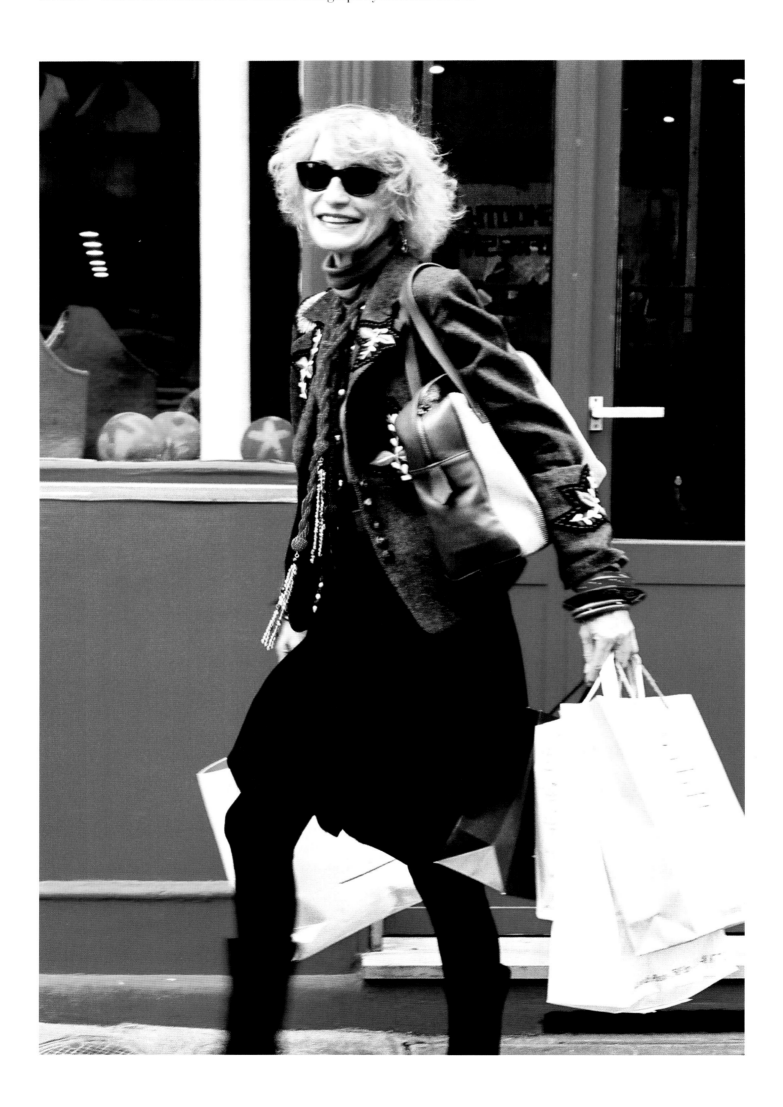

"Loulou opened her store as if it was her house. But I think that throughout her life she opened doors for people."

— Stefano Tonchi

On February 14, 2003, Loulou opened her eponymous boutique on the rue de Bourgogne. "She was determined to make it Valentine's Day," says Ariel de Ravenel, who helped Loulou with her new adventure. As can be imagined, it was a joyous event bursting with friends ranging from Yves Saint Laurent and Eric de Rothschild and his wife Beatrice Caracciolo to Ines de la Fressange, Christian Louboutin, and her former Saint Laurent assistants such as Charles Sebline, who viewed it as "Loulou's second baby." "I wouldn't mind one of these," enthused Farida Khelfa, then the noted muse of Azzedine Alaïa, holding up one of the tailored jackets while Louboutin and other stylish professionals swooned over Loulou's packaging, a combination of jade and garnet, her "fetish colors." Indeed, the only sour note was when Moujik III, Saint Laurent's dog, took a leak upstairs — an action that Loulou took in her stride.

In the heart of the 7th arrondissement, the Loulou de la Falaise boutique flowed over two floors and was designed by her brother Alexis, who also designed all the furniture. "I loved the charming little flowery curtains blowing in the wind in the flagship," says André Leon Talley, who was then at American *Vogue*. "I was so impressed that Loulou could put in that cozy, unexpected touch."

There were high hopes for the store, which Loulou described as "an English country house in Paris." It sold satin shirts, colorful knitwear, pinstripe trousers, velvet jackets, and jewelry. In style, it was a continuation of what she had been doing at the Yves Saint Laurent couture boutique.

BELOW — From top left: The doorknob at the 7 rue de Bourgogne boutique was a brass sculpture of Gribouille, Loulou's cat, made by Robert Goossens, Loulou's favorite jeweler - A red lacquered necklace display - The boutique façade, Loulou's intention was to make her boutique homey and cheerful.

OPPOSITE — The boutique and its furniture were designed by Loulou's brother Alexis.

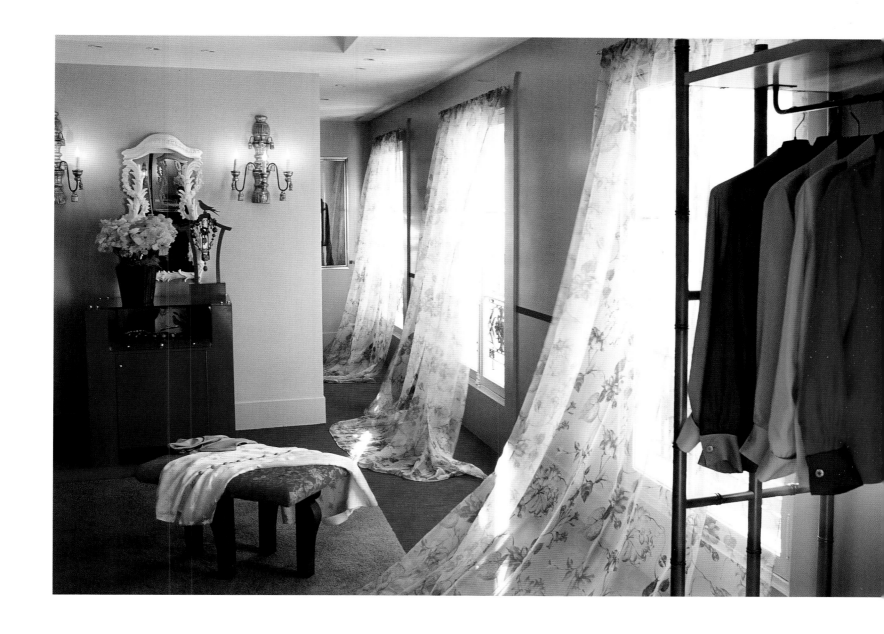

" Maman and Alexis were clan-like. She was terribly proud that they worked on the boutique together and of everything that Alexis designed for it." — Anna Klossowski

It had been over a year since Yves Saint Laurent had retired — he had announced the end of his couture house at the beginning of 2002 — and his former clients like Nan Kempner, Hélène Rochas, and Micheline Maus sauntered in to snap up Loulou's styles. "I was so happy," recalls Hubert de Givenchy, "because I thought 'finally a place where you can dress and learn about style.'" The boutique was also frequented by style icons like Sofia Coppola, Lee Radziwill, and Marisa Berenson. "I bought a lot of her knitwear, which I also gave away as presents," says Berenson, who still wears a jacket of Loulou's that she claims "goes with everything." Manolo Blahnik admired the jewels, particularly the large pieces that he described as "brutal and Edith Sitwell-like," whereas John Stefanidis knew "women transformed because they dressed in the clothes."

An instant success, Loulou had proved wrong the naysayers who questioned if she was a designer, as opposed to an inspired stylist and brilliant creator of costume jewelry — even devoted friends like Leonello Brandolini, then the head of Robert Laffont Editions, who admitted concern that she was self-funding the enterprise. Still, Brandolini and others realized that Loulou "had all this energy to work," pointing out that she was only fifty-four years old when Saint Laurent retired. The only advice he and others offered was "begin small, begin small."

But "small" was not a word that the wonderfully exuberant Loulou knew. At one point, she had about twenty people working for her. "She was trying to save people who had lost their jobs at Saint Laurent, which was a bit unrealistic," says Loulou's niece Lucie, who modeled for some of her lookbooks.

Two key figures from Saint Laurent — Jean-Christophe Laizeau, who became Loulou's press officer, and Elie Top, the chief designer of her studio — still regard the period as magical. "We would have put our hand in fire for Loulou," says Laizeau, now Ruinart's international communications director. "There was no money but we put our heart and soul into our work. And morning, noon and night, we used to really laugh." They were a young band, mostly in their twenties. "And it was so exciting because we felt like Loulou's 'Dream Team,'" says Top, who had worked with her on the Yves Saint Laurent Couture boutique. Describing her as someone who pushed, he was impressed by her lack of nostalgia for the past, her vibrant imagination, and, her healthy attitude about growing older. "Loulou was an eternal tomboy who took great pride in having dirty nails from working in her garden," he says. "Plastic surgery was not for her." Having been photographed by all the greats and been highly social, he reckons that Loulou had arrived at a peaceful crossroads in her personal life. "She wasn't running after anything," he says. "Having Thadée and being the mother of Anna was what counted for her."

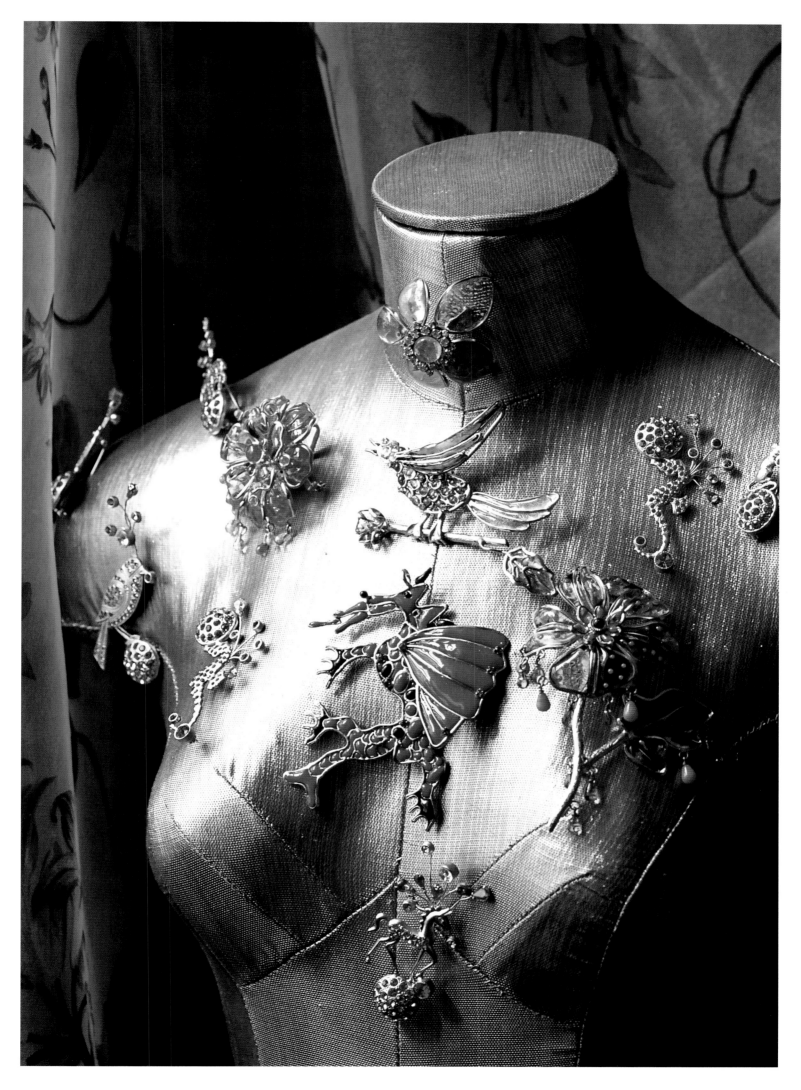

"I always think of Loulou wearing tartans, good colors, and of course her jewelry."
— Celia Birtwell

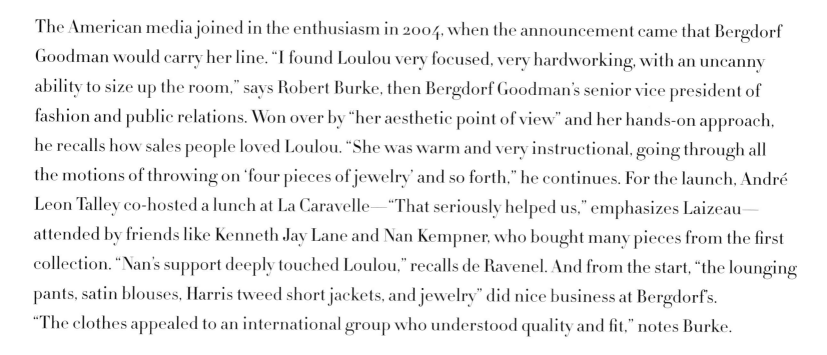

From the start, the European press praised Loulou's new venture. "Journalists loved her because she took time with their questions and made a point of saying different things to everyone," remembers Laizeau. That said, Loulou was not at ease being interviewed. "She would really stress out about it, which was strange when she was naturally good."

The American media joined in the enthusiasm in 2004, when the announcement came that Bergdorf Goodman would carry her line. "I found Loulou very focused, very hardworking, with an uncanny ability to size up the room," says Robert Burke, then Bergdorf Goodman's senior vice president of fashion and public relations. Won over by "her aesthetic point of view" and her hands-on approach, he recalls how sales people loved Loulou. "She was warm and very instructional, going through all the motions of throwing on 'four pieces of jewelry' and so forth," he continues. For the launch, André Leon Talley co-hosted a lunch at La Caravelle—"That seriously helped us," emphasizes Laizeau—attended by friends like Kenneth Jay Lane and Nan Kempner, who bought many pieces from the first collection. "Nan's support deeply touched Loulou," recalls de Ravenel. And from the start, "the lounging pants, satin blouses, Harris tweed short jackets, and jewelry" did nice business at Bergdorf's. "The clothes appealed to an international group who understood quality and fit," notes Burke.

However, as the seasons passed, Loulou began to lose sight of her "international group" and produced clothes that were trendier and younger in spirit, inspired, perhaps, by Anna and her eighteen-year-old friends. There were also problems within the company. Loulou, who was not the type to bother with bills ("She had no sense of figures," opines Leonello Brandolini) was spending more than she was making. "After working at Saint Laurent, she was used to a certain weight of tissue paper and wasn't going to compromise," notes Madison Cox. Loulou overextended and opened a second shop on the rue Cambon. "It was a mistake," says Brandolini. The possibility of doing a Loulou de la Falaise perfume—a financial boon for many designers, and something that would have been a natural fit due to Loulou's incredible knowledge and passion for flowers—was out because L'Oréal had a lock on the name Loulou in order to prevent competition with Loulou by Cacharel.

"Her ready-to-wear and jewelry spoke the language of the Bergdorf customer. Loulou had a highly educated and sophisticated eye."
— Robert Burke

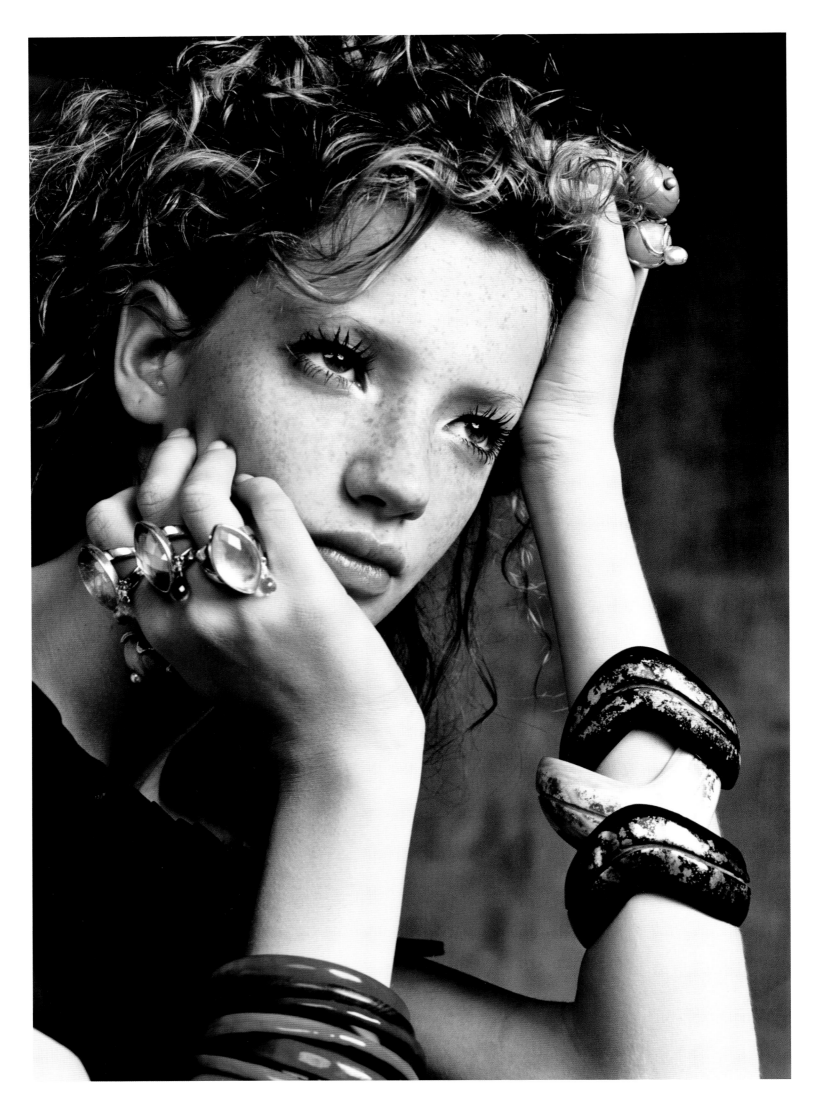

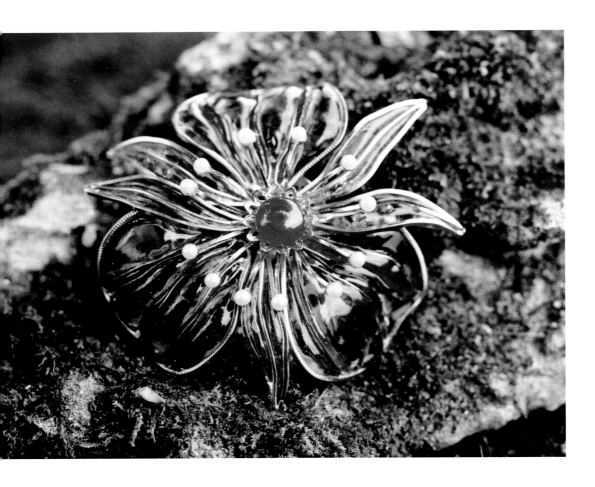

" Loulou possessed extraordinary playfulness and whimsy. " — Hamish Bowles

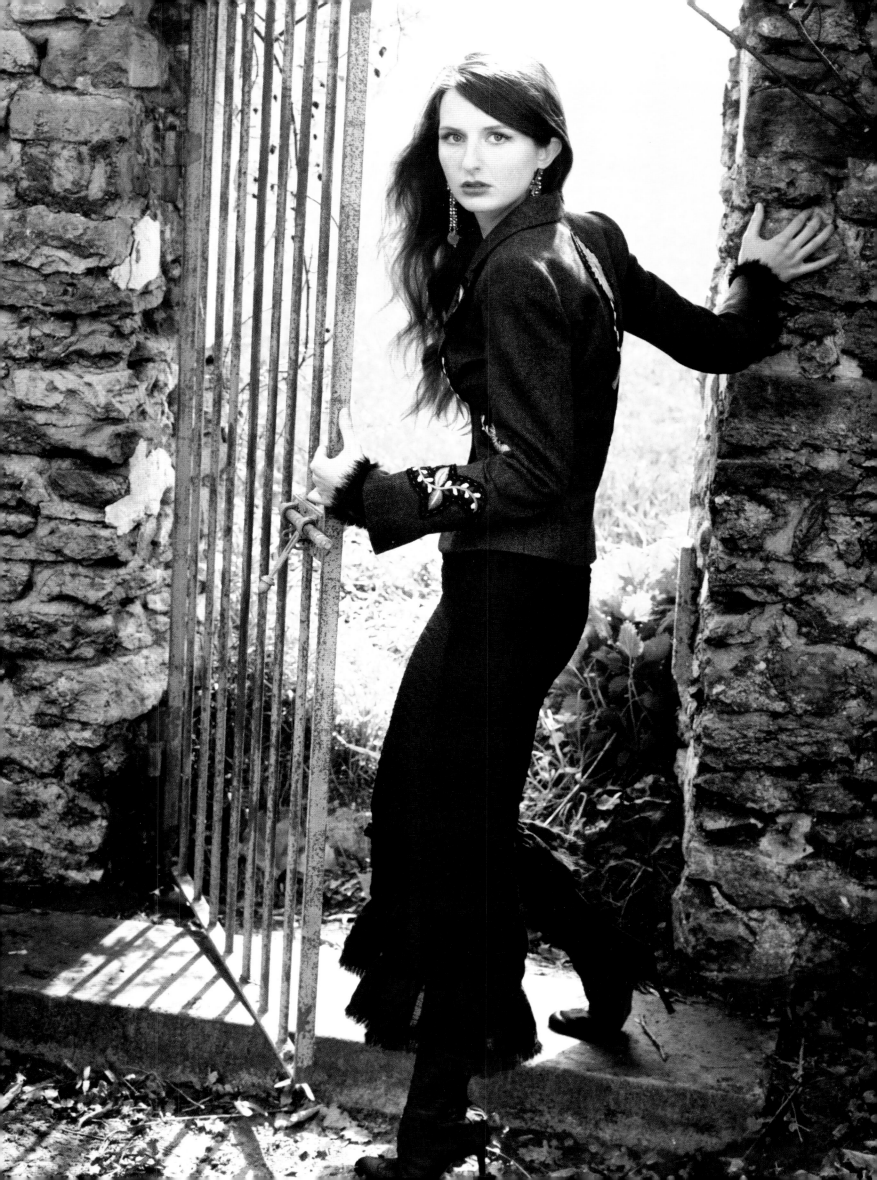

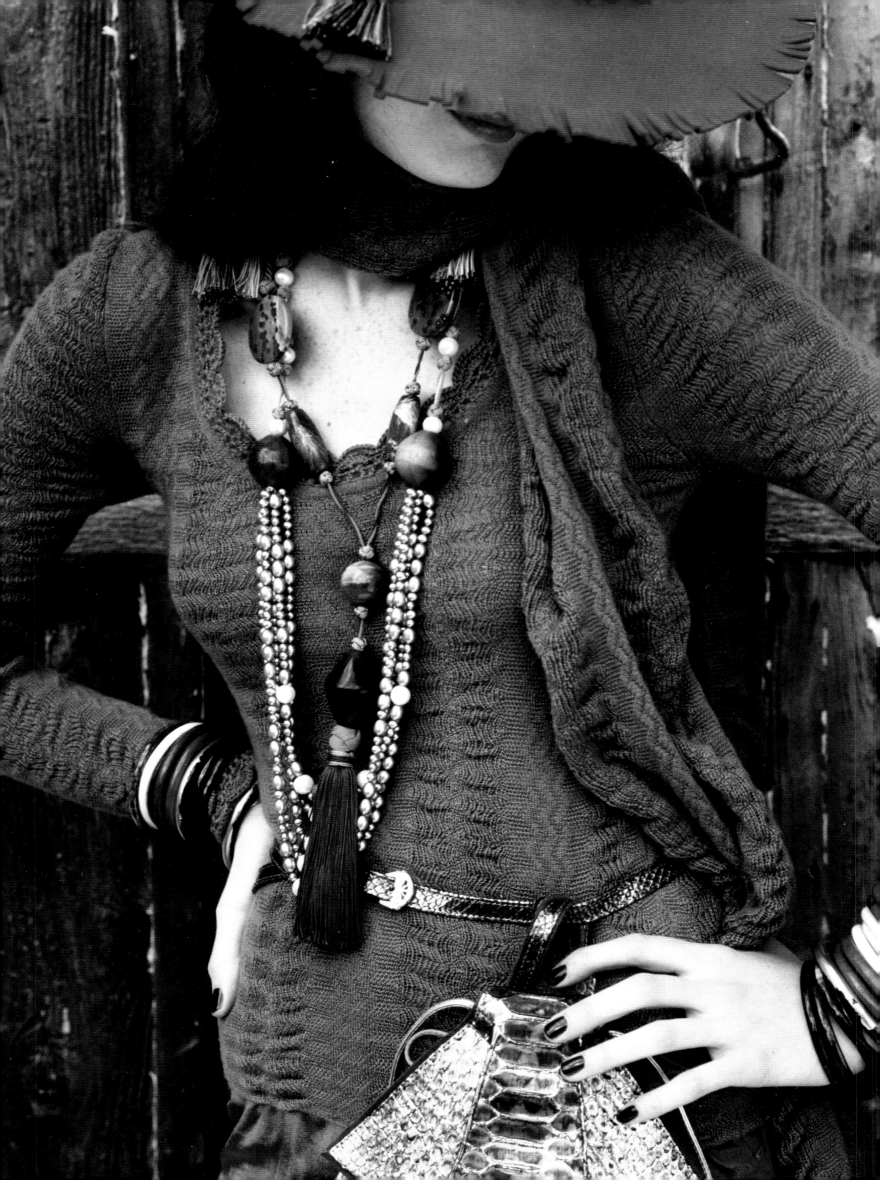

"With age, I realize how much Rhoda influenced me. I greatly admired her taste and eccentricity."

— Loulou de la Falaise

"Loulou's taste was madly personal, so joyous and poetic." — Betty Catroux

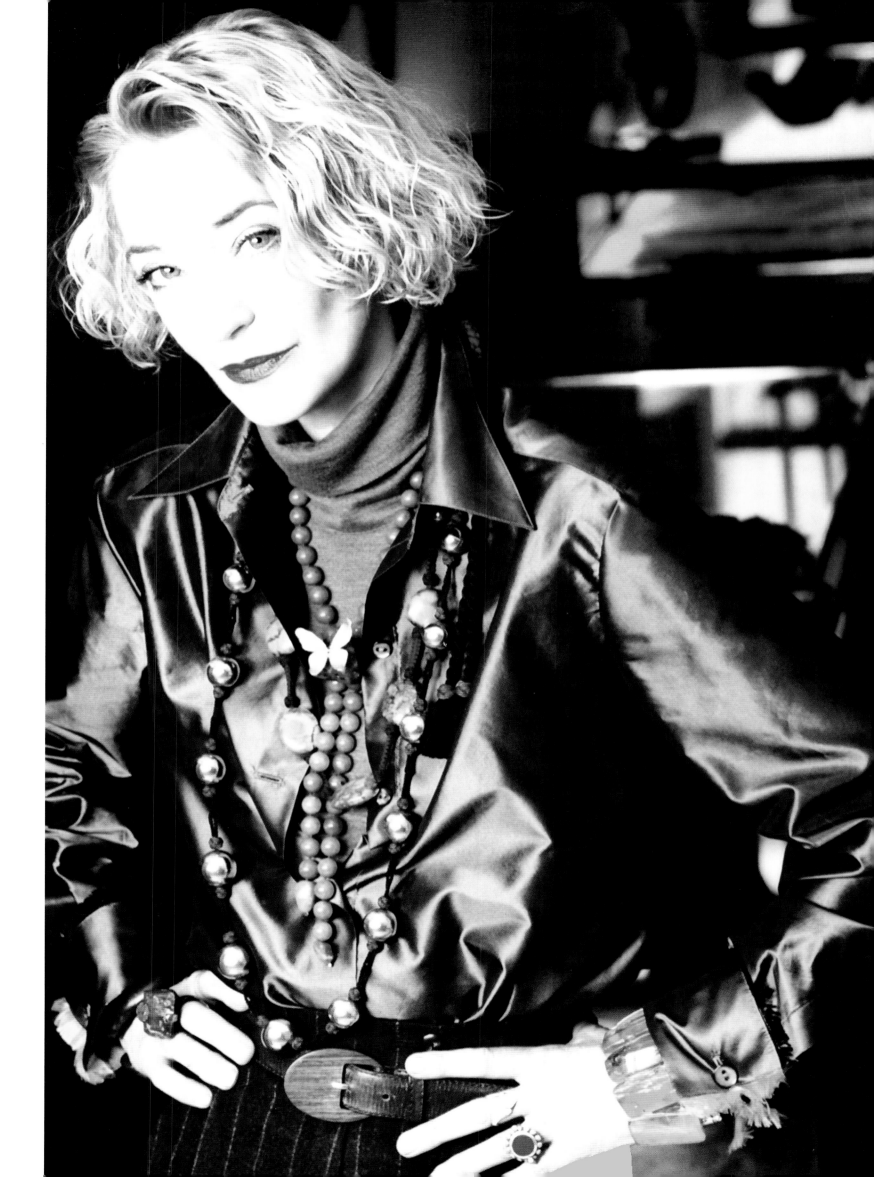

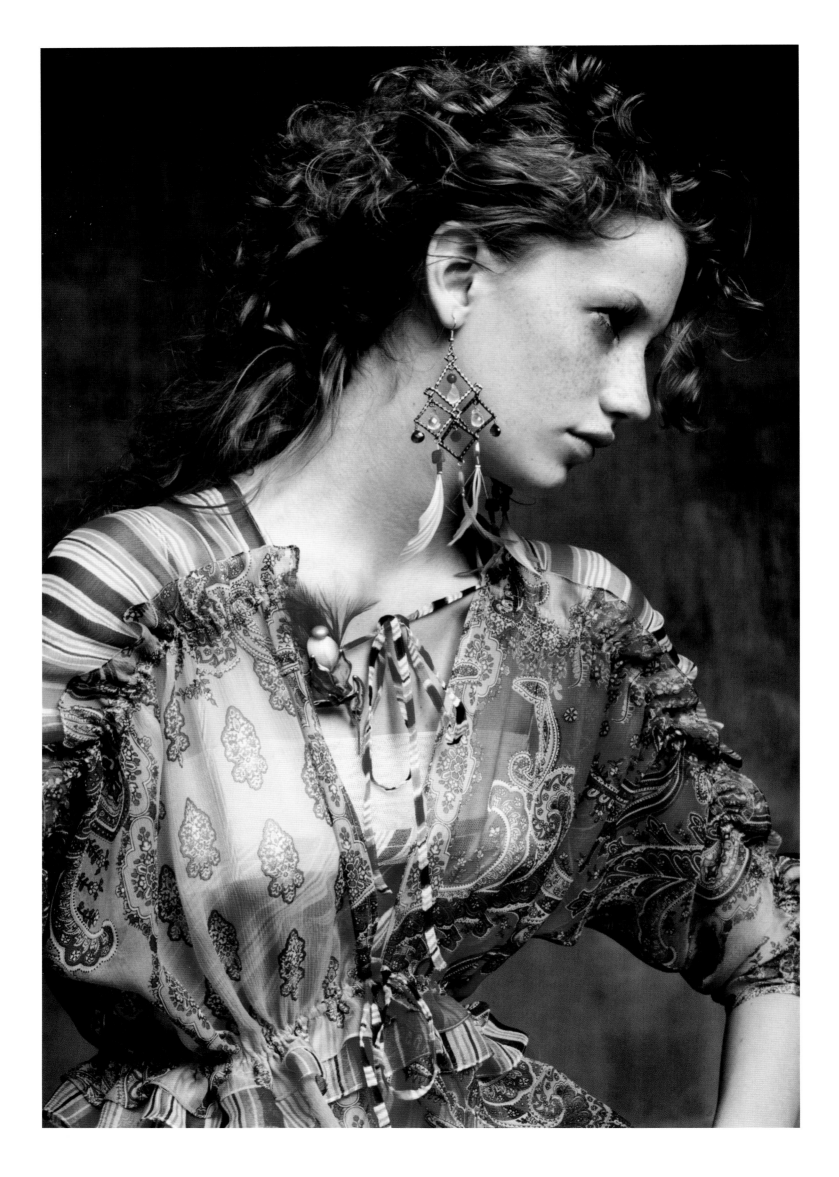

" Loulou used shapes and stones that implied pure fantasy and myth."

— Virginie Thevenet

In 2004, Loulou and her family suffered another blow when they lost Alexis, who died of lung cancer. "She was devastated and it was horrible," recalls Anna. Two years later, Loulou's close friends Luigi d'Urso and Fernando Sanchez passed away. Meanwhile, although Bergdorf's kept on with her jewelry, they stopped carrying her clothes. "The later collections were less focused and harder for us," says Burke. "In spite of her impeccable taste, Loulou could not be bothered with the details of the business." Little or no attention was paid to items that were selling, attention that is fundamental to furthering a fashion line. And the poor financial climate didn't help. "It's a shame that Loulou didn't just concentrate on jewelry," says de Givenchy. "What she did for Yves Saint Laurent was sublime and no one was doing the equivalent." Nevertheless, Bella Freud questions if it was a matter of timing. "Loulou's shop was too early and she got the worst end of fashion," the designer says. "Curiously enough, I think her clothes would work now."

At the end of 2006, due to mounting debts, Loulou was forced to pull the plug on the rue de Bourgogne boutique. No doubt, it took a toll on her health. "Having her own brand and boutique was much more exhausting than she thought," says Louboutin. "But being Loulou, she always laughed and found the funny side."

And being Loulou, she was snapped up by Oscar de la Renta in 2007 to design a fine jewelry colletion. "What was wonderful about working with Loulou was her gentle manner when expressing her opinion," says de la Renta. "As a result, I trusted her eye." Loulou worked in India with the jeweler Mahesh Bharany, who describes the experience as a professional high point that changed his concept of color combinations, designs, and approach to materials. "She would draw so fast that watching her churn out those sketches was unbelievable," he recalls. "Every page was a work of art. While we were just pondering over a concept, she would have drawn a few pages of designs from necklaces to pins to bracelets and earrings, each piece more creative than the next."

The fine jewelry line was then followed by a costume jewelry collection for de la Renta, which accessorized his designs with "her innate style." "Ten days beforehand, she'd arrive here in the studio and, oh my goodness, she was so inspiring," says the designer. "Loulou was a true original with unbelievable refinement."

An enamel butterfly on a necklace of pearl, fluorite, amethyst, and crystal.

"*Butterflies for her jewelry came so naturally to Loulou. She was enchanted by their movement, delicacy, and, of course, their extraordinary colors.*"

— Ariel de Ravenel

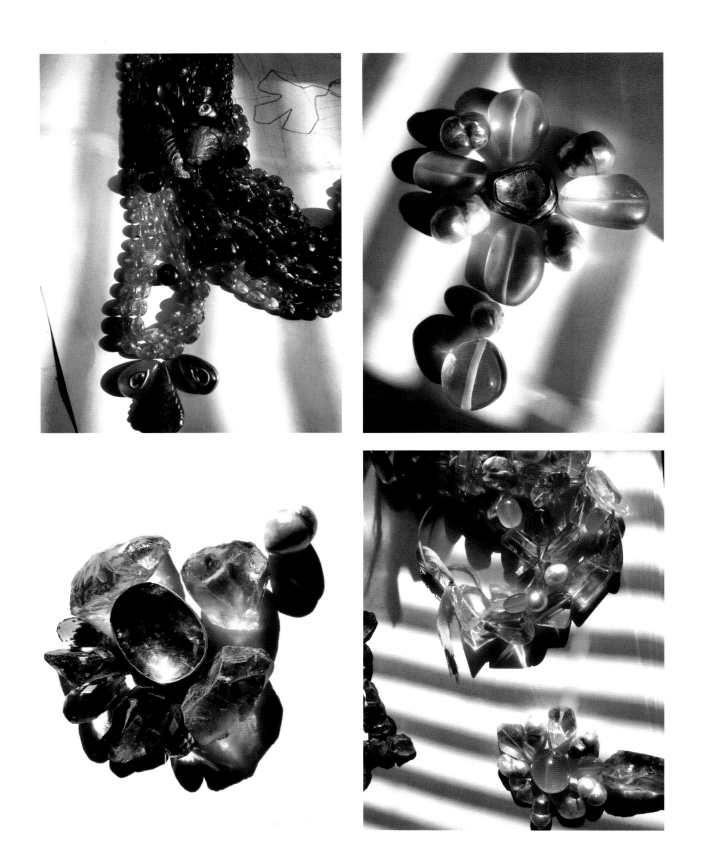

" Luxurious gypsy was the idea behind the fine jewelry line; I knew Loulou would be the perfect fit."

— Oscar de la Renta

"Under that fabulous vernis, Loulou was much simpler than she seemed.
She saw the essential and went straight for it."

— Jean-Charles de Ravenel

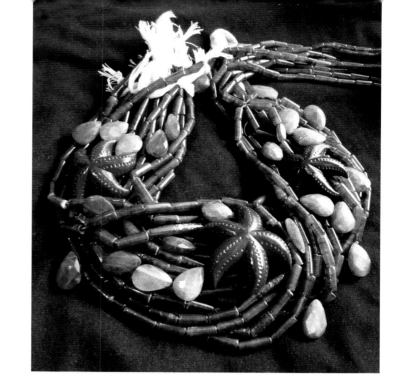

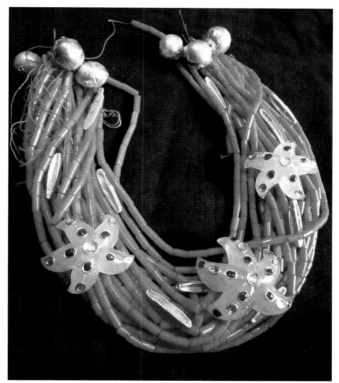

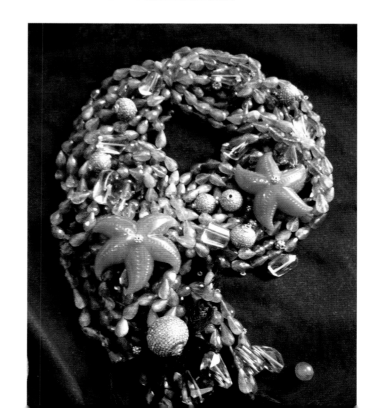

Around the same period, Loulou was approached by the Home Shopping Network. "Loulou goes from muse to mass," *Women's Wear Daily* reported. "I've always liked doing things that are affordable," Loulou told the fashion publication in 2008. "And when you've worked a lot in high luxury, you long to do things that are accessible for a wider market." The items offered on the network included color separates, jewelry featuring pearls, silk, wood, and horn, and bags woven out of soft leather. Although Mindy Grossman, Home Shopping Network's CEO, describes Loulou as "truly special and unique," and Loulou referred to the experience as "very inspirational and great fun," her accessories were deemed too rarefied. Nevertheless, Loulou enjoyed driving around Florida with de Ravenel (who had become her business partner) "pretending we were *Thelma & Louise*." "Whatever the situation, Loulou and I always found a reason to laugh, and we laughed a lot!" says de Ravenel.

Loulou's attitude impressed fellow creators like Louboutin. "She was adventurous and got off on the 'fish out of water' experience," he says. However, her friend Verde Visconti was mildly worried by her appearance. "I said 'Why are you doing this?'" recalls Visconti. "She looked so thin and worn." But Loulou was enjoying her American experiences and, more than anything, she was creating, which kept her going. Loulou was of the school of thought that "I can just put makeup on and I'll be fine."

Other highlights of this era included designing a line of home objects for Asiatides, the specialist in Asian furniture; two jewelry collections for L'Eclaireur, the upmarket multibrand boutique on the Right Bank; and, in November 2010, creating another line for Liwan, the hip Parisian store on the Left Bank. Charmed by Loulou's "lack of pretension," Liwan's owners Lina Audi, Dina Haidar, and Christine Bergstrom were awed by "her statement necklaces" and how she emanated "joy and lightness." Five months later, Loulou was the artistic director behind the triumphant Yves Saint Laurent *Rive Gauche* exhibition at the Pierre Bergé–Yves Saint Laurent Fondation. Loulou had all the mannequins painted Matisse colors for the occasion, the needed éclat that furthered Saint Laurent's genius and livened up the well-chosen group of iconic pea coats, smokings, and trench coats. "I was taken aback by how contemporary the clothes were, particularly the early pieces," Loulou then said.

"Loulou never thought about her style. It was natural, organic and done in ten minutes."
— Marisa Berenson

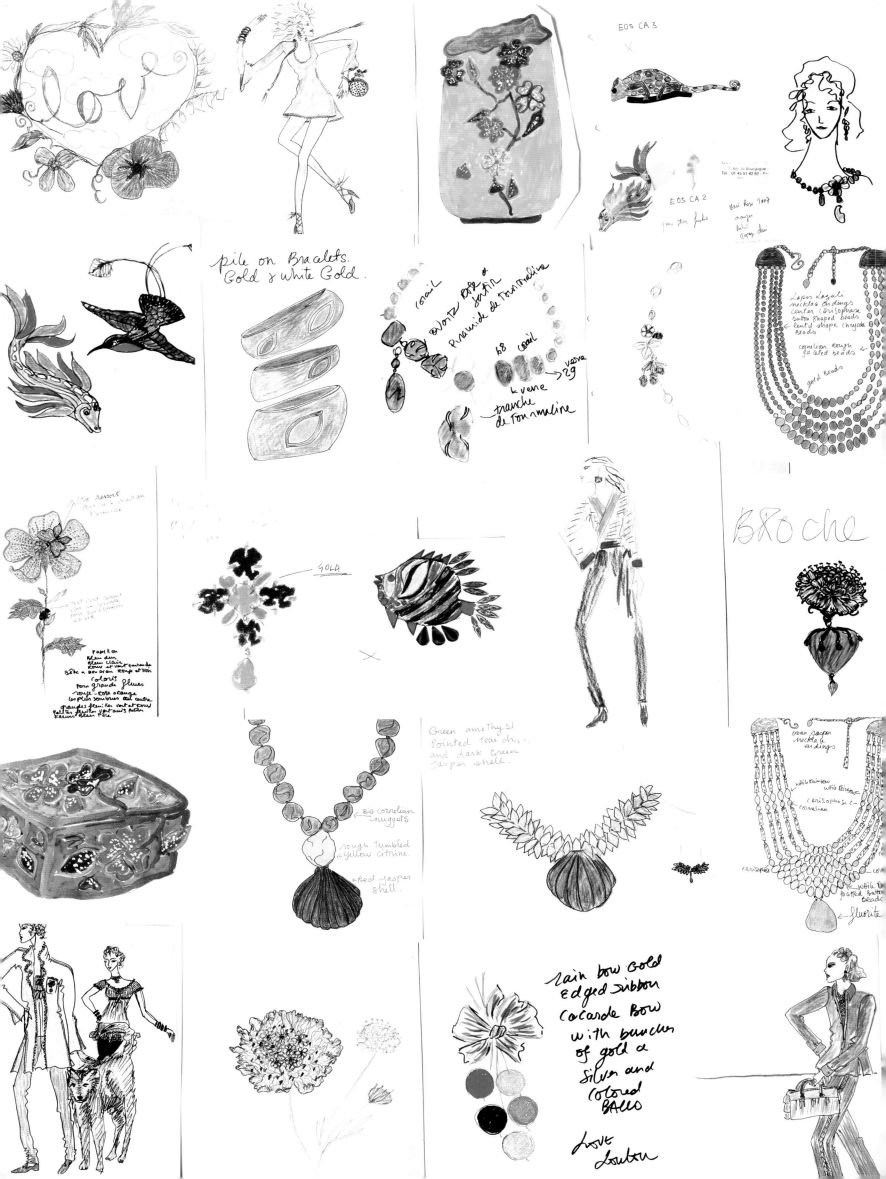

"Loulou asked for nothing and gave so much."

— Charlotte Aillaud

"Loulou had a talent for living. I miss her."

— Marie Beltrami

"What impressed me most about Loulou was how brave she was. She also possessed a wonderful talent for adapting."

— Gwendoline Bemberg

"I always admired Loulou. She was such a force in the fashion world, and so 'Studio 54'—it was only logical that I name a nightclub after her."

— Robin Birley

"Loulou's soul was so rare, she was inspired and inspiring."

— Betty Catroux

"Thadée always watched Loulou with such tenderness and love. I have never seen a man laugh and smile as much while looking at his wife."

— Ines de la Fressange

"Loulou had so much energy, she pushed our family to be active and saw inspiration in everything."

— Harumi Klossowska de Rola

"Balthus enjoyed Loulou's British nonsense and cosiness, he used to laugh and laugh and loved her beauty."

— Setsuko Klossowska de Rola

"Loulou was generous to a fault."

— André Leon Talley

"Loulou's never explain and never complain was very chic."

— Christian Louboutin

"Loulou is very much missed. We still yearn for her beauty, nonchalance, inspiring style, her colors, her voice, and her sweetness."

— Jean-Baptiste Mondino

"Loulou possessed the wonderful gift of bouncing back and looking forward."

— Virginie Thevenet

*"My garden is where I find inspiration. I'm always on the go, but in my house
in the Vexin I know how to take time to do nothing."*
— Loulou de la Falaise

"All birds were special to Loulou. She was always feeding them and loved to hear them sing."

— Ariel de Ravenel

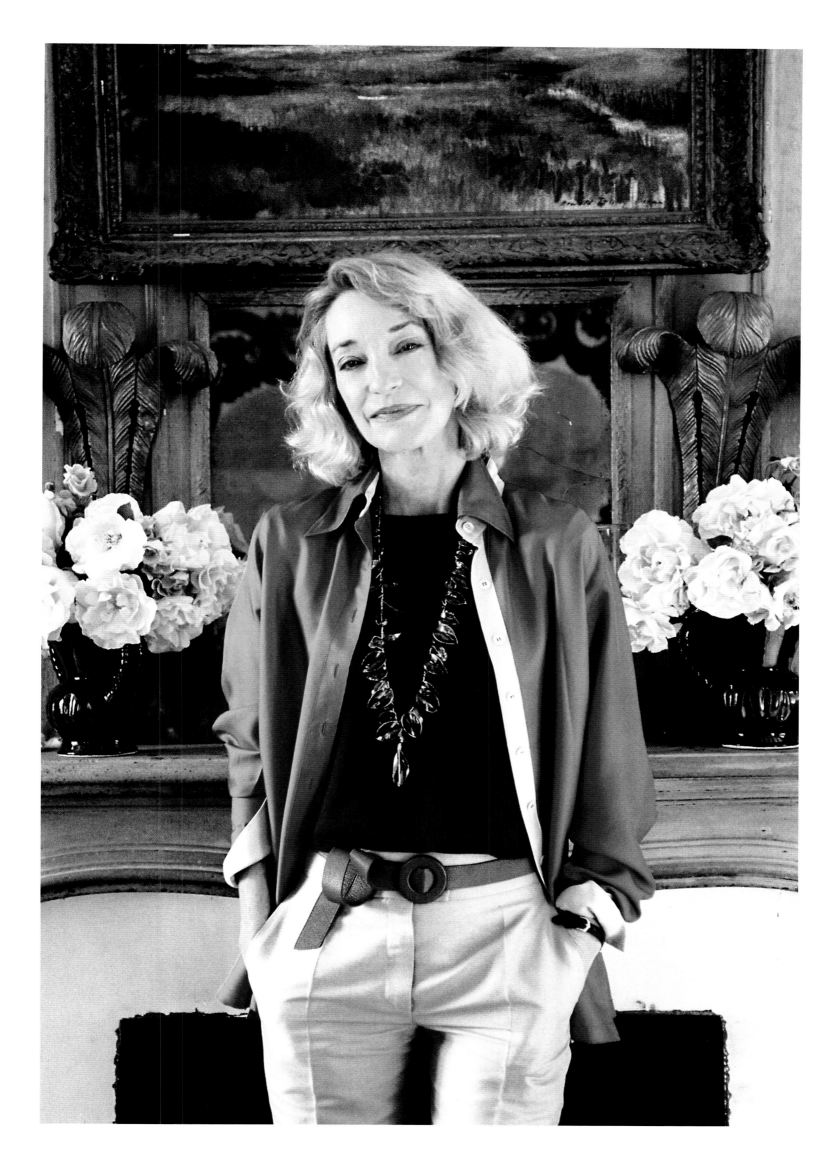

Loulou photographed at home in Paris by Ali Mahdavi, 2003.

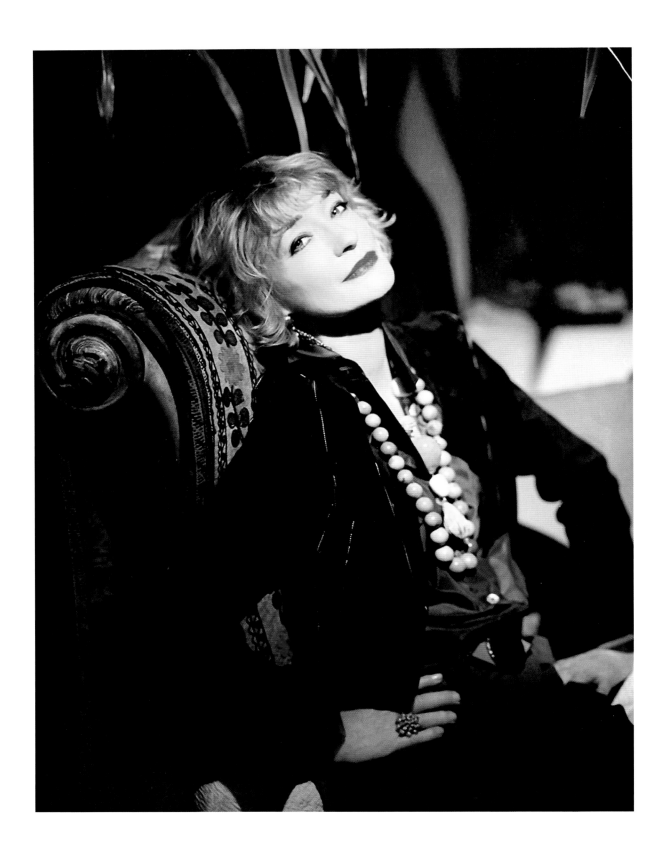

"Loulou proved that kindness was elegance. I was so intimidated when we met but she immediately put me at my ease."

— Ali Mahdavi

"She glowed with sweetness and intelligence. You always wanted to follow Loulou wherever she was going . . ."
— Haider Ackermann

"Loulou remains one of the key figures of 21st century fashion. Her influence is both extraordinary and significant."
— Hamish Bowles

"She was an amazing, amazing person, no wonder Yves Saint Laurent loved her."
— Grace Coddington

"Loulou had exquisite taste and was always the most chic woman in the room. Her heart and her wit are unforgettable."
— Francisco Costa

"Loulou was the real thing. It was not just style and chic but serious intelligence."
— Patrick Demarchelier

"I got to know Loulou during the freezing New York winter of 2009. She and Ariel would pass through town on their way to Florida where Loulou regularly appeared on HSN to sell her jewelry. Ariel was her manager. They were quite a funny double act – someone should have made a TV series.

We would set out for dinner in subzero temperatures and the two of them kept me going during a long lonely Broadway season. It felt to me as if we were a group of émigrés from another time, braving it in a world we no longer quite understood, but having a spirited thrash at it nonetheless. (At least they were.) Loulou looked like an exotic medium coiled in mysterious jewels and Ariel was her spirit guide. I was the whiny third party. Like me she forgot everything – keys, passport, purse – and we all spent hours searching before hitting the street going through our moves.

She must have known the clock was ticking by then but she never let on, never flagged. She was always interested and enthusiatic about what everyone else was doing, still curious about the world. The last time I ever saw her was at my fiftieth birthday party. A disparate group from across my life, all for some reason or other beached in Manhattan, no one knowing anyone else. Loulou sat in the middle and was the life and soul of the party. She had a way with people, simple and honest, like a teenager in a way. I didn't see her again."
— Rupert Everett

"*Loulou's inimitable style was a contrast of frivolity, fragility, and bubbly exuberance.*"
— Terry de Gunzburg

"*This serious artist knew how to have fun and create fantasy around herself.*"
— Carolina Herrera

"*My photograph of Yves and Loulou was taken from the back in an intense moment. I was very much aware of the depth of their shared feelings and that there was no space between them.*"
— Dominique Issermann

"*Often you're disappointed by your idols but Loulou's charm and magnetism went way beyond what you ever imagined.*"
— Rabih Kayrouz

"*When we eventually met, it was as if Loulou and I had known each other all our lives.*"
— Rifat Özbek

"*Loulou could take a three-dollar T-shirt and make it look like a billion. That's a special gift.*"
— Oscar de la Renta

"*Loulou is still my inspiration. No one could achieve eccentricity with elegance like Loulou.*"
— Mario Testino

"*I was familiar with Loulou's class and beauty from seeing her on TV from time to time as a child. Her voice, style, and Parisian way so perfectly embodied the aura of Yves Saint Laurent's world that I instantly understood how much a muse means to a 'créateur'. I met Loulou in my late twenties, and I can't measure the privilege it was to spend time, have fun, and enjoy many laughs with this woman who I'd always admired and considered an absolute reference.*"
— Olivier Theyskens

"*Loulou was a talented designer in her own right, a muse, a bohemian aesthete and I always greatly admired the role she played in Yves Saint Laurent's life as a dear friend.*"
— Dries Van Noten

Loulou's glass paste and crystal drop earrings, photographed by Rose Deren.

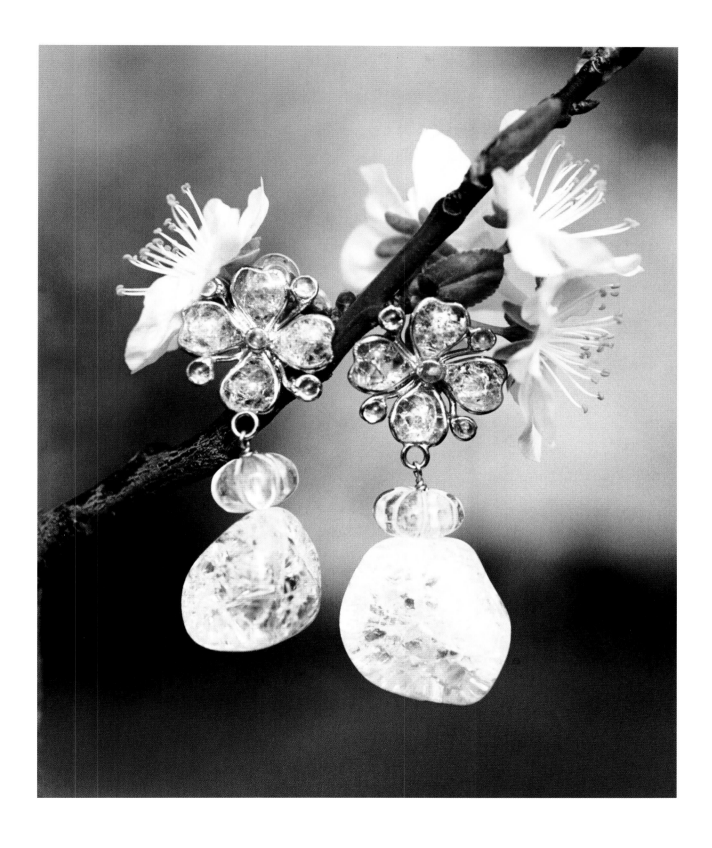

Tragically, that summer Loulou became terminally ill with liver cancer. "She kept it secret to protect her daughter, Anna," says de Ravenel. "She melted away in front of our eyes," says her niece Lucie. Having moved permanently to Boury, farewell lunches were held in the garden, organized by de Ravenel. "It was the most beautiful day," says Elie Top, referring to their last meeting. "No mention was made of her illness but we all knew." John Stefanidis described the experience as "heart wrenching." "But I came away admiring how uncomplaining she was," he says. Meanwhile, Loulou continued to create. "It gave her energy," recalls de Ravenel. "I conjured up things for her to do and was amazed by her capacity to still make everything she touched beautiful." She was also overjoyed when she was asked by Pierre Bergé and Madison Cox to create a collection for the Jardin Majorelle.

In the last weeks, Anna thought they needed to have "a final talk." "I said, 'Do you have any advice that you want to offer me? And Maman looked at me horrified and said, 'What are you talking about?' She was not into my melodrama or counting the days she had to live." Anna turned twenty-six years old ten days before her mother passed away. "Maman said, 'I have a present for you — it's in the dresser,'" she recalls. "I couldn't find it, presumed 'oh she's forgotten' and so I lied and said how lovely it was. But after she died, I found the package. Inside was a pair of beautiful Indian earrings."
Loulou de la Falaise: brave and thoughtful to the end.

"I was in awe of my mother's energy, strength, and how she helped and protected people."
— Anna Klossowski

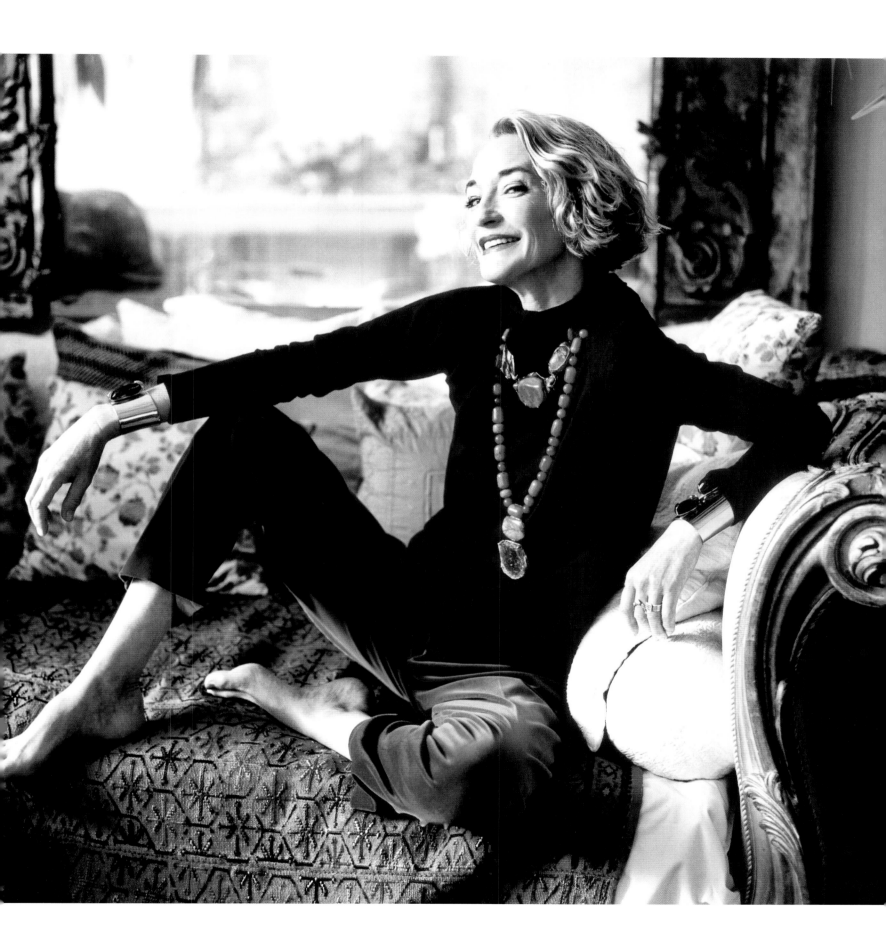

Thadée and Loulou in the courtyard of Palazzo Farnese, Caprarola, Italy. Photograph by Gwendoline Bemberg, 1977.

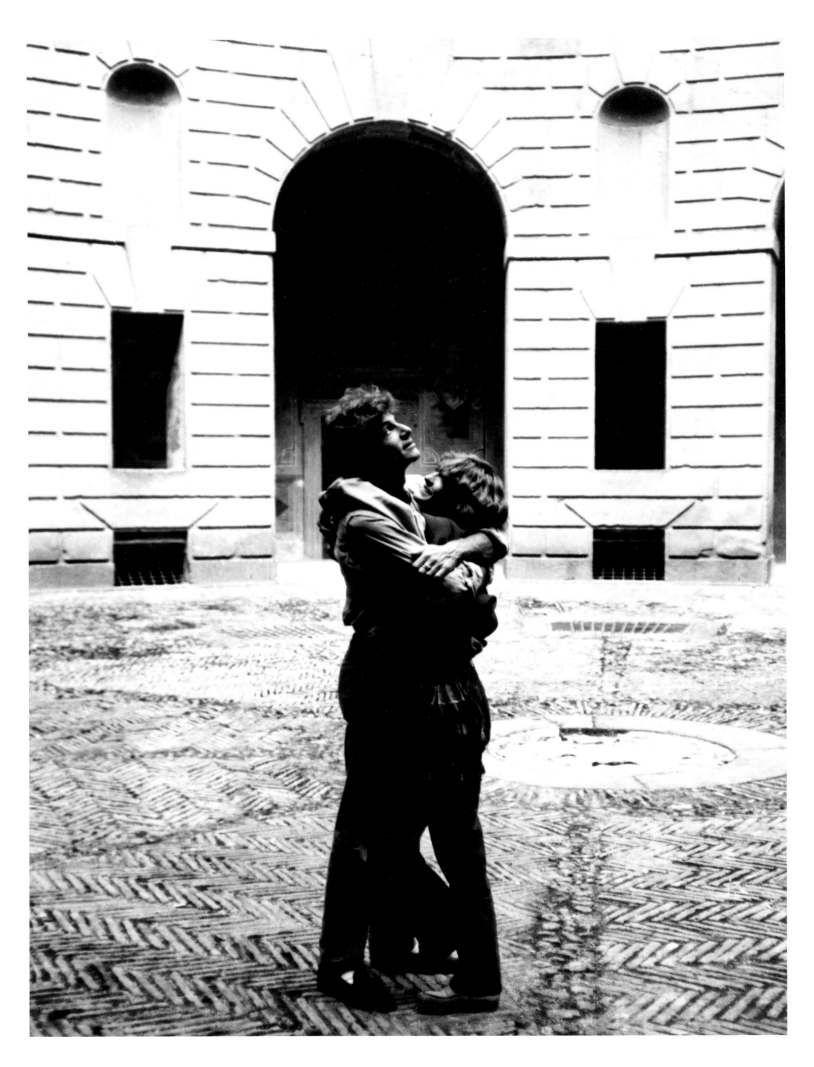

MY LOULOU

Fred Hughes (a young man with slick hair) once complained: "She's so excessive, it always ends up in a fist fight". Answered Loulou, grinning: "I have too much energy!"

Then she'd get very ill and, the faster to escape sermonizing, hurry herself back into long lasting mode (she would be nicknamed Duracell – a brand of extra-strong batteries – by the population of a little gay bar in Avignon, when she'd out-danced every one). She loved telling me of this chirpy toddler she had seen, who kept falling quite hard only to jump up again with a reassuring shout: "Doesn't matter!" – Loulou imitated him with relish: "Doesn't matter!"

In December 1972, she was recovering from her first bout of hepatitis (either from diving into the Nile while on a cruise with Ricardo Boffill, who admired her recklessness, or from dancing barefooted on broken glass in Mykonos with Hiram Keller, who was terrified): rue de Babylone, in a charming suite of *chambres de bonne* belonging to Yves and Pierre's apartment. Here she was, the tomboy, the daredevil, the mad reveler, resting. Almost plump. I adored her. I would visit her in the afternoon, sometimes share her early dinner (lovely baby food brought from downstairs by Yves's valet), and we'd smoke a joint and tease each other about our respective love lives, cry over *The Secret Garden* or talk of Virginia Woolf. We both had jumped for joy at the same paragraph in Quentin Bell's biography of Woolf, where her depressed father goes slowly up the stairs and moaning immensely: "Oh, why won't my whiskers grow?" – a delightful phrase that, in later years, she would throw at me if I dared look anguished.

Nearly twenty years later, when our daughter Anna was about six, we used to watch a cartoon with her – *Brave Little Choo-choo*? – where a small red steam-engine saves a whole train from catastrophe, such a courageous grin on its funny, panting red face, and I'd tell Anna: "See, Choo-choo looks just like your mom!" Well, that's one way of summing up Loulou's professional life: Brave Little Choo-choo!

Holidays, after our marriage, were spent mostly in Montecalvello, the dream castle (on very gracious loan from Balthus): drives and walks into the sensational landscape, endless sightseeing, hilarious times with marvelous friends. . . . Everyday Loulou would take me sauntering down the ravine below the walls, loading me, as she went, with ever-growing bouquets of wild flowers and prickly stuff, and then we'd lay down on the moss in a miraculous clearing with views like in the frescoes above, and we'd bask in our luck. Oh, my darling, you were so happy! My Loulou so sweet, so obstinately childlike. Now I bring these *fleurettes* that you loved to the center of the clearing, to the mossy obelisk we placed there for you, when we dispersed your ashes under the bright sky, amid all the merry chirping birds . . .

I write this in Loulou's garden, under the beautiful Ile-de-France sky. Precocious spring. I listen to the merry chirping birds. In the crisscross of bird songs, something is woven, something vibrates, something uplifts, something I recognize – I say: "Loulou?"

> flying high
> up in the trees up
> the deep deep sky

— Thadée

Loulou will always be remembered with her arms filled with a mix of bangles and her famous Afghan cuffs. Photographed by François-Marie Banier, May, 1980.

ACKNOWLEDGMENTS

I first met Loulou in 1969. She was a star in every sense, and she had a heart of gold. To capture Loulou's magic, I relied on many and want to thank all for their belief in my ability to achieve it.

First and foremost, I want to thank Thadée and Anna Klossowski, and also Pierre Bergé. I am immensely grateful for their immediate warm response. Their unquestioning trust and support have been truly amazing. This book would not have been possible without their blessings.

Working with Alexandre Wolkoff, the book's art director, has been a joy, due to his kindness, patience and creativity. The same applies to Natasha Fraser-Cavassoni who has been a dream to work with, due to her profound understanding of Loulou, her countless connections and her talent as a writer. Both were patient, generous and inspiring. I thank them deeply for helping me capture the essence of Loulou through the wonderful images of all the contributing photographers and the memories of her friends and family, and for making the journey truly fulfilling.

In addition I want to give a heartfelt and profound thank you:

To Madison Cox for his precious help and unfaltering friendship.

To my friends at the Pierre Bergé-Yves Saint Laurent Foundation: Philippe Mugnier, Dominique Deroche, Connie Uzzo, Olivier Segot, Laetitia Roux, Pauline Vidal, Catherine Gadala, Laurence Neveu, Pascal Sittler, Olivier Flaviano, Simon Freschard, and Alice Coulon. Their help has been invaluable.

To the brilliant Wolkoff & Arnodin team, who hosted me in the office, and particularly to Antoine Arnodin for being so generous and making me feel welcome at all times.

To Emmanuelle Miramand-Kaidi and Jean-Marie Picart who helped me so considerably in organizing documents and material.

To Alain Coblence for his friendship, generosity, and dedication to both Loulou and me.

This book was extremely gratifying but also occasionally challenging and Natasha and I relied on the support and humor of our team at Rizzoli, namely Anthony Petrillose, Caitlin Leffel, Julie Schumacher, Maria Pia Gramaglia, Kayleigh Jankowski and Supriya Malik, as well as Catherine Bonifassi and Vanessa Blondel in Paris. Charles Miers's early enthusiasm and constant encouragement throughout the project were hugely comforting. All caught Loulou fever and excelled in executing the book.

Throughout her life Loulou's exquisite style and beauty was captured by so many great photographers. Our special thanks to: David Bailey, Alexandre Bailhache, Hélène Bamberger, François-Marie Banier, Gilles Bensimon, Roland Beaufre, Eric Boman, Elisabetta Catalano, Pascal Chevallier, Bob Colacello, Rose Deren, Arthur Elgort, Martine Franck, Eric Gallais, Jean-François Gaté, Oberto Gili, Umberto Guidotti, François Halard, Marie Hennechart, Françoise Huguier, Jean-Luce Huré, Dominique Issermann, Bruno Jarret, Jean-François Jaussaud, Tim Jenkins, Lynn Karlin, Vincent Lappartient, Jean Larivière, Dominique Lauga, Annie Leibovitz, Peter Lindbergh, Roxanne Lowit, Ali Mahdavi, Gerard Malanga, Guy Marineau, Jean-Pierre Masclet, Nicolas Mathéus, Steven Meisel, John Minihan, Jean-Baptiste Mondino, Philippe Morillon, Carlos Muñoz-Yagüe, Gianni Penati, Andre Perlstein, Jean Pigozzi, Priscilla Rattazzi, Andre Rau, Bettina Rheims, Michael Roberts, Jack Robinson, Patrick Sauteret,

Peter Schlesinger, Stewart Shining, Alexia Silvagni, Christopher Simon Sykes, Alice Springs, Sophie Steinberger, André Leon Talley, Mario Testino, Yutaka Yamamoto, and Mike Yavel.

Both Natasha and I are hugely grateful to the following for keeping Loulou alive: Charlotte Aillaud, Haider Ackermann, Lina Audi, Catherine Baba, Agnès Boulard, Marie Beltrami, Gwendoline Bemberg, Louis Benech, Gilles Bensimon, Marisa Berenson, Christine Bergström, Mahesh Bharany, Robin Birley, Celia Birtwell, Eric Boman, Manolo Blahnik, Hamish Bowles, Leonello Brandolini d'Adda, Joan Juliet Buck, Robert Burke, Beatrice Caracciolo, Betty Catroux, François Catroux, Carlyne Cerf de Dudzeele, Grace Coddington, Bob Colacello, Sofia Coppola, Madison Cox, David Croland, Vincent Darré, Patrick Demarchelier, Catherine Deneuve, Alicia Drake, Rupert Everett, John Fairchild, Marianne Faithfull, Daniel de la Falaise, Lucie de la Falaise, Robert Forrest, Antonia Fraser, Shelley Fremont, Vincent Fremont, Ines de la Fressange, Bella Freud, Diane von Fürstenberg, Frank Giles, Hubert de Givenchy, Pamela Golbin, Annabel Goldsmith, Bettina Graziani, Mindy Grossman, Jacques de Gunzburg, Terry de Gunzburg, Dina Haidar, Carolina Herrera, Anjelica Huston, Lauren Hutton, Carolina Estrada Irving, Dominique Issermann, Jay Johnson, Grace Jones, Rabih Kayrouz, Michel Klein, Harumi Klossowska de Rola, Setsuko Klossowska de Rola, Stash Klossowski de Rola, Kenneth Jay Lane, Jean-Christophe Laizeau, Christian Louboutin, Roxanne Lowit, Hélène de Ludinghausen, Ali Mahdavi, Boaz Mazor, Marian McEvoy, David Mlinaric, Jean-Baptiste Mondino, Valentin Mordacq, Paul Morrissey, Kate Moss, Anne-Marie Muñoz-Yagüe, Dries van Noten, Robert O'Byrne, Rifat Özbek, John Pearse, Elsa Peretti, Paloma Picasso, Jackie de Ravenel, Jean-Charles de Ravenel, Rebecca de Ravenel, Oscar de la Renta, Constance Rebholz, Sir John Richardson, Bettina Rheims, Michael Roberts, Eric de Rothschild, Violetta Sanchez, Clara Saint, Charles Sebline, Stewart Shining, John Stefanidis, Frances Stein, Kenzo Takada, André Leon Talley, Mario Testino, Virginie Thevenet, Olivier Theyskens, Corey Grant Tippin, Elie Top, Susan Train, Stefano Tonchi, Danielle Vinmer, Verde Visconti, Nicole Wisniak, Kirat Young, and Vanessa van Zuylen-Menesguen.

And to the kindness of friends and acquaintances who helped us in many different ways: Joree Adilman, Doris Amor, Amélie de Andreis, Alex Anthony, Eugenia Bell, Caroline Berton, Kate Betts, Martha Botts, Annie Boulat, Penny Breia, Cian Brown, Liz Carbonell, Cynthia Cathcart, Robert Alan Clayton, Sandra Cohen Sousa, Elizabeth Covintree, Nichelle Dailey, Monica Adame Davis, Virginie Denaiffe, Nelly Dhoutaut, Claartje van Dijk, Marie Donnelly, Mary Farley, Gretchen Fenston, Lindsay Foster, Clémentine Gallix, Jorge Garcia, Marie-Laurence Gimeno, Alina Grosman, Yasmina Guerfi, Madison Harmer, Bettina von Hase, Alessa Herbosch, Jano Herbosch, Audrey Hoareau, Michael Van Horne, Karen Howes, Sasha Iglehart, Tony Kent, Asako Kitaori, Aline Lauvergeon, Kimberly La Porte, Dominique Lecourt, Valérie Lesauvage, Joanna Ling, Shereen Llewellin, Tiggy Maconochie, Katherine Marshall, Eleonore Marchand, Lucy Marsham, Victoria Martinez, Marlene Mayer, Leigh Montville, Maria Murguia, Richard Neel, Nicole Neltner, Michael Nisberg, Mathias Nouel, Dan Oppenheimer, Emily Oppenheimer, Férid Ouertani, Nathalie Ours, Lucien Pagès, Cristina Palumbo, Stefano Palumbo, Pierre Passebon, Maya Piergies, Bruno Pouchin, Paolo Raineri, Lori Reese, Fiona Da Rin, Barbara Rix-Sieff, Zachary Russell, Jeannie Rusten, Isabelle Sadys, Armelle Saint-Mleux, Raphael Santin, Valerie Santoni-Barussaud, Scott Sawyer, Patrick Scallon, Tasha Seren, Michael Shulman, Richard Sinnott, Amanda Smith, Jeffrey Smith, Massimo Sortino, Hannah Speller, Gregory Spencer, Jerry Stafford, Louise Stringer, Lorna Surtees, Shoko Takayasu, Misako Tamagawa, Guido Torlonia, Peter Tsidenkov, Roger Viollet, Andrea Vollmer-Hess, Billy Vong, Lucy Waitt, Gina Marie Whiterose, Molly Wicka, and Fiona Young.

The making of this book has been an emotional journey, Loulou died on November 5, 2011, and when Marc Beckman and Erin Hosier approached me in June 2012, I was still in deep mourning for my friend and everyday accomplice. It became instantly clear, however, that I had no choice. All through the process I was constantly reminded of Loulou's many extraordinary gifts, and this gave me hope and energy.

And finally, this considerable list of individuals would not be complete without a very special thank you to my beloved son Kim Rebholz for his enlightened comments and for being at my side at all times good and bad.

— Ariel de Ravenel

This book celebrating the life and talent of Loulou de la Falaise would not have been possible without Ariel de Ravenel. She was the motor throughout. Armed by the amazing talent of Alexandre Wolkoff, the project's art director, she was extremely clear about the book's vision, she was tireless about achieving it and also had the zillion contacts needed to bring it to fruition. True, I knew Loulou and felt lucky to interview her; she defined dream copy for a journalist. We also mixed in similar circles. However, Ariel brought another level of expertise and always proved a joy by being open-minded and inclusive. From A to Z, we had fun and shared quite a few jokes. I think Loulou would have approved.

In Chapter I, the magic of Rhoda, Maxime and Loulou was further enriched by the contribution of Robin Birley, Lucie de la Falaise, Antonia Fraser, Hubert de Givenchy, Frank Giles, Annabel Goldsmith, Bettina Graziani, Kenneth Jay Lane, André Leon Talley, John Richardson and Thadée Klossowski, Loulou's husband. Regarding Rhoda, I relied on two excellent articles, "*Vogue* Remembers Loulou de la Falaise" by Hamish Bowles and "A Better Class of Bedfellow" by Ursula Buchan.

Chapter II was brought to life via interviews with Marisa Berenson, Manolo Blahnik, Eric Boman, David Croland, Diane von Furstenberg, Corey Grant Tippin, Jay Johnson, Boaz Mazor, John Pearse, Elsa Peretti, Paloma Picasso, Peter Schlesinger, and John Stefanidis. A huge thank you also goes to Robert O'Byrne, the author of *The Last Knight*, who gave permission to quote from his superb biography on Desmond Fitzgerald.

Chapter III meant returning to members of the fabled Yves Saint Laurent fold. I refer to Gabrielle Buchaert, Betty Catroux, Dominique Deroche, Hélène de Ludinghausen, Anne-Marie Muñoz-Yagüe, Clara Saint, Charles Sebline, Danielle Vinmer, and Connie Uzzo. Other invaluable interviewees included Charlotte Aillaud, Marisa Berenson, Madison Cox, John Fairchild, Lucie de la Falaise, Marian McEvoy, Paloma Picasso, Kenzo Takada, Kirat Young, and Alicia Drake, author of *The Beautiful Fall*, the best book concerning Yves Saint Laurent's halcyon years. The latter also let me quote from her transcript with the late Fernando Sanchez.

Loulou was an inspired mother and had countless friends and admirers. For Chapter IV, I am grateful to Anna Klossowski, Loulou's daughter, Thadée Klossowski and the following for reaffirming Loulou's joie-de-vivre and sense of friendship: Charlotte Aillaud, Manolo Blahnik, Leonello Brandolini, Beatrice Caracciolo, Carolina Estrada Irving, Daniel de la Falaise, Lucie de la Falaise, Ines de la Fressange, Bella Freud, Diane von Fürstenberg, Madison Cox, André Leon Talley, Christian Louboutin, Paloma Picasso, Ariel de Ravenel, Bettina Rheims, John Richardson, John Stefanidis, Verde Visconti and Nicole Wisniak.

I still cannot believe that the lovely Loulou is no longer with us. Throughout this project, I kept on seeing her smile and hearing her laugh. She touched and helped so many. The difficulty of writing this final chapter was eased by the contributions of Lina Audi, Marisa Berenson, Christine Bergström, Mahesh Bharany, Manolo Blahnik, Leonello Brandolini, Robert Burke, Madison Cox, Lucie de la Falaise, Bella Freud, Dina Haidar, Mindy Grossman, Jean-Christophe Laizeau, André Leon Talley, Christian Louboutin, Oscar de la Renta, Ariel de Ravenel, Charles Sebline, John Stefanidis, Elie Top, Verde Visconti, and Anna Klossowski whose final anecdote continues to move me.

Finally, thanks to my darling daughters Cecilia and Allegra Cavassoni for their continued patience and my agents Ed Victor and Maggie Phillips who always score by being both positive and protective.

— Natasha Fraser-Cavassoni

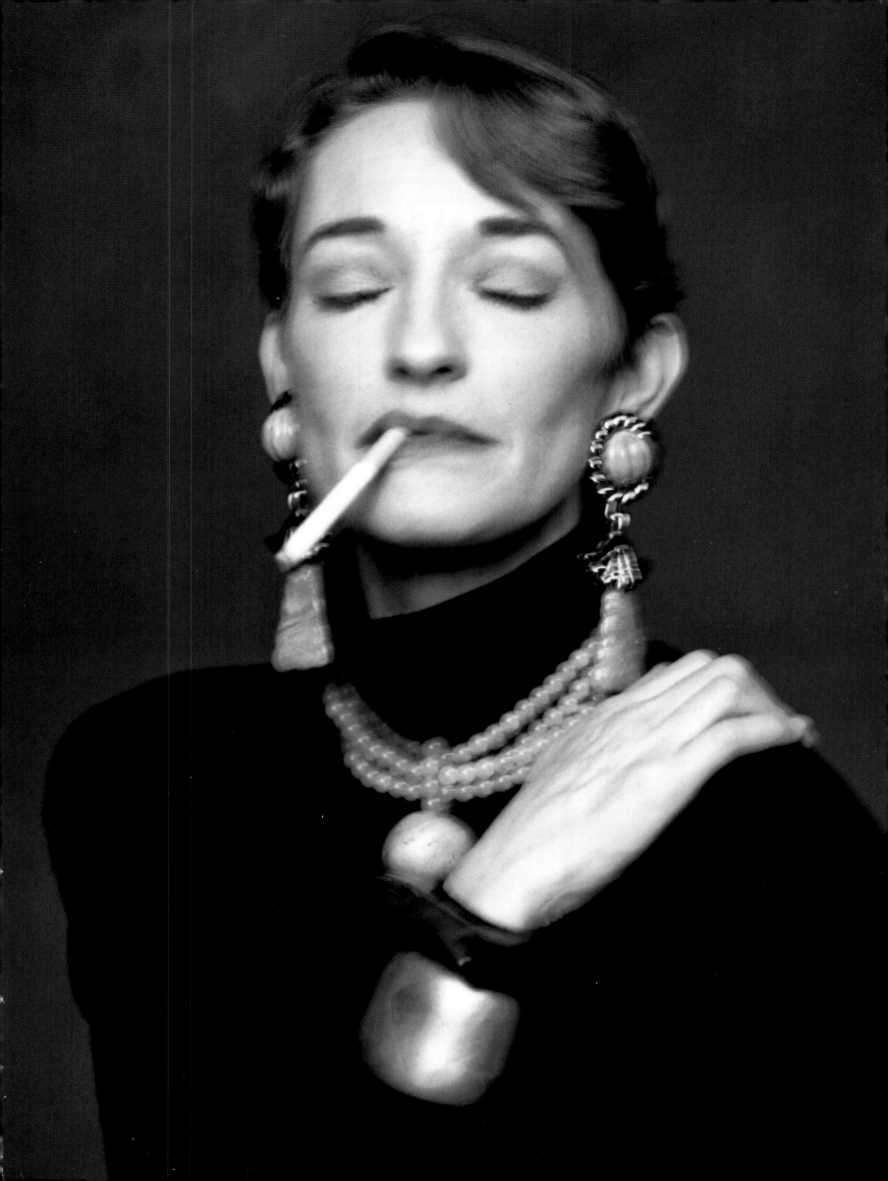

PHOTOGRAPHY CREDITS

TEXT CREDITS

Armstrong, Lisa. "Four Generations of style à la Falaise." *The Independent*, August 20, 1992.

Bluttal, Steven, and Patricia Mears. *Halston*. London: Phaidon, 2001.

Bowles, Hamish. "Vogue Remembers Loulou de la Falaise." *Vogue*, November 7, 2011.

Buchan, Ursula. "A Better Class of Bedfellow." *The Daily Telegraph*, May 4, 2007.

Buck, Joan Juliet. "Blithe Spirit." *W Magazine*, February 2012.

Colacello, Bob. *Holy Terror*. New York: Harper Collins, 1990.

Cutter, Kimberly. Pierre Berge Interview – Life With Loulou de la Falaise – Harper's Bazaar.com Jan 9 2012

Drake, Alicia. *The Beautiful Fall: Fashion, Genius and Glorious Excess in 1970s Paris*. London: Bloomsbury, 2006.

Dupont, Pepita. "Helmut Newton: le Scandaleux de Berlin." *Paris Match*, February 19 – 25 2004.

Fox, Margalit. "Maxime de la Falaise, Model, Designer and Muse, Is Dead at 86." *New York Times*, May 2, 2009.

Fraser, Natasha. "The Last Queen: Marie-Hélène de Rothschild." *W Magazine*, May 1996.

———. "The Other Side of Loulou." *W Magazine*, August 5 – 12, 1991.

Fraser, Natasha and William Middleton "'70s Paris, The Party Years." *W Magazine*, March 1997.

Grant, Maud. "Loulou Surnaturelle" *Stiletto*, Spring 2004.

von Hase, Bettina. "Loulou & Thadée Klossowski." *Interview Magazine*, 1984.

Hume, Marion. "The Eminence Chic." *The Independent on Sunday*, December 20, 1992.

Koski, Lorna and Natasha Fraser. "The Battle of Versailles." *W Magazine*, September 1993.

Lau, Venessa. "Two of a Kind." *W Magazine*, June 2008.

Leon Talley, André. "Red-Letter Wedding Day." *WWD*, May 10, 1978.

———. "Maxime de la Falaise, 1922 – 2009." *Vogue*, May 15, 2009.

Menkes, Suzy. "Old Guard and New Cross Swords at Saint Laurent." *International Herald Tribune*, October 3, 2000.

McEvoy, Marian. "Quality People – Maxime de la Falaise and Loulou de la Falaise." *W Magazine*, Oct 17 – 24, 1975.

———. "Family with Style." *W Magazine*, July 23 – 30, 1976.

O'Byrne, Robert. *The Last Knight: A Tribute to Desmond Fitzgerald, 29th Knight of Glin*. Dublin: The Lilliput Press, 2013.

Pigozzi, Jean. *Pigozzi's Journal of the Seventies*. New York: Doubleday, 1979.

Reginato, James. "Chateau Loulou." *W Magazine*, February 2000.

Tell, Caroline. "Loulou de la Falaise Line Heads to HSN." *WWD*, February 12, 2008.

Wasem, Frances. "A Life in Style." *Harper's & Queen*, October 2005.

Wilson, Eric. "Fernando Sanchez, Fashion Innovator, Is Dead At 70." *New York Times*, July 3, 2006.

First published in the United States in 2014 by

Rizzoli International Publications, Inc.

300 Park Avenue South

New York, NY 10010

www.rizzoliusa.com

ISBN: 978-0-8478-4329-9

Library of Congress Number: 2014936163

2014 2015 2016 2017

10 9 8 7 6 5 4 3 2 1

Printed in China